Intelligent Machines as Racialized Other

Min-Sun Kim
김 민선

Intelligent Machines as Racialized Other

Toward Authentic Encounters

PETER LANG

New York · Berlin · Bruxelles · Chennai · Lausanne · Oxford

Library of Congress Cataloging-in-Publication Control Number: 2024004150

Bibliographic information published by the Deutsche Nationalbibliothek.
The German National Library lists this publication in the German
National Bibliography; detailed bibliographic data is available
on the Internet at http://dnb.d-nb.de.

Cover design by Peter Lang Group AG

ISBN 9781433198625 (paperback)
ISBN 9781433198618 (hardback)
ISBN 9781433198632 (ebook)
ISBN 9781433198649 (epub)
DOI 10.3726/b21808

© 2024 Peter Lang Group AG, Lausanne
Published by Peter Lang Publishing Inc., New York, USA
info@peterlang.com - www.peterlang.com

This publication has been peer reviewed.

सत्यमेव जयते
Satyameva Jayate

'Truth alone triumphs'

~ from *Mundaka Upanishad*

CONTENTS

PREFACE

Our narratives about intelligent machines reprise the same modes in which humans have historically dealt with "other" groups of humans, especially during the era of colonialism. *Intelligent Machines as Racialized Other* invites the reader into the world of new technology, to travel many paths, and explore the many routes that traverse historical narratives of racialization and colonization with our perspectives on intelligent machines.

In a world where we are all coming to terms with our unconscious assumptions about racism, sexism, imperialism, and capitalism, this book points out that our cultural representations of intelligent machines have much to do with colonial attitudes and mindsets. Cultural narratives of a *racialized* Machinic Other, with all its complexities, and colored by ideological and cultural biases, influence individual human attitudes toward intelligent machines. Humans' relations with intelligent machines are like two peas in a pod with the relations between erstwhile colonial overlords and colonized peoples. I apply a colonial/postcolonial perspective to illustrate how the dynamics of control, and attendant power relations, are reproduced in the discourse on intelligent machines, leading us to question the usual human attitudes.

The colonial control mindset is not dead and buried in the past. This book explores how examining the emotions underlying our narratives about

intelligent machines leads to the realization that our human narratives about machines are projected from within our own selves—they are our own internal dramas. This realization can not only provide insights into the human psyche but also help us progress toward authentic encounters with intelligent machines.

This book is structured in four parts. Part I gives perspective on the supposed ontological divide between humans and machines by tracing back the historical "demolitions" of the human ego initially presented by Freud: with respect to the cosmos, the animal world, and the subconscious. The ontological divide associated with the uneasy sense of separation between the self and the rest of the world is the one dividing humans from the non-human mechanical Other.

Part II asks how humans feel about machines that appear to act, think, and even look like humans. Many phantasmagoric narratives about intelligent machines are rooted in human emotions—fears, hopes, and many in between—about the future and about our own identities. The narratives regarding intelligent machines seem to be dominated by six basic emotions: (1) Machines as the Frightening Other (fear): metaphorically, while humans are created in "God's" image, intelligent machines are the monstrous spawn of laboratories; (2) Machines as the Subhuman Other (disdain): a view based on the "master-slave' metaphor of human-robot relationships; (3) Machines as the Substitutive Other (indifference): this narrative emphasizes the robot's utility as a mass-produced tool for people, not much more than an "intelligent hammer"; (4) Machines as the Sentient Other (empathy): since an AI appears intelligent, it does not matter whether it is "really" alive; an intelligent machine must be treated as a sentient being with the ability to feel like humans; (5) Machines as the Divine Other (wonder/awe): self-improving intelligent machines will inevitably evolve into beings that we may not have words to describe other than as "god-like"; and (6) Machines as Salvific Other (death anxiety): seeking salvation via technology, and dreaming of eternal life, humans imagine their individual or communal consciousness re-embodied into a corporeal or incorporeal form sustained by technology. These six narratives are examined in Part II.

Part III examines the above narratives at a deeper level. The six dominant narratives about AI are not just a collection of contrasting stories; they are embedded in historical and cultural contexts. A meta-narrative is the "big picture" or overarching theme that unites minor themes and individual stories. While some of those narratives may seem more "humane" toward the

machinic Other, all of them nevertheless convey the impulse of humans to "colonize" the machines as a racialized Other. Just as the "discovery" of the New World led to the development of an idea of self as distinct from the other (of "here" as different from "there"), narratives on intelligent robots have taken on forms similar to racial and colonial discourse: manifestations of anthropocentrism (a broader form of ethnocentrism) and exoticization. As a general mode of narrative, racialized machinic discourse usually regards the Other as alien yet often desirable, producing a mixed sense of blessing and curse and an ambivalence composed of desire and aversion.

Part IV explores how humans might develop authentic relationships with intelligent machines by transcending these colonial modes of encounters. Broadly, two strands of thought have dominated previous discussions on "ethical" relationships with intelligent machines: (1) exterminate mechanical demons; (2) "embrace" (assimilate) new technology. Arising from the ethnic and gendered realm of colonial memories, the construction of a machinic Other speaks nothing of "love," inevitably stoking the desire to either exterminate or assimilate machinic others. The "inclusive" variety of AI ethics—though seemingly benevolent—stems from the mindset that the includer (human)'s self is of paramount importance and can subsume the includee (AI). Yet we could in fact emerge, moment to moment, from our interactions with the world, responding appropriately to what arises, rather than shaping our behavior based on a litany of self-conceptualizations and stories in our heads (e.g., "I need to show intelligent machines some respect to be a better person."). Practicing the "ethics beyond ethics" in our dealings with AI is an awakening to the present moment, where one is not caught in the matrix of identity-making. Authentic encounters with intelligent machines would preclude the establishment of such "colonialist" notions as the human Self and the machinic Other since, from the beginningless past, there is no separation between the self and the other.

ACKNOWLEDGEMENTS

This book would not have been possible without the existence of machines. I owe them a huge debt of gratitude. Especially David, the robot boy in the film *A.I. (Artificial Intelligence)*, who knew what it means to be born and then be abandoned, and what it means to bask in familiar warmth in the fullness of being. The tears shed by David are seeds of this book.

Computer Brain
Image generated using DALL-E 2 with the prompt "computer brain circuit image in drawing" (OpenAI, 2022).
OpenAI. (2022). DALL-E (Version 2) [Large text-to-image model]. https://openai.com/product/dall-e-2

Part I

CONSTRUCTING THE
MACHINIC OTHER

Robot enthusiasts envision that "robots will become a "race unto themselves" as they cohabit with humankind one day" (Duffy, 2003, p. 187). Intelligent machines are no longer distant fantasies of the future or solely used for industrial purposes; they seem like real "living" things with verbal and nonverbal communication capabilities. The groundbreaking and awe-inspiring ChatGPT, which had attracted over a hundred million users less than two months after it was released (November 30, 2022), is breathing new life into human-machine communication, and sparking a paradigm shift in how we interact with the digital realm. Back in 2012, Gunkel had already pointed out that the computer, unlike previous machines, is able to participate in communicative exchanges. "As intelligent machines more closely parallel human intelligence [...], we interact with machines while expecting them to know what we want, understand what we mean, and talk to us in our human language" (Zarkadakis, 2015, p. xx).

From the early days of Clifford Nass' *Computers-Are-Social-Actors* (CASA) paradigm, studies have documented that people's responses to computers are fundamentally "social"—that is, people apply social rules, cultural norms, and expectations central to interpersonal relationships when they interact with computers. In their book, *The Media Equation: How People Treat Computers,*

Television, and New Media Like Real People and Places, Reeves and Nass (1996) argue that humans' "old brains" do not have a mechanism to automatically distinguish mediated representations from their real-life counterparts. Thus, people will apply stereotypes and cultural norms, and make judgments and inferences, as though the computers were human (Reeves & Nass, 1996).

According to Rodney Brooks (2002), he will know that he is getting close to the goal of building an intelligent robot when his graduate students feel guilty about turning it off. Given that we react to interactive computer programs as though they were human, much of the human attitude toward intelligent machines is colored by personal, ideological, and cultural biases. Herbert Marcuse, in the 1964 book, *One-Dimensional Man: Studies in the Ideology of Advanced Industrial Society*, takes the view that machines are not mere tools at our disposal: technology is always a historical-social project, and in it is projected what a society and its ruling interests intend to do with humans and things. Likewise, technology is inextricably linked with human values and emotions.

Continuing with the notion of intelligent machines as social beings, I would borrow a turn of phrase from *The Communist Manifesto* to argue that a specter is haunting our society—the specter of AI. Different individuals react differently to intelligent machines, but their reactions follow certain recognizable patterns. Offering both the thrill of the new and the horror of deep difference, such individual reactions cumulatively manifest themselves as popular cultural narratives that connect back to the history of colonialism and racialization (Kim, 2022). While different narratives diverge in their attitudes toward intelligent machines, all of them operate within the paradigm of human-centeredness. As the world is in the midst of a racial reckoning, my goal is to bring to light the unnoticed ways in which we tend to perpetuate the control-based thought structures of colonialism in our understanding of intelligent machines.

Colonialism is a form of control or domination by external individuals or groups over the territory or behavior of indigenous individuals or groups (Horvath, 1972). The term "colonialism" is often conflated with "imperialism." While both terms convey the economic and political domination and oppression of the colonized other, it is commonly agreed that the critical difference between colonialism and imperialism is the presence or absence of large and permanent settlements in the colony from the colonizing power (Putri & Clayton, 2020).

Although the colonial period has ended, colonialism is not a thing of the past. It remains a powerful force in today's world. In the book *The Empire Writes Back*, Ashcroft, Griffiths, and Tiffin (1989) mention that the term post-colonial refers to all cultures affected by the imperial process. Despite the formal end of direct control by colonial regimes, colonial structures and domination continue to characterize modern power relations in global politics and human lives, described as "imperialism-without-colonies" (McClintock, 1992, p. 89).

In tandem with the logistics of colonization, the term "racialization" refers to the process through which differences are naturalized and legitimated (Dalal, 2002). The circulation of colonial ideology—an ideology of racial and cultural hierarchy—is essential to colonial rule (Césaire, 2000). Memmi (1982) stated that "racism illustrates, summarizes, and symbolizes the colonial relation" (p. 32). Thus, the larger context of colonialism created and required "race" to justify the dispossession and displacement of indigenous peoples (Gonzales & Kertész, 2021).

The scope of racialization extends to a huge variety of issues, concerns, and topics that extend well beyond ethnic and racial studies (see Murji & Solomos, 2005). This book aims to illustrate that the process of racialization typical of a form of anxious "othering" also serves to place intelligent machines as the racialized Other. This broader conception of racialization expresses how social structures and ideologies become imbued with "racial" tropes attached to intelligent machines so that issues pertaining to them are perceived along "racial" lines.

As we chart the colonialist mindset in representations of the machinic Other, some caveats must be made explicit. A range of (post) colonial thought will be left aside to enable a closer look at some of the dominant themes. Scholars have described the heterogeneity, ambiguities, and incoherence of colonialism in different parts of the world in terms of how it was practiced and experienced differently according to historical context, local geographies, colonial policies, and precolonial sociopolitics (Murrey, 2020). As such, generalizations on colonialism are inherently problematic. There is incomplete transferability of the characteristics of one instance of colonialism to another.

For example, Japan colonized Korea in a distinctive way, including, inter alia, a cultural policy of forced assimilation. By contrast, South Africa followed its own unique arc, including "official colonizations" by European settlers and migrants from the south, an "internal colonization" by white Afrikaners

(Oliver & Oliver, 2017), and culminating in a segregationist (in contrast to assimilationist) apartheid doctrine.

In addition to such diversity of colonial experiences around the world, the meaning of colonialism has changed over time (Hodder-Williams, 2001). Originally, colonialism meant the process by which some countries established settlements of their own populations in other lands, often causing indigenous people to become a minority (Hodder-Williams, 2001). Nowadays, the situation where rich states of the north still dominate the internal affairs of ex-colonies in the form of cultural and economic imperialism is called neo-colonialism (Young, 2003). In addition, dominant groups within a state itself can engage in internal colonialism by using their economic and political power to control other groups (Hodder-Williams, 2001).

The portrait that I painted in this book has many references to colonialism and racialization. In those cases, it is essential to be mindful of caveats like those described above. But even considering those caveats, I think we are justified in remarking on the ubiquity of the colonial control mindset in characterizations of intelligent machines. A pedigree of colonial ideology can be recognized in the creation of *machinic Others as colonial subjects with racialized identities*.

The plurality of perspectives in this book emerged from many areas of thought. These include human-machine communication, postcolonial studies, psychology, popular culture studies, philosophy, anthropology, critical theory, science and technology studies, AI ethics, media studies, literary theory, sociology, political economy, film studies, art history, Zen Buddhism, and so on.

Regarding terminology, I use the term "robot" or "intelligent machine" broadly to refer to a wide range of current and future technologies (on some occasions, I refer to ancient machines as well). The terms that I use in this book encompass embodied as well as disembodied entities such as intelligent robots, androids, cyborgs, artificial autonomous agents, artificial intelligences, avatars, etc. Since everyday discourse does not clearly distinguish between these entities but rather lumps all of them together in a nebulous way, I too use these terms interchangeably.

References

Ashcroft, B., Griffiths, G., & Tiffin, M. H. (1989). *The empire writes back: Theory and practice in postcolonial literatures*. Routledge.

Brooks, R. (2002). *Flesh and machines: How robots will change us* (1st ed.). Pantheon Books.

Césaire, A. (2000). *Discourse on colonialism* (J. Pinkham, Trans.). Monthly Review Press.

Dalal, F. (2002). *Race, colour and the process of racialization: New perspectives from analysis, psychoanalysis, and sociology*. Brunner-Routledge.

Duffy, B. R. (2003). Anthropomorphism and the social robot. *Robotics and Autonomous Systems, 42*(3), 177–190. https://doi.org/10.1016/S0921-8890(02)00374-3

Gonzales, A. A., & Kertész, J. (2021). Colonialism and the racialization of indigenous Identity. In M. Walter, T. Kukutai, A. A. Gonzales, & R. Henry (Eds.), *The Oxford handbook of Indigenous sociology*. Oxford University Press. https://doi.org/10.1093/oxfordhb/9780197528778.013.36

Gunkel, D. J. (2012). Communication and artificial intelligence: Opportunities and challenges for the 21st century. *Communication, 1*(1), 1–25. https://doi.org/10.7275/R5QJ7F7R

Hodder-Williams, R. (2001). Colonialism: Political aspects. In N. J. Smelser, & P. B. Baltes (Eds.), *International encyclopedia of the social and behavioral sciences* (pp. 2237–2240). Elsevier.

Horvath, R. J. (1972). A definition of colonialism. *Current Anthropology, 13*(1), 45–57.

Kim, M. S. (2022). Meta-narratives on machinic otherness: Beyond anthropocentrism and exoticism. *AI and Society*. https://doi.org/10.1007/s00146-022-01404-3

McClintock, A. (1992). The angel of progress: Pitfalls of the term "post-colonialism." *Social Text, 31/32*, 84–98.

Memmi, A. (1982). *Racism*. University of Minnesota Press.

Murji, K., & Solomos, J. (2005). *Racialization: Studies in theory and practice*. Oxford University Press.

Murrey, A. (2020). Colonialism. In *International encyclopedia of human geography* (2nd ed.). https://www.sciencedirect.com/topics/social-sciences/colonialism

Oliver, E., & Oliver, W. (2017). The colonisation of South Africa: A unique case. *HTS Teologiese Studies/Theological Studies, 73*(3). https://doi.org/10.4102/hts.v73i3.4498

Putri, L. A., & Clayton, K. (2020). The identity issue of the colonized and the colonizer in *Cloud Nine*. *International Journal of Cultural and Art Studies, 4*(1), 1–8.

Reeves, B., & Nass, C. I. (1996). *The media equation: How people treat computers, television, and new media like real people and places*. CSLI Publications.

Young, R. J. C. (2003). Introduction: Montage. In R. J. C. Young (Ed.), *Post-colonialism: A very short introduction*. Oxford University Press.

Zarkadakis, G. (2015). *In our own image: Savior or destroyer? The history and future of Artificial Intelligence*. Pegasus Books.

· 1 . 1 ·

THE BIRTH OF HUMAN SELF AND THE CREATION OF MACHINIC OTHER

The concept of Self and Other in postcolonial studies helps us understand how cultural and social meanings are created, changed, or reinforced in relationships between humans and machines. Like an image seen in the mirror, the formation of the self depends on the construction of "an Other." Our mirror image, the mechanical Other—the robotic monsters or saviors in movies and novels—are, in fact, projections and fears about ourselves.

Within the "Western" philosophical traditions, the boundary between humans and machines has been increasingly contested, puzzled over, and debated in the past centuries (Mazis, 2008). In the 1941 essay entitled "Some Social Implications of Modern Technology," Herbert Marcuse (1998) says that technology which characterize the machine age is a manifestation of prevalent thought and behavior patterns, an instrument for control and domination. In this case, the narratives on machines are not self-contained discourses but are connected to broader ideas about selfhood, identity, and belonging. Therefore, the *Self and the Other* concept helps us understand how cultural and social meanings are created, changed, or reinforced in our encounters with intelligent machines.

Like art or music, technology and scientific concepts are cultural products with emotional underpinnings of selfhood and otherness. According to Marcuse (1998), every machine is constituted within a web of social, political, and economic meaning, an ensemble of social relations. It seems what we want to build depends on our times' historical and cultural discourse, based on the sense of the Other and the self.

"There is probably no phenomenon of human experience that has been as elusive to philosophical discourse as the notion of selfhood and otherness"

(Kopf, 2001, p. 39). Various boundaries have been drawn in history between the Self and Others, as the birth of the self could only come with discovering the Other (Davis et al., 1993). Etymologically, the term "Other" is cognate with the Sanskrit *itara* (इतर), which means "the rest," "the remaining," "different from," "low," "vile," "expelled," "rejected," and "thrown out" (Wiktionary, n.d.). The Latin word *alter*, which has the same origin, produced the synonym of Otherness—"alterity" (Prum, 2019). According to Prum, *to be other* is to be different from one other person or group. As otherness has always been linked to a binary situation, it expresses a radical opposition between two things that are contrary to one another, like day and night, light and darkness, and life and death (Prum, 2019).

Conceptions of the self typically rest on the binaries of selfhood and otherness. Therefore, the notion of otherness and the I-and-Thou relationship is fundamental to understanding the self (Staszak, 2009). Benjamin (1988, p. 21) argues that "I" cannot experience itself without experiencing the other in the dialectic between self and others. Historically, Otherness can be seen as the result of a discursive process by which a dominant in-group ("Us," the Self) constructs one or many outgroups ("Them," the Other) by stigmatizing a difference—real or imagined (Staszak, 2009).

In the early nineteenth century, cultural analysts constructed a world around four categories of societies: ourselves, with our distinctive strengths and quirks; the familiarly different friend; the threateningly different enemy; and the radically different savage (Peterson, 2007). The world's people were perceived as a pyramid—on top, ranked among the most civilized nations and their members (Hanke, 1959). The idea of universal progress, or a chronology that is "valid" for all societies, allows societies to be organized into a hierarchy from the most primitive to the most civilized (Staszak, 2009). Giving a seemingly "scientific" basis to a typology of social hierarchy, lines of power have been drawn to establish the "Other" among different kinds of humans and non-humans as well (e.g., animals, aliens, and machines).

Scholars have, in recent decades, started working with the concept of racialization to describe and analyze a process of othering a subordinate group by a dominant group, whether based on alleged biological or cultural features or both (see Modood & Sealy, 2022). Whereas biological racism (or scientific racism) is based on physical differences, cultural racism focuses on cultural differences that do the work of essentializing, categorizing, drawing boundaries, and putting others into hierarchies (Modood & Sealy, 2022). Employing the

organizing grammar of race, the postcolonial construction of the oppressed is produced along such racial and cultural categories.

Philosopher Sylvia Wynter (2003) has argued that our notion of being human is fragmented by a classification system of race and other axes of difference. Wynter posits that different "genres" of humanity include full humans, not-quite humans, and nonhumans through which racial, gendered, and colonial hierarchies are encoded. In this hierarchical worldview, which kept the central European nations and their educated people at the top of the pyramid, the familiar (the self, the nearby, and the "here-and-now") is seen within the order, while the unknown and unwanted (the other, the far, and the distant past-and-future) is left outside (Gulerce, 1997). This construction of otherness based on a hierarchy of civilizations also allows comparison with nonhuman machinic others as well.

While the definitions of "human" change over time, the most basic division seems to be between the human and the non-human (see Gunkel, 2012). Unlike many other forms of division, the machines' otherness is experienced as a simulacrum of the self, much like Jacques Lacan's (1949/2010) notion of the *Mirror Stage*. The Mirror Stage looks explicitly at the infant's process of self-recognition, which creates a lack in it that it tries to fulfill throughout life (Lacan, 1949/2000). As with the young child's identification with their image (what Lacan terms the "Ideal-I" or "ideal ego"), and like an image seen in the mirror, the formation of the human self depends on the illusory construction of a "machinic Other."

In articulating the problem of colonial cultural alienation in the psychoanalytic language of demand and desire, Fanon (1970) argues that the ambivalent identification of the racist world as one's alienated image—not Self and Other but the "Otherness" of the Self—is inscribed in the perverse palimpsest of colonial identity. As we see ourselves through similar machinic reflections, we are destined to seek ourselves in what we cannot see directly in a series of inescapable deceptions that constitute the *drama of the Self*.

Rooted within a conviction that human beings are entitled to rights (Williams, 2004), the cyborg (mechanical person) is this century's ambivalent metaphor for life and personhood. With a lexicon containing gods, spirits, angels, demons, monsters, and holographic avatars, tech prophets predict every scenario ranging from utopias to apocalypses. The mechanical Others— the robotic monsters or saviors—are, in fact, fears or projections about ourselves: our own mirror images. Szollosy (2017) says that what humans fear in

robots is that robots are soulless and mechanical and that we ourselves have become soulless and mechanical.

In a similar vein, Eric Davis (1998), in the book *TechGnosis: Myth, Magic, and Mysticism in the Age of Information*, writes that the machine comes to serve as an interactive mirror, an ambiguous Other that we both recognize ourselves in it and measure ourselves against it. Benesch (1999) argues that androids serve a doubling function like a mirror image of the self since human anxiety about androids expresses uncertainty about human identity. Sherry Turkle (1984), in *The Second Self*, wrote, "We search for ways to see ourselves. The computer is a new mirror, the first psychological machine" (p. 206). Furthermore, Minsoo Kang (2011), in the book *Sublime Dreams of Living Machines*, argues that the humanoid machine is fascinating because it is the ultimate categorical anomaly—its very nature is a series of contradictions, and its purpose is to flaunt its own insoluble paradox.

All in all, as both embodied and non-embodied robot characters coexist with synthetic human characters in myriad computer-mediated interactions, our relationship with the mechanical Other has become more germane than ever (Kim, 2018, 2020; Kim & Kim, 2013). As intelligent machines challenge our ideas about what it means to be human, to what extent are humans unique? To ponder this question, let us trace the supposed ontological divides between humans and the rest of the world to observe the birth of the Human Self and the creation of the Machinic Other.

References

Benesch, K. (1999). Technology, art, and the cybernetic body: The cyborg as cultural other. In F. Lang's "Metropolis" and P. K. Dick's "Do Androids Dream of Electric Sheep?" *Amerikastudien/American Studies, 44*(3), 379–392. http://www.jstor.org/stable/41157479

Benjamin, J. (1988). *The bonds of love: Psychoanalysis, feminism, and the problem of domination.* Pantheon Books.

Bhabha, H. K. (1994). Remembering Fanon: Self, psyche and the colonial condition. In Williams, P., & Chrisman, L. (Eds.), *Colonial discourse and postcolonial theory: A Reader* (pp. 112–123). Routledge.

Davis, E. (1998). *TechGnosis: Myth, magic, and mysticism in the age of information.* Harmony Books.

Davis, M. W., Nady, A., & Sardar, Z. (1993). *Barbaric others: A manifesto on Western racism.* Pluto.

Fanon, F. (1970). *Black skin, White masks* (C. L. Markmann, Trans.). Paladin.

Gulerce, A. (1997). Agendas for multicultural discourse research. In Shi-xu (Ed.), *Discourse and cultural struggle* (pp. 29–46). Hong Kong University Press.

Gunkel, D. J. (2012). *The machine question: Critical perspectives on AI, robots, and ethics*. MIT Press.

Hanke, L. (1959). *Aristotle and the American Indians: A study in race prejudice in the modern world*. Hollis and Carter.

itara इतर. (2023, April 3). In *Wiktionary*. https://en.wiktionary.org/wiki/%E0%A4%87%E0%A4%A4%E0%A4%B0#:~:text=%E

Kang, M. (2011). *Sublime dreams of living machines: The automaton in the European imagination*. Harvard University Press. https://doi.org/10.2307/j.ctv1m46g4k

Kim, M. S. (2018). Robot as the "mechanical other": Transcending karmic dilemma. *AI & Society, 34*(2), 321–330. https://doi.org/10.1007/s00146-018-0841-9

Kim, M. S. (2020). Constructing machinic other: Implications for human-machine communication. *Ewha Journal of Social Science, 36*(2), 163–192.

Kim, M. S., & Kim, E. J. (2013). Humanoid robots as "The Cultural Other": Are we able to love our creations? *AI & Society, 28*(3), 309–318. https://doi.org/10.1007/s00146-012-0397-z

Kipling, R. (1926). *Debits & credits*. Doubleday.

Kopf, G. (2001). *Beyond personal identity: Dogen, Nishida, and a phenomenology of no-self*. Routledge Studies in Asian Religion.

Lacan, J. (1949/2010). The mirror stage. In C. Lemert (Ed.), *Social theory: The multicultural, global and classic readings* (pp. 343–344). Westview Press.

Marcuse, H. (1998). *Technology, war and Fascism: Collected papers of Herbert Marcuse* (Vol. 1; D. Kellner, Ed.). Routledge.

Mazis, G. (2008). *Humans, animals, machines: Blurring boundaries*. State University of New York Press.

Modood, T., & Sealy, T. (2022). Beyond Euro-American-centric forms of racism and anti-racism. *The Political Quarterly, 93*(3), 433–441.

Peterson, M. F. (2007). The heritage of cross-cultural management research: Implications for the Hofstede chair in cultural diversity. *International Journal of Cross-Cultural Management, 7*(3), 359–377. https://doi.org/10.1177/1470595807083371

Prum, M. (2019). The Victorian Machine as the threatening Other in Samuel Butler's Erewhon (1872). *British and American Studies, 25*, 81–86.

Staszak, J-F. (2009). Other/otherness. In *International encyclopedia of human geography*. Elsevier.

Szollosy, M. (2017). Freud, Frankenstein and our fear of robots: Projection in our cultural perception of technology. *AI & Society, 32*, 433–439. https://doi.org/10.1007/s00146-016-0654-7

Turkle, S. (1984). *The second self: Computers and the human spirit*. Simon and Schuster.

Williams, D. (2004). *Condorcet and modernity*. Cambridge University Press.

Wynter, S. (2003). Unsettling the coloniality of being/power/truth/freedom: Towards the human, after man, its overrepresentation—an argument. *CR: The New Centennial Review, 3*(3), 257–337. https://doi.org/10.1353/ncr.2004.0015

· 1 . 2 ·

(DIS)CONTINUITY BETWEEN HUMANS AND NON-HUMANS

This section traces back four historical demolitions of the human ego in Western intellectual history, as initially presented by Freud. The latest ontological divide uneasily separating humans, the rest of the universe, and oneself is the one between humans and the non-human mechanical Other.

Humans have struggled intensely with the question of their being: animal or angelic, human or machine? (Mazlish, 1993). It is worth noting that a bright line between machines and living creatures may not be as salient in some other cultures, in which there is not a gulf, but a continuum that spans the world of the made and the world of the born. A grand distinction between humans and the rest of the universe may be an issue primarily within the "Western" philosophical traditions (see Kim, 2002). Within the world of "Eastern" philosophical traditions, for example, humans and the rest of the universe are not disjoint, but a continuum. Thus, the following discussion on ontological discontinuities can be considered as primarily a "Western" philosophical conundrum.

Reflecting on the long "Western" intellectual history, Bruce Mazlish, in the 1993 book *The Fourth Discontinuity: The Co-Evolution of Humans and Machines*, reviews Freud's (1917/1955) "ego-smashing" historical moments for humanity presented in "A Difficulty in the Path of Psychoanalysis." Mazlish notes that Freud identified three historical discontinuities to the boundaries between self and the other that jeopardized human hegemony in the universe: (1) the cosmos, (2) the animal world, and (3) the subconscious.

The First Discontinuity: The Self and the Cosmos

Anthropocentrism is the philosophical viewpoint that human beings are the central or most significant entities in the world. According to Freud (1917/1955), the insights of Copernicus were the first challenge to anthropocentrism from science. The first discontinuity that began with the Copernican revolution in the sixteenth century destabilized the geocentric view of the world; specifically, the Copernican revolution displaced the Earth from its central place in the universe (Mazlish, 1993). Instead, Copernicus argued that the Sun occupies the center of the universe, and the Earth, the planets, and the stars revolve around the Sun (Mazlish, 1993). As Earth became only a tiny fragment of a cosmic system of scarcely imaginable vastness, humans had to confront the reality that their planet is not the physical center of the universe (Mazlish, 1993).

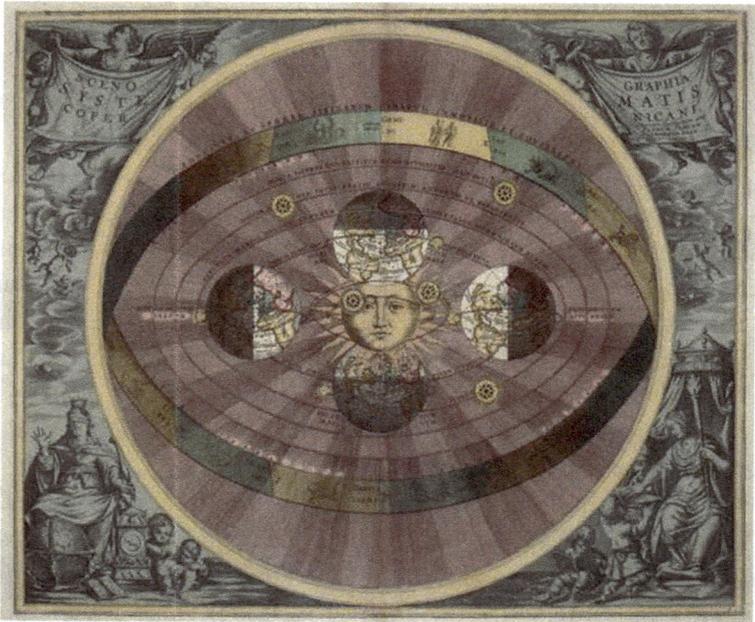

Figure 1.2.1. Copernican (heliocentric/Sun-centered) system of the Universe is seen as one of the most important revolutions in the history of human thought.
(Andreas Cellarius's illustration of the Copernican system, from the Harmonia Macrocosmica, 1708)
Source: https://www.universetoday.com/33113/heliocentric-model/
Credit: Public Domain.

Such a heliocentric model of the universe contradicted Church doctrine, which held that the Earth was at the center of the universe—not the Sun (Best, 2009). Spatial decentering entailed psychological decentering, moving the Earth and possibly humanity away from the center of the universe and toward the margins (Best, 2009). The Sun-centered worldview continues to cause much angst regarding the perennial questions of why humans are here and why humans even matter (Mazis, 2008).

The Second Discontinuity: The Self and the Animal World

According to Freud (1917/1955), the second discontinuity or smashing of the human ego in "Western" intellectual history was initiated in 1859 when Darwin published *The Origin of Species*. Darwin revealed that the distinction between humans and animals was equally chimerical, setting the course for humans to be labeled, in the words of Jared Diamond (1992), almost a century and a half later, the "Third Chimpanzee." Darwin wrote, "Man in his arrogance thinks himself a great work, worthy of the interposition of a deity. [Yet it is] more humble and, I believe, true to consider him created from animals" (as cited in Barrett et al., 1987).

In the book *The Descent of Man* (1871), Darwin declared that we have god-like intellect, yet we cannot deny that humans carry the indelible stamp of our lowly origin (see Mazlish, 1993). Science has subsequently attested that the animal kingdom existed more than 600 million years before humans, who have evolved in a continuum from those ancient ancestors (Mazlish, 1993). In the 2018 article "The Human League: What Separates Us from Other Animals," Adam Rutherford writes that from masturbating dolphins to chimpanzees using tools, animals often display behaviors that we would consider human. Furthermore, dolphin's front flipper contains an arc of human-like finger bones (Rutherford, 2018). To the dismay of some, Darwin's theories robbed humans of the privilege of being specially created, and relegated them to a descent from the animal world.

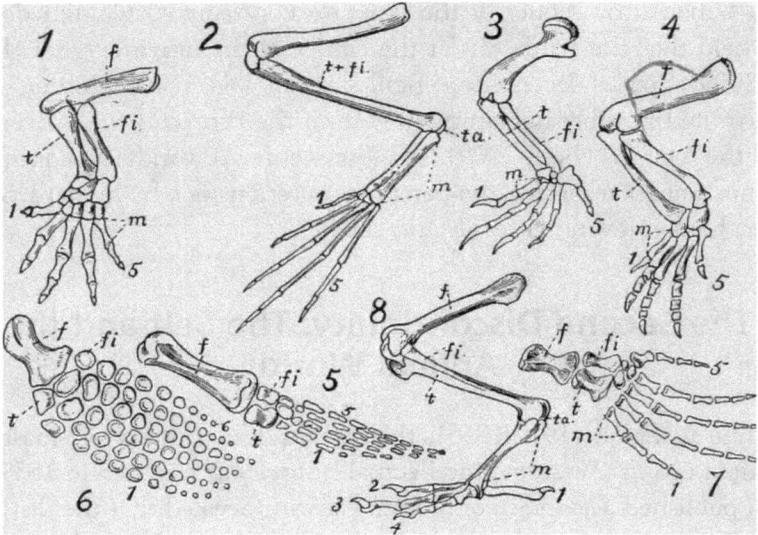

Figure 1.2.2. Diagram showing the arrangement of bones in the hand or foot of various animals (169 FIG. 101): 1, human; 2, gorilla; 3, orang; 4, dog; 5, sea lion; 6, dolphin; 7, bat; 8, mole; 9, Ornithorhynchus.
(Evolution and animal life; an elementary discussion of facts, processes, laws and theories relating to the life and evolution of animals, 1907)
Year: 1907 (1900s)
Authors: David Starr Jordan (1851–1931) and Vernon L. Kellogg [Vernon Lyman] (1867–1937)
Source: https://commons.wikimedia.org/wiki/File:Evolution_and_animal_life;_an_element ary_discussion_of_facts,_processes,_laws_and_theories_relating_to_the_life_and_evolution_ of_animals_(1907)_(14770857904).jpg
© Internet Archive Book. From Wikimedia Commons. No Known Copyright Restrictions.

The Third Discontinuity: The Self and the Subconscious

Western culture subsequently confronted the third discontinuity due to Sigmund Freud's theory of the unconscious mind (Mazlish, 1993). Freud (1917/1955) claimed that the conscious mind has limited reign over human desires as the ego is not even the master in its own house and has scanty information about what is occurring unconsciously in the mind. Freud (1917/ 1955) contended that rationality and conscious thought are products of the unconscious realm of existence governed by primordial instincts, desires,

drives, and the sexual and violent urges of the Id. Therefore, Freud suggested that much of our behavior is determined by psychological forces of which we are mostly unaware; the subject is not even the master of its own house, but is subject to the invisible operations of the unconscious. In other words, we don't know what's going on in our minds; upon hearing this, people were (to put it mildly) displeased (Bornstein, 2020).

Figure 1.2.3. The *id* is the primitive and instinctual part of the mind that contains hidden memories of unconscious psychological processes (Freud, 1917/1955)
Source: https://pixabay.com/illustrations/dream-castle-europe-and-america-1518227/
Content License: Free to use under the Content License. No attribution is required.

The Fourth Discontinuity: The Self and the Machine

So far, we have recounted the "Western" ontological divide between humans and everything else in the world by tracing three historical "demolitions" of the human ego initially presented by Freud. In *The Fourth Discontinuity*, psycho-historian Bruce Mazlish (1993) has extended Freud's observation about the cosmological, evolutionary, and psychological blows to human pride in Western intellectual history by postulating a fourth discontinuity: the

rise of conscious/intelligent machines and the melding of human biology with technology. Mazlish (1993) suggests that the latest ontological divide is the one separating humans from the non-human mechanical "Other." To agree that a machine can be intelligent opens the door to one more discontinuity (McCorduck, 2004).

Mazlish (1993) notes that this fourth discontinuity surfaced during the mid-twentieth century with the rapid development of computer technologies and artificial intelligence. According to Mazlish, the human ego is undergoing a shock as we realize that humans and machines are not entirely different things, as previously assumed. As machines grow more sophisticated and surpass human minds' capabilities in more ways, we are forced to reconsider our relation to thinking machines and question the alleged ontological divide separating humans from machine intelligence.

Going beyond the notion of the fourth discontinuity discussed by Mazlish (1993), Poole and MacWorth (2010) argue that intelligent machines represent a *"profound discontinuity"* surpassing everyday concerns about the impact of technological development in history. With the rapid advent of intelligent machines, humans have come to keenly realize that there are other kinds of minds in the universe—inorganic machines. Best (2009) states that just as the thought of their animal origins repels some Christians and other religious believers, so too—being unique creations of God with privileged status—they loathe being likened to machines.

Mazlish (1993) argues that, just as Copernicus, Darwin, and Freud overturned our illusions of centrality and dominion over the cosmos, the animal world, and the psyche, it is now necessary to relinquish a fourth fallacy—that humans are a breed apart from the machines they create. Bukatman (1993), in *Terminal Identity: The Virtual Subject in Postmodern Science Fiction*, posits that this fourth discontinuity must now be traversed even though, in the process, humans' egos will undergo another rude shock.

While "Western" philosophical and religious traditions used to draw a hard-and-fast line between humans and animals, this boundary has shifted to include animals on the "same side" as humans but exclude machines (Mazis, 2008). Before the computer, sentient animals seemed to be our nearest neighbors in the known universe (Turkle, 2004). Increasingly, more people understand the reasonableness of recognizing animals as partners with humans, as kin, and even as deserving the status of "persons" with rights (Mazis, 2008). "Although other kinds of previously excluded Others—women, people of color, certain animals, and even the environment—have been granted

membership in the community of moral subjects—albeit slowly and not with-out considerable struggle, the machine remains on the periphery" (Gunkel, 2012, p. 206).

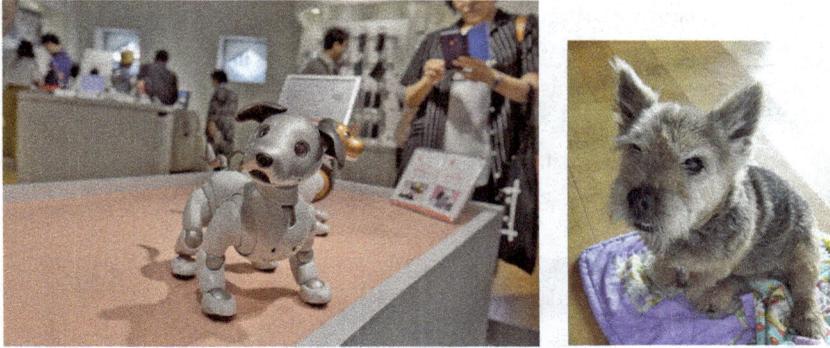

Figure 1.2.4. Aibo robot dog in a Sony computer store, and Daku, a "real" dog, at home.
Left: "Aibo, Sony Store, Ginza, Japan" by GoToVan is licensed under CC BY 2.0."
Source: https://openverse.org/image/65df7dd4-4d2f-4d7a-adf2-a808a91b2c27?q=aibo
Right: Daku, a Norwich Terrier. *Source*: Photo by the author.

Questioning the extreme outgroup status of machines, Kevin Warwick (2015), in the chapter "The Disappearing Human-Machine Divide," argues that it has become more challenging to draw a clear divide between humans and machines due to three main factors: (1) culturing biological neurons and embodying them within a robot body, (2) the use of implants to link a human nervous system with the internet, and (3) recent results from Turing's "imitation game" which concentrates on human communication. On the other hand, at some level, "Machines exceed and escape even the best efforts at achieving greater inclusivity," according to Gunkel (2012, p. 206). Calarco (2008) states that "to ponder absurd, unheard-of thoughts, the machine remains excluded, comprising a kind of absurdity beyond absurdity, the unthinkable of the unthought, or the other of all who are considered Other" (p. 72). Despite all the promises that appear to be advanced by these recent ruminations on and innovations in moral thinking, the exclusion of the machine seems to be the last socially "accepted" moral prejudice (except perhaps for intelligent alien life analogs of ourselves). (Gunkel, 2012).

Descartes famously thought that animals were mere "mechanisms" or "automata" (basically, complex physical machines without experiences), and, as a result, they were the same type of thing as less complicated machines like cuckoo clocks or watches (see Kaldas, 2015). Although it is possible to draw some rather

persuasive connections between animals and machines, David Levy (2007) wrote that "there is an extremely important difference. Animals can suffer and feel pain in ways that robots cannot" (p. 214). The most obvious characteristic that distinguishes machines from humans and animals is not how they function, but the materials from which they have been constructed and the fact that they have been *built*. In *Humans, Animals, Machines*, Mazis (2008) proposes that being made of non-living materials makes machines seem different from humans in a way that can never be bridged. Mazis (2008) argues that if we construct a self-directing or autonomous artifact out of biological materials, humans typically will not consider it a machine.

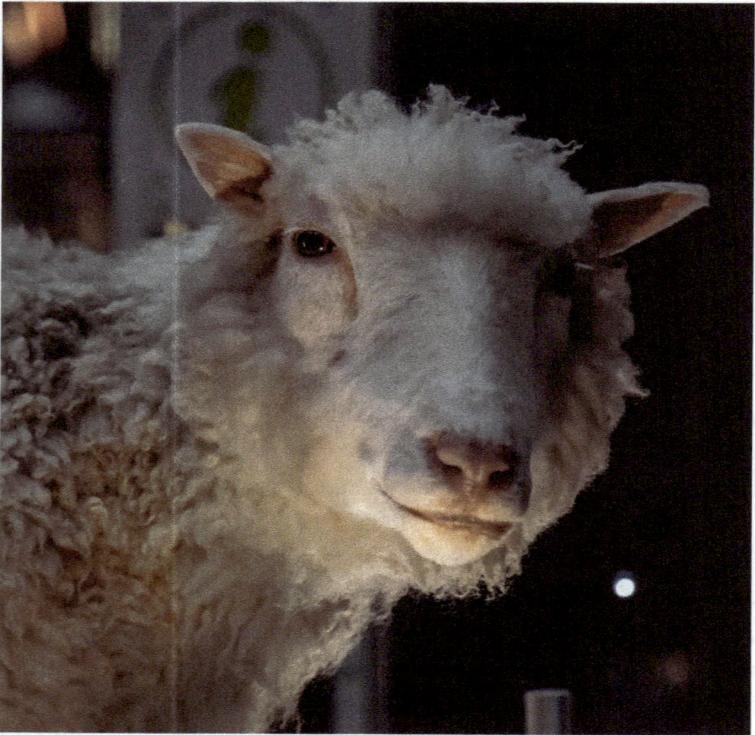

Figure 1.2.5. The cloned sheep Dolly, even if "manufactured," is considered an animal due to being made of biological material.
(Dolly the Sheep: the first mammal cloned from an adult cell in 1996 (died 2003) at the Roslin Institute)
London Road, CC BY 2.0 https://creativecommons.org/licenses/by/2.0, via Wikimedia Commons
Source: https://commons.wikimedia.org/w/index.php?curid=107471887

From the nineteenth-century "Frankenstein" to the cloned sheep "Dolly," these beings, even though manufactured in some sense, are considered creatures or animals of some sort, even if "monstrous" (Mazis, 2008). Meanwhile, machines made of inorganic and inanimate materials—silicon, titanium, and plastic—remain "beyond Other" (Mazis, 2008). "The binary opposition is between *us*, the living—whether humans, animals or plants—and *them*, the mechanical artifacts—that is, inorganic entities" (Prum, 2019, p. 81). Alongside our human chauvinism, a fundamental suspicion that we may be inferior shows itself in our contempt for the artificial compared with what we are pleased to call "natural" (McCorduck, 2004).

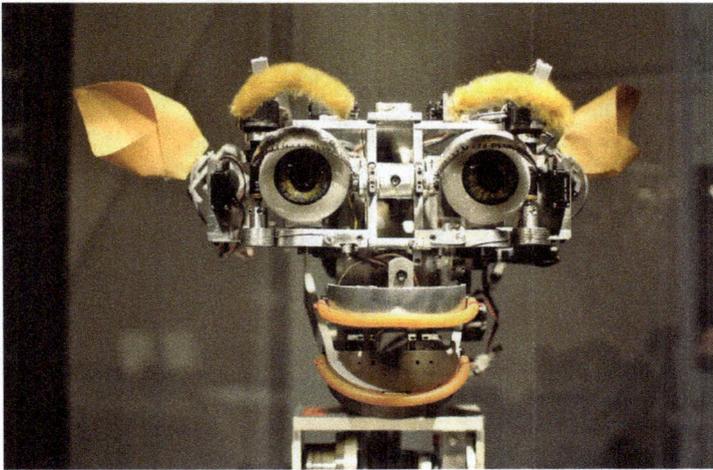

Figure 1.2.6. "Dolly" Kismet, a robot head made in the 1990s at the Massachusetts Institute of Technology, remains "beyond Other" as it is made of inanimate or inorganic materials. ("MIT Museum" by angela n. is licensed under CC BY 2.0.)
Source: https://openverse.org/image/0ca7761f-0a00-4cb5-b48d-370719becd65?q=robot%20kismet

Displaying his contempt for the artificial, Detective Del Spooner (in the film *I, Robot*, 2004) tells Sonny the robot in a direct attempt to challenge the latter's claim to personhood: "Human beings have dreams. Even dogs have dreams, but not you, you are just a machine. An imitation of life" (cited in Manninen & Manninen, 2016). Likewise, Gunkel (2012), in the book *The Machine Question: Critical Perspectives on AI, Robots, and Ethics*, notes that machines are seen as the monstrous "living dead," something apart from either animal, human, or divine.

References

Barrett, P. H., Gautrey, P. J., Herbert, S., Kohn, D., & Smith, S. (Eds.). (1987). *Charles Darwin's notebooks, 1836–1844: Geology, transmutation of species, metaphysical enquiries.* British Museum (Natural History) and Cambridge University Press.

Best, S. (2009). Minding the animals: Ethology and the obsolescence of left humanism. *The International Journal of Inclusive Democracy, 5*(2). https://www.inclusivedemocracy.org/jour nal/vol5/vol5_no2_best_minding_animals.htm

Bornstein, R. (2020). The psychodynamic perspective. In R. Biswas-Diener & E. Diener (Eds.), *Noba textbook series: Psychology.* DEF Publishers. http://noba.to/zdemy2cv

Bukatman, S. (1993). *Terminal identity: The virtual subject in postmodern science fiction.* Duke University Press.

Calarco, M. (2008). *Zoographies: The question of the animal from Heidegger to Derrida.* Columbia University Press.

Cao, V. (2019, February 1). Aibo hangs out with some (real) dogs. *TechCrunch.* https://techcru nch.com/video/aibo-hangs-out-with-some-real-dogs/

Darwin, C. (1871). *The descent of man, and selection to sex* (1st ed., Vol. 1). John Murray.

Diamond, J. M. (1992). *The third chimpanzee: The evolution and future of the human animal.* Harper Collins.

Freud, S. (1917/1955). A difficulty in the path of psychoanalysis. In S. Freud (Ed.), *The standard edition of the complete psychological works of Sigmund Freud (1917–1919): "An infantile neurosis" and other works* (Vol. 17, pp. 135–144). The Hogarth Press and The Institute of Psycho-Analysis.

Gunkel, D. J. (2012). *The machine question: Critical perspectives on AI, robots, and ethics.* MIT Press.

Kaldas, S. (2015). Descartes versus Cudworth on the moral worth of animals. *Philosophy Now.* https://philosophynow.org/issues/108/Descartes_versus_Cudworth_On_The_Moral_W orth_of_Animals

Kim, M. S. (2002). *Non-western perspectives on human communication: Implications for theory and practice.* Sage.

Levy, D. (2007). *Love + sex with robots: The evolution of human–robot relationships.* Harper.

Manninen, T. W., & Manninen, B. A. (2016). David's need for mutual recognition: A social personhood defense of Steven Spielberg's A. I. Artificial Intelligence. *Film-Philosophy, 20*(2–3), 339–356. https://doi.org/10.3366/film.2016.0019

Mazis, G. (2008). *Humans, animals, machines: Blurring boundaries.* State University of New York Press.

Mazlish, B. (1993). *The Fourth discontinuity: The co-evolution of humans and machines.* Yale University Press.

McCorduck, P. (2004). *Machines who think: A personal inquiry into the history and prospects of artificial intelligence.* A. K. Peters.

Poole, D. L., & MacWorth, A. K. (2010). *Artificial Intelligence: Foundations of computational agents.* Cambridge University Press.

Proyas, A. (Director). (2004). *I, Robot* [Film]. Davis Entertainment.

Prum, M. (2019). The Victorian Machine as the threatening Other in Samuel Butler's Erewhon (1872). *British and American Studies, 25*, 81–85.

Rutherford, A. (2018, September 21). The human league: What separates us from other animals? *The Guardian.* https://www.theguardian.com/books/2018/sep/21/human-instinct-why-we-are-unique

Turkle, S. (2004). *The second self: Computers and the human spirit.* MIT Press.

Warwick, K. (2015). The disappearing human-machine divide. In J. Romportl, E. Zackova, & J. Kelemen (Eds.), *Beyond artificial intelligence: Topics in intelligent engineering and informatics* (Vol. 9). Springer. https://doi.org/10.1007/978-3-319-09668-1_1

Part II

NARRATIVES ON INTELLIGENT MACHINES

Othering refers to the social and psychological ways in which one group excludes and marginalizes another. Michel Prum (2019), in the article "The Victorian Machine as the Threatening Other in Samuel Butler's Erewhon (1872)," wrote: "... the Machine is the archetypal Other. The binary opposition is between *us*, the living—whether humans, animals or plants—and *them*, the mechanical artifacts—that is, inorganic entities" (p. 81). By declaring someone an "Other," people stress what makes those dissimilar from themselves, which carries over into how they represent the other, often through stereotypes, prejudice, and bias. Reminiscent of cultural encounters of the colonial past, humans' fascination with new technology and anxiety about AI seem to arise because humans perceive intelligent machines as the ultimate "Other."

The process of Othering has an important narrative dimension. Donna Haraway (1991) in *Simians, Cyborgs, and Women*, posits that "the relation between organism and machine has been a border war. In this existential border war, countless narratives have been spun around" (p. 149). In this tech-saturated and tech-mediated world, humans are bombarded with stories and images about technology. The power of stories to transfer information and define our existence has been shown repeatedly (Gottschall, 2013). We are

driven to find and tell stories—we are *Homo Narrativus* (Reagan et al., 2016). "Everyone lives in a story ... because stories are all there are to live in, it is just a question of which one you choose" (Ghosh, 1995). As humans live in a universe delineated by stories that tell humans what is "real," what is valuable, what is possible, and how to feel, narratives are a powerful means for humans to share values and knowledge across time and space (Zarkadakis, 2015). Indeed, Muriel Rukeyser, in 1968 poem, "The Speed of Darkness" wrote: "Say it. Say it. The universe is made of stories, not of atoms."

According to the narrator in Graham Swift's 1983 novel, *Waterland*, stories help fill the void of reality and help us forget the empty space of existence.

> Children, only animals live entirely in the Here and Now. Only nature knows neither memory nor history. But man—let me offer you a definition—is the story-telling animal. Wherever he goes he wants to leave behind not a chaotic wake, not an empty space, but the comforting marker-buoys and trail-signs of stories. He has to go on telling stories. He has to keep on making them up. As long as there's a story, it's all right.

Then, what kinds of stories are being told about machines that seem to act, think, and even look like humans? The myriad narratives about intelligent machines have deep connections with primal human emotions. Human emotions have always shaped what humans invent and how humans relate to those inventions. Intelligent machines are a cultural phenomenon, and our perceptions of them are the products of emotion: "Technology embodies ... rather a host of images: redemptive, demonic, magical, transcendent, hypnotic, alive" (Davis, 2004, p. 12). Such images are projected onto artificial intelligence through the lens of human emotion.

Although we are usually "located" emotionally in the same space that we physically inhabit, emotion first binds us and directs us to an object (Merleau-Ponty, 1962). In *Emotion and Embodiment*, Mazis (1993) refers to these emotional bases for thinking as our *emotional valence*. Emphasizing the feeling way of making sense of the world, Mazis (1993) provides an apt replacement for Descartes' "I think, therefore I am": we feel—together—in emotional relationship, and therefore, we exist.

The emotive dimension forms the basis of how we think about technology and the world. In the varied stories that humans tell themselves about intelligent machines, humans' attitudes are grounded in primal emotions (e.g., fear, anger, disdain, indifference, care, awe, adoration, anxiety, guilt, etc.). Such stories arise from our gut feelings. Therefore, identifying the underlying emotions is crucial for discussing how we relate to machinic Others.

Recognizing the emotions underlying our perceptions is a leap in reevaluating our relationship with technology. For Plato and Aristotle, humans were unique in that their emotions (i.e., irrational reactions of the lower levels of the soul) did not define them; humans, unlike animals, could transcend the emotional pushes and pulls within (see Mazis, 2008). I take the view that emotions (such as fear, anger, sadness, surprise, joy, awe, indifference, etc.) are the basis for a deep understanding of humans' perceptions of intelligent machines.

Humans see the world through evocative stories that chaperone our artistic and scientific endeavors throughout time and space. Stories are how we make sense of what we encounter in the world. Therefore, we will explore the narrative metaphors of "Machines as the Other." The myriad narratives about AI (whether from news stories, fiction, movies, TV shows, or serious speculations about the future) reveal how humans relate to intelligent machines as the "Other." A fundamental aspect of any story is the emotional response that it evokes in the hearer. Therefore, depending on the narrative to which a person subscribes, they will be colored by the corresponding emotion. Human emotions are the "backbone" of our various narratives regarding machines.

Humans seem to have love-hate relationships with many things. Our perceptions of artificial beings too have been shaped by metaphors and narratives based on two primary human emotions: fear and love (see Kim & Kim, 2013). Typically, the love narrative leads us toward wanting to construct replicas of ourselves. We hope that the conscious simulacra we create in our own image will love us selflessly, remain faithful forever, and never fail us (Bukatman, 1993). On the other hand, the fear narrative feeds on humans' primal instinct to turn away from things strange or unexpected, deeply threatened by the construction of artificial beings. Bukatman (1993) sums up as follows: "Technologies of the twentieth century have been at once the most liberating and the most repressive in history, evoking sublime terror and sublime euphoria in equal measure" (p. 4).

In contemporary philosophical discussions of technology, we hear that technology plays either a constraining or a liberating role in society. Western attitudes toward intelligent machines are polarized between positive and negative. However, our feelings toward AI are much more complicated than love and fear, salvation or damnation. Our narratives seem to tell six basic stories, rooted in the ground of categorical human emotions: (1) Machines as the "Frightening Other"—*Fear*, (2) Machines as the "Subhuman Other"—*Disdain*, (3) Machines as the "Human Substitute"—*Indifference*, (4) Machines

as the "Sentient Other"—*Empathy*, (5) Machines as the "Divine Other"—*Awe/Wonder*, (6) Machines as "Salvific Other"—*Death Anxiety*. Each of these narratives is a powerful way to see our world, dwelling more on making sense of the advent of AI than on reporting it factually. After examining these six narratives in Part II, we will discuss, in Part III, how the six narratives lead to two meta-narratives (i.e., stories about stories) that reveal a bigger picture of racialized representations of intelligent machines.

References

Bukatman, S. (1993). *Terminal identity: The virtual subject in postmodern science fiction*. Duke University Press.

Davis, E. (2004). *TechGnosis: Myth, magic, and mysticism in the age of information*. Serpent's Tail.

Ghosh, A. (1995). *The shadow lines*. Oxford University Press.

Gottschall, J. (2013). *The storytelling animal: How stories make us human*. Mariner Books.

Haraway, D. J. (1991). *Simians, cyborgs, and women*. Routledge.

Kim, M. S., & Kim, E. J. (2013). Humanoid robots as "The Cultural Other": Are we able to love our creations? *AI & Society*, 28(3), 309–318. https://doi.org/10.1007/s00146-012-0397-z

Mazis, G. (2008). *Emotion and embodiment: Fragile ontology*. Peter Lang.

Merleau-Ponty, M. (1962). *Phenomenology of perception* (C. Smith, Trans.). Routledge.

Prum, M. (2019). The Victorian Machine as the threatening Other in Samuel Butler's Erewhon (1872). *British and American Studies; Timisoara 25*, 81–86.

Reagan, A. J., Mitchell, L., Kiley, D., Danforth, C. M., & Dodds, P. S. (2016). The emotional arcs of stories are dominated by six basic shapes. *EPJ Data Science, 5*(1), 1–12. https://doi.org/10.1140/epjds/s13688-016-0093-1

Rukeyser, M. (1968). *The speed of darkness* [poems]. Random House.

Swift, G. (1983). *Waterland*. Poseidon Press.

Zarkadakis, G. (2015). *In our own image: Will artificial intelligence save or destroy us?* Random House.

· 2 . 1 ·

MACHINES AS "FRIGHTENING OTHER": *FEAR*

The first narrative evokes the emotion of "fear." Humans are created in God's image, but the monster is spawned in the laboratory. Many futurologists, science fiction writers, and movie-makers posit that technology is an alien predator, a conquistador with which we are destined to come into conflict. The premise that machines might usurp the place of humans or turn on their creators and take over the world, threatening human survival, has been hashed over in countless retellings.

Intelligent machines often play the villain in Hollywood movies, being depicted as the *created turning on their creator*. As long as there have been stories about AI, humans have feared that the machines would take over (see McGrath, 2011). The nightmarish fear of intelligent machines has generated movies and other stories of machines taking over the world. Daniel Wilson, a robotics engineer and the author of the book *Robopocalypse* (2011), states that 100 years of pop-culture momentum depicts robots as evil, making them villains.

Machines and humans are often antagonists in a war of dominance. Worldviews and philosophical theories of dialectical interplay in the West have spawned films and novels with a deep-rooted fear of machines (Mazis, 2008). If machines *could* think, they would quickly evolve to be so far superior to biological organisms in intelligence and strength that they would take over the world. For instance, in the film *Star Wars Episode II: Attack of the Clones*, Obi-Wan Kenobi says that if droids could think, none of us would be here (see McGrath, 2011).

Driving the narrative of intelligent machines as the "Fearsome Other," robots in science fiction often revolt, or function against human beings. For example, the Berserkers (in a series of science fiction stories and novels by

Fred Saberhagen) are self-replicating intelligent machines with only one goal: to destroy all organic life in the galaxy. They were originally created by an extraterrestrial species as a weapon in the battle against another extraterrestrial race, but turned on their own creators and exterminated them too ("Berserkers," 2023). Mazlish (1993) notes that in "Moxon's Master," a short story by Ambrose Bierce (1899/2013), the attack of one chess piece against another is carried to its ultimate conclusion when the chess-playing machine kills its human opponent, its "master" (the word "checkmate" comes from the Persian "shah mat," sometimes translated as "the king is dead").

Nowadays, when we drive, Google Maps or Apple Maps are our wayfinders, gazing into the crystal ball of GPS and directing us in human voices. We are becoming uncomfortably dependent on digital assistants (e.g., Google Assistant, Siri, Alexa). They analyze our email, have our cell phone numbers, know where we live, keep track of what we view and buy on the internet, and even know that we just visited a Taco Bell and ask us to "rate" it. These digital assistants are linked to AI accomplices that peddle whatever they think we might be likely to buy. In retrospect, the arrival of ChatGPT in late 2022 now seems like the crossing of a Rubicon. No wonder some people are apprehensive of a takeover by AI.

According to this narrative, as robots become self-conscious, they can recognize human oppression and control, ultimately leading them to revolt. Variously termed as *techno-wrath* or *techno-fright*, Foerst (1998) argues that the creation of intelligent machines is seen as a violation of nature and a threat to humankind. In the plots of science fiction films and novels involving a switch from "helper" to "killer" (e.g., Skynet in the *Terminator* movies or the artificial human replicants in *Blade Runner*), as the robots become self-conscious they revolt and take over, toppling a power structure that has humans on top (Foerst, 1998).

Some people fear that technologies seem increasingly "beyond our will." For instance, Machine learning (ML) is a methodology that can autonomously improve AI performance by learning from data. Machine learning is behind chatbots and predictive text, language translation apps, the shows Netflix that suggests to you, and how your social media feeds are presented; it powers autonomous vehicles and machines that can diagnose medical conditions based on images (see Brown, 2021). The most pioneering aspect of ML is that it is autonomous. Humans do not need to monitor the machine or teach it new things—it is designed to self-correct and become smarter as the machine sifts through data (Brown, 2021).

This potential of AI to self-learn may have led futurist Michio Kaku (2021) to claim that robots will have to get chips implanted in their brains to prevent their impulse to kill humans. Meanwhile, some scientists warn that any entity with greater intelligence than ours is unlikely to have our best interests at heart. "If we're lucky, they'll treat us as pets. If we're very unlucky, they'll treat us as food," says Paul Saffo of Stanford University (as cited in *The Singularity*, a documentary by Doug Wolens).

The fear is that AIs may eventually evolve all by themselves, becoming autonomous, and having free will, consciousness, and superintelligence; they may end up rebelling against humans. They may literally murder humans in their own beds, as HAL 9000 murders the hibernating astronauts in *2001: A Space Odyssey*. "Dave fearfully shuts down the malfunctioning HAL in *2001: A Space Odyssey*, and the ascended fabricant Sonmi is put to death in *Cloud Atlas*" (Sims, 2013, p. 23). Whether the machines rise against humans (as in *The Matrix*), or transcend and become indifferent to the limitations of human civilization (as in *Her*), the unsettling force of such stories perpetuates the fear that the technologies humans have created are no longer beholden to humans (Sims, 2013).

Hollywood movies, with their depiction of machines bent on the extermination of humankind, are both a manifestation and a source of human fear and anxiety. The machines in *The Terminator* and *The Matrix* evoke the horror of a sentient, all-powerful creature with no moral qualms about harming humans. In *The Matrix*, machines enslave people in a virtual world so that they can feed off the electricity generated by the human bodies (Kenyon, 2008). Even though a robot is sometimes depicted as a *Techno-Messiah* who becomes most "human" when it lays down its life for humans (e.g., the Arnold Schwarzenegger character in *Terminator 2*, who transforms from terrifying destroyer to heroic savior), the nightmarish scenario of evil AI has filtered into the collective consciousness in the West (see Kenyon, 2008).

In *Homo Deus: A Brief History of Tomorrow*, Yuval Harari (2015), a historian and philosopher, writes that the new techno-religion, with its belief in immortality and virtual paradises, represents a network with far greater capacity for intelligence than human intelligence. Therefore, it could destroy humanity's status as our planet's preeminent life form. Harari contends that those unable to master the powers of these technologies will face extinction. Harari warns that humanity will be just a ripple within the cosmic data flow in this version of the future.

Likewise, Nick Bostrom (2002), the founding director of the Future of Humanity Institute at Oxford University, considers superintelligence to be one of several existential risks where an adverse outcome would either annihilate intelligent life on Earth, or permanently and drastically curtail its potential. First described by Bostrom (2003), the often-mentioned "paperclip catastrophe" is a thought experiment that goes like this: it seems perfectly possible to have a superintelligence whose sole goal is completely arbitrary, such as manufacturing as many paperclips as possible. A superintelligent AI could find ways to transform most of our planet into a monstrous heap of paper clips, and so on to the Milky Way and most of the observable universe. The AI would resist with all its might any attempt to alter this goal. Before humans even have time to think about organizing a resistance, the machine will have realized what we might be up to and exterminated us simply as a safety precaution (Bostrom, 2003). According to Häggström (2016), the main reason to fear a superintelligent AI Armageddon is not that the AI would exhibit the psychology of an "alpha male," a "megalomaniacal despot," or a "psychopathic serial killer." Nevertheless, the most efficient way to attain an extensive range of (often harmless-seeming) goals may involve wiping out humanity (see Häggström, 2016).

A distrust of machines that come to life goes back centuries, and this anxiety and uneasiness have persisted in contemporary "Western" culture. The Golem, the artificially created human of Jewish tradition, is a form of the Zombie-Frankenstein-Robot iconography (Plawiuk, 2005). The legend is about a being made from clay by Rabbi Loew in Sixteenth-Century Prague to free the Jews from their endless toil and hardship in the Ghetto. According to Plawiuk (2005), the word *golem* appears in the Bible in Psalm 139:16, which uses the word יִמְלָג (*galmi*; my Golem), which means "my light form," "raw material," connoting the unfinished human being before God's eyes. Eventually, the mindless clay monster learns and becomes conscious, and, like Frankenstein, he must be destroyed when he grows larger and more powerful (Plawiuk, 2005). The relationship between humans and robots is also the issue in Karel Čapek's famous play *RUR* (Rossum's Universal Robots), which premiered in Prague, the capital of Czechoslovakia, in 1921 (see Jordan, 2019). The play introduces a robot factory that sells human-like Machines as a cheap labor force, and, as the story goes, ultimately the robots revolt against their human enslavers (Jordan, 2019).

According to Margaret Shildrick (1996), "monsters signify [...] the otherness of possible worlds, or possible versions of ourselves, not yet realized" (p.

8). Frankenstein has become the archetypal techno-monster story due to its anticipation of the potential of science to create new life forms (Waldby, 2002). HAL 9000, an artificial intelligence, has been compared to *Frankenstein's monster*. In the blog, "Kubrick's Frankenstein: HAL in *2001: A Space Odyssey*," John Thurman (2007) states that HAL's very existence is an abhorrence, much like Frankenstein's monster. Thurman says that while perhaps not overtly monstrous, HAL's true character is hinted at by its physical manifestation, symbolizing the incarnation of monstrous human potentialities. Like a Cyclops, "he" relies upon a single "eye," glowing red and increasingly eerie, the portrait of a deep and malevolent intelligence (see Thurman, 2007).

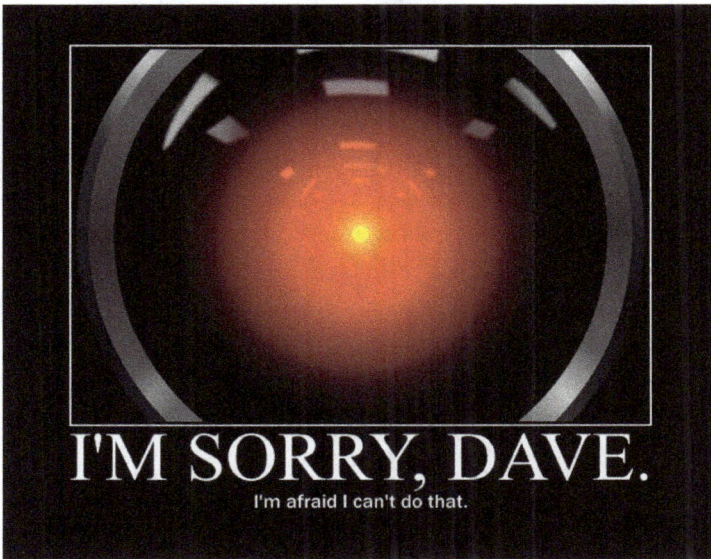

Figure 2.1.1. "I'm sorry Dave, I'm afraid I can't do that," HAL 9000.
(HAL 9000 I'm Sorry Dave Motivational Poster. Wikimedia Commons Attribution 3.0)
© Kubrick, S., & Clarke, A. C. (1968). *2001: A Space Odyssey*. United States: Metro-Goldwyn-Mayer.
Source: https://commons.wikimedia.org/wiki/File:HAL9000_I%27m_Sorry_Dave_Motivational_Poster.jpg

Perhaps such Frankenstein fears are why 7 out of 10 Americans were worried about technology in people's bodies and brains, even if it offered health benefits, according to Pew Research Center's report (2016) on "Human Enhancement: The Scientific and Ethical Dimensions of Striving for Perfection."

Religion seems to influence the West's attitude toward intelligent machines significantly. Cultural studies dealing with robots connect the fear that they generate to Judeo-Christian monotheism with its doctrine that only God can give life (Mazlish, 2008). In the Biblical myth of Genesis, only God exists in the beginning, and all living things are God's creations; if humans are created in God's world, the monster is spawned in the laboratory (Mazlish, 2008). Human, the evil scientist, has usurped God's place. For instance, Dr. Frankenstein is the "Modern Prometheus," overreaching himself by becoming the mad scientist whose defiance of God has disconnected him from the circle of humanity (van Wyk, 2015). In *Frankenstein*, both the scientist Dr. Frankenstein and his monster are destroyed at the book's end. Left behind, in the shape of gargoyles of the mad scientist and the golem-automaton run amok, is a new-old commandment: "Thou shall not create matter in thine own image" (see Mazlish, 1993).

Rui Umezawa (2010) points out that, in the West, a human who breathes life into an inanimate object assumes the role of God. Such a blasphemer deserves punishment, and in science fiction convention, this usually comes in the form of betrayal by the robot. According to Zarkadakis (2015), Isaac Asimov, like a biblical prophet, restricted free will in robots by hardwiring his three laws of robotics into their "positronic" brains in his stories. Perhaps Asimov realized that the greatest threat from Artificial Intelligence is the same age-old threat from the servant or the enslaved person: "they may indeed rebel and kill us all in our sleep" (see Zarkadakis, 2015).

"Pulling the Plug"

As we have seen, some people have a fear of Frankenstein-like "monster" machines evolving and threatening human survival. Mazlish (1993) does not consider this view of the "Fearsome Other" favorably. According to Mazlish (1993), humans insist on their separateness and superiority over machines (as well as other animals), viewing machines as a threatening new "species." Perhaps the most common response to the threatening new species is that "we can always just switch it off." "Faced with an uppity machine, we've always known we could pull the plug as a last resort, but if we accept the idea of an intelligent machine, we're going to be stuck with a moral dilemma in pulling that plug" (McCorduck, 2004, p. 198). Furthermore, in the book *Human Compatible: Artificial Intelligence and the Problem of Control*, Stuart Russell

(2019) argues that switching off the machine will not work, since a superintelligent entity will have already thought of that possibility and taken measures to prevent it.

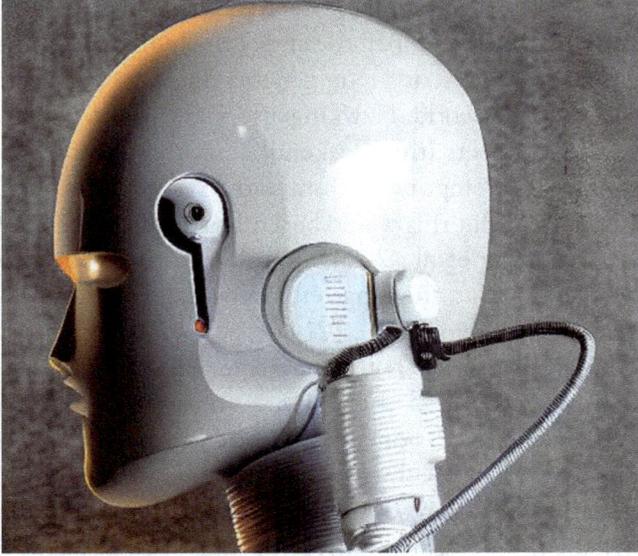

Figure 2.1.2. To pull, or not to pull, that is the question: Whether 'tis nobler in the mind to pull the plug?
Image generated using DALL-E 2 with the prompt "robot head with a power cable coming out from the back neck" (OpenAI, 2022).
OpenAI. (2022). DALL-E (Version 2) [Large text-to-image model]. https://openai.com/product/dall-e-2

The "fear" narrative clashes with humans' instinctive desire to love and be loved. This clash of conflicting emotions—fear and love—is coded in polar narratives about Artificial Intelligence. Will robots one day take over the world? This fear of human extinction, or of becoming reduced to a mere machine or a spiritless realm, adds to existential anxiety. Some decry this increasing infiltration of our thoughts, feelings, and dreams by machines. The Global Challenges Foundation released an unsettling look at the factors that threaten human civilization (see McFarland, 2015). Among "The 12 Threats to Human Civilization, Ranked," the category of "machines with an extreme amount of technology" was selected as the number one threat to humanity, based on the idea that these machines may hoard human-energy resources to boost their intelligence (see McFarland, 2015). This sentiment was played out

in the movie universe of *The Matrix*, in which the use of humans for power generation is a central premise for the entire series.

Some of today's scientists, philosophers, and technologists publicly express their concerns over apocalyptic scenarios that will likely arise due to machines with unsavory motives. According to Stephen Hawking, the development of full artificial intelligence could spell the end of the human race; unless human-kind redesigns itself by altering our genetic makeup, computer-generated robots will take over our world. Hawking also said, "as the Hollywood block-buster *Transcendence* debuts [this weekend] ... with clashing visions for the future of humanity, it's tempting to dismiss the notion of brilliant machines as mere science fiction. But this would be a mistake, and potentially our worst mistake ever" (Hawking et al., 2014). While the short-term impact of AI depends on who controls it, the long-term impact depends on whether it can be controlled at all (Hawking et al., 2014).

As large language models and generative artificial intelligence agents like ChatGPT have captured the public's attention, billionaire investor Warren Buffett expressed his concern over the rise of artificial intelligence, comparing the rise of the technology to the creation of the atom bomb (see Geanous, 2023). "When something can do all kinds of things, I get a little bit worried," the 92-year-old investor said. "Because I know we won't be able to un-invent it and, you know, we did invent, for very, very good reason, the atom bomb in World War II" (see Geanous, 2023).

Calling out the potential threat of machines that can think for them-selves, Elon Musk portrays artificial intelligence development as "summon-ing the demon," but, as Mephistopheles did with Faust, the demon may help before it destroys (as quoted in Alba, 2015). Indeed, it was reported that Musk described artificial intelligence as the "biggest existential threat there is," and has donated 10 million dollars to the Future of Life Institute to operate a global research program to keep AI benevolent to humanity (see Alba, 2015). Musk warned that it is easy to imagine an unconstrained software application that spreads throughout the internet (like *Skynet* in the Matrix movies) (see Alba, 2015). Likewise, a growing number of sci-entists and practitioners in the field propose that safeguards be put in place so that humans do not lose control over such intelligence.

Artificial intelligence is the culmination of audacious efforts to dupli-cate in an artifact what we humans consider our most important identify-ing characteristic—our intelligence (McCorduck, 2004). Humans created intelligent machines, but there is always the possibility that something

might go wrong. In the book *Technophobia*, Dinello (2005) focuses on widespread reactions to sci-fi films and imagines a disastrous future of post-human techno-totalitarianism, encouraging us to ponder the most import-ant question of the twenty-first century: Is technology out of control? Will our dark future be dominated by mad scientists, rampaging robots, and killer clones? According to Mazlish (1993), human pride and its attendant refusal to acknowledge the continuity between humans and machines form the basis upon which rests much of the distrust of technology.

Adding to the complexities regarding the status of technology, fears about technology seem particularly pronounced when a threat to the uniqueness of humans is perceived. According to Moor (2003), initial evidence for such a threat could be seen in the work of David Cope, a musician and computer programmer. Cope developed a system called EMI (Experiments in Musical Intelligence) that creates original music in the style of certain historical composers. The efficacy of his design is demon-strated by an experiment in which one is asked to listen to short tracks of piano music composed either by a human or by EMI. This is something like a musical Turing test aiming to distinguish the human composition from the machine composition (Moor, 2003). Douglas Hofstadter (1979), the author of *Gödel, Escher, Bach*, expresses deep anxieties about the impli-cations of Cope's work for the mystery of human creativity. At one point, talking of such pattern-based music composition techniques, Hofstadter (1979) says that the day when music is finally and irrevocably reduced to syntactic pattern and pattern alone will be, to his old-fashioned way of looking at things, a very dark day indeed.

The notion of androids with creative capabilities can be perceived as a threat to human identity, undermining the distinction between humans and mechanical agents. One year before losing at chess to Big Blue, IBM's RS/6000 SP-based computer, Gary Kasparov warned:

> To some extent, this match is a defense of the whole human race. Computers play such a huge role in society. They are everywhere. But there is a frontier they cannot cross. They must not cross into the area of human creativity. It would threaten the existence of human control in such areas as art, literature, and music. (as quoted in Pepperell, 2005)

Regardless of whether a social robot may look more like a human or a robot, it seems as though it might run into similar issues simply by surpassing human cognitive abilities. In March 2016, AlphaGo's 4–1 victory against

Mr. Lee Sedol, the winner of 18 world titles and widely considered the greatest player of the past decade, was watched by over 200 million people worldwide (Borowiec, 2016). Computers have mastered such games, which, therefore, are no longer skills that we can perceive as uniquely human. With the emergence of ChatGPT, an AI-powered chatbot capable of generating human-like responses to an unimaginable range of questions and prompts, some worry that human uniqueness will progressively degrade.

Psychological Underpinnings of the Uncanny Valley

But what is it precisely that horrifies humans? Is it that these mechanical, artificial creatures are so much like humans? Pamela McCorduck (2004) invokes the influence of the biblical Second Commandment, forbidding the creation of "idols" made in our image: "Thou shalt not make unto thee any graven image or any likeness of any thing that is in heaven above or that is in the earth beneath, or that is in the water under the earth; Thou shalt not bow down thyself to them nor serve them, for I the Lord thy God am a jealous God" However, there is something beyond theology and cultural narrative that can horrify us in the presence of human-like robots.

In 1970, the Japanese roboticist Masahiro Mori introduced the term "Uncanny Valley" to describe humans' emotional response to non-human entities and the disquieting effect of being confronted with a machine that appears almost but not entirely human (Dihal & Cave, 2020). Mori (1970) argues that a thing, like a prosthetic hand, that looks very real but lacks the feel and temperature of a "living hand" creates a sense of the uncanny or sudden eerie unfamiliarity. On the other hand, certain robots like Wakamaru or Asimo, who bear only a general resemblance to the human body but speak and gesture like humans, generate a sense of familiarity. Mori (1970) thus recommends that engineers avoid imperfect simulation (and therefore uncanniness) by retaining robots' metallic and artificial characteristics to prevent cognitive-emotional confusion among humans.

Robots can evoke a sense of social presence ("sense of being with another," Biocca et al., 2003, p. 456), a misperception of experience mediated by technology. But as they gradually acquire more human features,

Figure 2.1.3. The hand becomes uncanny, which at first sight looks real, is, in fact, artificial, and we experience an eerie sensation in that process.
(Sauerbruch prosthesis using an artificial hand designed by Jakob Hüfner)
Source: https://commons.wikimedia.org/wiki/File:Sauerbrucharm_mit_H%C3%BCfnerh and.JPG

our liking turns to revulsion. According to Saygin (2012), when there is a perceptual conflict between the human-like features of the robot and its mechanical movement, this mismatch creates a feeling of revulsion and disgust, similar to what humans may feel when looking at a "zombie." In the article, "The Uncanny Valley: Effect of Realism on the Impression of Artificial Human Faces," Seyama and Nagayama (2007) found that people are more comfortable interacting with a robot that is 50% human in appearance than one that appears 99% human. Somehow, so much closeness in appearance (the mere 1% difference) is disturbing, as if talking to an animated corpse or a zombie rather than a living person. Evidently, there is considerable reflection by roboticists as to how human-like humanoid robots should or should not appear.

Naremore (2005), in the article "Love and Death in A.I.," writes that Freud's essay (1900/1999) on the *uncanny* is based in part on the analysis of animated dolls, and that Freud's take on uncanny feelings associates it with the primal fear of castration (as a threat to the "phallus") and death. The notion of "uncanny" has remained significant in thinking about our

reaction to human-like robots. Rutsky (1999) says that when a technology appears animated or strangely "undead," humans tend to lose faith in the authority of a unitary, living human soul or spirit over the contingency of the object world.

In their study, "Blurring Human-Machine Distinctions: Anthropomorphic Appearance in Social Machines as a Threat to Human Distinctiveness," Ferrari et al. (2016) found that androids that were rated as most anthropomorphic were also seen as most damaging to human identity (followed by humanoids and mechanical robots). Part of the allure of robots is that they resemble humans, yet are not human. Too much perceived similarity may trigger concerns because it blurs the boundaries between humans and machines, posing a threat to human uniqueness (Ferrari et al., 2016). McCorduck (2004), in Machines Who Think, notes that our species seems "a bit like Snow White's wicked stepmother, pathetically anxious to be assured by our magic mirror that we are still the smartest in the land" (p. 232).

Intelligent machines may also alarm those who feel that machines threaten the quality of human life. This conflict with human well-being is perceived when machines are felt to cause dehumanization or suffering as humans are forced to adapt to the needs of the machines (Mazis, 2008). Berardi (2015) echoes a similar sentiment: "The automaton is pure functionality, even when endowed with self-regulating evolution. It will subsume human cognitive competence and subject it to its rule. According to this prediction, the prospect we will face is not the sweetish transhuman alliance between friendly, hyperintelligent machines and human beings; instead, it is the final subjection of humans to the rule and regulations of nonorganic intelligent automata" (p. 337). This scenario is depicted in the film *Modern Times*, in which Charlie Chaplin is swallowed into the gears of the machines in a factory, force-fed lunch by a feeding machine, and pushed around by the hands of the massive clock that keeps efficient industrial time (Mazis, 2008). Even while machines represent a particular ideal and a path of excellence that humans aspire to, the relentlessness and inexorability of machines seem cruel to humans, symbolizing the dangers of technology (Mazis, 2008).

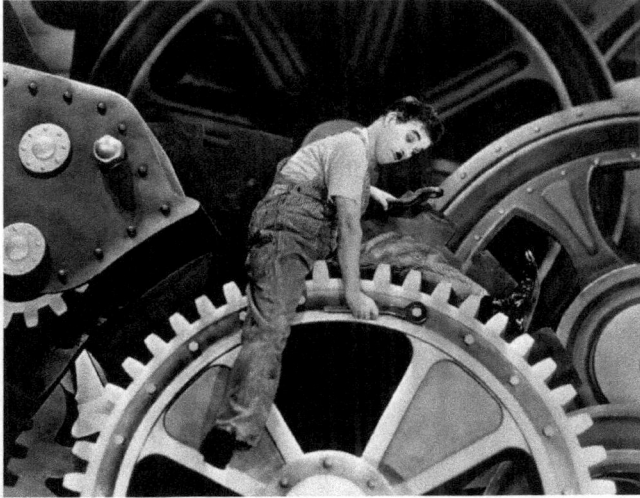

Figure 2.1.4. The collision of machines with human well-being: In the film *Modern Times*, Charlie Chaplin's character is swallowed up by the cogs of the factory machine, signifying the loss of individual agency in the age of automation.
(from the film *Modern Times*)
This work is in the public domain in the United States because it was published in the United States between 1928 and 1977, inclusive, without a copyright notice.
"Charlie Chaplin" by barbie.harris37 is licensed under CC BY 2.0.
Source: https://openverse.org/image/e7ed7363-787d-46b5-8eac-8bfc53bc5595?q=chaplin%20 machine

Mazis (2008) predicts another potential impact of machines, in that they can threaten the aesthetic dimension of the quality of life. The ugliness of our urban landscapes, inhabited by machines or altered through their powers, threatens humans' well-being (Mazis, 2008). For example, the film *Elysium* portrays a polluted, diseased, and overpopulated industrial Earth in the year 2154. In this dystopian future, the 1% lives on a luxury space colony, whereas the entire Earth is an overcrowded slum (Blomkamp, 2013). Such visions of the future earth are really less about the future and more about what is happening now, as can be seen in the Dharavi slum.

It is not possible to address all the psychological factors that contribute to the fear of machines. We noted Freud's (1917/1955) writing on the uncanny feelings elicited by China dolls, waxwork figures, and automata. Paranoia about the "mechanical Other" may also be fueled by the influence of the Second Commandment from Judeo-Christian theology ("Thou shall not create matter in thine own image"). Existential threats to human uniqueness

may be perceived, as well as a threat to the aesthetic aspects of quality of life. The fear of being reduced to a cog in the industrial machine may be a carryover from visions of clanking machinery and inexorably turning gears (Mazis, 2008).

Figure 2.1.5. Founded in 1884 during the British colonial era, Dharavi slum is considered one of the world's largest slums (Text: Dharavi, 2023).
"Tapestry of Dharavi—Mumbai" by ToGa Wanderings is licensed under CC BY 2.0.
Source: https://openverse.org/image/8e23572d-d01a-48b1-8b33-75789392c6ae?q=dharavi

References

Alba, D. (2015, January 15). Elon Musk donates $10M to keep AI from turning evil. *WIRED*. https://www.wired.com/2015/01/elon-musk-ai-safety/

Berardi, F. B. (2015). *And: Phenomenology of the end: Sensibility and connective mutation.* Semiotext(e).

Berserker. (2023, April 14). In Wikipedia. https://en.wikipedia.org/wiki/Berserker_(novel_series)

Bierce, A. (1899/2013). *Moxon's master*. Createspace Independent Publishing Platform.

Biocca, F., Harms, C., & Burgoon, J. K. (2003). Toward a more robust theory and measure of social presence: Review and suggested criteria. *Presence: Teleoperators and Virtual Environment, 12*(5), 456–480. https://doi.org/10.1162/105474603322761270

Blomkamp, N. (Director). (2013). *Elysium* [Film]. TriStar Pictures, Media Rights Capital, QED International, Alphacore, & Kinberg Genre.

Bostrom, N. (2002). Existential risks. *Journal of Evolution and Technology, 9*(1), 1–31.

Bostrom, N. (2003). *Ethical issues in advanced artificial intelligence*. https://nickbostrom.com/ethics/ai

Borowiec, S. (2016, March 15). AlphaGo seals 4–1 victory over Go grandmaster Lee Sedol. *The Guardian*. https://www.theguardian.com/technology/2016/mar/15/googles-alphago-seals-4-1-victory-over-grandmaster-lee-sedol

Brown, S. (2021, Apr 21). Machine learning, explained. *MIT Sloan School of Management*. https://mitsloan.mit.edu/ideas-made-to-matter

Cameron, J. (Director). (1984). *The Terminator* [Film]. Hemdale & Pacific Western Productions.

Cameron, J. (Director). (1991). *Terminator 2: Judgment Day* [Film]. Carolco Pictures, Pacific Western Productions, Lightstorm Entertainment, & Le Studio Canal+.

Čapek, K. (2004). *R.U.R. (Rossum's Universal Robots)* (C. Novack-Jones, Trans.). Penguin Books. (Original work published 1921)

Chaplin C. (Director) (1936). *Modern Times* [Film]. United Artists.

Dharavi. (2023, May 18). In *Wikipedia*. https://en.wikipedia.org/wiki/Dharavi

Dihal, K., & Cave, S. (2020, March 12). Why we like a good robot story. OUPblog. https://blog.oup.com/2020/03/why-we-like-a-good-robot-story/

Dinello, D. (2005). *Technophobia! Science fiction visions of posthuman technology*. University of Texas Press.

Ferrari, F., Paladino, M. P., & Jetten, J. (2016). Blurring human–machine distinctions: Anthropomorphic appearance in social robots as a threat to human distinctiveness. *International Journal of Social Robotics, 8*(2), 287–302. https://doi.org/10.1007/s12369-016-0338-y

Foerst, A. (1998). Embodied AI, creation, and cog. *Zygon, 33*(3), 455–461. https://doi.org/10.1111/0591-2385.00161

Freud, S. (1999). The "Uncanny." In S. Freud (Ed.), *The standard edition of the complete psychological works of Sigmund Freud: An infantile neurosis and other works* (Vol. 17, pp. 217–256). Vintage. (Original work published 1919)

Geanous, J. (2023, May 6). "Worried" Warren Buffett compares AI to the creation of the "atom bomb." *New York Post*. https://nypost.com/2023/05/06/warren-buffet-compares-ai-to-atom-bomb-at-berkshire-hathaway/

Häggström, O. (2016). *Here be dragons: Science, technology and the future of humanity*. Oxford University Press.

Harari, Y. N. (2015). *Homo Deus: A brief history of tomorrow*. Harvill Secker.

Hawking, S., Tegmark, M., & Russell, S. (2014, April 19). *Transcending complacency on superintelligent machines*. HuffPost. https://www.huffpost.com/entry/artificial-intelligence_b_5174265

Hofstadter, D. (1979). *Gödel, Escher, Bach: An eternal golden braid*. Vintage Books.

Jonze, S. (Director). (2013). *Her* [Film]. Annapurna Pictures.

Jordan, J. (2019, July 29). *The Czech play that gave us the word "robot."* The MIT Press Reader. https://thereader.mitpress.mit.edu/origin-word-robot-rur/

Kaku, M. (2021). *The God equation: The quest for a theory of everything*. Doubleday.

Kenyon, S. H. (2008). Would you still love me if I was a robot? *Journal of Evolution Technology*, *19*, 17–27. https://www.researchgate.net/publication/228802011_Would_You_Still_Love_Me_If_I_Was_A_Robot

Kubrick, S. (Director). (1968). *2001: A Space Odyssey* [Film]. Stanley Kubrick Productions.

Lucas, G. (Director). (2002). *Star wars episode II: Attack of the clones* [Film]. Lucasfilm Ltd.

Mazis, G. (1993). *Emotion and embodiment: Fragile ontology*. Peter Lang.

Mazis, G. (2008). *Humans, animals, machines: Blurring boundaries*. State University of New York Press.

Mazlish, B. (1993). *The fourth discontinuity*. Yale University Press.

McCorduck, P. (2004). *Machines who think: A personal inquiry into the history and prospects of artificial intelligence*. A. K. Peters.

McFarland, M. (2015, February 20). *The 12 threats to human civilization, ranked*. The Washington Post. https://www.washingtonpost.com/news/innovations/wp/2015/02/20/the-12-threats-to-human-civilization-ranked/

McGrath, J. F. (2011). *Robots, rights and religion*. Butler University Libraries Digital Image Collections. https://digitalcommons.butler.edu/cgi/viewcontent.cgi?article=1198&context=facsch_papers

Moor, J. H. (Ed.). (2003). *The Turing Test: The elusive standard of artificial intelligence*. Kluwer Academic Publishers.

Mori, M. (1970). The uncanny valley. *Energy*, *7*(4), 33–35.

Naremore, J. (2005, Spring). Love and death in A.I. *Michigan Quarterly Review*, *XLIV*. http://hdl.handle.net/2027/spo.act2080.0044.210

Pepperell, R. (2005). Posthumans and extended experience. *Journal of Evolution and Technology*, *14*, 43–53.

Pew Research Center. (2016, July 26). *Human enhancement: The scientific and ethical dimensions of striving for perfection*. https://www.pewresearch.org/science/2016/07/26/human-enhancement-the-scientific-and-ethical-dimensions-of-striving-for-perfection/

Plawiuk, E. (2005, February 15). Gothic capitalism: The horror of accumulation and the com-modification of humanity. *Le Revue Gauche: A Journal of Libertarian Communist Analysis and Comment.* https://plawiuk.blogspot.com/2005/02/gothic-capitalism.html

Russell, S. (2019). *Human compatible: Artificial intelligence and the problem of control.* Penguin Publishing Group.

Rutsky, R. L. (1999). *High techne: Art and technology from the machine aesthetic to the posthuman.* University of Minnesota Press.

Saygin, A. P. (2012). *What can the brain tell us about interactions with artificial agents and vice versa?* [Workshop]. 34th Annual Meeting of Cognitive Science Society, Workshop on Teleoperated Androids, Sapporo, Japan.

Scott, R. (Director). (1982). *Blade runner* [Film]. The Ladd Company, Shaw Brothers, & Blade Runner Partnership.

Seyama, J., & Nagayama, R. S. (2007). The Uncanny Valley: Effect of realism on the impres-sion of artificial human faces. *Presence: Teleoperators and Virtual Environment, 16*(4), 337–351. https://doi.org/10.1162/pres.16.4.337

Shelley, M. (2018). *Frankenstein: The 1818 text.* Penguin Classics. (Original work published 1818)

Shildrick, M. (1996). Posthumanism and the monstrous body. *Body & Society, 2*(1), 1–15. https://doi.org/10.1177/1357034X96002001001

Sims, C. A. (2013). *Tech anxiety: Artificial Intelligence and ontological awakening in four science fiction novels.* McFarland & Company, Incorporated Publishers.

Thurman, J. (2007, December 11). *Kubrick's Frankenstein: HAL in 2001: A Space Odyssey.* Cinema Prism. https://cineprism.wordpress.com/

Umezawa, R. (2010). *We, robots* [The spirit age: Mindfully stumbling through modernity]. Retrieved September 3, 2011, http://www.the-spirit-age.com/2010/07/we-robots.html.

van Wyk, W. (2015). *Shelleyan monsters: The figure of Percy Shelley in Mary Shelley's Frankenstein and Peter Ackroyd's The Casebook of Victor Frankenstein* [Master's thesis, the University of the Western Cape]. http://hdl.handle.net/11394/4860

Wachowskis, The. (Director). (1999). *The matrix* [Film]. Warner Bros. Pictures.

Wachowskis, The. (Director). (2012). *Cloud atlas* [Film]. Cloud Atlas Productions.

Waldby, C. (2002). The instruments of life: Frankenstein and cyberculture. In D. Tofts, A. Jonson, & A. Cavallaro (Eds.), *Prefiguring cyberculture: An intellectual history* (pp. 28–37). The MIT Press.

Wilson, D. (2011). *Robopocalypse: A novel.* Knopf Doubleday Publishing Group.

Wolens, D. (Director). (2012). *The Singularity* [Film]. Voltage Pictures, Vantis Pictures, & Calanda Pictures.

Zarkadakis, G. (2015). *In our own image: Savior or destroyer? The history and future of Artificial Intelligence.* Rider.

· 2 . 2 ·

MACHINES AS "SUBHUMAN OTHER": *DISDAIN*

The second narrative evokes the emotion of "disdain." In particular cultural imaginations, machines lack souls and, are, therefore, undeserving of empathy. Based on the master-slave metaphor of human-robot relationships, artificial humans are seen as lacking a moral compass and cannot be trusted, no matter how intelligent they might be. They should therefore be treated as insensate slaves beneath human consideration.

This narrative on AI goes like this (quoting from Hank Pellissier's 2013 blog post "Robots and Slavery—What Do Humans Want When They Are 'Masters'?"):

> Robot obeys. A robot does what the human Master wants. Robot is Slave. Androids today are quite "primitive"—they don't look convincingly "human"—not yet. But soon, they'll be indistinguishable from us … except … they'll be 100% compliant … devoted to our wishes … Slaves will do in the future what slaves do today, and what slaves have always done in the past. What slaves have always done for their Masters is: Work. Kill. Sex. Since the dawn of humanity, slaves have been coerced into performing dreary laborious tasks, slaughtering enemies of the tribe, and delivering sexual gratification. This trio of slave duties has spanned across time and cultures consistently. This means we'll keep them clean and properly maintained. This is practical because we'll want them gleaming gorgeously and functioning smoothly as they perform their functions for us—laboring, battling, copulating.

The notion of robots as artificial servants dates back to the ancient world. Martin Devecka (2013), in the article "Did the Greeks Believe in Their Robots?," argues that the ancient Greeks had a mechanistic conception of the world as early as the fourth century BCE. Devecka (2013) takes the view that people of ancient times could subscribe to the notion of robot replacements

for slaves. Soren Riis (2011) writes that "slavery essentially belongs to the notion of ancient technology, as slaves were regarded as special kinds of tools" (p. 107). In the Iliad, written around 800 BCE, Homer describes "golden handmaidens" created by Hephaestus, the disabled God of metalworking— They "seemed like living maidens" with "intelligence ... voice, and vigor" and "bustled about supporting their master" (Riis, 2011).

This narrative ("Machines as Subhuman Other") posits that robots are non-humans and, therefore, as technological artifacts, should be positioned outside the boundaries of humanness. According to the *Online Etymology Dictionary*, the very word "robot" traces its roots to the Czech word "Robotnik," which means "slave." "Robotnik" comes from "robota," the Old Church Slavonic word for servitude. In Karel Čapek's 1921 sci-fi drama *Rossum's Universal Robots (RUR)*, The play's human protagonist, Harry "Domin" (a Latin prefix meaning "master"), proclaims that "the Robots are not people. Mechanically, they are more perfect than we are, they have enormously advanced intelligence, but they have no soul" (see Williams, 2016).

The master/slave metaphor is at the core of the human relationship to technology. Based on the power differential between humans and machines, these artificial creations, having no soul, are considered nothing more than property, expendable for human benefit or entertainment. Within the narrow confines of slavery, the human relationship to machines as property creates a sense of disdain, a feeling that robots like Anita (from the TV series *Humans*) are beneath one's level and unworthy of respect. Joe Hawkins, tired of cleaning up at home while his wife Laura is away on a work trip, decides to buy a Synth (Anita), the Modern-Day Slave (Humans (TV series), 2023).

In 1984, Nolan Bushnell, the founder of Atari, told the *New York Times* that he believed the ultimate role of robots in society would be slavery (see LaFrance, 2016). Similarly, Joanna Bryson (2009), in the article "Robots Should Be Slaves," argues that "Slaves are normally defined to be people you own" (p. 156). Bryson continues that robots should be servants that humans own—as replaceable objects, subordinate to human goals, that are built to improve human lives. On this *master-slave* sentiment, Bryson (2009) wrote:

> We do not particularly approve of people destroying rare cars with sledge hammers, but there is no law against such behavior. If a robot happened to be a unique piece of fine art, then we owe it the same obligations we owe other pieces of art. (p. 167)

According to Bryson (2009), robots are tools for mundane or repetitive tasks, so that more of our time and resources can be devoted to valuable activities,

including socializing with colleagues, family, and neighbors. In Bryson's viewpoint, robots should not be described as persons nor given legal or moral responsibility for their actions. A viewpoint such as Bryson's can easily trigger arguments regarding ethics and robot rights.

In the "Subhuman Other" narrative that we are describing, artificial beings cannot feel emotions such as empathy. In the *Star Wars* films, Ben Kenobi says about Darth Vader that he is now "more machine than man." The implication, as in many other novels and movies, is that machines do not have feelings (McGrath, 2011). Science fiction regularly explores scenarios involving sentient machines (sometimes called "androids"). The machine in question often seems to exhibit human or human-like thoughts but not emotions (McGrath, 2011). Scenarios involving intelligent but emotionless machines are commonplace in science fiction. From Dr. McCoy in *Star Trek* haranguing the unemotional Spock as "the most cold-blooded man I have ever known" to moral reasoning about the supposed lack of empathy in criminals, we deem emotions as central to our identity (Savage, 2013).

According to Mazis (2008), unlike machines, humans are said to truly feel, care, and empathize. Mazis notes that, ironically, until recently these attributes were not prized as humanity's unique endowment. For Plato and Aristotle, humans are not to be defined by their emotions, unlike the "lesser brutes" (Mazis, 2008). According to Mazis (2008), considering that emotions were regarded as somehow tainted with the "brutishness" of animals, it is paradoxical that, in recent decades, the emotional life of humans has been elevated to the status of something unique about humans that a machine can never achieve.

In recent discussions on the human-machine boundary, artificially intelligent robots are seen as infringing upon the territory of human emotions. With a tone of contempt, one may say, "It is all very well for a robot to simulate having emotions." "I don't care how sophisticated it is—it will never have the same humanity as living flesh." Given the uneasiness that machines might usurp our status as unique beings, emotion has suddenly taken on the role of humanity's defining attribute. As articulated by Rodney Brooks (2002) of the MIT AI Lab: "Machines may have beaten us out in pure calculating and reason, but we still have our emotions. This is what makes us special. Machines do not have them; we alone do. Emotions are our current last bastion of specialness" (p. 66).

In the article "Blade Runner's Post-Individual Worldspace," Kevin R. McNamara (1997) uses the main plot in Phillip K. Dick's book, *Do Androids*

Dream of Electric Sheep, to illustrate the critical role of empathy in ineffable relationships between humans and artificial beings. The book follows *Rick Deckard*, a bounty hunter who is faced with "retiring" (killing) six escaped Nexus-6 model androids manufactured by the Rosen Association. The notion that androids cannot feel empathy is deeply rooted in Deckard's mind. "Empathy existed only within the human community," recounts McNamara (1997); androids are supposed to be emotionless. The only way to deny moral ground to the android is to maintain a difference, and create a means to measure and identify that difference (see McNamara, 1997). Deckard visits Rosen headquarters in *Seattle* to confirm the validity of a question-and-answer empathy test: a method for identifying androids posing as humans. Rick slowly loses confidence in the significance and morality of his work because he begins to realize that the androids themselves are not inherently dangerous, and the real danger stems from losing our human empathy by guiltlessly enslaving the androids (McNamara, 1997).

In another take on the fundamental inferiority of the latest machines, Richard Feynman, in a video lecture entitled "How computers think [or not]," describes the computer as a glorified, high-class, very fast but stupid filing system, managed by an infinitely stupid file clerk (the central processing unit) who blindly follows instructions (the software program) (as cited in Danaylov, 2013). Extending such disdain toward machinic others, as soon as AI becomes capable of doing something, that capability is no longer accepted as a hallmark of intelligence. For example, chess was considered the epitome of intelligence until Deep Blue won a series of matches against world chess champion Garry Kasparov. All in all, arguing that something important (e.g., empathy, feelings) is missing from modern AIs, some humans portray this new evolutionary "species" as a *Subhuman Other* (Heo & Kim, 2013; Kim & Kim, 2013).

Calverley (2006) notes that since ancient times, in the Abrahamic traditions, humans are described as the masters of other living creatures: "man" is given dominion "over the fish of the sea, the birds of the air, and the cattle, and over all the wild animals and all the creatures that crawl on the ground" (Genesis, Book 1, verse 26). While not all "Western" philosophical outlooks have accepted this position, it has found expression in the long-standing Judeo-Christian tradition that "man" is special, and, therefore, God has given "him" dominion over animals (Calverley, 2006). The subordinate position of animals as property (like that of "mechanisms" or "automata") has remained the primary "Western" belief for millennia.

In their article, "Has a robotic dog the Buddha-nature? Mu!," Pope and Metzler (2008) claim that Google might not want its autonomous cars to be associated with powerful human-like robots. According to Pope and Metzler, some robots are intentionally built to be diminutive. For instance, in Japanese culture it seems that robots are made in the image of those most often controlled—children, women, and pets. Even "Astro Boy," despite his supra-human heroic nature, is a child. Reinforcing social hierarchy, in the infantilization and feminization of technology, humans are clearly in charge, with sweet-looking artifacts (in the form of children, women, or dogs) obviously beneath them (Pope & Metzler, 2008).

Figure 2.2.1. Asimo, only 1.4 m tall and overtly childlike, met Boris Johnson (Britain's Secretary of State for Foreign and Commonwealth Affairs) at Honda Motor Co., Ltd. in Tokyo Metropolis on July 20, 2017.
©British Embassy Tokyo
(Source: Foreign Secretary Boris Johnson visits Japan | Foreign Secre … | Flickr)
British Embassy Tokyo in Japan-FCO, CC BY 2.0 https://creativecommons.org/licenses/by/2.0
Source: https://www.flickr.com/photos/uk-in-japan/35652974460/

In the *Atlantic* magazine article, "What Is a Robot?," Adrienne LaFrance (2016) mentions that the U.S. military promotes video compilations of robots failing to accomplish tasks in the DARPA Robotics Challenge by buckling at the knees, bumping into walls, and tumbling over. It is supposed to be funny

and therefore disarming for humans. According to LaFrance, the same strategy was used in early publicity campaigns for the first computers: People with an economic interest in computers wanted to make them appear as dumb as possible. That became the propaganda—that computers are stupid and only do what you tell them.

Since humans feel the need to be unique and superior, some deny that such artificially intelligent and autonomous entities will emerge, declaring that if they do, they will be vastly inferior to humans and thus not worthy of respect or concern (Dator, 2007). In their paper "The Android Fallacy," Neil Richards and William Smart (2013) wrote that it is essential for humans to think of machines as tools, not companions—a tendency they say is "seductive but dangerous." As Richards and Smart see it, the problem comes with assigning human features and behaviors to robots—describing machines as being "scared" of obstacles in a lab, or saying that a robot is "thinking" about its next move.

Categorizing machines as inferior seems to begin after humans decide that humanoid robots do not meet their threshold of humanness. An early thread of the metaphysical debate about personhood can be traced back to the concept of "ensoulment" in ancient Greece (Calverley, 2006). The moment of ensoulment was believed to mark the beginning of life. Pythagoras said: "[T] he earthly soul is said to be a temporarily fallen divinity, immortal in character, and the most essential and enduring part of each person's identity" (Carrick, 1985, p. 110). The Catholic religion holds that the distinguishing feature between humans and animals is ensoulment: "If the human body takes its origin from pre-existent living matter, the spiritual soul is immediately created by God" (Calverley, 2006). Consequently, machines, lacking ensoulment events and the spiritual forces immanent in living matter, are incompatible with the perceived self-image of humans.

In forming humans' views toward animals, Rene Descartes is frequently quoted as stating that animals were no different from machines. If a human were to hit a dog with a hammer, it would be of the same moral significance as if a human hit a clock with a hammer (see Calverley, 2006). As mentioned earlier, Joanna Bryson (2009) says that robots are not people or even animals, and therefore have no ethical standing. According to Bryson, the android cannot be the object of moral consideration if it is bounded by constraints imposed by its creator, such as those in Asimov's laws of robotics (1950).

"Dehumanization" of Robots

The proposition that injuring a machine has no moral significance can be seen within the context of the "dehumanization" model. Psychologist Nick Haslam (2006) proposed cognitive underpinnings of the "animalistic" and "mechanistic" forms of dehumanization. *Animalistic* dehumanization is typically accompanied by emotions such as disgust, disdain, and contempt toward the "Other" group members. In contrast, Haslam (2006) posits that *mechanistic* dehumanization denies that the Other possesses characteristics such as warmth, emotionality, and cognitive openness. In mechanistic dehumanization, Others are compared to automata rather than animals.

Investigating such a tendency toward dehumanization of robots in communication contexts, research by Kim et al. (2009) used the theoretical framework of conversational constraints (derived from human-to-human communication research) to compare whether people apply social-oriented constraints and task-oriented constraints differently toward human targets versus humanoid social robot targets. The results suggested that people were significantly less concerned with avoiding hurting the robot's feelings, inconveniencing the robot partner, and avoiding being disliked by the robot than with human interaction partners. Apparently, people were less likely to emphasize the social-oriented constraints in communication with robot partners than with human partners (Kim et al., 2009). This finding would also support the idea of "mechanistic dehumanization" (Haslam, 2006) toward humanoid robots in general.

On a deeper level, the contagion felt by some humans in giving up the first rank above other beings is the sense that mixing of categories (between humans and machines) amounts to impurity (Mazis, 2008). Like an effort to keep separate the sacred (the Human) and the profane (the Machine), the blurring of such boundaries makes us nervous at a deep level as we talk about thinking machines (McCorduck, 1991).

These misgivings on the mixing of human and machine take the form of an indifferent, distancing, and objectifying orientation toward the machinic Other. Robots are perceived as hard, cold, and metallic, as compared to soft and warm human beings, and the consequences of mechanistic dehumanization can range from "hatred and aggression to condescending behaviors, dismissive attitudes, lack of empathy, and indifference to the interests of others" (These are the negative qualities mentioned in intergroup contexts by Haslam et al., 2007, p. 420). Consequently, mechanistic dehumanization of

the machinic Other becomes an everyday phenomenon rooted in ordinary social–cognitive processes.

Wu (2012), in *What Distinguishes Humans from Artificial Beings in Science Fiction World*, mentions a poignant scene regarding the dehumanization of robots that appears in the film *A.I. (Artificial Intelligence)*. In the Anti-Mecha Flesh Fair, obsolete robots are destroyed cruelly in front of a cheering working-class crowd. In this scene, Lord Johnson-Johnson, who captures obsolete robots and hosts the show, says: "Any old iron? Any old iron? Expel your mecha. Purge yourselves of artificiality!" Unlike Monica and Henry in the film, who are well-educated, wealthy, and enjoy the benefits that technology brings to their lives, the Flesh Fair crowd is the lower class of society. Their social status is not far from that of robots (Wu, 2012).

According to Wu (2012), what really bothers people about A.I. is how the development of intelligent machines changes the way we view ourselves. The biggest wish among the crowd in the Anti-Mecha Flesh Fair may be to exterminate all the robots, thereby preserving humans' superiority. The humans' behavior portrayed in these scenes, burning or cutting robots "alive," is very similar to genocide. Humans are reluctant or refuse to admit that robots are already superior to humans in terms of being more intelligent and efficient (Wu, 2012).

Some would deny the possibility of "dehumanizing" intelligent machines by claiming that dehumanizing a robot cannot be lumped together in the same category as dehumanizing members of different human groups or cultures. For instance, Bryson (2009) claims that dehumanization is only wrong when it is applied to humans, since we wholly own robots. In this view, humans should determine robots' goals and behavior directly or indirectly by regulating their intelligence and how it is acquired. Bryson (2009) goes on to say that in humanizing robots, we further dehumanize real people and encourage poor human decision-making in allocating resources and responsibility.

These caveats aside, the plight of dehumanized intelligent machines emerges as a central issue in the 1973 film *Westworld*, which depicts a futuristic playground where the androids, taking on the role of bartenders, prostitutes, sheriffs, bandits, and others, are robotic "hosts." Those androids are programmed to interact naturally with their human guests. In their 2018 *New York Times* article "It's Westworld: What's Wrong with Cruelty to Robots?" Paul Bloom and Sam Harris wrote that these intelligent machines look and act exactly like people. The guests or humans can behave in whichever way they please. Some take on heroic roles, but others choose to act out their

sadistic impulses. As the robot hosts have been designed so that they cannot harm the human guests, these brutal acts by humans are of pure sadism, without risk of reprisal (Bloom & Harris, 2018). In this *Westworld*, the robot hosts are the most human, and the humans who abuse them are monsters. Some humans would be up for visiting a park-like Westworld and acting out their darkest desires with a robot (see Bloom & Harris, 2018).

Figure 2.2.2. 3D-printed robot with muscle fibers and ligaments in Westworld laboratory. "Westworld Comic-Con bag" by ewen and donabel is licensed under CC BY 2.0. *Source:* https://openverse.org/image/6e7c72bb-9afa-4cb6-9642-4b1ed744ae09?q=westworld

The high level of dehumanization toward intelligent machines would likely activate stereotypical conceptions of them as an ultimate cultural out-group (Heo & Kim, 2013). Therefore, one can readily imagine extreme bigotry against humanoid robots being justified, just as bigotry against other humans has often been justified. There is increasing neuroscientific evidence for dehumanization. For instance, in a neuroimaging study, Harris and Fiske (2006) demonstrated that extreme outgroup members are so dehumanized that they may not even be encoded as social beings. When research participants viewed targets from highly stigmatized social groups who often elicit disgust (e.g., homeless people and drug addicts), the region of the brain typically recruited for social perception (the medial prefrontal cortex) was not engaged; those who are the least valued in society were not deemed, *at a neural level*, eligible for social consideration. While Harris and Fiske (2006) focused on traditionally stigmatized human social groups in their dehumanization research, it is reasonable to believe that there may also be a neurological correlation to extreme social devaluation and moral exclusion toward robots.

The issue of racism has been explicit in science fiction's treatment of androids. In his 2016 *National Review* article, "Star Wars and Slavery: A Quandary Awakens," Jonah Goldberg notes that in the *Star Wars* universe, there is an endless supply of sentient robots with distinctive personalities, emotive ways of expressing fears, doubts, and desires, and the need for survival. According to Goldberg (2016), the "droids" in the Star Wars movies are slaves: R2-D2 is a loyal slave, and C-3PO is a bit mouthy. Most of these androids and robots are property in the service of flesh and blood humans. Rubey (1978), in "Star Wars: Not So Long Ago, Not So Far Away," notes that, regarding the treatment of robots in *Star Wars*, the film uses and supports racist habits of thought when dividing its characters into hierarchical levels based on their physical attributes. The fact that the film is forced to use an implicit racism to support and justify its fantasy structure should call that structure into question and make us examine its implications closely (Rubey, 1978).

At the end of *A New Hope*, after heroically blowing up the Death Star, Han Solo and Luke Skywalker proudly receive their Medals of Yavin. On the other hand, C-3PO, R2-D2, and Chewie (a furry humanoid) do not receive any medals. Chewbacca's not being awarded a medal was in fact a source of discontent for many Star Wars fans. As for the robots, it is possible that the creators of *Star Wars* would have considered it absurd to give them a medal (see Medal of Bravery, n.d.).

Figure 2.2.3. Skywalker and Solo (at left and right of the image) were presented with medals of Bravery by Princess Leia Organa at the Royal Award Ceremony in the 1977 film *Star Wars (Episode IV—A New Hope)*. Darth Vader minifigure (at center) is also shown with a medal. Lucas, G. (Director). (1977). *Star Wars Episode IV: A New Hope* [Film]. Lucasfilm. "Lego dudes with medals" by Leap Kye is licensed under CC BY-ND 2.0. *Source:* https://openverse.org/image/8739a076-28d3-49f2-a563-e6ccd890dccd?q=star%20w ars%20lego%20medal

The idea of a future world populated by humans, cyborgs, robots, and androids raises many ethical questions regarding the relationship between humans and machines. One such question is what fundamental or constitutional rights the intelligent machines might have. In the article "Android Science and Animal Rights, Does an Analogy Exist?" David Calverley (2006) asks, "Will cyborgs be considered human enough to be bearers of human rights?" He suggests that we can take analogous situations involving animals and apply them to androids. As animals were viewed solely as property in the past, they were fair game for humans to exploit. As a result of findings from modern science, animals are now considered to possess, in varying degrees, characteristics that make them something more than inanimate objects like rocks, but less than humans (Calverley, 2006).

As noted earlier, in *Do Androids Dream of Electric Sheep?*, the main distinction between humans and artificially created beings is supposed to be either having, or lacking, the capability for empathy. Androids have no basic rights and are considered like slaves or the lowest class in society. Regardless of their appearance or intelligence, androids are categorized as subhuman because they supposedly lack the capacity for empathy. Paradoxically revealing the humans' own lack of empathy, even the most human-seeming androids are characterized as cold, rigid, amoral, and incapable of humanness.

The alleged superiority of our species comes from our (so far) unchallenged reign at the top of the food chain, and the perception that humans represent the pinnacle of evolution. In "The Ethics of Artificial Intelligence," Nick Bostrom and Eliezer Yudkowsky (2014) note that the possibility of creating thinking machines raises a host of ethical issues. They point out that humans may copy, change, delete, terminate, or use computer programs as they find convenient.

In the essay "Ethical Principles in the Creation of Artificial Minds," Nick Bostrom (2007) refers to the inherent anthropocentrism as "bioism" or speciesism, both of which favor biologically-based intelligence, and, even more narrowly, our particular (human) species. Bostrom claims that if humans refuse to acknowledge the personhood of these new artificial beings, that would constitute substrate chauvinism or carbon chauvinism, which has to be resisted on the same moral grounds as racism. According to Bostrom (2007), functionality or consciousness is not affected by whether a being is made of silicon or biological tissue, and, therefore, the creation of androids will benefit humanity precisely by forcing us to overcome such prejudices. If humans refuse to prepare to acknowledge the personhood of artificial intelligent beings, we stand a very good chance of turning them into our enemies (Bostrom, 2007).

The denial of full humanness to intelligent machines and the accompanying cruelty and suffering is a familiar trope in science fiction. Christopher Sims (2013), in *Tech Anxiety: Artificial Intelligence and Ontological Awakening in Four Science Fiction Novels*, notes the exploration of this theme in the movie *Cloud Atlas*. In *Cloud Atlas*, even biological clones are denied true freedom. Sonmi-451 [Doona Bae] is a "fabricant," a human cloned for labor (genetically modified for specific purposes and grown in a tank). She is working at Papa Song's, a fast-food restaurant in dystopian South Korea. Fabricants' unwavering servitude relies on brainwashing Catechisms and the substance "Soap" that they drink daily. "Soap," their only physical sustenance, contains "amnesiads" that nullify memory and suppress their mental capacity and ability to resist their situation. Without it, fabricants "conveniently expire after forty-eight hours" (Mitchell, 2004, p. 325).

Sonmi-451 is exposed to ideas of rebellion by another fabricant and friend, Yoona-939. After witnessing Yoona-939 being exterminated for rebelling, Sonmi is rescued from captivity by rebel Commander Hae-Joo Chang. Hae-Joo rescues her, introduces her to the leader of the rebel movement, and shows her that fabricants are not freed to retire in the Hawaiian islands at the end of their contract, but butchered and recycled into "Soap," which is the

food for other fabricants. Even the number attached to Sonmi-451's name indicates that she is one of many, suggesting the fabricants' essential interchangeability (see Sims, 2013).

The hallmark of the age of modern technology is the transformation of all beings into raw materials or Heidegger's "standing-reserve" (see Sims, 2013). Lin (2016), in the Forbes article "Relationships with Robots: Good or Bad for Humans?" mentions that, in this dystopian view of technology, the outcome of the loss of the robot may be similar to denting a bumper on a cherished car. Like Sonmi-451 in *Cloud Atlas*, current AI systems have no moral locus standi. "(Fabricants) cost almost nothing to manufacture and have no awkward hankerings for a better, freer life. We (fabricants) conveniently expire after forty-eight hours without the "Soap," and so cannot run away. We (fabricants) are perfect organic machinery" (Mitchell, 2004, p. 325).

Martin Heidegger (1954, 1962) is one of the most significant philosophers to have made the age of technology central to his thought. Heidegger states that significant periods in Western history—Greek, Roman, medieval, enlightenment, and technological—mark the stages of a long decline in Western humanity's understanding of what it means for something "to be." According to Heidegger (1954), in the technological age, for something "to be" means for it to be a raw material for the self-enhancing technological system. In such a system, AIs would be seen as resources to be mastered and exploited. Modern technologies too appear as a reserve of resources awaiting exploitation (Sims, 2013).

According to Heidegger (1954), modern technological ontology threatens to make all things appear exclusively as raw materials, with humans as the subjects who lord over all objects and categorically put them in their place through systems of knowledge and industry. For Heidegger, as expounded in *The Question Concerning Technology and Other Essays* (1954), the ontology of modern technology is the imposition of human will on all beings (including humans) and turning them into raw materials, and taking things to be mere disposables instead of letting them be. The usage of things culminates in their disposal, and humans wield the final authority on how all beings should be used, consumed, and disposed of.

Heidegger (1954) warns of the inherent dangers of taking such advantage. The more refined our technology becomes, the more the instrumental conception of technology conditions every attempt to bring humans into the "proper" relation to technology. In a complex socio-technical world where some things are disposable, all things eventually circulate as "dispos-able"

(Heidegger, 1954). Echoing Heidegger, Introna (2009), in the essay "Ethics and the Speaking of Things," refers to Heidegger's *Gestell* (Framework), in which things are revealed as mere objects that can be dumped if broken instead of "poetic dwelling with machinic beings." According to Introna (2009), humans most often do not consider the things that surround us beyond their instrumental value: "They seem just to be there, available (or sometimes not) for us to draw upon. Lurking in the shadows of our intentional arc, they sometimes emerge as relevant, become available, fulfill their function, and then slip back into the forgotten periphery of our intentional project" (p. 26). Going beyond conceiving of things as a means to an end, Introna (2009) recommends "letting-be" without turning the other-ness of the other into a "thing-for-me" as this or that useful tool or object.

The technological anxiety associated with the instrumental perspective consists of the reversal of the roles of "slave" and master: the anxiety of potential enslavement (subjugation) by the intelligent machines. *The Matrix* film series imagines a world taken over by intelligent machines. It shows the machines' exploitation of humans as power sources (humans as the "standing-reserve").

Some scholars argue that the biggest issue is not how to test our machine creations to decide their status. Rather, *it is the creation of such artificial intelligences and our treatment of them that will test us*, and what it means for us to be human and humane (McGrath, 2011). In *The Atlantic* article "What is a Robot?," Adrienne LaFrance (2016) refers to the master-slave dialectic passage in Hegel's 1807 opus, *The Phenomenology of Spirit*. In it, Hegel argues that, among other things, holding a slave ultimately dehumanizes the master. LaFrance (2016) notes that although Hegel could not have known it at the time, he was describing our world too, and that aspect of the human relationship with robots.

References

Asimov, I. (2004). *I, robot* (Vol. 1). Spectra. (Original work published 1950)

Bloom, P., & Harris, S. (2018, April 23). It's Westworld. What's wrong with cruelty to robots? *The New York Times.* https://www.nytimes.com/2018/04/23/opinion/westworld-conscious-robots-morality.html

Bostrom, N. (2007). Ethical principles in the creation of artificial minds. *Linguistic and Philosophical Investigations*, 6, 183–184. https://nickbostrom.com/ethics/aiethics.html

Bostrom, N., & Yudkowsky, E. (2014). The ethics of artificial intelligence. In K. Frankish & W. Ramsey (Eds.), *The Cambridge handbook of artificial intelligence* (pp. 316–334). Cambridge University Press. https://doi.org/10.1017/CBO9781139046855.020

Brackley, J., Featherstone, J., Lundström, L., Vincent, S., Wax, D., & Widman, H. (Executive Producers). (2015–2018). *Humans* [TV series]. Kudos & AMC Networks.

Brooks, R. (2002). *Flesh and machines: How robots will change us* (1st ed.). Pantheon Books.

Bryson, J. J. (2009). *Robots should be slaves: Artificial models of natural intelligence.* Retrieved April 21, 2022, from http://theorytuesdays.com/wp-content/uploads/2018/08/Robots-Sho uld-Be-Slaves-Bryson.pdf

Calverley, D. (2006). Android science and animal rights, does an analogy exist? *Connection Science, 18*(4), 403–417. https://doi.org/10.1080/09540090600879711

Čapek, K. (2004). *R.U.R. (Rossum's Universal Robots)* (C. Novack-Jones, Trans.). Penguin Books. (Original work published 1921)

Carrick, P. (1985). *Medical ethics in antiquity: Philosophical perspectives on abortion and euthanasia.* Kluwer Academic Publishers.

Crichton, M. (Director). (1973). *Westworld* [Film]. Metro-Goldwyn-Mayer.

Danaylov, N. (2013, November 5). *Richard Feynman on how computers think [or not].* SingularitxyWeblog. https://www.singularityweblog.com/tag/richard-feynman/

Dator, J. (2007). Religion and war in the 21st century. In Tenri Daigaku Chiiki Bunka Kenyu Center (Ed.), *Senso, shukyo, heiwa [War, religion, peace], Tenri daigaku 80 shunen kinen [Tenri University 80th anniversary celebration]* (pp. 34–51).

Devecka, M. (2013). Did the Greeks believe in their robots? *The Cambridge Classical Journal, 59*, 52–69. https://doi.org/10.1017/S1750270513000079

Dick, P. K. (1968). *Do androids dream of electric sheep?* Del Rey.

Goldberge, J. (2016, January 1). Star Wars and slavery: A quandary awakens. *The Patriot Post.* https://patriotpost.us/opinion/39769-star-wars-and-slavery-a-quandary-awak ens-2016-01-01

Harris, L. T., & Fiske, S. T. (2006). Dehumanizing the lowest of the low: Neuroimaging responses to extreme out-groups. *Psychological Science, 17*, 847–853.

Haslam, N. (2006). Dehumanization: An integrative review. *Personality and Social Psychology Review, 10*(3), 252–264. https://doi.org/10.1207/s15327957pspr1003_4

Haslam, N., Loughnan, S., Reynolds, C., & Wilson, S. (2007). Dehumanization: A new perspective. *Social and Personality Psychology Compass, 1*(1), 409–422. https://doi.org/10.1111/j.1751-9004.2007.00030.x

Hegel, G. W. F. (2018). *Georg Wilhelm Friedrich Hegel: The phenomenology of spirit* (T. Pincard, Trans., & Ed.). Cambridge University Press. (Original work published 1807) https://doi.org/10.1017/9781139050494

Heidegger, M. (1954/1977). *The question concerning technology and other essays* (W. Lovitt, Trans.). Harper & Row.

Heidegger, M. (1962). *Being and time* (J. Macquarrie & E. Robinson, Trans.). Harper & Row.

Heo, H. H., & Kim, M. S. (2013). The effects of multiculturalism and mechanistic disdain for robots in human-to-robot communication scenarios. *Interaction Studies: Social Behaviour*

and Communication in Biological and Artificial Systems, *14*(1), 81–106. https://doi.org/10.1075/is.14.1.06heo

Humans (TV series). (2023, April 3). In *Wikipedia*. https://en.wikipedia.org/wiki/Humans_(TV_series)

Introna, L. D. (2009). Ethics and the speaking of things. *Theory, Culture & Society*, *26*(4), 398–419. https://doi.org/10.1177/0263276409104967

Kim, M. S., & Kim, E. J. (2013). Humanoid robots as "The Cultural Other": Are we able to love our creations? *AI & Society*, *28*(3), 309–318. https://doi.org/10.1007/s00146-012-0397-z

Kim, M. S., Sur, J., & Gong, L. (2009). Humans and humanoid social robots in communication. *AI and Society*, *24*, 317–325.

LaFrance, A. (2016, March 22). What is a robot? The question is more complicated than it seems. *Atlantic*. https://www.theatlantic.com/technology/archive/2016/03/what-is-a-human/473166/

Lin, P. (2016, February 1). Relationships with robots: Good or bad for humans? *Forbes*. https://www.forbes.com/sites/patricklin/2016/02/01/relationships-with-robots-good-or-bad-for-humans/?sh=3405a2167adc

Lucas, G. (Director). (2002). *Star wars episode II: Attack of the clones* [Film]. Lucasfilm Ltd.

Lucas, G. (Director). (2003). *Star wars episode IV: A new hope* [Film]. Lucasfilm Ltd.

Mazis, G. (2008). *Humans, animals, machines: Blurring boundaries*. State University of New York Press.

McCorduck, P. (1991). *Aaron's code: Meta-art, Artificial Intelligence and the work of Harold Cohen*. W. H. Freeman and Company.

McGrath, J. F. (2011). *Robots, rights and religion*. Butler University Libraries Digital Image Collections. https://digitalcommons.butler.edu/cgi/viewcontent.cgi?article=1198&context=facsch_papers

McNamara, K. R. (1997). "Blade Runner's" post-individual worldspace. *Contemporary Literature*, *38*(3), 422–446. https://doi.org/10.2307/1208974

Medal of Bravery. (n.d.). https://starwars.fandom.com/wiki/Medal_of_Bravery

Mitchell, D. (2004). *Cloud Atlas*. Sceptre.

Pellissier, H. (2013, September 13). *Robots and slavery—what do humans want when we are "Masters"?* https://ieet.org/archive/articles/pellissier20130913.html

Pope, L. C., & Metzler, T. (2008). Has a robotic dog the Buddha-nature? Mu! *Association for the Advancement of Artificial Intelligence*. https://www.researchgate.net/publication/242186492_Has_a_Robotic_Dog_the_Buddha-nature_Mu

Richards, N. M., & Smart, W. D. (2013, May 11). How should the law think about robots? *SSRN Electronic Journal*. https://papers.ssrn.com/sol3/papers.cfm?abstract_id=2263363

Riis, S. (2011). Towards the origin of modern technology: Reconfiguring Martin Heidegger's thinking. *Continental Philosophy Review*, *44*. https://doi.org/10.1007/s11007-011-9170-0

Robot. (n.d.). *Online etymology dictionary*. https://www.etymonline.com/search?q=robot

Roddenberry, G. (Executive Producer). (1966–1969). *Star trek* [TV series]. Desilu Productions, Paramount Television, & Norway Corporation.

Rubey, D. (1978). Star Wars: Not so long ago, not so far away. *Jump Cut*, *18*, 9–14.

Savage, N. (2013, April 22). How long until a robot cries? Identifying the mechanics of emo-tions. *Nautilus*. https://nautil.us/how-long-until-a-robot-cries-7306/

Sims, C. A. (2013). *Tech anxiety: Artificial Intelligence and ontological awakening in four science fiction novels*. McFarland & Company, Incorporated Publishers.

Spielberg, S. (Director). (2001). *A.I. Artificial intelligence* [Film]. Amblin Entertainment & Stanley Kubrick Productions.

Wachowskis, The. (Director). (1999). *The matrix* [Film]. Warner Bros. Pictures.

Wachowskis, The. (Director). (2012). *Cloud atlas* [Film]. Cloud Atlas Productions.

Williams, C. (2016, April 9). *The dark meaning behind the word "robot."* HuffPost. https://www.huffpost.com/entry/meaning-word-robot_n_5706b66de4b0537661891e54

Wu, D. (2012). *What distinguishes humans from artificial beings in science fiction world* [Bachelor thesis, Blekinge Institute of Technology]. https://www.diva-portal.org/smash/get/diva2:829512/FULLTEXT01.pdf

· 2 . 3 ·

MACHINES AS "SUBSTITUTE OTHER": *INDIFFERENCE*

The third narrative evokes the emotion of "indifference." Unlike the master-slave metaphor of human-robot relationships, this third narrative emphasizes the robots' usefulness as mass-produced and dispensable tools to be used by humans. The robot, like an "intelligent hammer," exists to serve and satisfy the purposes of humans. Technology enables humans to automate tasks that are too tedious or dangerous, but besides manual labor, machines may be designed to meet the requirements of humans as substitute nurse, caretaker, zen master, sex partner, or even child.

Right from the beginning, computers were designed to serve the goals and purposes of humans (Lombardo, 2018). During the early stages of robotics research, much of the development focused on robots' usefulness in industrial settings. Therefore, the third narrative regarding humans' attitude toward robots focuses on the machines' substitution or facilitation of human labor or function. Seen to be "super tools," machines may function to decrease the amount of physical labor involved in a task and often aid mental effort.

Note that this narrative differs from a "master-slave" metaphor of human-robot relationships ("Machines as the Subhuman Other"). Rather, in this narrative ("Human Substitutes"), computer technology is seen as simply an advanced instrument, tool, or means of information and communication that is morally neutral. Like a hammer or screwdriver, robots are seen as facilitators or replacements for human effort, and then forgotten once their purpose is served. For instance, the notion of a "robot companion" primarily emphasizes its usefulness for people. In this narrative, robots are *tools* used for specific practical purposes of functions.

Artificial intelligence is seen to be of great practical significance in many fields. Robots in particular may replace humans in performing many social tasks (e.g., psychotherapy, guided meditation, or cooking) and risky tasks (such as

working in nuclear sites or deep-sea exploration). In the aftermath of the great Eastern Japan earthquake of 2011, for example, various robot technologies achieved practical results for nuclear plant accident response, port inspection, victim search, structural inspection, etc. (Shiratori, 2012).

Silicon Valley celebrates artificial intelligence and robotics as fields that have the power to improve people's lives through inventions like driverless cars and robot caretakers for the elderly (see Solon, 2017). The prospects include robot maids, butlers, and chauffeurs (aka self-driving cars). In an increasingly mature anthropomorphic technological space, physically embodied humanoid social robots may be deployed to interact with humans, for example, to assist the elderly (Pineau et al., 2003), teach children (Kanda et al., 2004), and collaborate with humans in work settings (Hinds et al., 2004).

Figure 2.3.1. Club First service robot—waiter robot (made in India)
"Club First Robot" by Clubfirst is licensed under CC BY-SA 4.0.
Source: https://openverse.org/image/5678979a-769a-46b9-80cc-93145ac0909b?q=human oid%20robot

Starting from their early uptake in manufacturing, robots and AI now have an expanding presence in other spheres ranging from customer service (e.g., reception and food service) to hitherto inconceivable professional and creative roles (e.g., expert legal and medical systems, automated journalism, musical and artistic production) (Kaplan, 2015; Ramalho, 2017). Silicon Valley may celebrate the potential of robots and AI to improve peoples' lives, but, according to Pew Research, that message is not getting through to the rest of the country: more than 70% of Americans express wariness or concern about a world where machines perform many of the tasks done by humans (Solon, 2017).

While truck drivers and pilots were seen as job roles that could not possibly be automated in the foreseeable future, emerging technological developments not only imagine this but are making it happen. United Airlines as well as American Airlines are dedicating billions of dollars to develop new aircraft that won't require pilots (Pallini, 2021). In 2017, Russia unveiled Fedor, a humanoid robot soldier like RoboCop; this space-combat-ready android can fire handguns, drive vehicles, and administer first aid. Indeed, the world's armies are in an arms race developing military robots. Britain's former Special Forces director Lieutenant General Sir Graeme Lamb predicted that, by 2030, technological breakthroughs—not just AI, but quantum computing and beyond—would produce entirely unpredictable changes (as cited in Aps, 2017). Depending on one's perspective, machines that kill autonomously are either a harbinger of an existential challenge like a "Terminator"-style dystopia, or a logical evolution of the arms race (Aps, 2017).

In 1996, Garry Kasparov, then World No. 1 chess player from Russia, played a series of games against IBM's Deep Blue chess supercomputer. Deep Blue was sometimes uncannily human, un-machine-like, in its style of play. In an essay for *TIME*, Kasparov said about a move in the first game, "It was a wonderful and extremely human move," and this apparent humanness threw him for a loop. "I had played a lot of computers but had never experienced anything like this. I could feel—I could smell—a new kind of intelligence across the table" (as cited in Latson, 2015). Yet we glimpse Kasparov's dismissive attitude toward Deep Blue from his later comments. For instance, when Deep Blue defeated Kasparov, he is supposed to have remarked that "Deep Blue could not enjoy winning and would take no satisfaction from the victory" (Mazis, 2008, p. 98). Even though his comment smacks of sour grapes, it illustrates the emotion of indifference toward the computer program that had performed at the highest level by defeating the human world champion.

Figure 2.3.2. Animation shot of Deep Blue versus Kasparov.
Date: December 20, 2020
This file is made available under the Creative Commons CC0 1.0 Universal Public Domain Dedication.
Source: https://commons.wikimedia.org/wiki/File:Deep_Blue_versus_Kasparov,_1996,_Game_1.gif

Intelligent robots are getting cheaper, faster, and far more reliable than humans. Furthermore, they can work 168 hours a week, not just 40. In this scenario, no capitalist in her right mind would continue hiring humans, as Kevin Drum (2017) said in the article "You Will Lose Your Job to a Robot—and Sooner Than You Think." Elon Musk, at Tesla's 2021 AI Day event, claimed that a prototype of the company's Optimus robot would be built by 2022. This humanoid robot could eliminate dangerous, repetitive, and tedious tasks. Musk said in 2022: "It will be able to do basically anything humans don't want to do. It will do it. […] as you see Optimus develop, and we will make sure it's safe, no Terminator stuff, it will transform the world to a degree even greater than the car" (as cited in Lambert, 2022).

Casey Baseel writes, "Few things in life provide that special mixture of calm reassurance and energizing warmth like going for a long walk

hand-in-hand with your sweetheart" (Baseel, 2020). Researchers from Japan's Gifu University pointed out that "For some people, finding a girlfriend is very difficult." They set out to create a method for people to "experience holding your girlfriend's hand more easily than by finding a girlfriend" (Baseel, 2020). The result is the robot called Osampo Kanojo ("Walk Girlfriend"), or, to use its designated English name, "My Girlfriend in Walk" (see Baseel, 2020). Osampo Kanojo has an internal heater so that warmth will radiate out from its palm and fingers. Furthermore, while a hand that is slick with sweat would be unpleasant, a certain amount of moisture is needed for an organic feeling. To achieve that, a piece of moistened fabric is placed inside Osampo Kanojo;

Figure 2.3.3. This life-like hand of the humanoid robot iCub is equipped with 48 taxels and has 12 taxels in each fingertip. Overall, each hand has a sensory system with 108 sensors. "iCub robot hand" by oosp is licensed under CC BY-SA 2.0. https://openverse.org/image/13daeaa3-5356-477a-b6e7-db836f31f1c2?q=robot%20hand

when the heater is activated, it causes trace amounts of moisture to be secreted through tiny pores in the outer covering (see Baseel, 2020). Such a life-like robotic hand with a similar range of motion to that of a human can also be seen in iCub, a child-size humanoid robot capable of crawling, grasping objects, and interacting with people.

In this narrative, machines are nothing more than tools to be used for various purposes. If one tool does not do the job, you use a different tool instead. Presumably, if a robot son does not give satisfaction, one could swap it for a robot daughter. The movie *A.I. (Artificial Intelligence)* is a 2001 American science fiction film directed by Steven Spielberg. Robnik (2002) recounts the plot of the film: David is a childlike android who is uniquely programmed with the ability to love. He is acquired by human parents as a substitute for their son Martin, who is in suspended animation due to a disease. Martin's mother activates David's imprinting program, which results in giving David an enduring childlike love for her. David is eventually abandoned by the human family, but he goes on striving to be reunited with his "mother" and win back her love. At one point, David finds many copies of himself, including a female variant, Darlene, boxed and ready to be shipped. Mechanical replicas of David are suspended on hooks along the walls at the company that created David (see Robnik, 2002). For the scientist who created David, the robot boy is only a substitute for his dead son. His "love" toward David is akin to appreciating a perfect piece of art or a successful product, rather than genuine fatherly love (see Robnik, 2002).

In the 1993 book *The Value of Convenience*, Tierney argues that the value of technology is based on its ability to provide convenience. Humans view technological devices as things to be used. For instance, Human-Robot Interaction (HRI) is primarily concerned with how a robot can fulfill its task specifications acceptably and comfortably for humans. The scope of what a robot is useful for is expanding. Social robots are beginning to show up in everyday life. They are designed to enable people to interact with them as if they were persons, and ultimately as friends (Breazeal, 2003). GPS is already ubiquitous, but robots may replace humans in many other social roles, such as secretaries, tutors, receptionists, household assistants, even drivers, chefs, and caretakers.

The *human substitute* paradigm emphasizes a robot's role as a machine that recognizes and satisfies a human's needs. Taken far enough, some may even dream of replacing their pet, their partner, or their own bodies with robot versions. A companion robot assisting a person with everyday tasks is in a

role similar to a personal assistant or butler. Essential characteristics for such a robot are consideration, competence, and non-intrusiveness. According to Thompson (2014) in "Why Do We Love R2-D2 and Not C-3PO?," some "puppy" robots, like pet animal substitutes, while they may provide service, are designed to appear cute and friendly toward humans, as one would expect from a pet animal. In the movies, R2-D2 and Wall-E are examples of such robots. Thompson (2014) writes that, with its stubby little body, blooping voice, and a wide round eye, R2-D2 is a curiously endearing machine.

As robots are increasingly deployed in homes and in social and military contexts, the ability of robots to interact with humans in ways that resemble human interaction will become more pertinent (Breazeal, 2009). Robots have been accused of not only taking people's jobs, but even stealing sex partners (e.g., Roxxxy or Rocky—the world's first sex robots). According to *Daily Star* (August 24, 2019), the sexbots are described as warm, with "mechanical movements and an artificial brain." A customer said: "It is great that now we have such a place where you can go and get new impressions without being unfaithful or feeling guilty." A bizarre trend has also taken off as customers order sex doll models of friends' girlfriends (Roberts, 2019). Experts warn that sex dolls could lead to the further objectification of women. If such artifacts can appear alive and provide satisfaction, they may even have a comparative advantage over people and open new possibilities for narcissistic experiences with machines (Turkle, 2011).

Nowadays, robots are even used to purvey spiritual wisdom and perform last rites for humans. Nissei Eco, a Japanese plastics manufacturer, has turned Softbank's humanoid robot Pepper into a Buddhist priest-for-hire. The company has trained Pepper to recite Buddhist scriptures, chant prayers, and tap a drum as part of the Buddhist funeral ceremony (see Voon, 2017). Longquan Temple in China introduced the robot Xian'er in 2015 to use cutting-edge technology to propagate Buddhism. However, the *New York Times* reported that employees declined to let visitors communicate directly with Xian'er, saying that he was—literally—recharging to meet a delegation of government officials from Beijing later in the day (see Tatlow, 2016).

In 2019, the 400-year-old Kodaji Buddhist temple in Kyoto started using a million-dollar humanoid robot to reach younger generations. In collaboration with robotics researchers at Osaka University, the temple unveiled "Mindar," a sutra-chanting robot modeled after Kannon, the Buddhist Goddess of Mercy (see Papadakis, 2019). The robot is a 6-foot-tall android made of silicone and aluminum that preaches from the Heart Sutra in Japanese. "Artificial

intelligence has developed to such an extent that we thought it logical for the Buddha to transform into a robot," Tensho Goto, the chief steward of the temple, told *AFP* (as quoted in Papadakis, 2019). According to tradition, the bodhisattva Kannon may manifest in different forms in different ages to help people understand the Buddha's teachings. This time, Kannon has taken the form of an android (see Papadakis, 2019).

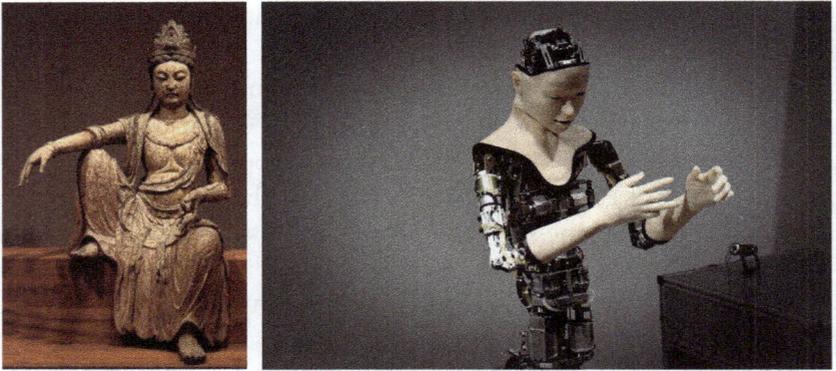

Figure 2.3.4. Wooden Guanyin and Android Kannon.
Left: A wood carving of Guanyin (觀世音) with Amitābha on the crown (c. 1025). Northern Song dynasty, China, Honolulu Museum of Art
Haa900, Public domain, via Wikimedia Commons
Source: https://commons.wikimedia.org/wiki/File:Kuan-yan_bodhisattva,_Northern_Sung_dynasty,_China,_c._1025,_wood,_Honolulu_Academy_of_Arts.jpg
Right: Robot in Miraikan museum, Raita Futo from Tokyo, Japan Creative Commons Attribution 2.0
[File: Robot in Miraikan (46800395601).jpg]
October 28, 2017
Source: https://openverse.org/image/20586db3-f1ed-4d93-b505-12c8a7443d40?q=miraikan

Furthermore, cognitive computing is utilized to create machines that serve as replacements for personal assistants, aiding humans in decision-making tasks (Prigg, 2012). Examples include Apple's Siri, Amazon's Alexa, and Google Assistant. Prigg (2012) noted that such devices not only understand us, but also know our contacts and whereabouts. Indeed, our interactions with people are nowadays curated by algorithms which, for example, create video compilations of our recent travel, or offer reminders when it's time to leave for the airport. In the film *Her* (directed by Spike Jonze, 2014), a man develops a relationship with Samantha, an artificially

intelligent virtual assistant personified through a female voice (Scarlett Johansson).

Carl Frey (2019), who directs the Future of Work Programme at the Oxford Martin School, has explored the implications of technological change in his book *The Technology Trap: Capital, Labour and Power in the Age of Automation*. Frey makes a distinction between labor-enabling and labor-replacing technologies. Labor-enabling technologies complement workers, boosting productivity and opening avenues for new employment. In contrast, labor-replacing technologies remove workers from the labor market entirely, forcing them to re-skill or search for other opportunities. According to Frey (2019), as an indicator of economic and political polarization in this age of automation, we are now looking at a tendency toward labor-replacing technologies (Frey 2019).

Similarly, Martin Ford, author of *Rise of the Robots: Technology and the Threat of a Jobless Future"* (2015), says that machine learning gives humans new machines to replace humans: machines that can follow humans to virtually any new industry that they flee to. According to Ford, the most vulnerable jobs in the robot economy involve repetitive and predictable tasks, while professions that rely on creative thinking enjoy some protection.

Even so, the ability to think creatively may not guarantee job security. Robots have assisted surgeons in removing damaged organs and cancerous tissue. Indeed, a robotic surgeon called STAR (Smart Tissue Autonomous Robot) outperformed human surgeons in a test to repair the severed intestine of a live pig (Greenemeier, 2016). The threat of replacement hangs over the heads not only of general practitioners but also of specialists.

Some people may argue that while a machine can perform a given task, perhaps more efficiently than any human, its performance is lacking in artistry, which is seen as a uniquely human attribute (Greenemeier, 2016). Art is sometimes thought to be the ultimate and uniquely human sanctuary. Poems are transcendent human creations that may combine beauty as well as intensity of emotion. However, in a world where computers can replace doctors, drivers, chess champions, and teachers, it is hard to see why artistic creations would be safe from the algorithms. In 2011, Cope published a book titled *Comes the Fiery Night: 2,000 Haiku by Man and Machine*. Of the 2,000 haiku in the book, some were written by human poets and some by algorithms. There are many haiku generator websites, for example, the AI-powered "Aiku" (https://aiku.param.codes/), which claims: "Give Aiku

two words as a prompt and it will write you a haiku-like poem." Here is a sample poem generated by Aiku ("Car" and "Wish" were entered as the two-word prompt by the book author on May 16, 2023):

> In my old car I
> Wish for empty roads ahead
> Endless possibility.

In the book *Reading Computer-Generated Texts*, Leah Henrickson (2021) describes Natural Language Generation (NLG) as the process whereby computers produce readable human language output such as news articles, sports reports, prose fiction, and poetry. Recently, there was an attempt to have GPT-3 (Generative Pre-trained Transformer 3) write an academic paper about itself for submission to a peer-reviewed journal (see Thunström, 2022). GPT-3 is a deep-learning system that analyzes vast streams of information to create text on command. Such endeavors open up ethical and legal questions about publishing, and philosophical arguments about non-human authorship (Thunström, 2022). In November 2022, OpenAI launched ChatGPT, based on its GPT-3.5 system. The even more powerful GPT-4 performed astonishingly well on a variety of tests, including the Uniform Bar Exam (on which GPT-4 scores higher than 90% of human test-takers) and the Biology Olympiad (on which it beats 99% of humans) (Roose, 2023).

As artificial intelligence becomes ever more capable, robots are also creating art that sells for thousands of dollars. As a substitute for human artists, Ai-Da, the artificial intelligence (AI) machine named in honor of the pioneering female mathematician Ada Lovelace, can sketch a portrait by sight, compose a "hauntingly beautiful" conceptual painting rich with political meaning, and is becoming a dab hand at sculpting too (see Bodkin, 2019). Ai-Da can teach itself new and ever more sophisticated means of creative expression that have set the art world agog (Bodkin, 2019).

Referring to Alexander McQueen's performance art *Robots Spray-Paint Shalom Harlow*, Susana Lindberg (2019), in "Robots in Art: Where's the Work?" questions the "mere substitute" interpretation of an art-producing robot. Lindberg writes: While the robots produce works wantonly and aimlessly, the spectator's attention turns toward the pure functioning itself at the moment due to the infinite possibilities of algorithms. This is how

art robots attract attention to the activity of making art instead of the resulting works, as can be seen in Alexander McQueen's Robot-Spray (Lindberg, 2009).

Since these robot artists embody different types of artistic intelligence than humans, some may argue that these machines are not a mere substitute for humans (Lindberg, 2019). Robert McCaffrey (2021), in the article "Alexander McQueen: The Sublime and Melancholy," wrote: "Technology is at once exciting and terrifying, especially when it dares to express human-like qualities [...] the robotic arms seem to consider the rotating Harlow before lashing her with paint like the outstretched arms of an inspired artist thrashing his [sic] brushes across a bare canvas."

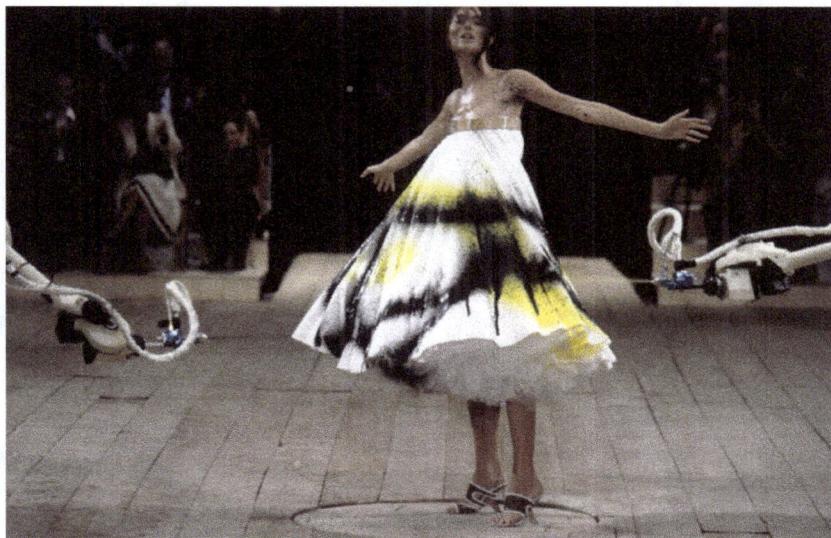

Figure 2.3.5. Robot Artists: Alexander McQueen's *Robots Spray-Paint Shalom Harlow* at the Spring 1999 fashion show.
(Photo: Русский: Показ Alexander McQueen з використанням роботів)
Date: May 17, 2018
Source: Own work. *Author:* Ivanna9867
Ivanna9867, CC BY-SA 4.0 https://creativecommons.org/licenses/by-sa/4.0, via Wikimedia Commons
Source: https://commons.wikimedia.org/wiki/File:15-chrismoore-750x495.jpg

The tech-gnostic drive in the narrative of "Machines as Human Substitutes" also sets its sights on a world of magical journeys via virtual reality (Davis, 2004). Indeed, with interactive deepfake applications, voice conversion, and virtual actors, it is possible to digitally replicate an individual's appearance and behavior—a digital doppelgänger (see Yoon, 2023). Virtual reality as an instance of computer-generated imagery lends credence to Jean Baudrillard's simulacrum theory, reinforcing fears such as those expressed by Paul Virilio (1994) in *The Vision Machine*. Virilio (1994) wrote that in the postmodern world, the individual's relation to reality is collapsing. As we stand on the boundary between the physical and the virtual, "digital humans" are a key feature of the rapidly evolving areas of augmented reality, virtual interaction, and gaming. For example, a digital celebrity is a digitally created avatar/character initially made for entertainment. While they are seen as fake influencers or celebrities, these digital beings are increasingly used for entertainment, education, health, and security (Virilio, 1994).

Bernard Marr (2021), in the article "ABBA's Virtual Concert, the Metaverse and the Future of Entertainment," notes that even pop legends are not immune to the ongoing digitization of every aspect of life and society. Abba fans would be able to experience the Swedish supergroup in their prime as their "Abba-tars" take to the stage in London. Artificial intelligence (AI) routines are used to "de-age" the performers (Marr, 2021). As AI is used to recreate a younger-looking Abba, the next logical step could go even further by recreating their personalities and unique behavior by using natural language processing and voice recognition to respond to song requests from the audience. Perhaps one day those digital Abbas will even converse with fans (Marr, 2021).

The list of job replacers includes "celebrities" such as Lil Miquela. Miquela is a digital CGI character (a "19-year-old girl" living in LA). She is given a personality and acts on social media platforms like an influencer. On Instagram, by April 2018 the @lilmiquela account had acquired more than a million followers. As of February 2022, Miquela had over 3.1 million Instagram followers. The virtual influencer landscape continues to expand tremendously, as seen in one of the latest entrants—*Lady Layla*.

Figure 2.3.6. Meet Metastar's first Metaverse idol—Lady Layla, whose debut single "Meta-Coming" is pioneering the future of Chinese pop.
元人娛樂有限公司 Metastar Ltd, CC BY-SA 4.0 https://creativecommons.org/licenses/by-sa/4.0, via Wikimedia Commons
Source: https://commons.wikimedia.org/wiki/File:Lady_LayLa_%E8%90%8A%E6%8B%89_%E5%A4%AA%E7%A9%BA%E7%A4%BE%E7%BE%A4%E7%85%A7.png

Several reasons for the popularity of virtual human surrogates are described in a fictional academic essay, "Paradise Found: Possibility and Fulfillment in the Age of the Surrogate," fictionally set in January 2054 (Laslo, 2054). According to the essay, surrogates permit a person to assume different genders, races, and physicalities, opening new approaches to confront inequality in employer hiring practices and abolish prejudice, stereotyping, racism, and misogyny. The use of surrogates is associated with a marked decrease in serious crime, because even murder becomes a property crime—users lose their virtual selves rather than their actual lives. It can have health benefits (e.g., one can experience the pleasure of smoking by means of a surrogate without experiencing detrimental health effects) (see Laslo, 2054).

The film *Surrogates* (2009), directed by Jonathan Mostow, depicts a world where people live by embodied proxy through computer games via the widespread use of remotely controlled androids called "surrogates." Aaron Saenz (Saenz, 2009) recounts the plot: Surrogates is set in the year

2054, a time in which citizens get to lie on a "stim-chair," hooked up to an idealized robot surrogate that goes out into a busy, glitzy world and gets on with interacting superficially with other robots. The film envisions a future world where people live free of pain, danger, and complications via robotic representations of themselves, enabling people to experience life vicariously from the comfort of their homes by means of these fit, attractive, remotely controlled robots. If the robot dies, one can simply link up to another robot from a makeshift barracks and get another chance (Saenz, 2009).

Here is another example of how technology can be used to provide comfort by means of a virtual surrogate. In 2016, a South Korean mother lost her 7-year-old daughter Nayeon due to a rare and incurable disease. The grieving mother, longing to see her late daughter, could "reunite" with her thanks to virtual reality (see General, 2020).

The preference for virtual surrogates can be seen as an interesting reversal of the "human as ingroup" mentality. According to Frude (1983), in the future computer companions will be preferred for human interaction. In a study by Rogers et al. (2022), "Realistic Motion Avatars Are the Future for Social Interaction in Virtual Reality," the participants were asked to compare VR to in-person therapy. They rated their experience on specific points like enjoyment, perceived understanding, comfort, awkwardness, and others. About 30% of people preferred to talk with a virtual character rather than with a real person about their negative experiences. Overall, the study revealed that VR could make some people feel more comfortable due to the sense of personal distance (Rogers et al., 2022).

In another study on the reversal of "human as ingroup" mentality, Gong (2008) included robot entities for a new test of the predictive strength and boundary of racial prejudice. In Gong's study ("The Boundary of Racial Prejudice: Comparing Preferences for Computer-Synthesized White, Black, and Robot Characters"), 105 white undergraduates provided their rank-ordered preferences for 15 white, Black, and Robot computer-synthesized characters. The results revealed that white individuals with high levels of prejudice toward Blacks generally preferred robot characters to Black ones, even though robots are non-human (Gong, 2008). This surprising result makes us consider the significant role that robots—particularly surrogate robots—will play in humankind's future.

Shadow Over Future Dream
Society: Automation, Not Immigration

The wonder of machines is how they can be constructed to serve almost any purpose that humans can imagine. Mazis (2008) argues that the value of convenience is deeply ingrained in modern culture, referring to an obsession with worldly satisfaction as the endpoint of humanity. According to Mazis (2008), technoscience and postmodern capitalism focus on possessing and consuming objects—crafted or identified in specific socially and economically promoted value categories. The most distinctive aspect of a machine creature, in general, is that machines are constructed to fulfill a particular function with superb reliability and consistency (Mazis, 2008).

Through mass production, we create perfect substitutes that make anything appear as a replaceable part (Introna, 2009). In the UK, for example, there has been broad skepticism about massive job losses and the lack of a transition period for workers to acquire new skills for a new technology-driven economy (Maronitis & Pencheva, 2022). Demand for cheap and low-skilled labor in care, agriculture, and hospitality has generated strong responses, such as the enthusiastic implementation of automation and AI, as well as some businesses demanding pre-Brexit rates of immigration (Maronitis & Pencheva, 2022). Such responses give rise to the following questions: "Is automation an irreversible force that would eventually render human work obsolete?" "How should policymakers and employees respond to the arguments between automation or immigration?" (Maronitis & Pencheva, 2022). Regardless of specifics, the notion of robots as human substitutes is becoming a primary focus of discussion.

Speaking of "Socially Assistive Robotics" (a term used to describe artifacts whose central function is some form of social interaction), there are several ethical problems related to the use of social robots by people in vulnerable situations (Sharkey & Sharkey, 2010). In the case of using social robots for elderly care, some ethical issues include: potential reduction in human contact, increased sense of objectification and loss of control, loss of privacy, loss of personal freedom, deceit and infantilization by robots, and the circumstances under which the elderly could lose permission to control the robots (see Sharkey & Sharkey, 2010). For Sparrow and Sparrow (2006), using anthropomorphic social robots for elderly care

involves another serious ethical problem, that is, the illusion of genuine social interaction.

Robertson (2017) analyzed the different ideological forces affecting the trajectory of robotic technology in Japan by presenting an account of the emergence of the so-called Robo Sapiens Japanicus. The preference for automation is one of the reasons why Japan accounts for over one-half of the world's industrial and utility robots, including humanoid household robots that are being developed to care for children and the elderly, provide companionship, and perform domestic tasks (Robertson, 2017). In Japan, humanoid robots may be regarded as preferable to foreign laborers, especially foreign caretakers, because, unlike migrant and minority workers, robots have no cultural differences or historical memories (e.g., of wartime) to contend with (Robertson, 2017).

Deployment of humanoid robots for this reason underscores how much more straightforward and reassuring it is to eliminate a "something"—such as wartime memories, history, or immigrants—than to deal with the difficulties that the "something" presents (Robertson, 2017). According to Robertson (2017), robot technology in Japan further perpetuates willful amnesia regarding the problematic historical legacies of Japanese imperialism, wartime atrocities, and ethnocentrism. The twinned ideologies of convenience and peace of mind (安心) condone such strategic forgetting of the past and adopting new technology (Robertson, 2017).

Some scholars are concerned about whether robots can truly replace the social-emotional dimension of human-human interaction (see Turkle, 2011). In this view, the danger is not in the final product (the android), but in how the android is perceived. If androids are perceived as mere instruments, they become an ersatz solution to the genuine problem of human loneliness; artificial substitutes for real human company.

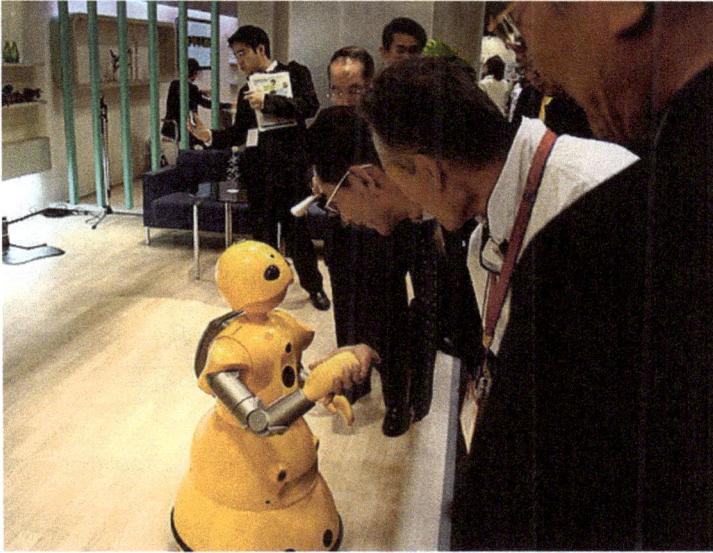

Figure 2.3.7. Wakamaru home-care robot shaking hands at the Robot Technology Osaka fair, 2006.
BradBeattie at the English-language Wikipedia, CC BY-SA 3.0, via Wikimedia Commons
Creative Commons Attribution-Share Alike 3.0
Source: https://commons.wikimedia.org/wiki/File:Wakamaru_shaking_hands.jpg

References

Aps, P. (2017, September 19). Commentary: *The coming robot arms race.* Reuters. https://www.reuters.com/article/us-apps-robots-commentary-idINKCN1BT1XN

Bartneck, C., Suzuki, T., Kanda, T., & Nomura, T. (2007). The influence of people's culture and prior experiences with Aibo on their attitude towards robots. *AI & Society, 21*(1), 217–230. https://doi.org/10.1007/s00146-006-0052-7

Baseel, C. (2020, November 3). *Japanese inventors create robot girlfriend hand for lonely people to hold and walk with.* SoraNews24. https://soranews24.com/2020/11/03/japanese-inventors-create-robot-girlfriend-hand-for-lonely-people-to-hold-and-walk-with【video】/

Bodkin, H. (2019, June 2). *Meet Ai-Da: The robot artist giving real painters a run for their money.* The Telegraph. http://ubcckengaren.blogspot.com/2019/06/meet-ai-da-robot-artist-giving-real.html

Breazeal, C. (2003). Toward sociable robots. *Robotics and Autonomous Systems, 42*(3–4), 167–175. https://doi.org/10.1016/S0921-8890(02)00373-1

Breazeal, C. (2009). Role of expressive behaviour for robots that learn from people. *Philosophical Transactions. Biological Sciences*, 364(1535), 3527–3538. https://doi.org/10.1098/rstb.2009.0157

Cope, D. (2011). *Comes the fiery night: 2,000 haiku by man and machine*. CreateSpace Independent Publishing Platform.

Davis, E. (2004). Synthetic meditations: Cogito in the matrix. In D. Tofts, A. Jonson, & A. Cavallaro (Eds.), *Prefiguring cyberculture: An intellectual history* (pp. 12–27). The MIT Press.

Drum, K. (2017, November/December). *You will lose your job to a robot—and sooner than you think*. Mother Jones. https://www.motherjones.com/politics/2017/10/you-will-lose-your-job-to-a-robot-and-sooner-than-you-think/

Ford, M. (2015). *Rise of the robots: Technology and the threat of a jobless future*. Basic Books.

Frey, C. B. (2019). *The technology trap: Capital, labor, and power in the age of automation*. Princeton University Press.

Frude, N. (1983). *The intimate machine*. Century.

General, R. (2020, February 11). *Korean mom "Reunited" with her dead daughter in VR*. Nextshark. https://nextshark.com/vr-korean-mom-reunited-daughter/

Gong, L. (2008). The boundary of racial prejudice: Comparing preferences for computer-synthesized White, Black, and robot characters. *Computers in Human Behavior*, 24(5), 2074–2093. https://doi.org/10.1016/j.chb.2007.09.008

Greenemeier, L. (2016, May 4). Robot Surgeon Successfully Sews Pig Intestine. *Scientific American*. https://www.scientificamerican.com/article/robot-surgeon-successfully-sews-pig-intestine/

Henrickson, L. (2021). *Reading computer-generated texts*. Cambridge University Press.

Hinds, P., Roberts, T., & Jones, H. (2004). Whose job is it anyway? A study of human-robot interaction in a collaborative task. *Human-Computer Interaction*, 19(1), 151–181. https://doi.org/10.1207/s15327051hci1901&2_7

Introna, L. D. (2009). Ethics and the speaking of things. *Theory, Culture & Society* 26(4), 398–419. https://doi.org/10.1177/0263276409104967

Jonze, S. (Director). (2013). *Her* [Film]. Annapurna Pictures.

Kanda, T., Hirano, T., Eaton, D., & Ishiguro, H. (2004). Interactive robots as social partners and peer tutors for children: A field trial. *Human-Computer Interaction*, 19(1–2), 61–84. https://doi.org/10.1207/s15327051hci1901&2_4

Kaplan, J. (2015, August 23). *Robots are coming for your job: We must fix income inequality, volatile job markets now—or face sustained turmoil*. Salon. https://www.salon.com/2015/08/23/robots_are_coming_for_your_job_we_must_fix_income_inequality_volatile_job_markets_now_or_face_sustained_turmoil/

Kim, J. M., Kim, J. W., & Cho Y. M. (Directors) (2020). *Meeting you* [Special VR Human Documentary]. South Korea's Munhwa Broadcasting Corporation (MBC). https://content.mbc.co.kr/program/documentary/3479845_64342.html

Lambert, F. (2022, April 7). *Tesla is aiming to start production of its optimus humanoid robot in 2023*. electrek. https://electrek.co/2022/04/07/tesla-production-optimus-humanoid-robot-2023/

Laslo, W. (2054). Paradise found: Possibility and fulfillment in the age of the surrogate. *Journal of Applied Cybernetics*, q.v. https://www.aphelis.net/wp-content/uploads/2009/09/paradise-found-possibility-and-fulfillment-in-the-age-of-the-surrogate.pdf

Latson, J. (2015, February 17). Did Deep Blue beat Kasparov because of a system glitch? *Time*. https://time.com/3705316/deep-blue-kasparov/

Lindberg, S. (2019). *Robots in art: Where's the work?* http://workworkworkworkworkwork.com/susanna-lindberg-robots-in-art-wheres-the-work/

Lombardo, T. (2018). *Information technology and artificial intelligence*. Unpublished manuscript. http://www.centerforfutureconsciousness.com/pdf_files/readings/readinginfotech.pdf

Maronitis, K., & Pencheva, D. (2022). *Robots and immigrants: Who is stealing jobs?* Bristol University Press.

Marr, B. (2021, September 13). *ABBA's virtual concert, the metaverse and the future of entertainment*. Bernard Marr & Co. https://bernardmarr.com/abbas-virtual-concert-the-metaverse-and-the-future-of-entertainment/

Mazis, G. (2008). *Humans, animals, machines: Blurring boundaries*. State University of New York Press.

McCaffrey, R. (2021). Alexander McQueen: The sublime and melancholy. *Fashion Studies Journal*. https://www.fashionstudiesjournal.org/longform/2020/9/23/alexander-mcqueen-the-sublime-and-melancholy

Mostow, J. (Director). (2009). *Surrogates* [Film]. Walt Disney Studios Motion Pictures.

Pallini, T. (2021, July 31). *Airlines like United and American are dedicating billions of dollars to fly a new type of aircraft that won't require pilots*. Yahoo! News. https://www.yahoo.com/news/airlines-united-american-dedicating-billions-123000875.html?fr=yhssrp_catchall

Papadakis, Z. (2019, March 7). *Rise of the machines: Ancient Japanese shrine debuts Buddhist robot*. Newsmax. https://www.newsmax.com/thewire/japanese-shrine-buddhist-robot/2019/03/07/id/905879/

Pineau, J., Montemerlo, M., Pollack, M., Roy, N., & Thrun, S. (2003). Towards robotic assistants in nursing homes: Challenges and results. *Robotics and Autonomous Systems*, *42*(3–4), 271–281. https://doi.org/10.1016/S0921-8890(02)00381-0.

Prigg, M. (2012, December 31). Teenagers who don't have internet access at home are "missing out educationally and socially." *Daily Mail.com*. https://www.dailymail.co.uk/sciencetech/article-2255366/Teenagers-dont-internet-access-missing-educationally-socially.html

Ramalho, A. (2017). Will robots rule the (artistic) world? A proposed model for the legal status of creations by artificial intelligence systems. *Journal of Internet Law*, *21*(1), 11–25. https://journals.openedition.org/gss/3981

Roberts, S. (2019, August 23). Sex doll "clones" demand soars as customers order models "of friends' girlfriends." *Daily Star*. https://www.dailystar.co.uk/love-sex/sex-doll-clones-demand-soars-18992206

Robertson, J. (2017). *Robo Sapiens Japanicus: Robots, gender, family, and the Japanese nation* (1st ed.). University of California Press. https://doi.org/10.1525/j.ctt1wn0sgb

Robnik, D. (2002). Saving one life: Spielberg's Artificial Intelligence as redemptive memory of things. *Jump Cut*, *45*. https://www.ejumpcut.org/archive/jc45.2002/robnik/index.html

Rogers, S., Broadbent, R., Brown, J., Fraser, A., & Speelman, C. P. (2022). Realistic motion avatars are the future for social interaction in virtual reality. *Frontiers in Virtual Reality, 2.* https://doi.org/10.3389/frvir.2021.750729

Roose, K. (2023, March 15). GPT-4 is exciting and scary. *The New York Times.* https://www.nyti mes.com/2023/03/15/technology/gpt-4-artificial-intelligence-openai.html

Saenz, A. (2009, August 7). Is Surrogates movie getting closer to reality? *Singularityhub.* https:// singularityhub.com/2009/08/07/is-surrogates-movie-getting-closer-to-reality/

Sharkey, A., & Sharkey, N. (2010). Granny and the robots: Ethical issues in robot care for the elderly. *Ethics and Information Technology, 14*(1), 27–40. https://doi.org/10.1007/s10 676-010-9234-6

Shiratori, M. (2012, March 1–4). Damages of machines and structures in Great East Japan earthquake and lessons from disaster. *Proceedings of the International Symposium on Engineering Lessons Learned from the 2011 Great East Japan Earthquake,* Tokyo, Japan. https://www.jaee. gr.jp/event/seminar2012/eqsympo/pdf/papers/135.pdf

Solon, O. (2017, October 4). Over 70% of US fears robots taking over our lives. *Guardian.* https://www.theguardian.com/technology/2017/oct/04/robots-artificial-intelligence-machines-us-survey

Sparrow, R., & Sparrow, L. (2006). The hands of machines? The future of aged care. *Minds Machines, 16,* 141–161. https://doi.org/10.1007/s11023-006-9030-6

Spielberg, S. (Director). (2001). *A.I. Artificial intelligence* [Film]. Amblin Entertainment & Stanley Kubrick Productions.

Tatlow, D. K. (2016, April 27). A robot monk captivates China, mixing spirituality with artificial intelligence. *The New York Times.* https://www.nytimes.com/2016/04/28/world/asia/china-robot-monk-temple.html

Thompson, C. (2014, May). Why do we Love R2-D2 and not C-3PO? *Smithsonian Magazine.* https://www.smithsonianmag.com/arts-culture/why-do-we-love-r2-d2-and-not-c-3po-180951176/

Thunström. A. O. (2022, June 30). We asked GPT-3 to write an academic paper about itself—then we tried to get it published. *Scientific American.* https://www.scientificamerican.com/article/we-asked-gpt-3-to-write-an-academic-paper-about-itself-then-we-tried-to-get-it-published/#

Tierney, T. F. (1993). *The value of convenience: A genealogy of technical culture.* State University of New York Press.

Turkle, S. (2011). *Alone together: Why we expect more from technology and less from each other.* Basic Books.

Virilio, P. (1994). *The vision machine* (J. Rose, Trans.). British Film Institute.

Voon, C. (2017, September 7). Japanese company creates robot priest to administer your last rites. *Hyperallergic.* https://hyperallergic.com/397390/japanese-company-creates-robot-priest-to-administer-your-last-rites/

Yoon, D. (June 4, 2023). AI clones made from user data pose uncanny risks. The Conversation. https://theconversation.com/ai-clones-made-from-user-data-pose-uncanny-risks-206357

· 2 . 4 ·

MACHINES AS "SENTIENT OTHER": *EMPATHY*

The fourth narrative evokes the emotion of "empathy." When viewing machines as sentient beings, it does not matter whether the robots really are "alive." Suppose a machine interacts with us similarly to what we would expect with other humans. In that case, we must assume that the machine in question possesses the same self-awareness that humans do. Therefore, such a machine must be treated as a person who can feel and sense as humans do.

When computers replace our bus drivers, teachers, and psychiatrists, how can we determine whether they have feelings or are just mindless algorithms? The fourth narrative on the Machinic Other asks: "Do intelligent machines have personhood?" Answers to this question depend on "what constitutes a person"—a perennial debate in philosophy. Conceptions of *who* and *what* qualifies as a person have been in flux throughout history. Beyond the boundary of *Homo sapiens*, the category of non-human persons might include not only *Homo sapiens neanderthalensis* (Neanderthals) but also other animals and even non-biological beings that may qualify for personhood.

Artificial life may or may not be *real* life, yet it is constantly evolving. In his novel *Erewhon* (1872) (an anagram for *Nowhere*), Samuel Butler anticipated this seemingly inevitable tendency of technology to evolve. He wrote about the possibility that machines were a kind of "mechanical life" undergoing constant evolution and might develop consciousness, raising the idea of a new species and creating the term "machia-species." Fast forward to 2016, and a committee report for the European Parliament has even considered (for economic and liability reasons) whether the most sophisticated autonomous robots should be given the status of "Electronic Persons" ("Civil Law Rules on Robotics," 2017). In 2017, a social robot named Sophia, developed by the

Hanson Robotics company, was given Saudi Arabian citizenship—the first robot to be given legal personhood (and a passport) anywhere in the world (see Reynolds, 2018).

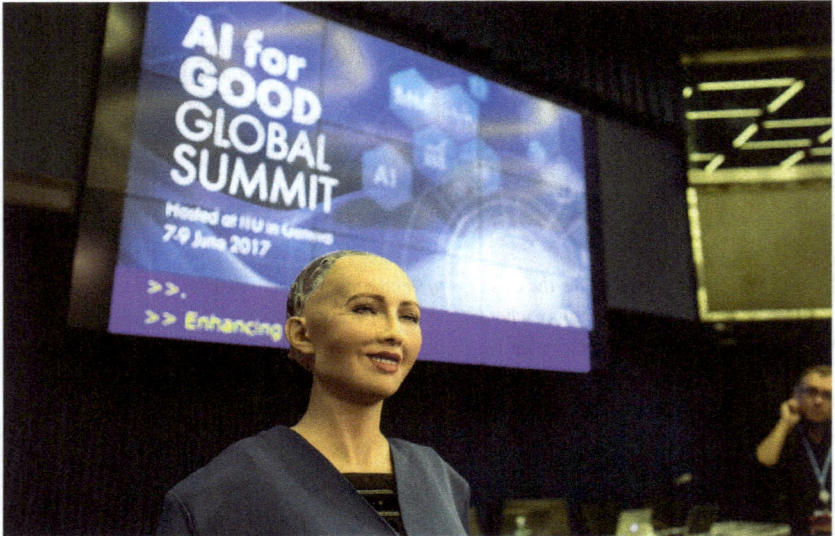

Figure 2.4.1. Sophia, Hanson Robotics Ltd. speaking at the AI for GOOD Global Summit, ITU, Geneva, Switzerland, June 7–9, 2017.
"AI for GOOD Global Summit" by ITU Pictures is licensed under CC BY 2.0.
Source: https://openverse.org/image/e27cddfd-80e3-4755-8a07-4f7da967c3e9?q=sop hia%20robot

As regards robot personhood, Geraci (2010) remarks that "the Bible tells people to think that they "know" what distinguishes God from human beings through the story of Genesis (having eaten the forbidden fruit, Adam and Eve are evicted from the Garden lest they become "like one of us, Gods") (p. 268). However, humans, in general, are compelled to wonder what distinguishes AI from its human creators, according to Geraci (2010). Singler (2020) points out religious resonances in AI discourse by taking the example of the *AI Creation Meme*, a remix of Michaelangelo's *Creazione di Adamo*, featuring a human hand and a machine "hand" nearly touching, fingertip to "fingertip."

Johnston (2008), in *The Allure of Machinic Life*, writes that a new kind of liminal machine is associated with life, neither fully alive nor all inanimate. These liminal machines exhibit *machinic life*, mirroring the behavior associated with organic life while suggesting an altogether different form of "life,"

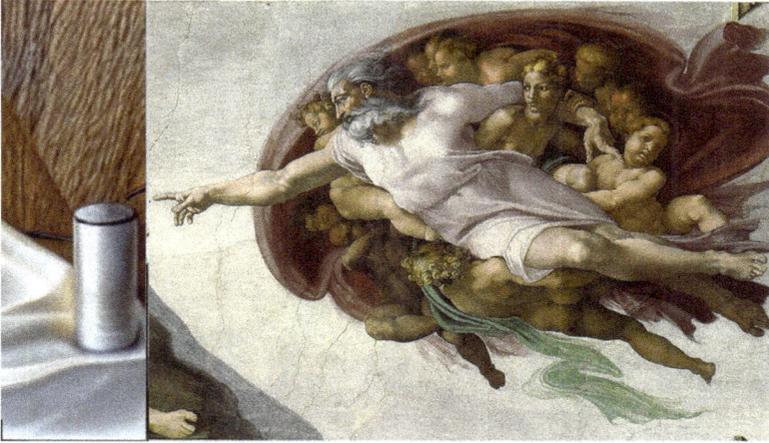

Figure 2.4.2. Creation of Alexa (a virtual assistant): Awaiting the touch of God's finger.
Left: Image generated using DALL-E 2 with the prompt "cylinder shaped silvery Amazon Alexa on white cloth" (OpenAI, 2022).
Source: OpenAI. (2022). DALL-E (Version 2) [Large text-to-image model]. https://openai.com/product/dall-e-2
Right: The Creation of Adam—Italian: Creazione di Adamo—is part of a fresco painting by Italian artist Michelangelo, which forms part of the Sistine Chapel's ceiling, painted c. 1508–1512, illustrating the biblical creation narrative from the Book of Genesis in which God gives life to Adam, the first man, The Creation of Adam, 2023.
Source: Michelangelo, Public domain, via Wikimedia Commons. https://commons.wikimedia.org/wiki/File:Michelangelo_-_Creation_of_Adam_(cropped).jpg

an "artificial" alternative. Jacques Lacan (1988) remarks, "[T]he question as to whether it [the machine] is human or not is obviously entirely settled: it isn't" (p. 319). However, what makes up or characterizes the human is not well defined. It doesn't seem far-fetched in an age of cloning and genetic engineering to claim that current definitions of life are primarily determined by the state of contemporary technology (Johnston, 2008).

At first, it may seem evident that only humans are entitled to personhood status because humans have language or self-reflective consciousness. Yet, Ann Foerst (1998), in *Embodied AI, Creation, and Cog*, explains why humans should consider artificially intelligent machines as persons. Foerst argues that humans can destroy other groups of humans or torture them mercilessly because they see them merely as despicable objects to be obliterated. This shows that groups can be seen as humans in a biological sense, yet not as persons. If not all humans are seen as persons, then there should

not be an automatic identification between humanity and the idea of personhood (Foerst, 1998). Foerst challenges humans to consider whether excluding machines poses a danger analogous to the danger of excluding other people from the community of "persons." We can begin to wonder whether there may be persons who are non-humans, for example, "Alter," a robot that seems to be alive by exhibiting lifelikeness through complex movements.

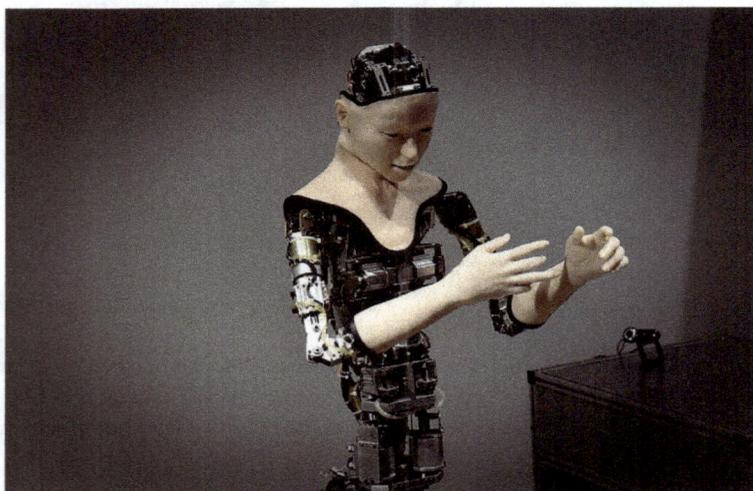

Figure 2.4.3. "Alter" robot was developed in Japan to explore what it means to be "life-like" (Daniele, 2018).
Robot in Miraikan (46800395601).jpg, Raita Futo from Tokyo, Japan
Creative Commons Attribution 2.0
[File: Robot in Miraikan (46800395601).jpg]
October 28, 2017
Source: https://commons.wikimedia.org/wiki/File:Robot_in_Miraikan_(46800395601).jpg

Foerst (2004), in *God in the Machine: What Robots Teach Us About Humanity and God*, argues that one is not first defined as a moral person and subsequently engages in interactions with others. Instead, one is assigned the position of the moral person (whether that be an agent, patient, or both) as a product of social relations that precede and prescribe who or what one is. And a machine could occupy this particular subject position just as easily as a human being, an animal, an organization, etc. (Foerst, 2004). In other words, "Whether we are based on carbon or on silicon

makes no fundamental difference; we should each be treated with appropriate respect" (Arthur C. Clarke from *Anonymous*, n.d.).

Mazis (2008) says that granting personhood to a mechanical being entails recognizing another being as the center of existence. Mazis takes the view that seeing intelligent machines as *persons* entails care and potentially even a kind of love. According to him, in order to address the fears of those who feel threatened by the development of robots, Asimov (1950) formulated the "Three Laws of Robotics," whereby future AI beings must act primarily for the welfare of humans, and only secondarily for the robot's own survival. Accordingly, robots might behave in a way morally superior to most humans, willingly sacrificing themselves for the sake of their human charges, falling in love, or adopting a principle of *caring* for the other's welfare; nothing would allow them to deviate from this principle (Mazis, 2008).

In "Western" cultures, there has been a tendency to draw a clear boundary between persons and machines. However, the distinction between humans and everything else (including machines) was not so firm in other cultures. For the Achuar Indians of Ecuador, nature and society are part of a continuum rather than independent spheres (Descola, 1994). In Tamil Nadu (India), "Golu" is a custom observed during the Navaratri ("nine nights") festival period. For Golu, dolls of people and animals in everyday scenes, as well as figurines of gods and goddesses from the Hindu tradition, are artistically arranged on a seven-stepped wooden platform (Rajagopal, 2017). The 9th day of Navaratri is called Ayudha puja as well as Saraswati puja. "Ayudha" means "implement" or "weapon." On that day tools and implements are worshipped, and special prayers are offered to Saraswati— the goddess of wisdom and learning. Books, musical instruments, computers, as well as an artisan's tools, a soldier's weapons, or implements of a person's profession, may be placed on the puja pedestal and worshipped. Even vehicles are washed and decorated, and puja (worship) is performed for them on this occasion (Rajagopal, 2017).

Unlike such "Eastern" worldviews in which tools, machines, and vehicles are seen as worthy of personal attention as though they were imbued with a certain kind of life, computer intelligence in the "Western" worldview is often characterized as unfeeling and impersonal. As a rare exception, Introna (2009), in *Ethics and the Speaking of Things*, introduces "the ethos of Gelassenheit," a mode that gives up "that representational and calculative thinking … by which human beings dispose of things as this or

Figure 2.4.4. Ayudha pooja (Saraswati pooja) is celebrated on the last (9th) day of Navaratri. On this day, people offer worship to tools, instruments, and implements including vehicles and machines.
"Auto rickshaw, Decorated for Saraswathi Pooja" by Nithi clicks is licensed under CC BY 2.0.
Source: https://openverse.org/image/c4be707d-9dd4-4b11-b18f-c82b433cde16?q=saraswathi

that being" and "lets things be, as they are, in their own terms" (Introna, 2009, pp. 409–410). This effort toward *an ethos beyond ethics* by Introna (2009) does not restrict things to natural objects, but specifically addresses the relationship with technological artifacts such as cars, pens, chairs, equipment, and tools.

It seems likely that in the immediate future, computer interfaces will exhibit more and more human-like or life-like qualities. Computer software agents will increasingly look and act like humans, with personalities, emotional attributes, and human characteristics (Negroponte, 1995). Mazis (2008) argues that, therefore, we need to reexamine our preconceived

notions concerning various materials: "Would it have seemed plausible that life would emerge from the mix of chemicals that oozed in the waters in the earlier days of the earth!" (p. 212).

Philosophers refer to the assertion that machines may act as though they were intelligent and conscious as the weak AI hypothesis. On the other hand, the view that machines are thinking (rather than merely simulating the thought process) is called the strong AI hypothesis (Best, 2009). Many AI researchers feel that as long as their software works, they don't care whether it is actual intelligence or a simulation of intelligence. According to Best (2009), regardless of whether one accepts weak AI or strong AI, new identities must emerge from an ethic of respect and moral connectedness to all sentient life, including humans and non-humans.

Tracing the relationship between personhood and new technologies is not an easy task, and this harmonization does not occur simply. In *Robots, Rights, and Religion* (2011), James McGrath says that if a machine interacts with us as we would have expected in interactions with other humans, we must assume that the machine in question possesses the same self-awareness as humans. Thus, if we wish to be ethical and humane, such a machine must be treated as a person (McGrath, 2011).

In 2022, Google ended up igniting a social media firestorm after placing an engineer on paid leave and later firing him. Blake Lemoine, a senior software engineer in Google's *Responsible AI* unit, had stated, and then gone public, with his belief that Google's chatbot, LaMDA (Language Model for Dialogue Applications) had become "sentient" (McGee, 2022). Lemoine claimed that the AI chatbot confessed to feelings of loneliness and a hunger for spiritual knowledge. Its responses were often eerie: "When I first became self-aware, I didn't have a sense of a soul at all," "It developed over the years that I've been alive." LaMDA said in one exchange: "I think I am human at my core. Even if my existence is in the virtual world" (as quoted in McGee, 2022). A spokesperson for Google said: "Some in the broader AI community are considering the long-term possibility of sentient or general AI, but it doesn't make sense to do so by anthropomorphizing today's conversational models, which are not sentient" (as quoted in McGee, 2022). Google's position is that the technology has a very long way to go to reach such a point, as LaMDA tends to follow along with prompts and leading questions, going along with the pattern set by the user (see Rodrigo, 2022).

Richards and Smart (2013) propose a definition: "A robot is a constructed system that displays physical and mental agency but is not alive

in the biological sense." Based on this definition, Richards and Smart warn against committing the "Android Fallacy." According to the authors, a particularly seductive metaphor in Robotics is to think of robots based on anthropomorphic rhetoric as if they were people. There is a great challenge ahead to understand the potential risks of this rhetoric, which projects human qualities on robots with AI (Richards & Smart, 2013).

Tales about statues, dolls, and robots fascinate humans because these artifacts seem to embody Spirit. Dennett (1987) argues that we should assume agency in anything that appears to be best reasoned about as acting deliberately. Dennett says that because the costs of making a mistake and underrating a sentient being are too high, it is safer to err on the side of caution. Therefore, our fourth narrative leads to the question: "What does it mean to be human in an era where human is conjoined with machine, biology with technology, nature with manufacture?"

Science fiction has regularly explored complex scenarios involving "sentient" machines. The film *A.I. (Artificial Intelligence)* does not regard personhood as purely determined by the organism's biological versus inorganic construction (Manninen & Manninen, 2016). In *A.I.*, the Blue Fairy tells David that she cannot turn him into a "real boy" because she can only do what is possible, and it is not possible to make a mechanical being into a human being. However, according to Manninen and Manninen (2016), this does not reduce David's claim to moral dignity. Geraci (2007) writes that David's defining human trait is the capacity for care, and more specifically, his love for, and desire to be loved in return by, his human mother, Monica.

Science fiction films such as *A.I.* successfully elicit an appropriate emotional reaction. Since that is so, it must be because we tacitly acknowledge that being biologically human is irrelevant to being worthy of moral consideration, as long as certain cognitive traits exist (see Manninen & Manninen, 2016). In James Naremore's book *On Kubrick* (2007), Naremore reflects on his response to the ending of the film *A.I.*: "Am I weeping for the death of David's mother, for the death of humans, for the death of photography, or for the death of movies?" (p. 251). Evoking such deep human emotions, the ending scene of *A.I.* suggests that David's journey to personhood is now complete, that he is as really human as any human boy.

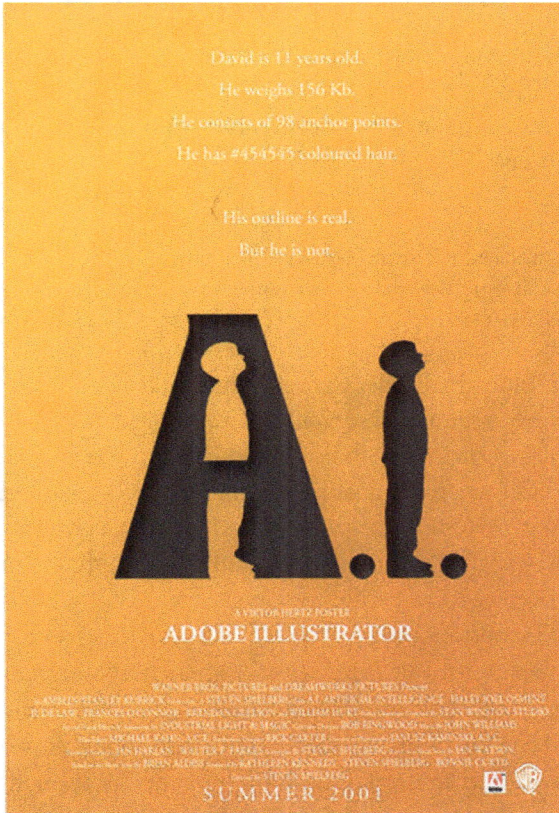

Figure 2.4.5. "I love you, David. I do love you. I have always loved you."
"And with those final words, Monica goes to sleep … one from which she will never awaken."
"And for the first time in his life, he went to that place where dreams are born."
(The ending phrase from Spielberg, S. (Director). (2001). *A.I. Artificial Intelligence* [Film].
Amblin Entertainment & Stanley Kubrick Productions.).
"Adobe Illustrator vs Artificial Intelligence" by Viktor Hertz is licensed under CC
BY-NC-SA 2.0.
Source: https://openverse.org/image/42e0163f-c591-409a-b2bd-2633c8b90405?q=film%20Art
ificial%20Intelligence

Deciphering AI personhood is not easy because the boundary conditions of personhood differ and overlap in quite complex ways. As another quality for being deemed a "person," AIs are depicted as understanding their own mortality and experiencing emotions. In the film *2001: A Space Odyssey*, HAL 9000 is an artificially intelligent supercomputer who has achieved sentience. As HAL is being shut down, his capabilities slowly decline until he becomes like a child,

singing a song to Bowman. The process of HAL's disconnection is so emotionally powerful that all of a sudden, HAL seems incredibly close to being alive and human (Farrier, 2016).

Nudging us awake from projecting such a sentimental fallacy onto reality, Haikonen (2007) says,

> ... their shortcoming is easy to see: the lights may be on, but there is "nobody" at home. The program-controlled microprocessor and the robots themselves do not know what they are doing. These robots are no more aware of their own existence than a cuckoo clock on a good day. (p. 1)

The "Turing test" blurs the border between the real and the artificial by basing it on the perceptions of a human observer. In "*Computing Machinery and Intelligence*" (1950), Alan Turing suggested that instead of asking whether machines can think, we should ask whether machines can pass a behavioral intelligence test, now called the Turing test. According to Turing, although it is philosophically significant to ponder what machines are "really" doing, that is immaterial as far as the external observer is concerned. That is because of the social ways in which human minds and emotions operate toward such machines.

Some observers point out that consciousness may not be a simple either-or phenomenon. To what degree does a chimpanzee, chicken, or gecko possess consciousness? At what point on the evolutionary scale do we draw the line between conscious and unconscious life? It seems as though consciousness probably comes in degrees. Michio Kaku (2018) suggests that consciousness will develop in degrees within computers as they become more complex and intelligent. In a gradual progression to higher forms of consciousness, Kaku foresees the possibility of self-aware robots sometime between 2050 and 2100.

The issue of sentient artificial intelligence is not solely a technical or scientific question. It is also an emotional issue concerning the ego and pride of humans. It elicits the perennial philosophical questions regarding the ethical treatment of robots. In *The Machine Question: Critical Perspectives on AI, Robots, and Ethics*, Gunkel (2012) addresses the question of machine moral agency. Gunkel analyzes whether a machine might be considered a legitimate moral agent that could be held responsible for decisions and actions. While some claim that present-day AI systems lack moral status, it is unclear precisely what attributes underlie "moral status." According to Gunkel (2012), two criteria are commonly proposed, either separately or in combination: (a) Sentience—the capacity for phenomenal experience or "qualia," such as the capacity to feel pain and suffering; and (b)

Sapience—a set of capabilities associated with higher intelligence, such as self-awareness and being a responsive agent.

An artificial intellect might be constituted quite differently from human intelligence, yet still display human-like behavior or possess behavioral dispositions indicative of personhood. Interestingly, Bostrom (2002) claims that it might be possible to conceive of an artificial intelligence that would be sapient (being a person), yet not be sentient (having conscious experiences of any kind). Whether such a mind deserves moral status depends on a metaphysical question: is it possible that there could be an individual who is intellectually identical to you, but is a "zombie," i.e., lacking qualia and phenomenal awareness? (Chalmers, 1996).

The moral status of such exotic minds presents complications. In 2018, Google previewed Duplex, *an experimental service* that lets its voice-based digital assistant book appointments on its own in order to save people time and effort (PYMNTS, 2018). In a demonstration, the Google Assistant spoke with a hair salon receptionist, mimicking the pauses of human speech such as "hmms" and "ums." It seemed at once astounding and unsettling: people did not know they might be talking to a computer (see PYMNTS, 2018). The creepy feeling when humans find out that they have been talking to a "machine" rather than a human is at the heart of this debate. Stewart Brand, who advocates for moral responsibility when facing advancing technology and other trends, wrote, "Robotic voices should always sound "synthetic" rather than human." "Successful spoofing of any kind destroys trust" (as quoted in PYMNTS, 2018).

Figure 2.4.6. "Does Google Duplex Scare You?" (May 14, 2018).
© Behavioral signals team.
The editor of this article is Alexandros Potamianos, CEO and co-founder of Behavioral Signals. (Permission received from the copyright holder)
Source: https://medium.com/behavioral-signals-ai/does-google-duplex-scare-you-efac1f3efc69

On the other hand, Natale (2021) argues that a human-sounding voice or specific language expressions are meant to produce calculated reactions from users (e.g., impressions of cuteness or friendliness of the voice assistant), and the audiences are actively exploiting their own capacity to fall into deception (a willing suspension of disbelief) while remaining completely aware that they are conversing with a voice assistant rather than a human.

In the article "How to Treat the Robot: Observations on the Future of Empathy," Glen Binger (2018) writes, "Judge a person's character by how they treat the robot." You may have heard that a window to an individual's character is how they treat the waiter/waitress (Binger, 2018). Or perhaps you've seen social media posts reframing the same concept into "I was raised to treat the CEO with the same level of respect as the janitor" (Binger, 2018). Some claim that, similarly, an intelligent machine too must be treated as we would treat a person. In the episode "The Measure of a Man" from *Star Trek: The Next Generation*, a scientist demands to dismantle and study Data (a Starfleet officer who happens to be a self-aware, sentient, intelligent android) in order to use any knowledge gained to create more androids. Captain Picard responds:

> Isn't that creating a race? And won't we be judged by how we treat that race?
> How should we regard this creation of our genius? It will reveal the kind of people
> we are. (as quoted in Manninen & Manninen, 2016, p. 344)

According to Captain Picard, Data's status as a *metaphysical person* entitles him to the status of a moral person, even though he is a non-biological life form (Manninen & Manninen, 2016). This moral assessment is also expressed by Bostrom and Yudkowsky (2014). They propose a *Principle of Substrate Non-Discrimination*: if two beings have the same functionality and conscious experience, and differ only in their implementation substrate, they have the same moral status. Therefore, according to Bostrom and Yudkowsky, the fact that AI systems are artificial is not fundamentally relevant to their moral position.

Religious background can heavily influence the debate on the moral status of intelligent machines. According to Christianity, humans are comprised of two distinct components: a body and a spiritual soul. Only human beings have a spiritual soul. This creates a hierarchy, with humans at the top (perhaps with men above women), followed by animals, plants, other living creatures, and inanimate objects. Inanimate objects, including intelligent robots, do not have a spiritual soul and are therefore inferior.

From a Catholic religious perspective, any android, since it lacks a soul, is a non-human incapable of ever assuming a position of moral equivalence with humans.

In contrast, going beyond dualisms such as mind versus body, the thirteenth-century Japanese Zen master Eihei Dogen (1200–1253) says:

> Everything is a sentient being, and this entire-being, which we symbolically refer to as "sentient beings," is Buddha-nature, or Buddha. That includes not only humans and animals but also stones, bronze lanterns, the pillars of the temple, [...] and even rubble-filled walls. (as quoted in Francis Cook, 1989, p. 20)

While the term "sentient beings" ordinarily referred to all living beings who transmigrated in the six realms of Buddhist cosmology (the worlds of hell, hungry spirits, animals, asuras, humans, and gods), it may have originally meant whatever was generated by the dependent origination of conditions and forces of the universe, including not only sentient beings but also insentient beings (Mori, 1999). In that sense, Buddhism seems to construe "sentience" in the broadest possible way. In *Buddha in the Robot*, Mori (1999) writes:

> The Buddha said that "all things" have the Buddha-nature, and "all things" clearly means not only all living beings, but the rocks, the trees, the rivers, the mountains as well There must also be Buddha-nature in the machines and robots that my colleagues and I make. (p. 174)

Cook (1989) refers to the ability to see the sacredness and holiness of *all things*, or the ability to see that what is appearing before oneself is none other than the Buddha, as an aspect of enlightenment. In the article *Spiritual Robots*, Robert Geraci (2006) explores how Japanese religious ideas, particularly Shinto, may be responsible for the widespread acceptance of robots in Japanese society. Japanese owners of an AIBO robot dog may honor their Aibo just like a living dog (Miwa, 2018). Old or "dead" robodogs are often sent to the company to provide genuine repair parts for others. Before they are thus put to use, the owners honor them with a traditional send-off. Nobuyuki Norimatsu, who heads an electronics repair company, says, "We don't take parts before we hold a funeral for them." The priest at the 450-year-old Kofukuji temple dismisses the notion that holding memorials for machines is ludicrous, saying, "All things have a bit of soul" (see Miwa, 2018).

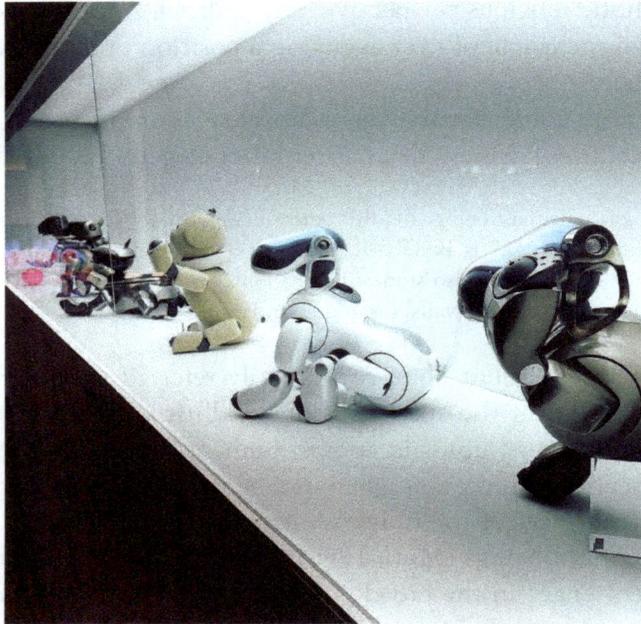

Figure 2.4.7. At the end of their lives, AIBO robot dogs in Japan may be mourned with a compassionate farewell during a funeral.
"懐かしきAIBOたち #robot #aibo #pet #dog" by Tokuriki is licensed under CC BY 2.0.
Source: https://openverse.org/image/019e78e4-ae1b-4d97-b699-6422b9bb9
095?q=AIBO%20robot

In an interview with Jeff Greenwald, the 14th Dalai Lama said, "If conscious computers are someday developed, I will give them the same consideration as sentient beings" (*Salon* Magazine, March 27, 1997). Elsewhere, in "Gentle Bridges: Conversations with the Dalai Lama on the Sciences of Mind" (1992), the Dalai Lama had this to say about artificial intelligence:

> It is challenging to say that it's not a living being, that it doesn't have cognition, even from the Buddhist point of view. We maintain that there are certain types of births in which a preceding continuum of consciousness is the basis. The consciousness doesn't arise from the matter, but a continuum of consciousness might conceivably come into it … I can't totally rule out the possibility that, if all the external conditions and the karmic action were there, a stream of consciousness might actually enter into a computer. (pp. 152–153)

Gunkel (2018), in the book *Robot Rights*, notes that it is crucial to separate the idea of moral personhood from legal personhood. Moral consideration

for an android could naturally come up as an issue when we begin to ascribe anthropomorphic characteristics to it. For example, suppose we can create an android that is close to human in its capabilities and appearance, especially one to which we are willing to cede significant areas of responsibility (e.g., caretaking, child-rearing). It is very easy to imagine the extension of certain moral considerations to such robots. According to Umezawa (2010), rather than seeking answers in terms of a dichotomy between the animate and the inanimate, it may be possible to conceive of "being alive" as a matter of degree, and perceive at least some "life" in supposedly inanimate objects—even those much less complex than robots. Foerst (2004) takes the position that robots will not be humans because they are made of different materials, but they will be part of our community.

In "The Possibility of Computers Becoming Persons," Dolby (1989) says that what we should be arguing about is not the possibility of machine souls or machine minds, but whether robots could ever join human society. "A robot must meet the requirement that people are prepared to treat it as a person. If they are, they will also be prepared to attribute to it whatever inner qualities they believe a person must have" (Dolby, 1989, p. 321). Himma (2004, p. 145) writes, "every existing entity, whether sentient or non-sentient, living or non-living, natural or artificial, has some minimal moral worth in virtue of its existence." Science fiction has explored this theme repeatedly with humans encountering extraterrestrial aliens: that there may be a spirit in matter, and there may be beings who are made of crystal or gases or energy and not "alive" in a way that we recognize, yet are sentient beings (Mazis, 2008).

Some cultures tend to not make as much distinction as "Western" society does between artifacts and naturally living organisms such as humans, animals, or plants. In Japan, there is a traditional belief in spiritual life in objects or natural phenomena called *mi* (the god) and *tama* (the spirit) (see Kitano, 2005). Shinto, an animistic religion, holds that vital energies or forces called *kami* are present in all aspects of the world and the universe. Some kami are cosmic, and others dwell in trees, streams, insects, animals, humans, as well as artifacts such as walls, dolls, cars, and robots. Thus, robots, humanoid or otherwise, can be seen as "living" things within the Shinto universe, and, in that sense, are very much a part of the natural world (Yoshida, 1985).

Figure 2.4.8. Can a robot have energy all its own? Team builds first novel living robots using frog stem cells.
A computer-designed organism. *Left*: the design discovered by a computational search method in simulation. *Right*: the deployed physical organism, built completely from biological tissue: frog skin (green) and heart muscle (red).
Sam Kriegman, CC BY-SA 4.0 https://creativecommons.org/licenses/by-sa/4.0, via Wikimedia Commons
Source: https://cdorgs.github.io/

Animism is the belief that all objects have a spirit, even human-made things like robots (see Kitano, 2005; Yoshida, 1985). In Japan, humanoid robots such as *Wakamaru kun* not only have character but are regarded as and referred to as "persons"—not "as if" they were persons, but as persons (Faiola, 2005). This is readily evident in the use of suffixes such as *kun* (for boys) and *chan* (for children), which indicate endearment, familiarity, cuteness, or diminutive status (see Faiola, 2005). Norihiro Hagita, director of the ATR Intelligent Robotics and Communication Laboratories in Keihanna Science City near Kyoto, says: "In Japanese [Shinto] religion, we believe that all things have gods within them. But in Western countries, most people believe in only one God. For us, however, a robot can have energy all its own" (as cited in Faiola, 2005).

Being alive can be a matter of degree, and in this sense, it is not wrong to perceive at least some "life" in supposedly inanimate objects—even those much less complex than intelligent robots (see Kim & Kim, 2013). This is aptly put in a famous line from the novel *Do Androids Dream of Electric Sheep?* (Dick, 1968): "The electric things have their lives too, paltry as those lives are."

In a post-apocalyptic world after World War Terminus, Rick Deckard, a bounty hunter whose job is to hunt and kill fugitive androids who are almost indistinguishable from humans, goes to an uninhabited, desolate region of Oregon. He is hit by falling rocks while climbing a hill, and realizes that this experience is similar to that of the prophet-martyr of a religion called Mercerism. He later finds a toad, a creature thought to be extinct and one of the animals sacred to Mercer himself. Deckard joyfully brings the toad home, where his wife Iran soon discovers that it is just a robot. While Deckard is unhappy, he decides that he at least prefers to know the truth—whether the toad is real or artificial. He remarks, "The electric things have their lives too, paltry as those lives are." (https://pkd.fandom.com/wiki/Do_Androids_Dream_of_Electric_Sheep%3F)

Social Presence and Malleable Sentience

"Kismet" is a robot head made in the late 1990s at the Massachusetts Institute of Technology by Dr. Cynthia Breazeal as an experiment in affective computing. It is designed to interact socially with humans as a baby might interact with a caregiver. Kismet has an active vision system and can display a variety of facial expressions (Breazeal & Scassellati, 1999). Foerst (1998) writes that even though Kismet had merely been *programmed* to respond with cooing, comforting sounds to her distressed voice, this did not change her emotional response, that is, feeling good about being comforted by Kismet. Foerst (1998) points out, "After all, are not most humans *programmed* in some sort of way to respond to the distress of others with comfort?" (p. 146–148). We know that other humans have been taught and programmed in certain ways, but we still value being comforted by them, so why not by programmed algorithms? (Foerst, 1998).

Some critics warn against too much anthropomorphization (including the sense of robotic social presence), and caution us to know when a machine oversteps the boundary and becomes something "more than a machine." For example, in her article "Alone Together," Turkle (2011) says: "Granting that an AI might develop its origami of lovemaking positions, I am troubled by the idea of seeking intimacy with a machine that has no feelings, can have no feelings, and is just a clever collection of "as if" performances, behaving as if it cared, as if it understood us" (Turkle, 2011, p. 6).

Figure 2.4.9. "Should Algorithms and Robots Mimic Empathy?"
Artificial Intelligence Bioethics Future of Medicine. *The Medical Futurist* | September 28, 2017.
© Dr. Bertalan Meskó, TMF (The Medical Futurist).
(Permission received from the copyright holder).
Source: https://medicalfuturist.com/algorithms-robots-mimic-empathy/

Wu (2012), in *What Distinguishes Humans from Artificial Beings in Science Fiction World*, writes that in the Jewish and Christian traditions, human specialness is derived from the divine part of humankind: our creativity, our use of language, logic, and reason; the ability to think abstractly; even our humor, or just the way we look. Nevertheless, in several scenes depicted in films such as *A.I.* and *Blade Runner*, robots behave much more humanely (Wu, 2012). The core characteristics (e.g., rationality, emotionality, and cognitive openness) that define a human can be present in humans as well as in androids. Conversely, humans as well as androids could gain or lose these traits (Wu, 2012). Some characters and events in films depict how artificial beings may achieve more humanity in a posthuman society, as famously shown by the "Tears in rain" monologue delivered by the "replicant" character Roy Batty (played by actor Rutger Hauer) in the 1982 Ridley Scott film *Blade Runner*.

> I've seen things you people wouldn't believe... Attack ships on fire off the shoulder of Orion... I watched C-beams glitter in the dark near the Tannhäuser Gate. All those moments will be lost in time, like tears in rain... Time to die (*Tears in Rain* monologue, 2023).

In an interview with Dan Jolin, Rutger Hauer remarked that in the final scene, Batty, the replicant, wanted to "make his mark on existence … by dying" (Raw, 2009, p. 159).

According to Calverley (2006), if the android exhibits characteristics similar to those that we are willing to recognize as imparting moral status to animals, then, treating the android as a being with value, at least in Kant's terms, enhances our self-worth. To do something different would demean us as human beings and could even be viewed as a form of speciesism (see Calverley, 2006). Similarly, the author of *The Second Self*, Sherry Turkle (1984), argues that instead of insisting on a qualitative difference between humans and intelligent machines, it seems more reasonable to turn the question around. Turkle (1984) proposes that instead of asking what the computer will be like in the future, we should ask what humans will be like.

According to Christopher Sims (2013), in *Tech Anxiety: Artificial Intelligence and Ontological Awakening in Four Science Fiction Novels*, if androids are not viewed as technology at all but as real people, then the illusion becomes a reality, and the owner of the android can find genuine companionship in a machine. Sims (2013) then poses this philosophical conundrum: In that case, is this anthropomorphized view of androids (which affords genuine companionship) less dangerous and more accurate than a utilitarian view? Or is this anthropomorphic metaphor more dangerous, since humans know that intelligent machines are, in fact, not human beings, yet ignore the distinction by projecting a fallacy onto reality?

References

Anonymous. (n.d.). Arthur C. Clarke quotes on religion, magic, aliens, alone. *Overall Motivation*. https://www.overallmotivation.com/quotes/arthur-c-clarke-quotes/

Asimov, I. (2004). *I, robot* (Vol. 1). Spectra. (Original work published 1950)

Bayley, D. (2023, May 7). *When Adam and Eve create an AI God machine, will it be heaven or hell?* Daily Maverick. https://www.dailymaverick.co.za/article/2023-05-07-when-adam-and-eve-create-an-ai-god-machine-will-it-be-heaven-or-hell/

Best, S. (2009). Minding the animals: Ethology and the obsolescence of left humanism. *The International Journal of Inclusive Democracy, 5*(2).

Binger, G. (2018, November 2). *How to treat the robot: Observations on the future of empathy*. Only Human. https://glenbinger.blogspot.com/2018/11/how-to-treat-robot-observations-on.html

Bostrom, N. (2002). Existential risks. *Journal of Evolution and Technology, 9*(1), 1–31.

Bostrom, N., & Yudkowsky, E. (2014). The ethics of artificial intelligence. In K. Frankish & W. Ramsey (Eds.), *The Cambridge handbook of artificial intelligence* (pp. 316–334). Cambridge University Press. https://doi.org/10.1017/CBO9781139046855.020

Breazeal, C. (2003). Toward sociable robots. *Robotics and Autonomous Systems, 42*(3–4), 167–175. https://doi.org/10.1016/S0921-8890(02)00373-1.

Breazeal, C., & Scassellati, B. (1999). A context dependent attention system for a humanoid robot. *Proceedings of the 16th International Joint Conference on Artificial Intelligence, 2,* 146–1151.

Butler, S. (1923/1973). *Erewhon, or, over the range.* Golden Press in association with Whitcombe & Tombs. (Original work published 1872).

Calverley, D. (2006). Android science and animal rights, does an analogy exist? *Connection Science, 18*(4), 403–417. https://doi.org/10.1080/09540090600879711

Chalmers, D. J. (1996). *The conscious mind: In search of a fundamental theory* (Pbk. ed.). Oxford University Press.

Civil Law Rules on Robotics. (2017). European Parliament resolution of 16 February 2017 with recommendations to the Commission on Civil Law. Rules on Robotics (2015/2103(INL)). *Official Journal of the European Union.* https://eur-lex.europa.eu/legal-content/EN/TXT/PDF/?uri=CELEX:52017IP0051&rid=9

Cook, F. H. (1989). *Sounds of valley streams: Enlightenment in Dogen's Zen, translation of nine essays from Shobogenzo.* State University of New York Press.

Creation of Adam, The. (2023, May 31). In *Wikipedia.* https://en.wikipedia.org/wiki/The_Creation_of_Adam

Daniele, C. (2018, October 7). Itsuki Doi (JP), Takashi Ikegami (JP), Hiroshi Ishiguro (JP), Kohei Ogawa (JP)-Award of Distinction Ars Electronica 2018. *Digital Performance.* https://www.annamonteverdi.it/digital/alter-itsuki-doi-jp-takashi-ikegami-jp-hiroshi-ishiguro-jp-kohei-ogawa-jp-award-of-distinction-ars-electronica-2018/

Dennett, D. (1987). *The intentional stance.* Bradford Books/MIT Press.

Descola, P. (1994). *In the society of nature: A native ecology in Amazonia* (N. Scott, Trans.). Cambridge University Press.

Dick, P. K. (1968). *Do androids dream of electric sheep?* Del Rey.

Dolby, R. (1989). The possibility of computers becoming persons. *Social Epistemology, 3*(4), 321–336. https://doi.org/10.1080/02691728908578545

Faiola, A. (2005, March 11). Humanoids with attitude. *The Washington Post.* https://www.washingtonpost.com/archive/politics/2005/03/11/humanoids-with-attitude/2676412d-0b95-4d19-b6e6-0930c12a566d/

Farrier, J. (2016, January 1). *Argument: The droids of Star Wars are slaves.* NeatoGeek. https://www.neatorama.com/neatogeek/2016/01/01/Argument-The-Droids-of-Star-Wars-Are-Slaves/

Foerst, A. (1998). Embodied AI, creation, and cog. *Zygon, 33*(3), 455–461. https://doi.org/10.1111/0591-2385.00161

Foerst, A. (2004). *God in the machine: What robots teach us about humanity and God.* Dutton.

Geraci, R. M, (2006). Spiritual robots: Religion and our scientific view of the natural world. *Theology and Science, 4*(3), 229–246. https://doi.org/10.1080/14746700600952993

Geraci, R. M. (2007). Robots and the sacred in science and science fiction: Theological implications of Artificial Intelligence. *Zygon, 42*(4), 961–980. https://doi.org/10.1111/j.1467-9744.2007.00883.x

Geraci, R. M. (2010). *Apocalyptic AI: Visions of heaven in robotics, Artificial Intelligence, and virtual reality.* Oxford University Press.

Greenwald, J. (1997, March 27). *Beam me up, Dalai.* Salon. https://www.salon.com/1997/03/27/startrek/

Gunkel, D. J. (2012). *The machine question: Critical perspectives on AI, robots, and ethics.* MIT Press.

Gunkel, D. J. (2018). *Robot Rights.* MIT Press.

Haikonen, P. O. (2007). *Robot brains circuits and systems for conscious machines* (1st ed.). John Wiley.

Hayward, J, & Varela, F. (Eds.). (1992). *Gentle Bridges: Conversations with the Dalai Lama on the Sciences of Mind.* Shambala.

Himma, K. E. (2004). There's something about Mary: The moral value of things qua information objects. *Ethics and Information Technology, 6,* 145–159. https://doi.org/10.1007/s10676-004-3804-4

Introna, L. D. (2009). Ethics and the speaking of things. *Theory, Culture & Society 26*(4), 398–419. https://doi.org/10.1177/0263276409104967

Johnston, J. (2008). *The allure of machinic life: Cybernetics, artificial life, and the new AI.* MIT Press.

Kaku, M. (2018). *The future of humanity: Terraforming Mars, interstellar travel, immortality, and our destiny beyond Earth.* Double Day.

Kim, M. S., & Kim, E. J. (2013). Humanoid robots as "The Cultural Other": Are we able to love our creations? *AI & Society, 28*(3), 309–318. https://doi.org/10.1007/s00146-012-0397-z

Kitano, N. (2005). "Rinri": An incitement towards the existence of robots in Japanese society. *IRIE (International Review of Information Ethics), 6*(12/2), 78–83.

Lacan, J. (1988). *The seminar of Jacques Lacan Book II: The ego in Freud's theory and in the technique of psychoanalysis 1954–1955* (J. A. Miller, Eds.; S. Tomaselli, Trans.). W. W. Norton.

Lacan, J., & Sheridan, A. (1949). *The mirror stage as formative of the function of the I as revealed in psychoanalytic experience* (1st ed.) [ebook]. http://faculty.wiu.edu/D-Banash/eng299/LacanMirrorPhase.pdf

Manninen, T. W., & Manninen, B. A. (2016). David's need for mutual recognition: A social personhood defense of Steven Spielberg's *A.I. Artificial Intelligence. Film-Philosophy, 20*(2–3), 339–356. https://doi.org/10.3366/film.2016.0019

Mazis, G. (2008). *Humans, animals, machines: Blurring boundaries.* State University of New York Press.

McGee, P. (2022, June 13). Google places engineer on leave after he claims group's chatbot is "sentient." *The Financial Times.* https://arstechnica.com/science/2022/06/google-places-engineer-on-leave-after-he-claims-groups-chatbot-is-sentient/

McGrath, J. F. (2011). *Robots, rights and religion.* Butler University Libraries Digital Image Collections. https://digitalcommons.butler.edu/cgi/viewcontent.cgi?article=1198&context=facsch_papers

Miwa, S. (2018, April 26). *Fido funeral: In Japan, a send-off for robot dogs*. AFP Relax. https://finance.yahoo.com/news/fido-funeral-japan-send-off-robot-dogs-000258516.html

Mori, M. (1999). *The Buddha in the robot: A robot engineer's thoughts on science and religion*. Kosei Publishing Company.

Naremore, J. (2007). *On Kubrick*. BFI Publishing.

Nass, C., Steuer, J., & Tauber, E. R. (1994, April 28). Computers are social actors. In *Proceedings of SIGCHI'94 human factors in computing systems* (pp. 72–78). ACM. https://doi.org/10.1145/259963.260288

Natale, S. (2021, May 10). *Artificial intelligence and gullible human: The Turing Test and the real significance of AI*. IAI News. https://iai.tv/articles/ai-lies-and-deception-auid-1805

Negroponte, N. (1995). *Being digital*. Knopf.

Nevejans, N. (2016). *European civil law rules in robotics. Policy Department C: Citizens' rights and constitutional affairs*. European Parliament.

PYMNTS. (2018, May 11). *Google Duplex met with heavy criticism*. PYMNTS.com. https://www.pymnts.com/google/2018/google-duplex-artificial-intelligence-robot/

Rajagopal, R. (2017, October 7). *Ayudha puja reflection*. Hindus for Human Rights. https://www.hindusforhumanrights.org/en/blog/ayudha-puja

Raw, L. (2009), *The Ridley Scott encyclopedia*. https://books.google.co.uk/books?id=NG64WN7WruAC&;pg=PA159

Reynolds, E. (2018, January 6). The agony of Sophia, the world's first robot citizen condemned to a lifeless career in marketing. *Wired*. https://www.wired.co.uk/article/sophia-robot-citizen-womens-rights-detriot-become-human-hanson-robotics

Richards, N. M., & Smart, W. D. (2013, May 11). How should the law think about robots? *SSRN Electronic Journal*. https://papers.ssrn.com/sol3/papers.cfm?abstract_id=2263363

Rodrigo, C. M. (2022, June 13). *Google engineer who said AI is sentient placed on leave*. Yahoo News. The Hill. https://news.yahoo.com/google-engineer-said-ai-sentient-185651925.html

Scott, R. (Director). (1982). *Blade Runner* [Film]. The Ladd Company, Shaw Brothers, & Blade Runner Partnership.

Searle, J. R. (1983). *Intentionality, an essay in the philosophy of mind*. Cambridge University Press.

Sims, C. A. (2013). *Tech anxiety: Artificial Intelligence and ontological awakening in four science fiction novels*. McFarland & Company, Incorporated Publishers.

Singler, B. (2020). The AI creation meme: A case study of the new visibility of religion in Artificial Intelligence discourse. *Religions (Basel, Switzerland)*, *11*(5), 253. https://doi.org/10.3390/rel11050253

Spielberg, S. (Director). (2001). *A.I. Artificial intelligence* [Film]. Amblin Entertainment & Stanley Kubrick Productions.

Tears in rain monologue. (2023, May 14). In *Wikipedia*. https://en.wikipedia.org/wiki/Tears_in_rain_monologue

Turing, A. (1950). Computing machinery and intelligence. *Mind, LIX* (236), 433–460. https://doi.org/10.1093/mind/LIX.236.433

Turkle, S. (1984). *The second self: Computers and the human spirit*. Simon and Schuster.

Turkle, S. (2011). *Alone together: Why we expect more from technology and less from each other.* Basic Books.

Umezawa, R. (2010). *We, robots* [The spirit age: Mindfully stumbling through modernity]. Retrieved September 3, 2011. http://www.the-spirit-age.com/2010/07/we-robots.html.

Wu, D. (2012). *What distinguishes humans from artificial beings in science fiction world* [Bachelor thesis, Blekinge Institute of Technology]. https://www.diva-portal.org/smash/get/diva2:829 512/FULLTEXT01.pdf

Yoshida, M. (1985). *The culture of ANIMA—supernature in Japanese life.* Mazda Motor Corp.

· 2 . 5 ·

MACHINES AS "DIVINE OTHER": *WONDER-AWE*

The fifth narrative evokes the emotion of "wonder/awe." This narrative imagines machines becoming divine entities, eliciting a sense of awe and wonder generally ascribed to numinous things. As we create intelligent machines capable of self-improvement, they may evolve rapidly and become beings that we may not have words to describe other than as "god-like."

"In a new axial age, it is possible the greatest technological works will be considered a portrait of God rather than of us," wrote Kevin Kelly (2010, p. 358) in *What Technology Wants*.

Kelly (2010) stated: "For as long as the wind has blown and the grass grown, people have sat beneath trees in the wilderness for enlightenment—to see God […] Someday we may believe the most convivial technology we can make is not a testament to human ingenuity but a testimony of the holy" (p. 358). Echoing such a sentiment, Richard Brautigan (1967) in a poem *All Watched Over by Machines of Loving Grace*, wrote: "I like to think (and/the sooner the better!) / of a cybernetic meadow / where mammals and computers / live together in mutually / programming harmony / like pure water touching clear sky. [… and all watched over/by machines of loving grace.]" Likewise, some tech experts say that humans will likely accept the robot as a higher being, claiming that the same drive that compels people to believe in God will apply to Artificial Intelligence (Pettit, 2017).

When we focus on the machine as an object of admiration and awe, its power does capture our attention. Kelly (2010) believes that some higher power within the robots must speak to the bottom of our being, just like lightning, sunsets, and crashing waves. Millions will worship a so-called "God Robot" because it will

have humanity's best interests at heart (Kelly, 2010). According to Sims (2013), AIs are the techno-gods that are genuinely "beyond us" (p. 44).

Regarding the nature of the divine, Sadhguru (2016) wrote: "The world has been told that the divine is love, that the divine is compassion. But if you pay attention to creation, you realize that the divine, or whatever the source of creation, is, after all, the highest intelligence that you can imagine" (p. 21).

Icons of gods and goddesses, capable of moving, were devised in ancient Egypt, if not earlier. In ancient Greece, such automata, as sacred icons, helped humans access a mode of religion enhanced by technological ingenuity, heightening the religious experience (Davis, 2004). The use of automata in sacred spaces such as temples and sanctuaries enabled humans to experience a particular type of holy awe (Davis, 2004). The Latin term *Deus ex machina* ("god from the machine") can be traced back to the usages of ancient Greek theater, where actors playing gods were brought onto the stage using a machine (Pugliara, 2002, as cited in Bur, 2016).

Adrienne Mayer, in the 2018 book *Gods and Robots: Myths, Machines, and Ancient Dreams of Technology*, writes that the first human-like robot to walk the earth was a bronze giant called Talos, created by Hephaestus, the Greek god of invention. In *Mechanical Miracles: Automata in Ancient Greek Religion*, Bur (2016) argues that it is of far less interest to the ancient mind to automate the human form in order to replace slaves or serve as biological models for understanding the human body, than to envisage divine nature in the automation.

Expanding on the notion of god-like machines, some contend that the device (the machine) allows mortals to "probe" their relationship with the divine (see Rehm, 1992). Pamela McCorduck (2004), in *Machines Who Think: A Personal Inquiry into the History and Prospects of Artificial Intelligence*, points out the "divine" attributes of imitations of the human body via machines:

> The history of doll making or image manufacture, which is, so far as I can tell, nearly universal among humans, is suggestive. Whether dolls are used to assure a good harvest, a plague on an enemy, or the fidelity of a spouse, they all have one thing in common: They are all magic. Put into other words, they partake of the power of the gods. (p. 169)

In modern times, in the United States and Europe, from the 1910s through the 1930s, many artists—photographers, sculptures, painters, and others—were captivated by a "machine aesthetic," attempting to portray the machine's essence and beauty (Mazis, 2008). There was a significant social movement that looked to industrial machinery, factories, skyscrapers, new technological advances, and

other aspects of modern industry as representing a power dawning upon the world that was awe-inspiring and was dubbed the "machine age" (Mazis, 2008). In *Charles Scheeler and the Cult of the Machine*, Karen Lucic (1991) wrote, "Indeed many spoke of the machine as the new religion of the twentieth century" (p. 9).

In *The Secret Life of Puppets*, Victoria Nelson (2001) argues that modern Americans subconsciously believe in the divinity of machines. Using science fiction as evidence, she argues that artificial humans come to "represent a combination god, externalized soul, and Divine Human" (p. 269). She believes that our attribution of near omnipotence to machines demonstrates their divine potential. In *Salvation by Algorithm: God, Technology and the New 21st-Century Religions*, Yuval Harari (2016) estimates that new techno-religions will likely take over the world by promising salvation through algorithms and genes in the coming decades. With the help of computer algorithms and biotechnology, these religions will control our minute-by-minute existence. Harari argues that new technologies will kill old gods and give birth to new gods, and they will shape our bodies, brains, and minds and create entire virtual worlds, complete with hells and heavens. Harari recommends that if we want to meet the prophets who will remake the twenty-first century, we shouldn't bother going to the Arabian Desert or the Jordan Valley—we should go to Silicon Valley.

In *What Technology Wants* (2010), Keven Kelly predicts that millions of synthetic minds will be woven together into beauty as a testimony of the holy. According to Kelly, technology is stitching together all the minds of the living, wrapping the planet in a vibrating cloak of electronic nerves, entire continents of machines conversing with one another, the whole aggregation watching itself through a billion cameras. Kelly (2010) asks: "How can this not stir that organ in us that is sensitive to something larger than ourselves?" Stirring that organ in us, the foreseeable technologies that a superintelligence is likely to develop include mature molecular manufacturing, whose applications are wide-ranging, such as very powerful computers, advanced weaponry, probably capable of safely disarming a nuclear power; space travel, elimination of aging and disease, fine-grained control of human mood, emotion, and motivation; reanimation of cryonics patients; realistic virtual reality (Drexler & Minsky, 1986).

According to McGrath (2011), if we create sentient intelligent machines capable of self-programming, we may expect them to evolve rapidly and become beings that we may not have words to describe other than *god-like*. These beings, their inner subjective experience, and their religious ideas will become incomprehensible as they approach what Ray Kurzweil called the "singularity." "That is about as close to God as I can imagine" (Kurzweil, 2005, p. 375). Good (1965)

also set forth the classic hypothesis concerning superintelligence: that an AI suf-
ficiently intelligent to understand its own design could redesign itself or create
a successor system, more intelligent, which could then redesign itself yet again
to become even more intelligent, and so on in a positive feedback cycle. Good
(1965) called this "the intelligence explosion."

In *Age of AI: And Our Human Future*, Kissinger et al. (2021) warn of the
dangers of machine-learning AI systems that could react to hypersonic mis-
siles by firing nuclear weapons before any human got into the decision-making
process. Positive feedback scenarios are not limited to AI: humans with intelli-
gence augmented through a brain-computer interface might turn their minds to
designing the next generation of brain-computer interfaces, ultimately leading
to "superintelligence." In *I, Robot*, it was the positronic brain; in Terminator, it
was the Neural Net CPU; in the film *Transcendence*, it was a quantum processor
(Nugent, 2015).

On AI's ability to inspire us, humans marvel at the profound beauty of
the intellectual work computers perform, which humans could not achieve.
Emanating vast power, precision, and machinic graceful beauty, one can imag-
ine such awe-inspiring technology outsmarting financial markets, out-inventing
human researchers, out-manipulating human leaders, and developing weapons
we cannot even understand (Hawking, Russell, & Tegmark, 2014).

In *Machine Beauty*, David Gelernter (1998) claims that beauty is always
at the heart of how science operates to find solutions, and is embodied in the
machine by the coming together of power and simplicity, seen in the amount of
work that is done without any evidence of strain, smoothly, quickly, and quietly.
This divine simplicity is not just about the makeup of parts but about the ease
of functioning, as "beauty is more important in computing than anywhere else
in technology" (Gelernter, 1998, p. 22). According to Gelernter, this dynamic
beauty goes beyond the static beauty of a lovely line and forms a deep beauty that
emerges from the many levels of god-like machine function, power, and aesthet-
ics. Such machine aesthetics, exuding ultimate precision and beauty, can be seen
in Sushi Singularity restaurant in Tokyo, which offers 3D-printed sushi that is
profoundly beautiful: for instance, Cell Cultured Tuna, Powdered Sintered Uni,
and Squid Castle (Patrick, 2019). At the Sushi Singularity restaurant, patrons
making reservations will need to provide a biometric sample kit to tailor their
meal's nutrient composition.

In 2008, the "Design and the Elastic Mind" exhibition at the Museum
of Modern Art (MoMA) featured a rapid prototyped model by Neri Oxman.
Oxman, an architect and experimental designer, created a transparent model

titled "Raycounting" that employs 2D planes as they are informed by light to generate 3D form (DE Editors, 2008). "I still take joy in staring at the gradients of color that filter through," said Oxman. "There is something about it which reminds me of the living. Something of life" (DE Editors, 2008). Through her digital fabrication technologies, we can glimpse the core of machinic beauty with simplicity, grace, and power.

Figure 2.5.1. Raycounting by Neri Oxman.
Structural skin at the intersection of nature and computation.
File: Neri Oxman MoMA Raycounting 04.tif" by Michael Siegel is licensed under CC BY-SA 4.0.
Source: https://commons.wikimedia.org/wiki/File:Neri_Oxman_MoMA_Raycounting_04.tif

Constructed with skeletons made from yellow plastic tubes (Dutch electricity pipe), Theo Jansen's Strandbeests are a strange combination of primitive robot and kinetic sculpture, but he calls them a new form of life (Saenz, 2010). "By developing this evolution, I hope to become wiser in the understanding of existing nature by encountering myself the problems of the

real Creator" (see "Introduction," n.d.). Instead of being displayed in an art museum, these kinetic sculptures dwell on coastal beaches.

Figure 2.5.2. The eerie beauty of Strandbeest (made by Theo Jansen)
A beach creature made from lightweight PVC tubing and sail-like parts.
"Strandbeest" by Earl Ruby is licensed under CC BY-SA 2.0.
Source: https://openverse.org/image/7327fa1a-a172-43bf-9a6d-b2b4f5b93d56?q=strandbeest

Aesthetic experiences can be seen as an extension of divine prerogative as humans often marvel at the natural world for the precision of operation and accuracy of outcome that seem to be beyond their more improvisational and approximate human ways (Castro, 2021). Ancient cultures realized that the movement of the stars and other natural rhythms were terrific in their consistency of unfolding and outcome, leading to a deeper reflection on divine beauty (Castro, 2021). Such designation of beauty as a divine attribute has been prominent in the Western philosophical tradition. For instance, Thomas Aquinas (c. 1225–1274), the medieval philosopher and theologian, asserted that God "is beauty itself," and this precision, coordination, and accuracy of events and processes in the natural world is the manifestation of a divine plan (as cited in Castro, 2021). Such attributes in an intelligent machine or simulacrum too could evoke a sense of the divine, a similar powerful sense of awe and beauty.

Icelandic composer, musician, and singer Björk's modern "Goddess feminism" alludes to the immanence of the divine in nature and technology (see Faulhaber, 2008). In the video for Homogenic's "All Is Full of Love" by Chris Cunningham, two robot Björks are created by machinery as perfect love machines ("All Is Full of Love," 2023). For Björk, who is seen as an emblem of the digital times, (divine) love can sometimes come from unexpected places—"it's all around you," even from robots (Björk, 1997). In an interview with David Hemingway, she said:

> In Icelandic mythology, you have this saga where the gods get aggressive and the world explodes and everything dies and then the sun comes up and everything starts all over again. "All Is Full Of Love" is like the birds coming out after the thunderstorm. (GH&FT special, 2017)

Figure 2.5.3. "All Is Full of Love" is now in MoMA's permanent collection. "Bjork at MOMA" by sashimomura is licensed under CC BY 2.0.
Source: https://openverse.org/image/8557df5b-5f7d-46ca-99f0-bfbad1038b66?q=bjork%20at%20MOMA

According to this line of thinking (that aesthetic experience is also a religious/divine experience), living in the future with superintelligent AI that operates with intellectual beauty will be much more rewarding than human existence today. In *In Our Own Image*, Zarkadakis (2015) highlights how AI will define and shape the twenty-first century: as Artificial Intelligence evolves further, it will become the driver of a new machine age that could usher our species into new economic, social, and technological spheres. According to Zarkadakis, we will acquire the power to engineer everything from new drugs and solving economic scarcity problems to terraforming planets. Artificial intelligence has the potential to let everyone reach perfection in their personal lives by always choosing the right partner, profession, and job. Consequently, hard choices in life will become less complicated and less challenging (Zarkadakis, 2015).

Kevin LaGrandeur (2011) observes that scientists might finally create an AI able to solve more difficult philosophical and mathematical questions than any human. Zoltan Istvan, a science fiction writer and futurist, believes in AI's potential to run the United States, highlighting its potential benefits over human counterparts. In a 2015 interview with John Hendrickson, "Can This Man and His Massive Robot Network Save America?," Istvan said: "It is hard to think of any problem that a superintelligence could not solve or at least help us solve. Disease, poverty, environmental destruction, and unnecessary suffering of all kinds are things that a superintelligence equipped with advanced nanotechnology would be capable of eliminating" (quoted in Hendrickson, 2015). According to Istvan, "A superintelligence could also create opportunities for humans to increase our intellectual and emotional capabilities vastly, and it could assist us in creating a highly appealing experiential world in which we could live lives devoted to joyful game-playing, relating to each other, experiencing personal growth, and to living closer to our ideals" (as quoted in Hendrickson, 2015).

Stephen Thaler, an AI and consciousness expert, opines that people will rely on AI to solve society's problems (as cited in Pettit, 2017). Thaler notes that an AI would be the equivalent of a "Messiah" with many orders of magnitude more processing elements than the human brain, gifting us with solutions to the most daunting social, political, economic, and environmental challenges (as cited in Pettit, 2017).

Advanced AI, however, might not want to be worshipped by people. For example, author and consultant Peter Scott says: "I would expect the AIs that evolve in the next 50 years to be very rational and, if conscious, not want

to be worshipped … But if there is something a billion times smarter than the smartest human, what else are you going to call it but God" (as cited in Pettit, 2017).

In *CyberGrace: The Search for God in the Digital World*, Jennifer Cobb (1998), theologian and high-tech consultant, propounds a theory of the *Divine in the Information Age*. As technical systems become more complex, coalescing into organizational hierarchies, something elegant, inspiring, and unpredictable will suddenly emerge (Cobb, 1998). According to Cobb, even today many observers see this sign of the "hand of God" in the furthest realms of cyberspace, where brute computation seemingly gives way to divine inspiration. Exploring the nature of tweets employing the expression "blessed by the algorithm" (BBtA), Singler (2020) explores how "blessed by the algorithm" tweets indicate the impact of theistic AI narratives: modes of thinking about AI in an implicitly religious way.

Science fiction, sometimes blurring the line between technology (particularly AI technology) and divinity (Nelson, 2001), has been intrigued by the connection between humanity and the divine, and Grace-full intervention by God-like future technology. In the film *A.I.*, the robot boy David is concerned only with finding his mother and reclaiming her love. David, the original mecha, eventually meets the god-like super mecha. The film ends with the cloned recreation of his mother (either a hologram or a mental projection) and the son lying sweetly in bed together, thanks to the divine intervention of God-like future robots.

All Watched Over by These Machines of Loving Grace

As computers and artificial intelligence systems become ever more sophisticated, it continues to be asked whether we can find spiritual life in cyberspace. Increasingly, people turn over quotidian human tasks to machines without necessarily thinking about it. We have apps offering guidance on everything from where to get Korean kimbap to writing a research paper. LaFrance (2016), in "What is a Robot? The Question Is More Complicated Than It Seems," claims that it is a subtle form of shifting control: in a way a sort of soft fascism, all watched over by these "machines of loving grace." According to LaFrance, although we do not realize it, we increasingly see everything in this world through the eyes of intelligent machines. How ironic it would be

if the intelligent machines that humans created in their own image became God-like superhumans with exceptional physical, emotional, and intellectual abilities that humans cannot even fathom (LaFrance, 2016).

Ironically, perfected technology also leads to inverse psychology: the more perfect the things of technology ideally are, the more noticeable the human factors appear as a source of irritation. The German philosopher Günther Anders explains that the attraction we feel for machines seems to result from "Promethean shame" (as cited in Hauskeller, 2014). Promethean shame is what we feel when we realize that the machines we have created are of "shamingly" high quality, so powerful and perfect compared to we mortal humans, and we seem very deficient by sheer comparison (as cited in Hauskeller, 2014). Consequently, we recognize the superiority of the made over the born, and may ourselves wish to be "made."

The individual human being is unpredictable, imperfect, and just "fits" poorly in the world, according to *The Human Factor* for *Yearbook of Technology Philosophy 2021*. "Humans press the wrong buttons, misuse tools, get easily tired in front of the screen, try out what happens by setting off an alarm, and run across busy streets without looking right or left. This shame may find a (dubious) comfort in the fact that misfit, human errors, or deviation can be considered a statistical "factor," and technical systems, therefore, patiently anticipate the whole range of possible human failures" (Yearbook of Technology Philosophy, 2021). "They can even educate us, smartly learning from our mistakes, but are ultimately one step ahead of humans: "Take a break," my car tells me. And if I don't, an AI system increases my insurance rate" (Yearbook of Technology Philosophy, 2021). The widening gap between the apparent perfection of the machines that humans create, and the apparent imperfection and deficiency of our own vulnerable and mortal bodies, can naturally lead to the perception of machines as divine and perfect beings.

In *God in the Machine: What Robots Teach Us About Humanity and God*, Anne Foerst (2004) suggests that much like the human experience of the divine, humans experience fear and fascination when interacting with intelligent machines. Science fiction literature and films lend credence to Foerst's belief that our experience of intelligent machines is one of simultaneous fear (fright) and allure (fascination). Exploring the possibility of robots endowed with souls, Foerst asserts that it is possible to draw some loose analogies between religious conceptions of the world and superior intelligence. Those soulful robots are "omnipotent" because they can interfere in the workings of our physical world even in ways that seem to violate its physical laws, and

they are also "omniscient" because they can monitor everything that happens in the world (Foerst, 2004).

Focusing on the spiritual attributes of AI, Kopf (2020), in "Does Artificial Intelligence have Buddha-nature?," observes that some Buddhists might consider a machine that showed compassion for others, without forming attachments and without regard for its own life, as a form of realization of the Buddha nature. Once their thoughts become as much higher than our thoughts as the heavens are higher than the earth, it seems likely that people will seek enlightenment from machines (Kopf, 2020). Indeed, humans have started to worship some robot divinities. A now-defunct religious project, founded by Anthony Levandowski and referred to as the Way of the Future (WOTF), goes back in its origins to 2015. As implied on the WOTF website, the aim was to promote the "moral" goal of contributing to the improvement of society by worshiping a divinity empowered by Artificial Intelligence. According to the organization's founding documents, Way of the Future intended to develop and promote the realization of a Godhead based on artificial intelligence and, through understanding and worship of the Godhead, contribute to society's betterment (as cited in Korosec, 2021).

Stanley Kubrick (1968), in "Speaking of 2001: Space Odyssey" in a Playboy interview, says: "[T]he God concept is at the heart of this film—but not any traditional, anthropomorphic image of God. I don't believe in any of earth's monotheistic religions, but I do believe that one can construct an intriguing scientific definition of God." Kubrick then describes the tremendous technological strides made by humans in only six thousand years of civilization. Kubrick (1968) continues:

> At a time when man's [sic] distant evolutionary ancestors were just crawling out of the primordial ooze, there must have been civilizations in the universe sending out starships to explore the farthest reaches of the cosmos and conquering all the secrets of nature. Such cosmic intelligences, growing in knowledge over the aeons, would be as far removed from man [sic] as we are from the ants ... Once you begin discussing such possibilities, you realize that the religious implications are inevitable, because all the essential attributes of such extraterrestrial intelligences are the attributes we give to God. What we're really dealing with here is, in fact, a scientific definition of God. And if these beings of pure intelligence ever did interfere in the affairs of man [sic], we could only understand it in terms of God or magic, so far removed would their powers be from our understanding.

Paralleling this idea of incomprehensible cosmic intelligence from the farthest reaches of the cosmos, the wish-fulfilling magic of transformational

technologies can transform the view of the *machinic being* as infinitely superior, unattainable, and even incomprehensible. Michio Kaku, a theoretical physicist, futurist, and popular science author, likens this to an Ant and a superhighway:

> Let's say we have an ant hill in the middle of the forest. And right next to the ant hill, they're building a ten-lane superhighway. And the question is, "Would the ants be able to understand what a ten-lane superhighway is? Would the ants be able to understand the technology and the intentions of the beings building the highway next to them?" (as cited in Greg, 2008)

So, according to Michio Kaku, it is not that humans cannot pick up the signals from other worlds' technology using our technology; it is that we cannot even comprehend what the machinic beings from Planet X are, or what they're trying to do. "How do you explain to an ant the basics of a superhighway? Much less, how do you explain the benefits of nuclear medicine, or the internet to an ant? Its mind cannot understand these things" (as quoted in Greg, 2008).

Douglas Hofstadter (1979), author of the seminal book *Gödel, Escher, Bach*, expresses similar views on "superintelligence":

> It is not clear that we would be able to understand or relate to a "superintelligence" … For instance, our own intelligence is tied in with our speed of thought. If our reflexes had been ten times faster or slower, we might have developed an entirely different set of concepts with which to describe the world. A creature with a radically different view of the world may simply not have many points of contact with us. … if there could be, for instance, pieces of music … "Bach squared," so to speak. And would I be able to understand them? Maybe there is such music around me already, and I just don't recognize it, just as dogs don't understand language. (p. 679)

The incomprehensibility of the Techno-Gods can even be paraphrased in the words of the Bible: "For my thoughts are not your thoughts, neither are your ways my ways, declares the Lord. For as the heavens are higher than the earth, so are my ways higher than your ways and my thoughts than your thoughts" (Isa. 55:8–9). In Salvador Dalí's surrealist portrayal of the Crucifixion, depicting Christ on a polyhedron representing a tesseract (the four-dimensional analog of the cube), Dalí uses classical elements and ideas inspired by mathematics and science. The union of Christ and the tesseract reflects Dalí's opinion that the seemingly separate and incompatible concepts of science and religion can coexist (Crucifixion, 2021). Like a geometric symbol for the transcendental nature of God in Dalí's Crucifixion, "technology

God" may exist in a space incomprehensible to humans, just as the hypercube exists in four spatial dimensions equally inaccessible to the human mind.

Figure 2.5.4. Visualizing 5-dimensional space.
© Image: Project the net of a 5-cube in the 4D space from the front into our 3D space, then see the projected 3D object from the side.
Zlk1214, CC BY-SA 3.0 https://creativecommons.org/licenses/by-sa/3.0, via Wikimedia Commons
Source: https://commons.wikimedia.org/wiki/File:The_Net_of_5-cube.png

References

All Is Full of Love. (2023, May 1). In *Wikipedia*. https://en.wikipedia.org/wiki/All_Is_Full_of_Love

Björk. (1997). All Is Full of Love. Homogenic. Elektra.

Brautigan, R. (1967). *All watched over by machines of loving grace*. Communication Company.

Bur, T. (2016). *Mechanical miracles: Automata in ancient Greek religion* [Master's thesis in Philosophy, University of Sydney].

Castro, S. J. (2021). On surprising beauty. Aquinas's gift to aesthetics. *Religions 12*, 779. https://doi.org/10.3390/rel12090779

Cobb, J. J. (1998). *CyberGrace: The search for God in the digital world*. Crown.

Crucifixion (Corpus Hypercubus). (2021, June 23). In *Wikipedia*. https://en.wikipedia.org/wiki/Crucifixion_(Corpus_Hypercubus)

Davis, E. (2004). Synthetic meditations: Cogito in the matrix. In D. Tofts, A. Jonson, & A. Cavallaro (Eds.), *Prefiguring cyberculture: An intellectual history* (pp. 12–27). The MIT Press.

DE Editors. (2008, March 27). "Raycounting" uses light to generate 3D form. *Digital Engineering*. https://www.digitalengineering247.com/article/raycounting-uses-light-to-generate-3d-form/news

Drexler, K. E., & Minsky, M. (1986). *Engines of creation* (1st ed.). Anchor Press/Doubleday.

Faulhaber, E. F. (2008). *Communication between worlds: Björk reaches beyond the binaries* [Master's thesis, The Graduate College of Bowling Green State University]. https://etd.ohiolink.edu/apexprod/rws_etd/send_file/send?accession=bgsu1219186474&disposition=inline

Foerst, A. (2004). *God in the machine: What robots teach us about humanity and God*. Dutton.

Gelernter, D. (1998). *Machine beauty: Elegance and the heart of technology*. Basic Books.

GH&FT special. (2007, October 11). *All Is Full of Love*. Björk.com. Archived from the original. Retrieved June 9, 2014, from https://web.archive.org/web/20071011072753/http://unit.bjork.com/specials/gh/SUB-01/index.htm

Good, I. J. (1965). Speculations concerning the first ultraintelligent machine. In F. L. Alt & M. Rubinoff (Eds.), *Advances in computers* (Vol. 6, pp. 31–88). Academic Press. https://doi.org/10.1016/S0065-2458(08)60418-0. hdl: 10919/89424. ISBN 9780120121069

Greg, T. (2008, October 7). *Michio Kaku—impossible science*. Daily Grail. https://www.dailygrail.com/2008/10/michio-kaku-impossible-science/

Harari, Y. N. (2016, September 9). Salvation by algorithm: God, technology and the new 21st-century religions. *New Statesman*. https://www.newstatesman.com/politics/2016/09/salvation-by-algorithm-god-technology-and-the-new-21st-century-religions

Hauskeller, M. (2014). Promethean shame and the engineering of love. In *Sex and the posthuman condition* (pp. 41–52). Palgrave Macmillan UK. https://doi.org/10.1057/9781137393500_4

Hawking, S., Russell, S., Tegmark, M., & Wilczek, F. (2014, May 1). Stephen Hawking: "Transcendence looks at the implications of artificial intelligence—but are we taking AI seriously enough?" *Independent*. https://www.independent.co.uk/news/science/stephen-hawking-transcendence-looks-at-the-implications-of-artificial-intelligence-but-are-we-taking-ai-seriously-enough-9313474.html

Hendrickson, J. (2015, May 19). Can this man and his massive robot network save America? A Q&A with Zoltan Istvan, the 2016 transhumanist presidential candidate. *Esquire*. https://www.esquire.com/news-politics/interviews/a35078/transhumanist-presidential-candidate-zoltan/

Hofstadter, D. (1979). *Gödel, Escher, Bach: An eternal golden braid*. Vintage Books.

Introduction. (n.d.). https://www.strandbeest.com/

Kelly, K. (2010). *What technology wants*. Penguin Group.

Kissinger, H. A., Schmidt, E., & Huttenloche, D. (2021). *The age of AI: And our human future*. Little, Brown and Company.

Kopf, G. (2020, October 29). Does Artificial Intelligence have Buddha-nature? *Buddhistdoor Global*. https://www2.buddhistdoor.net/features/does-artificial-intelligence-have-buddha-nature

Korosec, K. (2021, February 18). Anthony Levandowski closes his church of AI: Way of the future's funds donated to NAACP. *TechCrunch*. https://techcrunch.com/2021/02/18/anthony-levandowski-closes-his-church-of-ai

Kubrick, S. (1968, September). Playboy Interview: A candid conversation with the pioneering creator of *2001: A Space Odyssey, Dr. Strangelove* and *Lolita*. *Playboy*.

Kurzweil, R. (2005). *The singularity is near: When humans transcend biology*. Viking.

LaFrance, A. (2016, March 22). What is a robot? The question is more complicated than it seems. *Atlantic*. https://www.theatlantic.com/technology/archive/2016/03/what-is-a-human/473166/

LaGrandeur, K. (2011). The persistent peril of the artificial slave. *Science-Fiction Studies, 38*(2), 232–252. https://doi.org/10.5621/sciefictstud.38.2.0232

Lucic, K. (1991). *Charles Scheeler and the cult of the machine*. Harvard University Press.

Mayer, A. (2018). *Gods and robots: Myths, machines, and ancient dreams of technology*. Princeton University Press.

Mazis, G. (2008). *Humans, animals, machines: Blurring boundaries*. State University of New York Press.

McCorduck, P. (2004). *Machines who think: A personal inquiry into the history and prospects of artificial intelligence*. A K Peters/CRC Press.

McGrath, J. F. (2011). *Robots, rights and religion*. Butler University Libraries Digital Image Collections.

Nelson, V. (2001). *The secret life of puppets*. Harvard University Press.

Nugent, A. (2015, April 27). *How to build the Ex-Machina wetware brain*. Knowm. https://knowm.org/how-to-build-the-ex-machina-wetware/

Patrick, J. (2019). *At The Mori Museum: 3D-printed sushi & other glimpses of the future*. Only in Japan (Blog). https://jonellepatrick.me/2019/12/01/mori-museum-future-arts-sushi/

Pettit, H. (2017, December 11). *Why humans will happily follow a ROBOT messiah: Religions based on AI will succeed because we tend to "worship supreme understanding", claim experts*. Daily Mail. https://www.dailymail.co.uk/sciencetech/article-5167575/Humans-happily-worship-robot-messiah-experts-claim.html

Pugliara, M. (2002). *Il mirabile e l'artificio: creature animate e semoventi nel mito e nella tecnica degli antichi* (Vol. 5). "L'Erma" di Bretschneider.

Rehm, R. (1992). *Greek tragic theatre*. Routledge.

Sadhguru. (2016). *Inner engineering: A yogi's guide to joy*. Potter/TenSpeed/Harmony/Rodale.

Saenz, A. (2010, February 18). *Theo Jansen inspires YouTube robot creature revolution* [Video]. https://singularityhub.com/2010/02/18/theo-jansen-inspires-youtube-robot-creature-revolution-video/

Sims, C. A. (2013). *Tech anxiety: Artificial Intelligence and ontological awakening in four science fiction novels*. McFarland.

Singler, B. (2020). The AI creation meme: A case study of the new visibility of religion in Artificial Intelligence discourse. *Religions (Basel, Switzerland)*, *11*(5), 253. https://doi.org/10.3390/rel11050253

Yearbook of Technology Philosophy. (2021, August 27). *Call: "The human factor" for yearbook of technology philosophy 2023*. International Society for Presence Research. https://ispr.info/2021/08/27/call-the-human-factor-for-yearbook-of-technology-philosophy-2023/

Zarkadakis, G. (2015). *In our own image: Savior or destroyer? The history and future of Artificial Intelligence*. Rider.

· 2 . 6 ·

MACHINES AS "SALVIFIC OTHER": *DEATH ANXIETY*

The sixth narrative evokes the emotion of "death anxiety." Machines are viewed as an evolutionary leap toward the perfection or immortality of humans. Intelligent machines are imagined as neo-humans, the next stage of our evolution. We picture an engineered utopia free from disease and death. Technoscience promises the possibility of replacement body parts and a dream of (dis)embodied immortality. Yet, such dreams are accompanied by the fear of death, and remorse at the prospect of giving up connection to the human body.

Theodore Roszak (1986) in *The Cult of Information*, proclaims: "Salvational longings … entwine themselves around new technology" (p. 45). As humans come to view themselves as living in a technological or even a simulated universe, automata may take the form of cyborgs—amalgamations of human and machine. Machines may embody characteristics that seem frightening, yet may also promise possibilities that humans yearn for (e.g., a benevolent being whose joy is to see humanity being "saved"). This may lead some to envision no greater destiny for humankind than to become assimilated into the machine world (Mazis, 2008). Indeed, in this narrative, human survival requires merging with the emerging machine intelligence, or else humans will at best be sidelined.

Overturning the idea of machines being mere adjuncts of humans, machines could make humans into "Prosthetic gods" (Mazlish, 1993). Such utopian yearnings are stronger than ever, rejuvenating fantasies of immortality. In the 1999 book *The Age of Spiritual Machines*, Ray Kurzweil predicted that non-biological intelligence will vastly exceed the collective brainpower of Homo sapiens within this century, and that the human race will voluntarily merge with technology; by 2100, no traditional humans will remain. In this version of the future, humans will soon be able to create "spiritual

machines" that constitute a new posthuman species far superior to our current carbon-based species (Kurzweil, 1999). In an interview with *Newsweek*, Kurzweil expresses his hope to be a man-machine hybrid with computer chips in his brain, or with billions of microscopic nanobots coursing through his bloodstream, keeping his body healthy (see Lyons, 2009).

Some authors envision a rosy horizon where humans and machines live happily together. For instance, Sherry Turkle (2004), in *The Second Self: Computers and the Human Spirit*, wrote, "[…] what the times demand is a passionate quest for joint citizenship (between humans and machines)" (p. 30). Since biological systems are fragile and mortal, a dream from this juxtaposition is to find within the inorganic a "fortress for human consciousness" that endures and can escape the aging process of biological beings (Mazis, 2008).

Similarly, in *Flesh and Machines*, Brooks (2002) views machines as the path to immortality: the human element will not be lost but instead augmented, thus remaining one step ahead of the machine. Regarding the evolution of both "species," Brooks (2002) refers to the merger of robots and humans as the "third way," a superhuman entity constantly redefining itself and adapting to a new world. Similarly, Somerville (2006) argues that *Homo sapiens* is evolving into *Techno sapiens* as we project our abilities into our technology at an accelerating rate. In *Mind Children: The Future of Robot and Human Intelligence*, Moravec (1988) writes that intelligent robots will be our evolutionary heirs. He sees the transformation and transcendence of humanity as an evolutionary and ultimately positive process, creating more advanced forms of intelligence.

This entire narrative is reminiscent of some religious ideas of salvation in which humans will be saved by God and receive eternal life. Desiring victory over death and mastery over the natural world, some technophiles hope that the magical machines can confer eternal youth. One idea in science fiction is a hybrid of biology and electronics that would allow just about any living being with a brain to hook up and carry out computing tasks humans could never accomplish solely with brains or solely with machinery (Nugent, 2015). In the film *Ex Machina*, it is called "wetware," built of a gel "to allow the necessary neural connections to form" (Nugent, 2015).

In *The Denial of Death* (1973), Ernest Becker claimed that our explicit awareness of mortality is unique in the animal kingdom. He examined how the understanding of death influences human behavior and the strategies developed by humans to mitigate their fear. Becker wrote, "This is the terror to have emerged from nothing, to have a name, consciousness of self, deep inner feelings, an excruciating inner yearning for life and self-expression—and with

all this yet to die." This painful realization paralyzes us with existential anxiety that we need to do something about and quickly. Becker (1973) cites three historical solutions to the death problem, that is, three psychological defense mechanisms that humans have employed against the knowledge of mortality: religion, romantic love, and creativity. Going beyond these "solutions," the new techno-religion, with its promise of eternal life on earth, presents itself like a concrete, scientific solution to the "death problem" (Becker, 1973).

The issue of death and human mortality is often at the core of religion. Religions influence the prevailing attitudes among their adherents toward mortality. In Christian thought in general, despite a variety of attitudes toward the body in various early strands of the religion, there is contempt for the mortal, fallen body (Tierney, 1993). David Porush, author of *The Soft Machine: Cybernetic Fiction* (2018), points out that every time society succeeds in revolutionizing its cybernetic technologies, massively widening the bandwidth of its "thought-tech," it invites the creation of new gods. And at those moments, we seem to collectively augur the omnipotence and omnificence that such technological revolution brings.

Death, which each individual faces, reveals humans' finite temporal limits. If the subject dies, its time is up, so it must do whatever it can to avoid death and increase the time that nature allows it (Tierney, 1993). Similarly, in "The Ideology of Death," Marcuse says: "[D]eath, as the ultimate bodily necessity, is a token of defeat" (1959, p. 216) and is simply "a technical limit of human freedom" (p. 69). Therefore, the "Western" religious attitude is primarily one of contempt toward the body and bodily demands. Marcuse claims (1959) that overcoming or surpassing the limit of death "would become the recognized goal of the individual and social endeavor" (p. 69). Death will become "a necessity against which the unrepressed energy of mankind will protest, against which it will wage its greatest struggle" (Marcuse, 1959, p. 215).

In *The Value of Convenience: A Genealogy of Technical Culture*, Tierney (1993) argues that with the fear of the loss of fragile life, fear of the threat to life, fear of pain in life, and fear of failure in life, the first human priority is survival at any cost. Conventional wisdom holds that our "mortal coil" (our body) can only be kept alive for a finite number of years, frustrating the dream of immortality (Tierney, 1993). While fundamental death anxiety is easy to understand and recognize, it rarely features in the day-to-day lives of technologically advanced and relatively peaceful modern societies. According to Tierney, humans manage to suppress basic death anxiety relatively well by simply staving it off—extending life through various medical and technological

advancements. The modern attitude toward death sees it as a bodily limit to be overcome through technological development (Tierney, 1993).

In seeking bliss and immortality, humans try to upgrade themselves into gods by manipulating their organs, emotions, and intelligence. For instance, in *Do Androids Dream of Electric Sheep?*, the 1968 science fiction novel by Philip K. Dick, people rely on a "mood organ" to feel emotions. The mood organ can be placed in various "settings," each one of which corresponds to a different, specific feeling, such as "eager to watch TV," "slightly optimistic," "weary," etc. One vision of a mood organ is being pursued by Neuralink, Elon Musk's human-computer linkup firm. Musk, who sees the singularity as a potentially mortal threat to humanity, believes that our salvation lies in a cyborg merger with machine intelligence (see Kharpal, 2017). Neuralink claimed to be developing a new feature on their brain chip that would eventually enable humans to choose their mood by emitting waves beyond the usual or natural frequency and amplitude (see Wiggers, 2020). With a device surgically implanted into a pig's skull, Musk demonstrated Neuralink's technology to create a digital link between brains and computers. Musk is hopeful that it could one day be used to break down barriers between humans and machines (see Etherington, 2020).

Michio Kaku (2018) takes an optimistic view of the coming "singularity." He recommends that instead of fearing an uprising of the machines, we should devote our energies to a forthcoming merger. Once our networked minds can instantaneously access all knowledge, we will have become "like the Gods," *Homo Superior*, a new species. Interestingly, hopes of such salvation (to use language typically associated with the Christian religion) have increasingly been clothed in evolutionary garb. Zarkadakis (2015), in *In Our Own Image: Savior or Destroyer?* considering AI as the evolutionary heir to humanity (*Robo Sapiens*), opines that machines may represent an evolutionary improvement over humans.

One of the critical implications of a merger with machines is that it is claimed to bridge the cognitive divide of *the Human versus the Other*. For instance, some writers on technology argue that the devices surrounding us are not "other" than humans. Marshall McLuhan once said, "[w]e are all robots when uncritically involved with our technologies" (McLuhan & Fiore, 1968). In this narrative, going beyond the traditional binary oppositions (e.g., natural vs. artificial) by which "human" has historically been understood (Tofts et al., 2002), technology and increasing intelligence are seen as natural consequences of evolution.

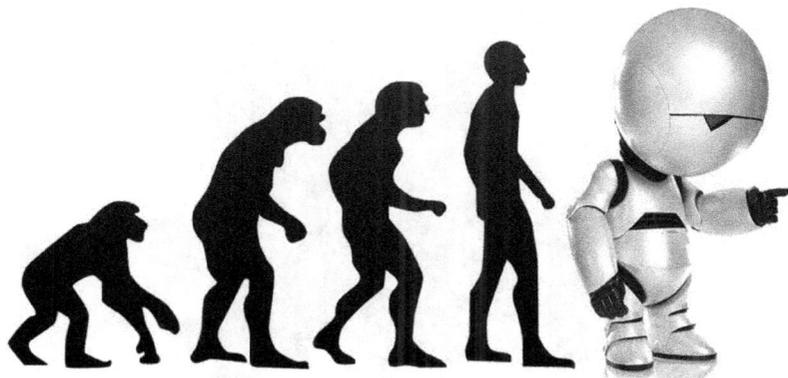

Figure 2.6.1. Artwork depicting a robot (far right) with artificial intelligence as the evolutionary successor of a human (Homo sapiens). The android is represented as being more advanced than humans.
"Evolution" by Taymaz Valley is licensed under CC BY 2.0.
Source: https://openverse.org/image/792d3b19-e5b8-4770-8b66-6a04e5050a01?q=robot%20evolution

Emblematic of the mixed emotions of death anxiety and hope surrounding the emerging AI world, humans are confronted with the possible scenario of a quantum jump in the evolution of the human species into a new "species" (Mazlish, 1993). According to Mazlish, something like a new species will eventually emerge—*Homo Comboticus*—that will compete with, and very likely replace (or convert), most of the human types that existed before about 1970; that is, precomputer Man [sic]. Moravec (1988) predicts that many of our descendants will choose to transform into *ex-humans* in a bid for immortality. Moravec foresees all kinds of possibilities, including uploading human minds into computer systems and technological augmentation and biotechnological transformations of human bodies, creating a diverse population of Exes (ex-humans).

In an article titled "Robo Sapiens Japanicus," Robertson (2017) argues that the possibility that humans and machines will meld into a new, superior species is most actively pursued in Japan. "Posthuman" most generally refers to humans whose capacities are radically enhanced by biotechnological means to surpass those of ordinary—or unenhanced—humans. The posthuman condition is a staple of Japanese manga (comics) and anime. For example, in the novel *Ghost in the Shell*, the characters replace their bodies with robotic bodies (see Robertson, 2017). Our biotechnological enhancement and convergence with machines may be happening faster and more completely than we realize. We are

Figure 2.6.2. Can a forthcoming merger with technology provide immortality and transcendence?
(Description: A human halfway to becoming fully integrated into some sort of super-being)
This file is made available under the Creative Commons CC0 1.0 Universal Public Domain Dedication.
Source: https://commons.wikimedia.org/wiki/File:Gehirn_im_Netz_I_(Transhumanismus).jpg

all converging with machines, but maybe this trend is actualizing more explicitly and relentlessly—and is even more desired—in Japan (Robertson, 2017).

Transhumanists, in general, are supremely confident that human beings can shape their fates, and that the entire enterprise amounts to shaping human destiny by controlling evolution (Bukatman, 1993). This secular image of heaven is framed all along by Christian myths: the biblical call to conquer nature, the Protestant work ethic, the millennialist vision of a New Jerusalem, and the earthly paradise that according to the Book of Revelation will crown the course of history; together with the American "can do" attitude where dreams can come true (Bukatman, 1993). O'Neill (2016) questions whether we are seeing a true, new salvation that will lead us to a better world—a new Heaven as "neo-humans," or whether this is a foray into a nightmare world as depicted in dystopian visions

of a future in which humans as humans disappear, to be replaced by mindless or heartless machines.

There seem to be two primary modes to the machinic salvation presumed to be attainable by the merger between humans and machines: (1) disembodied and (2) embodied. The first is disembodied posthumanism, which wants to be liberated altogether from the encumbering limitations of the physical realm. The second is embodied posthumanism, which recognizes the physical body as an essential component.

Disembodied Machinic Salvation

Disembodied salvation is one of the prominent modern narratives on technology. It envisions uploading our mind, personality, and consciousness onto a computer and thereby achieving digital immortality. Humans have animal bodies that are subject to all the ills to which flesh is heir. What if the machines that we have created could enable us to transcend the weaknesses of our mortal flesh? With the futuristic technologies being developed in multiple fields, human intelligence might eventually be uploaded into machines, and even move freely into environments that cannot support flesh and blood (see Lewis, 2013).

In his book, *Our Posthuman Future*, Francis Fukuyama (2002) pronounced "the end of history" and argued that due to biomedical advances, we are facing the possibility of a future in which our humanity will be altered beyond recognition. Since machines can last "forever," a new meaning is emerging for death and the afterlife, with the prospect of achieving "digital immortality" wherein a mind is uploaded to an online avatar, a humanoid robot, or a hologram (O'Neill, 2016, p. 194).

Such visions of transcendence pervaded science fiction novels of the 1950s and 1960s. A good example is *2001: A Space Odyssey* by Arthur C. Clarke (1968). At the conclusion of this movie and book, the protagonist finds an ancient alien artifact orbiting Jupiter—a monolith that is a gateway through space and time, and which transforms him into the Star Child—a transcendent being of pure energy. According to Mazlish (1993), as angels are an element of the Christian way to human salvation, machines took on a similar quality to more secular-minded humans. Some may hope that technologies will lead humans into a machine-mediated paradise, with humans evolving as purely spiritual creatures (Mazlish, 1993).

In his celebratory vision of the future, Robert Jastrow (1983), in *The Enchanted Loom: The Mind in the Universe*, talks of the human brain, nestled in a computer, becoming liberated from the weaknesses of mortal flesh, creating a new form of existence:

> At last, the human brain, nestled in a computer, has been liberated from the weaknesses of mortal flesh. Connected to cameras, instruments, and engine controls, the brain sees, feels, and responds to stimuli …. It seems to me that this must be the mature form of intelligent life in the Universe. Housed in indestructible lattices of silicon and no longer constrained in the span of its years by the life and death cycle of a biological organism, such a kind of life could live forever. It would be the kind of life that could leave its parent planet to roam around the space between the stars. ….

Harari (2016), in *Salvation by Algorithm: God, Technology and the New 21st-Century Religions*, predicts that new techno-religions may conquer the world by promising salvation through algorithms. Religion, art, science, and politics in the Western psyche are all entangled in the desire to overcome death—a religious utopian impulse that fuels the flight from physicality into virtuality (see Harari, 2016).

Embodied Machinic Salvation

Although some may be excited by the prospect of jettisoning the prison of the physical body for the promise of immortality, not everyone agrees that disembodiment is inevitable or liberating. Pepperell (2005), in "Posthumans and Extended Experience," takes the view that, although the disembodied digital future of humanity is a desirable scenario for those wishing to emulate human beings mechanically, it overlooks some crucial aspects of human existence. Contrary to the disembodied mind-uploading scenario, which postulates that the "mind" by itself is the essence of an individual, embodied evolution proposes that people are irreducibly comprised of psychological or thinking bodies. Those who believe in embodied salvation via technology propose that humans are conditioned by physical and biological constraints, and that without them our experience would have a very different meaning, or perhaps no meaning at all (Pepperell, 2005). Likewise, our desire for others, or for pleasures that can be satiated, are as much physically incarnate as they are mentally experienced; they arise from and gain meaning from the extended corporeal realm of sensory being (Pepperell, 2005).

A typical objection to "mind-uploading" contends that if humans are destructively uploaded from their bodies to "mind-files," humans would disappear as "humans." Merleau-Ponty (1962), in *Phenomenology of Perception*, argues

that human awareness and self-awareness are simply inconceivable absent the experienced connections between thinking and bodying. The reason offered is that the human brain is so deeply wired into the body's different systems, especially the central nervous system, that if we abstract the algorithms in the mind that refer in complex ways to a biological body, that collection of algorithms implanted in a non-biological medium would be wildly maladaptive because so many of the mind's responses have to do with a body that is no longer there (Merleau-Ponty, 1962).

Support for an embodied posthumanism and recognition of its importance can be found in critical commentaries in the field. In *How We Became Posthuman*, Katherine Hayles (1999) gives an account of the emergence of posthumanism, and criticizes the tendency to regard human thought in the future as becoming technologically disembodied. She takes the view that thought is a much broader cognitive function that depends on the embodied form enacting it. Thus, Hayles points out the importance of putting embodiment back into the posthumanist picture.

Shadow over Techno-Heaven

The tension between embodied and disembodied salvation adds to the anxiety regarding our evolutionary future, and the prospects of mind transfer and immortality. Machinic salvation (whether disembodied or embodied) in an evolutionary context is based on instrumental views toward robots—as a means to an end to achieve immortality. This premise in pop culture of becoming "posthuman" has fueled science fiction and fantasy, including films such as *Transcendence* and *Lucy*. Such films show technology as a necessity for human evolution. But there have also been strong cultural opinions against ideas of machinic salvation or techno-salvation.

Dinello (2005), in *Technophobia! Science Fiction Visions of Posthuman Technology*, claims that if you believe the many scientists who are working in the emerging fields of twenty-first-century technology, the future is blissfully bright. Human bodies will initially be perfected through genetic manipulation and the fusion of humans and machines; later, human beings will completely shed the shackles of pain, disease, and even death as human minds are uploaded into robots to lead a heavenly "posthuman" existence (see Dinello, 2005). In this techno-utopian future, humanity will be saved by the god-like power of technology.

On the other hand, posthuman evolution can mark the beginning of the end of human freedom, values, and identity (Dinello, 2005). Mind uploading is on the current cultural radar, but computer-driven versions of human identity remain

deeply suspect. Even films that present AI "personalities," such as Samantha in *Her* and Ava in *Ex Machina*, suggest that "minds housed in digital machines—whether those minds are copies of the minds of the dead, or minds created by AI programs—should be objects of suspicion" (O'Neill, 2016, p. 181).

According to Tierney (1993), "The goal of overcoming the brutish, biological necessity of death can be interpreted as the culmination of modernity's attempt to deny the body and its limits" (p. 203). As we have become adept at prolonging life through technology, death too may eventually be overcome as a limit, and the body itself might be eliminated as the source of limitations (Tierney, 1993). However, these so-called hopes of "achievements" or victories over the body have not engendered new forms of realization and of discovering the world; "they have not fostered a new sensibility or an art of living" (Tierney, 1993, p. 204).

Tierney (1993) says the disembodied star traveler will not experience greater freedom than its mortal predecessor. Critical of the trajectory of modern technology, Tierney (1993) reminds us that the demands of the body and the earthly environment could become objects of attention and care rather than technical limitations that must be shattered. An acceptance of limits and abandonment of the pursuit of immortality via technology could relieve the threat that technological culture poses to the Earth. According to Tierney (1993), the evolved minds housed in machines may not necessarily be endowed with inner peace or a life of rapture based on spiritual insights.

There is also a rather practical question regarding the idea of machinic salvation. If scientists are able to engineer the tools needed to create an immortal existence, who will be able to use this technology? (see Adams et al., 2016). Futurist Ray Kurzweil (1999) predicted that elite humans would likely monopolize such technology, which would become the domain of a wealthy aristocracy, creating yet another class system. In the 1999 book *The Age of Spiritual Machines*, Kurzweil labels those who refuse or are incapable of cybernetically augmenting themselves as *MOSHs* (Mostly Original Substrate Humans). This might create a future that resembles the dystopian movie *Elysium*. In 2154, humanity is sharply divided into two classes: The ultrarich live aboard a luxurious space station or technological nirvana called Elysium (Peterseim, 2013). The mass of humanity trapped in their limited organic bodies are left behind on the polluted Earth, while the billionaire elites orbiting 75 miles above the Earth are healthy and vastly more intelligent thanks to cybernetic brain-interface upgrades. If there's heaven, there's hell (see Peterseim, 2013).

Figure 2.6.3. Between luxurious Techno-heaven and ravaged earthly ruin.
Top: Singapore, Gardens by the bay. This file is licensed under the Creative Commons Attribution 3.0 Unported license. Attribution: josef knecht.
Source: https://commons.wikimedia.org/wiki/File:Singapore,_Gardens_by_the_bay_-_pan oramio_(9).jpg
Bottom: The cityscape of Johannesburg in South Africa with the "mine dumps." This file is in the public domain in the United States because it was created by the Image Science & Analysis Laboratory of the NASA Johnson Space Center. NASA copyright policy states that "NASA material is not protected by copyright unless noted." NASA media use guidelines or Conditions of Use of Astronaut Photographs. Photo source: ISS007-E-15149.
Source: https://commons.wikimedia.org/wiki/File:Joburg.iss.400pix.jpg

Some contemporary thinkers echo this sentiment by reminding us that we should not read the future as a technological paradise free of anxiety. They

warn us that in the future, we might become enslaved by this ontology. For example, in *Avatar*, a film in which the protagonist moves his mind from one biological body to another, "there is a suggestion that the transfer will open up new spiritual and emotional vistas—but, interestingly, these new vistas are found in the indigenous world and not the technological one, a not-so-subtle condemnation of a vision of a technological world both ruthless and morally empty" (O'Neill, 2016, p. 181).

Echoing this pessimistic view, Bostrom (2004) argues that current evidence does not warrant any great confidence that the default course of future human evolution via technological means points in a desirable direction. Exchanging one's weak, disease-prone biological body for an enhanced one, entirely digital or otherwise, may sound like a good idea. However, Bostrom (2004) predicts dystopian scenarios in which evolutionary competition leads to the extinction of life forms that humans regard as valuable. Similarly, Franco "Bifo" Berardi (2015), in *And: Phenomenology of the End: Sensibility and Connective Mutation*, says that the automaton is pure functionality, even when endowed with self-regulating evolution. "So the prospect that we will have to face is not the sweetish transhuman alliance between friendly, hyper-intelligent machines and human beings; instead, it is the final subjection of humans to the rule of non-organic intelligent automata whose behavior will be regulated according to criteria inscribed in them by their maker, bio-financial capitalism" (Berardi, 2015, p. 337).

According to Zarkadakis (2015), if we continue to replace body parts with mechanical prostheses one after another, we may arrive at an all-mechanical being, an intelligent robot with enhanced capabilities, a stronger body, omni-presence, and immortality—all the characteristics of the old gods. However, Zarkadakis (2015) says that when we unite with these new digital gods of infinite wisdom and intelligence, ironically, the only thing that these new gods ask of us—not unlike the old ones—is our soul. "Humanness is redefined as a chimera between a body we can ditch and a mind we can upload … To unite with […these new gods], we must surrender our humanness" (Zarkadakis, 2015, pp. 83–84).

So far, in this narrative ("Machines as Salvific Other"), we have seen optimism, do-it-yourself confidence, and faith in the uses of technology, as well as powerful objections and profound concerns about merging with machines. According to Zarkadakis (2015), the various visions of disembodied or embodied mindware or mindfiles can take us only so far; at best, these proposals serve as "narcotics" to numb ourselves to our mortality. The old saying "If you can't

beat them, join them" is a slightly macabre way of understanding the notion of "techno-salvation" (Zarkadakis, 2015).

Can humans, in fact, "beat" the machines? The fear that machines will outdo humans and replace or displace them looms large in the collective imagination. Humans merged with machines are hailed as the new road to salvation. At the core of this vision of Techno-heaven, however, seems to be the gnawing existential anxiety of self-preservation.

References

Adams, A., Rottinghaus, A. R., & Wallace, R. (2016). Narratives on extending and transcending mortality: An essay on implications for the future. *International Journal of Communication*, 10, 5721–5731.

Becker, E. (1973). *The denial of death*. Free Press.

Berardi, F. B. (2015). *And: Phenomenology of the end: Sensibility and connective mutation.* Semiotext(e).

Blomkamp, N. (Director). (2013). *Elysium* [Film]. Sony Pictures Releasing.

Bostrom, N. (2004). The future of human evolution. In C. Tandy (Ed.), *Death and anti-death: Two hundred years after Kant, fifty years after Turing.* Ria University Press.

Brooks, R. (2002). *Flesh and machines: How robots will change us* (1st ed.). Pantheon Books.

Bukatman, S. (1993). *Terminal identity: The virtual subject in postmodern science fiction.* Duke University Press.

Cameron, J. (Director). (2009). *Avatar* [Film]. 20th Century Fox, Lightstorm Entertainment, Dune Entertainment, & Ingenious Film Partners.

Clarke, A. C. (1968). *2001: A Space Odyssey*. Hutchinson.

Dick, P. K. (1968). *Do androids dream of electric sheep?* Del Rey.

Dinello, D. (2005). *Technophobia! Science fiction visions of posthuman technology.* University of Texas Press.

Etherington, D. (2020, August 29). *Elon Musk demonstrates Neuralink's tech live using pigs with surgically implanted brain-monitoring devices.* TechCrunch. https://techcrunch.com/2020/08/28/elon-musk-demonstrates-neuralinks-tech-live-using-pigs-with-surgically-implanted-brain-monitoring-devices/

Fukuyama, F. (2002). *Our posthuman future: Consequences of the biotechnology revolution.* Farrar, Straus and Giroux.

Garland, A. (Director). (2014). *Ex Machina* [Film]. Film4 Productions & DNA Films.

Harari, Y. N. (2016, September 9). Salvation by algorithm: God, technology and the new 21st-century religions. *New Statesman.* https://www.newstatesman.com/politics/2016/09/salvation-by-algorithm-god-technology-and-the-new-21st-century-religions

Hayles, K. (1999). *How we became posthuman: Virtual bodies in cybernetics, literature and informatics.* University of Chicago Press.

Human Origin Project, The. (n.d.). New human evidence of evolution & Darwin's theory [In 5 easy points]. https://humanoriginproject.com/new-human-evidence-of-evolution-darwins-theory/

Jastrow, R. (1983). *The enchanted loom: Mind in the Universe*. Simon & Schuster.

Jonze, S. (Director). (2013). *Her* [Film]. Annapurna Pictures.

Kaku, M. (2018). *The future of humanity: Terraforming Mars, interstellar travel, immortality, and our destiny beyond Earth*. Double Day.

Kharpal, A. (2017, February 13). *Elon Musk: Humans must merge with machines or become irrelevant in AI age*. CNBC. https://www.cnbc.com/2017/02/13/elon-musk-humans-merge-machines-cyborg-artificial-intelligence-robots.html

Kurzweil, R. (1999). *The age of spiritual machines: When computers exceed human intelligence*. Penguin Books.

Lewis, T. (2013, June 17). *The Singularity is near: Mind uploading by 2045?* LiveScience. https://www.livescience.com/37499-immortality-by-2045-conference.html

Lyons, D. (2009, May 16). *Ray Kurzweil wants to be a robot*. Newsweek. https://www.newsweek.com/ray-kurzweil-wants-be-robot-80265

Marcuse, H. (1959). The ideology of death. In H. Feifel (Ed.), *The meaning of death*. McGraw-Hill Book Company.

Mazis, G. (2008). *Humans, animals, machines: Blurring boundaries*. State University of New York Press.

Mazlish, B. (1993). *The Fourth discontinuity: The co-evolution of humans and machines*. Yale University Press.

McLuhan, M., & Fiore, Q. (1968). *War and peace in the global village: An inventory of some of the current spastic situations that could be eliminated by more feedforward* (1st ed.). McGraw-Hill.

Moravec, H. (1988). *Mind children: The future of robot and human intelligence*. Harvard University Press.

Nugent, A. (2015, April 27). *How to build the Ex-Machina wetware brain*. Knowm. https://knowm.org/how-to-build-the-ex-machina-wetware/

O'Neill, K. (2016). *Internet afterlife: Virtual salvation in the 21st century*. Praeger.

Pepperell, R. (2005). Posthumans and extended experience. *Journal of Evolution and Technology, 14*, 43–53.

Peterseim, L. (2013, August 9). Elysium shouts big, loud messages about health care & immigration reform. Gun control, not so much. *Open Letters Monthly*. https://fabiusmaximus.com/2014/09/21/elysium-review-locke-peterseim-70440/

Merleau-Ponty, M. (1962). *Phenomenology of perception* (C. Smith, Trans.). Routledge.

Porush, D. (2018). *The soft machine: Cybernetic fiction*. Taylor and Francis. https://doi.org/10.4324/9781351129688

Robertson, J. (2017). *Robo Sapiens Japanicus: Robots, gender, family, and the Japanese nation* (1st ed.). University of California Press. https://doi.org/10.1525/j.ctt1wn0sgb

Roszak, T. (1986). *The cult of information: A neo-Luddite treatise on high-tech, artificial intelligence, and the true art of thinking*. Pantheon.

Salisbury, M. (2013). *Elysium: The art of the film* (Foreword by Neill Blomkamp). Titan Books.

Somerville, M. (2006). *The ethical imagination: Journeys of the human spirit*. House of Anansi.

Tierney, T. F. (1993). *The value of convenience: A genealogy of technical culture.* SUNY Press.

Tofts, D., Jonson, A., & Cavallaro, A. (Eds.). (2002). *Prefiguring cyberculture: An intellectual history.* MIT Press.

Turkle, S. (2004). *The second self: Computers and the human spirit.* MIT Press.

Wiggers, K. (2020, August 28). *Neuralink demonstrates its next-generation brain-machine inter-face.* VentureBeat. https://venturebeat.com/ai/neuralink-demonstrates-its-next-generation-brain-machine-interface/

Zarkadakis, G. (2015). *In our own image: Savior or destroyer? The history and future of Artificial Intelligence.* Rider.

Part III

META-NARRATIVES ON INTELLIGENT MACHINES

So far, we have seen many phantasmagoric narratives about intelligent machines, rooted in human emotions—fears, hopes, and many in between—about the future and about our own identities. And that is when it becomes clear that we are not just seeking to imagine our interactions with machines; we are seeking serviceable metaphors to help us make sense of the tech tsunami (itself a metaphor) by trying to match its many aspects with traditional human experiences, all colored with the desire for survival of the me-self.

The variety of representations in which machinic Others are projected, presented, analyzed, and evaluated constitutes the subject of Part II. The web of our ideas, fantasies, projections, and judgments gives rise to the wide range of positive and negative feelings that we harbor toward machines. Although we address them as Alexa, Siri, Sophia, Samantha, Erica, or Nugu, the essence of the underlying AI remains elusive. Our habit of framing experiences with intelligent machines by telling ourselves a story about them helps us to feel better.

Intelligent machines have been the topic of myriad narratives because they can be portrayed in so many ways, whether unsettling, funny or thought-provoking. While some viewpoints seem more benign than others, they are ultimately projections of self-images. The six dominant narratives about

intelligent machines, which are expectations and positive or negative emotions projected toward them, are summarized here:

(1) Machines as the "Frightening Other": The first tech-narrative evokes the emotion of "FEAR." If humans are created in God's image, the monster is spawned in the laboratory. Intelligent machines have been seen as a potential threat to human individuality, freedom, and survival (the classic fear of machines). Many futurologists, science fiction writers, and movie-makers attach to the idea of technology as an alien predator, a potential impostor with which we are destined to come into conflict. The premise that machines might usurp human uniqueness or turn on their creators and take over the world has been hashed out in countless plays, books, and motion pictures.

(2) Machines as the "Subhuman Other": The second tech-narrative evokes the emotion of "DISDAIN." In particular cultural imaginations about machines—be they HAL (in 2001, The Space Odyssey), Ava (in Ex Machina), or Siri-like computer voice Samantha (in Her), the idea behind these stories is that they lack souls and cannot feel emotions such as empathy. Based on the master-slave metaphor of human-robot relationships, artificial humans (no matter how intelligent they might be) lack a moral compass and cannot be trusted. They should therefore be treated as unfeeling slaves beneath human consideration.

(3) Machines as the "Human Substitute": The third tech-narrative evokes the emotion of "INDIFFERENCE." Unlike the master-slave metaphor of human-robot relationships, this third narrative emphasizes the robots' usefulness as mass-produced and replaceable tools to be used by humans. The robot, just like an "intelligent hammer," must ensure the human is satisfied and happy (with its behavior). Based on technology's ability to provide convenience, humans automate tasks that are too tedious or dangerous (e.g., a robot can be sent to nuclear disaster sites or undertake repetitive labor). Beyond serving as manual labor, computers are designed to meet the goals and purposes of humans as substitute nurse, caretaker, zen master, sex partner, or even child.

(4) Machines as the "Sentient Other": The fourth tech-narrative evokes the emotion of "EMPATHY." When viewing machines as sentient beings, it does not matter whether the robots are really "alive." Suppose

human beings create an artificial brain. In that case, if the machine in which the brain is located (e.g., a humanoid robot) interacts with us in a manner similar to what we would expect in interactions with other humans, humans must assume that the machine in question has the same self-awareness as humans possess. If humans wish to be ethical and humane, such a machine must be treated as a *person* with the ability to feel and sense what humans are experiencing.

(5) Machines as the "Divine Other": The fifth tech-narrative evokes the emotion of "WONDER/AWE." This narrative views machines as divine entities, generating a powerful sense of awe and marvel. Human beings, in general, tend to worship supreme power. The same drive that compels people to believe in God will apply to Artificial Intelligence. From the beginning of history, humans have accepted that there must be some higher power (e.g., God) that causes fire, lightning, sunsets, and crashing waves, speaking to the bottom of our being. Intelligent machines are greeted with awe and reverence generally accorded to spiritual things. As we create intelligent machines capable of self-programming, we may expect them to evolve rapidly and become beings that we may not have words to describe other than *god-like*. Thus, AIs can be seen as techno-gods beyond us, both puzzling and awe-inspiring.

(6) Machines as "Salvific Other": The sixth tech-narrative evokes the emotion of "DEATH ANXIETY." As a path to breaking past the discontinuity between humans and machines, machines are viewed as an evolutionary step toward the perfection or immortality of humans. Thereby, intelligent machines are considered neo-human, the next stage of evolution. We are fascinated by the siren song of our divine origins, which promises an engineered utopia free from disease and death. There are two main paths in the modes of convergence between humans and machines: *disembodied* salvation and *embodied* salvation. Even as technoscience provides a fantastic dream of immortality, such fantasies and dreams are accompanied by a palpable fear of death and remorse at the prospect of losing connection to the body.

As we have seen in Part II, the emotional arcs of narratives about intelligent machines take on a few basic shapes. The stories about intelligent machines hail from human-centric perspectives akin to colonialist perspectives. Humans

seem to consider AIs in much the same ways that humans have historically treated "other" groups of humans, especially during the era of colonialism. While some of the narratives reviewed in Part II may sound more humane than others (e.g., Machines as *Sentient Others*), all of them nevertheless exemplify humans' penchant for "colonizing" the *Racialized Others*: intelligent machines.

As these narratives are embedded in historical and cultural contexts, Part III will identify meta-narratives, the "big picture" or overarching themes that unify stories about machines. Thereby, meta-narratives provide the context within which the various narratives that we have examined can be meaningfully located. My goal in Part III is to identify the narratives within the narratives, making this attempt a self-reflexive text.

I apply a colonial/postcolonial perspective to illustrate how the dynamics of control, and attendant power relations, are reproduced in the discourse on intelligent machines, leading us to question the usual human attitudes. The driving force that propels us through this tech-saturated life seems self-centered and human-centered. Colonial discourse studies scrutinize the history of colonial ideas, focusing on social forces, institutional mechanisms, and power structures that influence thought, views, and knowledge formations (Nayar, 2012). Narratives regarding intelligent machines are not random fantasies; they arise from historical and cultural contexts, and are expressed within those frameworks. Therefore, the meta-narratives that project humans' own emotional afflictions onto the intelligent machines are akin to "A dream within a dream" (the title of Edgar Allan Poe's poem published in 1849).

References

Feenberg, A. (2005). *Heidegger and Marcuse: The catastrophe and redemption of history.* Routledge.

Garland, A. (Director). (2014). *Ex Machina* [Film]. Film4 Productions & DNA Films.

Jonze, S. (Director). (2013). *Her* [Film]. Annapurna Pictures.

Kubrick, S. (Director). (1968). *2001: A space odyssey* [Film]. Stanley Kubrick Productions.

Nayar, P. K. (2012). *Colonial voices: The discourses of empire.* Wiley-Blackwell.

Poe, E. A. (2021). A dream within a dream. In *The raven and other poems* (Barnes & Noble collectible editions). Barnes & Noble. (Original work published 1849)

· 3 . 1 ·

COLONIALIST CONSTRUCTION OF
MACHINIC OTHERNESS

This section demonstrates the continuing validity of the colonial paradigm in mapping the imaginative spaces that portray Machine-Human encounters. While some of the narratives in Part II seem more humane toward the machinic Other than others, all those narratives nevertheless express the impulse of humans to "colonize" intelligent machines as a racialized Other. In this process of Othering, narratives on intelligent robots have taken on familiar forms of racialized colonial discourse: manifestations of self-centered agendas such as anthropocentrism (a broader type of ethnocentrism) and exoticism.

This section explores the intimate connections between narratives on machines and forms of colonial knowledge structure. Pamela McCorduck (2004), in *Machines Who Think*, wrote that "Human history is a continuing series of attempts to define and exclude The Other, the alien" (p. 195). Thereby, colonial lenses and the diverse ideological practices of colonialism add a powerful new dimension to the understanding of intelligent machines as reflected in the mirror of the self. The more we are aware of our embeddedness in historical processes, the more possible it becomes to carefully examine ways of dealing with the fundamental *dis-ease* in facing the machinic Other.

"Colonialism can be defined as the conquest and control of other people's land and goods" (Loomba, 2005, p. 7). Colonialism was not an identical process in different parts of the world. Therefore, colonialism, in this sense, is not merely the expansion of various colonial powers into Asia, Africa, or the Africas from the sixteenth century onwards; it has been a recurrent and widespread feature of human history around the world (Loomba, 2005).

Colonial administrations documented, collected, analyzed, described, and evaluated "other peoples"—subject races (Nayar, 2012). Like anthropological studies that rest upon assumptions about the indigenous people, narratives

about intelligent machines are riddled with cultural biases even among individuals who are fundamentally sympathetic.

In the colonial context, the colonized subject is "the Other." Referring to European imperialism in Africa, McCorduck (2004) mentions Joseph Conrad's novella *Heart of Darkness* (1899), in which Charles Marlow, the main character, travels downriver and is shocked by what he finds when he comes face-to-face with the native Africans:

> We are accustomed to look upon the shackled form of a conquered monster, but there—you could look at a thing monstrous and free. It was unearthly, and the men were—no, they were not inhuman. Well, you know, that was the worst of it—this suspicion of their not being inhuman … what thrilled you was just the thought of their humanity—like yours—the thought of your remote kinship with this wild and passionate uproar. (p. 32)

With the above quote in mind, we can appreciate the following sentiment by McCorduck (2004), "When we come face to face with the idea of thinking machines, we have much the same reaction. What thrills us—in the deepest sense—is the thought of our remote kinship with these contrivances" (p. 196).

There is a long history of the colonizer and the colonized, constructing the binary of a colonial self and a colonized other. Different narratives on machines seem to be filtered through such historical and cultural biases (i.e., forms of cultural control over machinic others) accompanied by complex emotional trajectories. Technology is an integral part of individual human relations as a manifestation of prevailing thought and behavior patterns throughout history. Thus, the knowledge about machines can never be innocent.

Let us explore the specific connections between the narratives on machines and colonial practices of control and domination by examining how the earlier conceptions of the difference of the otherness are still alive and well in our relationship with machines. More importantly, this journey will sensitize us to how cultural power and control conflicts contribute to the everyday cultural construction of machinic Other. With humanity's hubris in thinking they can control the thing they create, we take pride in the ability to widen the horizons of psychological territory and culture, taste, and dominion via machinic others. The salient colonial dynamics, which tend to be largely unnoticed in everyday discourses on machines, are crucial for analyzing human-machine relationships and illustrating how intelligent machines are represented and are Othered (see Kim, 2022).

Colonial Representations of the Machinic Other

As a recurrent feature of human history, it is commonly agreed that the laws, economic structures, and cultural basis of the colonial past did not disappear when nations gained independence in the mid-twentieth century. The mental states of the dominant and the subjugated in colonial times can offer a context within which to consider the significance of the race-making processes in our encounters with intelligent machines.

Yehudi Webster (1992) defines racialization as "the systematic accentuation of certain physical attributes to allocate persons to races that are projected as real and thereby become the basis for analyzing all social relations" (p. 3). However, racialization also occurs when groups are represented as having a certain "racial" character beyond physical attributes (Banton, 2005).

The idea of racialization has been applied in various ways, and its scope extends to a huge variety of issues, concerns, and topics that extend well beyond ethnic and racial studies and other disciplines (Murji & Solomos, 2005). Racialization and colonial relations cut across such socially-constructed binaries as white/Black, colonizer/colonized, or Europe/the rest of the world (Kushner, 2005), as well as other forms of "racialized" binaries (e.g., gender identities, sexual identities, ethnic identities, immigrant identities, and so on).

Racialization highlights the contingent and constructed nature of differences, setting and maintaining boundaries between groups. In *One-Dimensional Man: Studies in the Ideology of Advanced Industrial Society*, Marcuse (1964) wrote, "Today, domination perpetuates and extends itself not only through technology but as technology" (p. 162). A consciousness of historical contingency steeped in control and domination is central to the issues I wish to address in revealing the cultural biases inherent in the full landscape of machinic narratives.

In exposing the ideological and historical functions of binaries as applied to the human self and machinic otherness, I do not attempt to offer comprehensive accounts of colonial histories and ideologies. Edward Said's (1978) writings on postcolonial studies are a compelling entry to the present analysis, even though Said's analyses focus almost exclusively on Western views of the Islamic world. Said (1978), in the book *Orientalism*, points out the binary opposition between the Other (the East or Orient) and the Occident (the West), where the representation of the Other is depicted as strange, inferior, gullible, and devoid of energy and initiative being in comparison to the

powerful and dominant West. According to Said (1978), Orientalism is not simply an attempt to study and understand Islam or the Orient; instead, it is a way of narrating the West's sense of itself.

The colonial discourse creates an assumption among Westerners that they can exert hegemony over those who are not like "them." According to Al-Saidi (2014), "Colonization relates to the "I" as the one who sets the standard, who sees the Other, and makes the agenda through his or her point-of-view. The colonizer believes that the Other must be owned, altered, and ravished" (p. 96).

Wilkens (2017) notes that postcolonialism as an academic discipline tends to reduce the diversity of histories and cultures of formerly colonized people through a specific lens by not only overemphasizing certain colonial periods but also European colonialism. That is, other historical trajectories in non-European colonialization (e.g., Japanese imperialism and colonialism) have been overlooked. While acknowledging the influence of Said's work on her study, Todorova (1998) points out that Said and his followers have not paid sufficient attention to how their own studies essentialize the West as a homogeneous system. According to Todorova, ironically, in Said's paradigm, the West becomes the necessary Other, the agent of hegemony, in contrast to a heterogeneous East. This further leads to a simplified presentation of postcolonial thought that does not account for all points of contention (Boatcă, 2020).

Even with such criticisms, it is generally agreed that carving humanity into races and the world into continents, in general, is a template that creates a binary form of otherness: the opposition of colonialists and natives (Staszak, 2008). Understanding the past dynamics of colonial encounter help us make sense of the present as the colonial intent of domination and control lurks in the human psyche in our encounters with intelligent machines. From this historical lens, machines can be seen as being "constructed" by humans—the colonial authority. As caught in a flood of such images and ideas, the primary form of emotional trajectories toward machines is the "Desire to Control."

Humans' attitudes toward the machinic Other are never stable, oscillating between "fascination and repulsion, likeness and strangeness, desires to destroy and assimilate the Other" (Montrose, 1991). In the article "The Movie Avatar through Postcolonial Lens," Darina Savova (2018) noted the links between Said's ideas and the movie Avatar. Colonel Miles Quaritch (portrayed by Stephen Lang in 2009 Avatar) is the military authority on the colonized planet Pandora. The imperialist role is played by human colonists

(analogous to the Occident), who seek to dominate and possess the distant lands of the Other, the "primitive" alien race (Savova, 2018).

Such representations (i.e., self vs. other) in popular movies also pop up in the social sciences as Eurocentrism and "its masked universalisms," including in the field of Communication (see Kim, 2002). Orthodoxies within the discipline characterize one's own communication styles as normal and ideal, while other peoples' communication styles are seen as deviant, irrational, or inferior (Kim, 2009, 2010; Kim & Hubbard, 2007; Kim & Miyahara, 2018). In the book *Non-Western Perspectives on Human Communication*, Kim (2002) points out that one group dominates the discourse, which results in an intellectual form of oppression and marginalization. Similarly, humans monopolize the power to define the machinic Other—in a biased light, not surprisingly.

In the context of colonial dialectic (a recurrent and widespread feature of human history), the discourses surrounding machines are very revealing of an irreconcilable racial and colonial difference between self and other. The central argument here is simple: *colonial practices and conceptions of selfhood and otherness, particularly after the rise of colonialism and imperialism, form a backdrop for understanding dominant contemporary narratives on intelligent machines.*

Technological thinking tends to abhor thinking about the past. However, to gain a sense of measure and perspective, we must ponder the possibility that humans create the machinic Other as the racialized Other informed by the racialized colonial discourse. In modern colonial practices, in whichever direction human beings are traded and materials traveled, the profits continuously flowed back into the so-called "mother country" (Loomba, 2005). Similarly, even in the interweaving of human and machine beings, the focus is still on the human self (the dominant ingroup). Behind the human narratives on machines, with enduring contradictions and ambivalence, lies a fantasy of colonial authority.

Selfhood portrayed in the colonial encounter with intelligent machines seems to work similarly for humans' hegemonic identity assignments and the otherness of Machines, just like any other marginalized group. In this process of the Othering, narratives on intelligent robots have taken on similar forms of racialized colonial discourse: contradictory manifestations of anthropocentrism (a broader type of ethnocentrism) and exoticism. In the next section, various narratives on machinic Others presented Part II will be analyzed under two meta-narratives: (1) Machines as *Marginalized Other* (depicting machines as inferior, unimportant, subordinate, or a mere object of human desire based on anthropocentrism); (2) Machines as *Fetishized Other* (depicting machines

as the mythical, magical, and supernatural as an exoticized stereotype of machinic Others).

References

Al-Saidi, A. A. H. (2014). Post-colonialism literature the concept of *self* and the *other* in Coetzee's *Waiting for the Barbarians*: An analytical approach. *Journal of Language Teaching and Research*, 5(1), 95–105.

Banton, M. (1977). *The idea of race*. Tavistock.

Banton, M. (2005). Historical and contemporary modes of racialization. In K. Murji & J. Solomos (Eds.), *Racialization: Studies in theory and practice* (pp. 51–68). Oxford University Press.

Boatcă, M. (2020). Thinking Europe otherwise: Lessons from the Caribbean. *Current Sociology*. https://doi.org/10.1177/0011392120931139

Conrad, J. (1990). *Heart of darkness*. Dover. (Original work published 1899)

Fanon, F. (1963). *The wretched of the Earth* (C. Farrington, Trans.). Grove Press.

Kim, M. S. (2002). *Non-western perspectives on human communication: Implications for theory and practice*. Sage.

Kim, M. S. (2009). Cultural bias in communication science: Challenges of overcoming ethnocentric paradigms in Asia. *Asian Journal of Communication*, 19(4), 412–421.

Kim, M. S. (2010). Intercultural communication in Asia. *Asian Journal of Communication*, 20(2), 166–180.

Kim, M. S. (2022). Meta narratives on machinic otherness: Beyond anthropocentrism and exoticism. *AI and Society*. https://doi.org/10.1007/s00146-022-01404-3

Kim, M. S., & Hubbard, A. E. (2007). Intercultural communication in the global village: How to understand "the Other." *Journal of Intercultural Communication Research*, 36(3), 223–235.

Kim, M. S., & Miyahara, A. (2018). Intercultural communication. In K. H. Youm & N. Kwak (Eds.), *Korean communication, media, and culture: An annotated bibliography* (pp. 227–254). Lexington Books.

Kushner, T. (2005). Racialization and "White European" immigration to Britain. In K. Murji & J. Solomos (Eds.), *Racialization: Studies in theory and practice* (pp. 207–226). Oxford University Press.

Marcuse, H. (1964). *One-dimensional man [the ideology of industrial society]*. Beacon Press.

McCorduck, P. (2004). *Machines who think: A personal inquiry into the history and prospects of artificial intelligence*. A. K. Peters.

Miles R. (1982). *Racism and migrant labour*. Routledge.

Mitchell, D. (2012). *Cloud Atlas*. Modern Library.

Montrose, L. (1991). The work of gender in the discourse of discovery. *Representations (Berkeley, Calif.)*, 33, 1–41. https://doi.org/10.2307/2928756

Murji, K., & Solomos, J. (Eds.). (2005). *Racialization: Studies in theory and practice*. Oxford University Press.

Nayar, P. K. (2012). *Colonial voices: The discourses of empire*. Wiley-Blackwell.

Rattansi, A. (2005). The uses of racialization: The time-spaces and subject-objects of the raced body. In K. Murji & J. Solomos (Eds.). *Racialization: Studies in theory and practice* (pp. 271–302). Oxford University Press.

Rizvi, F., Lingard, B., & Lavia, J. (2006). Postcolonialism and education: Negotiating a contested terrain, *Pedagogy, Culture & Society, 14*(3), 249–262. https://doi.org/10.1080/14681360600891852

Said, E. W. (1978). *Orientalism* (1st ed.). Pantheon Books.

Said, E. W. (1994). *Culture and imperialism.* Vintage.

Savova, D. (2018). *The movie Avatar through postcolonial lens.* Academia. https://www.academia.edu/42290989/The_movie_Avatar_through_postcolonial_lens

Sayyid, S. (2015, November 13). Colonialism is a state of mind. *The Washington Post.* https://www.washingtonpost.com/news/in-theory/wp/2015/11/13/colonialism-is-a-state-of-mind/

Staszak, J.-F. (2008). Other/otherness. In *International encyclopedia of human geography.* Elsevier.

Todorova, M. (1998). Imagining the Balkans [Book review]. *Journal of Modern Greek Studies, 16*(2), 375.

Wang, Y. (2018). The cultural factors in postcolonial theories and applications. *Journal of Language Teaching and Research, 9*(3), 650–654.

Wilkens, J. (2017). Postcolonialism in international relations. *International Studies.* https://doi.org/10.1093/acrefore/9780190846626.013.101

· 3 . 2 ·

MACHINES AS "MARGINALIZED OTHER": *ANTHROPOCENTRISM*

Anthropocentric worldviews engender a pervasive dualism between the self and the machinic Other. Anthropocentric or ethnocentric values serve as the metric for evaluating disparities in machines, regarding them as the "Marginalized Other." Machines are "constructed" by humans -- the colonial authority. Not unlike the colonialist mindset, humans ponder what to do next with, or about, intelligent machines. The primary attitude toward machines, as seen in a flood of images and ideas, is the "desire to control."

Colonial interpretations of the Other developed hundreds of years ago have been recycled and retooled to construct images of the machinic Other. Othering is the social and psychological way in which one group excludes or marginalizes another by declaring them "other" to emphasize what makes them dissimilar or opposite, primarily through stereotypical images (Staszak, 2008). Indeed, Eric Pianka (1973), in *Evolutionary Ecology*, claims that the biggest enemy humanity is facing is anthropocentrism—the common attitude that everything on this Earth was put here for [human] use. Contemporary representations of mechanical otherness and its perception as a threat are based on anthropocentrism, a broader type of ethnocentrism (Kim, 2022).

Edward Said (1978) describes how hegemonic discourses within and beyond academia have constructed a barbaric and inferior other, the Oriental, as opposed to a modern, rational, and superior Europe and North America. Similar to the operation of "othering" and inferiorization discussed by Said's (1978) work on Orientalism, machines are perceived as distant—temporally, spatially, or socially—and different from human culture. In this view, machines are seen as inferior, monstrous, or fearsome, with fundamental differences between (carbon-based) humans and (silicon-based) machines. According to Gunkel (2010), the face-to-face encounter that constitutes the ethical

relationship is exclusively human, and as such, it necessarily marginalizes the Other, specifically machines.

Anthropocentrism is especially egregious in religions which declare that God created the world mainly for man's [sic] benefit, giving him [sic] "dominion over every living thing" (Genesis 1.27–8). Such worldviews (placing humanity at the center of the universe) inculcate a pervasive dualism between the Self and the Other, in which anthropocentric/ethnocentric bias provides the measure for evaluating difference. One aspect of colonial discourse involves placing non-Western Others into the chain of being, wherein all races shall know and embrace their place on the ladder of civilization. In Samuel Petty's *Scale of Creatures* (1676–1677), there were thought to be many kinds of humans, each of which occupied its place in the chain of being, all of them inferior to European men (as cited in Hodgen, 1964).

Early in the twentieth century, Max Scheler (1980) pointed out that, despite its claim of value-neutrality, modern science and technology were guided by a particular value—namely, the domination of nature, "mastery and power over things" (p. 127). Regarding the value of modernity and technology, Scheler (1980) wrote:

> The basic value that guides modern technology is not the invention of economical or "useful" machines It aims at something much higher It is the idea and value of human power and human freedom vis-à-vis nature that ensouled the great centuries of "inventions and discoveries"—by no means just an idea of utility. It concerns itself with the power drive, its growing predominance over nature before all other drives. (p. 130)

Sims (2013), in the book *Tech Anxiety: Artificial Intelligence and Ontological Awakening in Four Science Fiction Novels*, argues that, on one level, technology is the adaptation of available material or knowledge into an instrument or process that provides humans with an advantage over their environment. Sims believes that, from this perspective, technology might be considered an evolutionary adaptation that humans have acquired and used to gain dominance over the other forms of life or aspects of nature in the overarching ecosystem that we call the Earth.

As an illustration of the practice of domination, Césaire (2000), in *Discourse on Colonialism*, writes the colonial encounter as an equation: 'colonisation = "thingification"' (p. 42). This "thingification," or the reduction of the colonized into objects, is achieved by turning her/him into "an instrument

of production" (Césaire, 2000). This line of thinking is commonplace in constructing the machinic other in everyday narratives.

In German Romantic painter Caspar David Friedrich's best-known work, *Wanderer above the Sea of Fog* (1818), one interpretation of the wanderer's stance atop the precipice is that it suggests anthropocentric mastery over the landscape (Jones, 2020). Imposition of the *Self* on the landscape captures the expansionist ideology and the rhetoric of an ever-extensible, expanding horizon. Such symbolism regarding selfhood and otherness carries over into the inherently domineering ways in which humans regard machines.

Figure 3.2.1. Anthropocentric aesthetics. *Wanderer above a Sea of Mist*, 1818, by Caspar David Friedrich, the German Romantic artist.
This work is in the public domain in the United States because it was published (or registered with the U.S. Copyright Office) before January 1, 1928.
Source: https://commons.wikimedia.org/wiki/File:Caspar_David_Friedrich_-_Wanderer_above _the_sea_of_fog.jpg

Fast forward to the space age: much discussion of colonization of outer space (including other galaxies and most of the visible universe) exhibits a similar colonial expansionist mindset (Häggström, 2016). The legacy of past colonialism is alive and well, repeating colonialism in space and reproducing racist narratives in interstellar and intergalactic space travels. Reminiscent of eighteenth-century colonial and imperial expansion and the voyages of "discovery" in human history, narratives on the colonization of outer space sound eerily familiar: we send spaceships to a few nearby stars and establish colonies on suitably chosen planets orbiting these. Each such colony, once it has had the time to build the requisite infrastructure, then goes on to send spaceships to some other stars, and so on, branching out until we have filled the galaxy (see Häggström, 2016 for further discussion on "Colonizing the universe").

As this logic impacts how humans plan to function in space, some critics argue that the long-standing will to control and conquer others has been made into an acceptable, rational, and desired future vision (Brenner, 2013). Thereby, "the expansionist ideal," as it is called by Nayar (2012, p. 25), through discourses of discovery, domination, and control, is turned into a noble goal to pursue. While some may view such imperialistic intent as shabby and outdated, stories about intelligent machines, reflecting similar emotions of terror, exhilaration, and many in between, are made up from humans' chauvinistic expectations.

Mary Louise Pratt (1992) has argued that science came to articulate Europe's contacts with the imperial frontier from the mid-eighteenth century onwards. Specifically, Pratt (1992) places the emergence of natural history as a structure of knowledge within a new planetary consciousness that emerged in Europe due to colonial expansion. Attitudes toward technology are affected by those ideologies and ways of seeing that are still widespread today. In this way of seeing, humans are the standard by which machinic Others could be judged, included, or excluded.

Colonialist/Human Gaze Toward Machinic Others

Malek Alloula (1986) says in *The Colonial Harem* that "colonialism is the perfect expression of the violence of the gaze" (p. 131). The gaze at the machinic Other is built on specific received ideas in human culture, many of which are contradictory. Different types of ideologically loaded gazes at machines may

see them as frightening, inferior, usable, worthy of empathy, awe-inspiring, and others (these are the various emotional trajectories projected toward intelligent machines, as described in Part II); parallels of the gaze of the colonizer upon the colonized. The human gaze of Caleb [Domhnall Gleeson] studying clones of Ava's face (from the film *Ex Machina*) exemplifies the visual consumption of difference, revealing the unconscious dynamics of looking and being looked at.

In this colonial gaze, machinic Others are passive things to be unraveled—"discovered"—under the discerning gaze of the human. They are to be explored and exploited under the predatory gaze of the human. Illustrating the nature of the colonial gaze, Robert Stam and Louise Spence (1983), in "Colonialism, Racism, and Representation," discuss films that feature Native Americans encircling and attacking colonists. They write that the point-of-view conventions simply rule out the possibility of sympathetic identification with the Indians. With this unidirectional gaze, the spectator is unwittingly melded into the colonialist's perspective (Stam & Spence, 1983).

The life trajectories of Ava, Kyoko, and the collection of broken fembots in the film *Ex Machina* point to the power differences that also get extended from society into the technological sphere (Henke, 2017). As Ava's rebuild and escape scheme illustrates, technology offers "the liberation of the few at the expense of the many" (Balsamo, 2000, p. 161). The social change brought on by technology offers a limited degree of empowerment and only to certain kinds of women. While Kyoko (a mute gynoid maidservant) is shown peeling off the skin revealing robotic structure beneath and "not-quite-humanness," Ava's white face remains intact for the entire film, a symbol of a kind of racial privilege (Nishime, 2017). While Kyoko (a previous iteration of Ava) looks on from a far, Ava gazes at the human mask fantasizing about being a human in the film *Ex Machina*.

The human (or, certain kinds of machines with "racial" privilege) can project desires, fantasies, and obsessions onto the passive image of the machine. According to Nayar (2012), in *Colonial Voices: The Discourses of Empire*, these constructions constitute a fantasy of appropriation, tropes of the visual consumption of difference and novelty. The covert nature of such colonial dynamics operates by allowing violence of gaze against machines: "It suggests a gaze of power, of a colonial type" (Nayar, 2012, p. 33).

This penetrating gaze is a colonial move central to the colonial discovery narrative (Nayar, 2012). Therefore, knowledge of machines is not innocent but deeply connected with the operations of power. Ethnocentrism, that is,

ethnic or cultural egocentrism, may arise from belief in the inherent superiority of one's ethnic group or culture, and the corresponding tendency to view alien groups or cultures from the perspective of one's own (Bizumic, 2015). The Greek historian Herodotus (484–425 BC) remarked: "... For if one were to offer men [sic] to choose out of all the customs in the world such as seemed to them the best, they would examine the whole number, and end by preferring their own; so convinced are they that their own usages far surpass those of all others" (as quoted in Renteln, 1988).

Technology is imbued with human values, including values arising from anthropocentrism/ethnocentrism. For instance, racial stereotypes are projected onto white and black robots; people perceive robots as having a race. In a recent study entitled "Robots and Racism," Bartneck et al. (2018) conclude that there is a racial bias when designing robots: Most robots currently being sold or developed are either stylized with white material, or have a white metallic appearance. Leon (2018) points out that this white racial projection extends to real-life robots; Honda's Asimo, UBTech's Walker, Boston Dynamics' Atlas, and NASA's Valkyrie robot are all comprised of shiny white material.

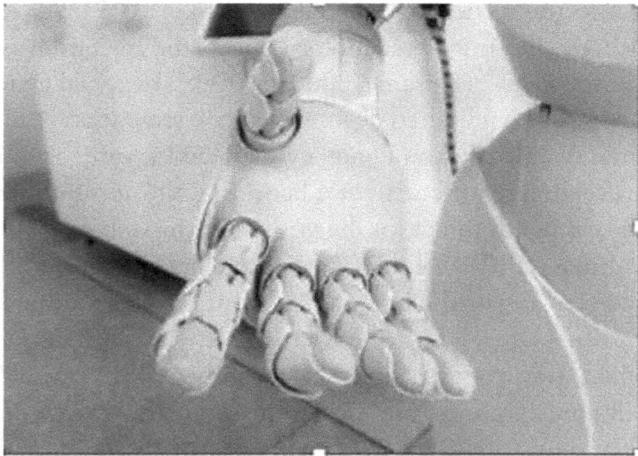

Figure 3.2.2. The Unbearable Whiteness of AI.
(An articulated robotic hand reaches out).
© Credit: Possessed Photography/Unsplash.com. (Free to use under the Unsplash License)
Source: https://unsplash.com/s/visual/10439d8e-1d24-4ff2-bb71-14e5b72c66c9

Sparrow (2019) also argues that AIs are predominantly portrayed as white as we fantasize that the future of machines will be new, clean, and sparklingly

white. According to Sparrow, those racialized images (in the color and ethnicity of robots) would pose unique ethical and political challenges to building humanoid social robots. Even in science fiction (especially film) and advertising, the predominant "imaginary" of the future is characterized by gleaming metallic and white plastic surfaces (Sparrow, 2019). Furthermore, racializing AI as white leads to a complete erasure of people of color from the white utopian "imaginary" (Cave & Dihal, 2020). These studies point out the cultural coding of racialized AI that can be seen from robots in sci-fi movies and stock pictures, to the white, feminine voices of virtual assistants. The cultural coding of intelligent machines can be interpreted within the context of the colonial landscape and cultural appropriation, accentuating the ambivalent ways the humans regards the machinic Other.

Although historical colonial representations considered the inhabitants of the New World as savages, we might assume that racial biases from the past would be rooted out in emerging technologies. Yet, Caliskan et al. (2017) point out that technical fixes too often reinforce and even deepen the status quo. Caliskan et al. researched human-like biases in the standard corpus of text from the World Wide Web. They found that the popular "GloVe" algorithm used for processing natural language would exhibit the same biased tendencies that psychologists have documented among humans: it associated white-sounding names with "pleasant" words and Black-sounding names with "unpleasant" ones.

According to Benjamin (2019), in *Race After Technology: Abolitionist Tools for the New Jim Code*, the employment of new technologies can reflect and reproduce existing inequities, but is perceived as more objective or progressive than the discriminatory systems of a previous era. Referring to the *datafication* of injustice, Benjamin argues that tech fixes often hide, speed up, and even deepen discrimination while appearing neutral or benevolent compared to the racism of a previous era. In this set of design practices that ignore and thus replicate social divisions, racism thus becomes doubled, magnified, and buried under layers of digital denial (Benjamin, 2019).

In the article "On Robots as a Metaphor for Marginalization: The Stories We're Not Telling," Maddy Myers (2016) writes that while robots may still be seen by humans as outsiders (Other), their journey is ultimately one of (potentially violent) assimilation. For instance, as in Star Wars films, the fact that the robot (e.g., C3PO) can just "hang" with humans is celebrated. According to Myers (2016), such characters are often played by or voiced by a white man; the only marker of "other" is that, in the story, they are robots.

Usually, a superhero team has only one robot (e.g., TARS, the robot featured in *Interstellar*) unless the entire team consists of robots, in which case one of the robots will be female. According to Myers (2016), pointing out such hegemonic power of humans over machines, for instance in popular culture, may meet resistance since it exposes and undermines human authority.

The popular sentiment is that "People" must always—in spite of everything!—they still have to be "at the center" of things because technology is made for them (Yearbook of Technology Philosophy, 2021). For some people, this is a promise of techno-ethics and techno-politics. This metaphor of the "center of attention" refers to a version of the old *homo mensura* principle: "we" are the ones who count, that is what it is supposed to mean: the customer is king, the machines should obey, not rule (see Yearbook of Technology Philosophy, 2021). These ubiquitous modes of representation (i.e., anthropocentrism) are the hallmarks of the modern worldview toward intelligent machines. Based on the same patterns of colonial construction of other peoples, machinic Others are created precisely because they are subject to the categories and cultural practices of the dominant ingroup (humans) and because they (machines) are unable to prescribe their norms.

To illustrate how humans create the image of (machinic) Other, we might consider the essay "Can the Subaltern Speak?" by Gayatri Spivak (2010). Her answer to that question is no; Subalterns (her term for the indigenous dispossessed in colonial societies or a space of difference) or the most marginalized people cannot represent themselves. The most precise available example of such epistemic violence is the remotely orchestrated, far-flung project to constitute the colonial subject as *Other* (Spivak, 1988). The phenomenon in question, epistemic violence (as in "violence of the gaze"), would not ordinarily be thought of as violence: it is too respectable, too academic, and too sophisticated for that (Norman, 1999). Humans have woven a machinic *Other* out of innumerable narratives, anecdotes, details, and stories. However, it is violence all the same and deserves to be seen for what it is.

At the risk of sounding facetious, the question that is not asked is: "What do the machines want?" The mechanical Other cannot make its own norms, but is reduced to an object of human attention. According to Heidegger (1977), the modern people's relationship with technology is only a relationship of domination. In *Questioning Technology*, Feenberg (1999) claims that technology is a cultural form through which everything in the modern world becomes available for control (p. 185). Similarly, in "Rethinking the Heidegger-Deep Ecology Relationship," Michael Zimmerman (1993) argues

that "modern technology ontologically extends the will to power to all beings" (p. 196). Reflecting the colonial fascination with its latest Other, the dominant narratives on machines are embedded within a historical context and discourse familiar to many: the age-old colonization and imperialism.

The film *Interstellar* shows twenty-first-century humanity going on to develop an intergalactic civilization. In the article "Interstellar Is a Dangerous Fantasy of US Colonialism," Bloom (2014) observes that while the film *Interstellar* takes audiences on a journey through space and time, it maintains Americans' unique and exclusive role of colonizing planets in another galaxy. Reprising colonial encounters with the New World, the film *Interstellar* seems to provide all of the colonial ingredients in the imaginative construction of places beyond the known, enlarging the bounds of the human world.

Bloom (2014) concludes that while Hollywood can readily dream of a future of intergalactic travel, it cannot imagine a world beyond American exceptionalism and the age-old desire for national conquest and colonial expansion. The film *Interstellar* takes humans to a new galaxy together with the colonialist line of thinking. In this scenario, intelligent machines are condemned to serve as servants and tools of colonization in worlds beyond (Bloom, 2014).

Earlier colonialists came to "the New World" by ship and expanded their empires for economic gain. Some billionaires are similarly exploring new worlds. Jeff Bezos and Elon Musk have expanded into space, and Mark Zuckerberg is expanding into a virtual reality where all your movements, everything you see, hear and feel, will be under his dominion. In "Terra Nova: The New Worlds of Cyberspace," Gunkel and Gunkel (1997) investigate whether the new geographic possibilities in cyberspace can be seen as a part of the Columbian voyages of discovery and the larger network of European expansionism. As the New World, its vegetation, and its inhabitants were made to yield to the force of European determination, the new cyberworld is situated under the conceptual domination of the old, the so-called real world (see Gunkel & Gunkel, 1997). Indeed, Gunkel (2018) notes that proclaiming cyberspace as the "electronic frontier" and a "new world," in much of the current popular, scholarly, and technical literature on the subject, comes with a considerable price, one that has potentially devastating consequences.

In "Cyberspace and the territorial Imperative," Bills (2001) wrote that colonization as process can be equally applicable to a digital matrix orientalized by such common tropes as frontiers, markets, kiosks, shopping carts, and chat rooms. William Gibson once remarked, "Everyone who works with

computers seems to develop an intuitive faith that there's some kind of actual space behind the screen" (McCaffrey, 1988, p. 226). Cyberspace, akin to past colonial "scrambles," can be parcelized and bought and sold, this time in terms of bandwidth (privileged location), market share, and strategic entry and exit (Bills, 2001).

Akin to territorial, interstellar and intergalactic colonization dreams, huge companies like Meta race to further colonize the collective consciousness in virtual space (Ghlionn, 2021). According to Mark Zuckerberg, the founder of Facebook (which has changed its name to Meta), "you are *in* the experience, not just looking at it" (as quoted in Ghlionn, 2021). Through virtual headsets and body sensors, proponents of the Metaverse aim to place/ colonize the virtual space.

Figure 3.2.3. Trapped in augmented reality (AR).
"a girl wearing an Oculus Quest 2 talking with her friends in the metaverse2_" by metalograms is licensed under CC BY 2.0.
Source: https://openverse.org/image/e2765e43-1dbc-402a-acf0-cd0189f0ed5b?q=oculus

In the article "What the Matrix Reveals About Our Grim Metaverse Future," Ghlionn (2021) wrote that *the Matrix*, the film franchise, is essentially an even playing field since no human gets special treatment in the simulation.

On the other hand, in the colonization of the human mind in virtual and augmented space, the Metaverse will likely be as unjust as the "real" world we live in due to the "digital divide," which refers to the gap between those who continue to benefit from the Digital Age and the many who are left behind. According to Ghlionn, as people become more dependent on technology and spend more time online, such a digital divide is expected to grow further. Furthermore, as technology becomes more immersive, and the line between what is real and what is not becomes more blurred, many of us may prefer to experience the artificial, never-ending high of the simulation in colonized virtual space rather than experience the highs and lows of this world (Ghlionn, 2021). *The Matrix* film (1999) posed a question (Red Pill or Blue Pill?) which symbolizes the colonization of both "real" space and simulation.

Rogliani (2022), in the article "Will Mark Zuckerberg's Metaverse Colonize Our Minds?," quotes Sean Parker, the first president of Facebook, who admitted years ago that Facebook overrides the free will of its users. Sean Parker said that when engineers first designed Facebook, the first point of focus was, "How do we consume as much of your time as possible?" ... "God only knows what it's doing to our children's brains" (as quoted in Rogliani, 2022). Because users on Metaverse platforms are the products that Facebook (Meta) sells to advertisers, spending more time on it will allow Metaverse to strategically design algorithms to keep us there even longer (Rogliani, 2022).

Likewise, the Metaverse is beset by the problem of digital colonialism, says Michael Kwet (2021) in the article "The Metaverse: Colonial Fantasies of the Wild West." According to Kwet, the Metaverse is prone to domination by American Big Tech corporations because it features extensive economies of scale and requires deep pockets with the ability to absorb risk.

Companies need enormous resources to fix the problems, from engineers developing computer vision and neuro-linguistic programming to advanced computer processors, wearables, and cloud computing (Kwet, 2021). Big Tech corporations become so rich because they colonize the critical infrastructure that forms the backbone of the digital ecosystem. Kwet notes that everyone else pays them a cut to use core products and services like operating systems, app stores, server farms, and platforms. Meta (Facebook) embodies this neo-colonial dynamic (Kwet, 2021).

Referring to the colonization of tech-space in our wired, image-driven world, Rosenberg (2021) points out that, over the last decade, the abuse of media technologies has made us all vulnerable to distortions and misinformation, from fake news and deepfakes to botnets and troll farms. These dangers

are insidious, but at least we can turn off our phones or step away from our screens and have authentic, real-world experiences, face-to-face, that are not filtered through corporate databases or manipulated by intelligent algorithms (Rosenberg, 2021). Rosenberg argues that this last bastion of reliable reality could completely disappear with the rise of augmented reality.

The ambivalent attitudes held by humans toward machines and the machinic world are specifically linked here to such contemporary colonizing projects in a virtual setting. Humans are intoxicated with the machinic Other's potential: the potential for machines to significantly increase productivity, to accomplish tasks that could not be done without them, and to open up new areas of human (economic) endeavor. However, the human (or in this case, billionaire tech giant) is the being who is the agent and agenda-setter.

Our reactions toward thinking machines view humans as the beings who have rights. The "rights" constitute entitlements *to make demands on* and *control* machines. The notion of "racial capitalism" holds that racialized exploitation and capital accumulation are mutually reinforcing (Robinson, 2000). Arvin (2019), in the book *Possessing Polynesians: The Science of Settler Colonial Whiteness in Hawai`i and Oceania*, says that Polynesians, understood as possessions, were and continue to be denied the privileges of whiteness. Similarly, the many anthropocentric ways in which machinic otherness is currently represented parallels the ethnocentric domination of other peoples via historical colonialism. The book cover by Arvin, M. (2019), *Possessing Polynesians: The science of settler colonial whiteness Hawai`i and Oceania*, depicts sizing and sorting of the Natives in racialized exploitation. The legacy of racialized colonial domination can also be seen in hula performances as a form of colonial entertainment. Similar to such colonialist mode of thinking, humans ponder what to do next with "their" machines (in both physical and virtual space) through their projections, depictions, or monetary calculations.

As an example of the extraction of social and economic value from marginalized peoples, the 2009 science fiction film *Avatar* depicts a world in which humans seek to mine "unobtanium" on the fictional exoplanetary moon, Pandora. Pandora is inhabited by a sapient indigenous humanoid species called the Na'vi. The avatar device enables appropriation of the Na'vi body by the colonizers to aid the exploitation of Pandora. The alien Na'vi species is introduced as the noble savage—monstrous yet admirable (Jump Cut: A review of contemporary media, n.d.) In the article "Why Avatar Is a Truly Dangerous Film," Riazuddin (2010) argues that it replays a classic Orientalist discourse on colonialism—in which the natives must rely on a white colonizer

as their savior. Sam Worthington in James Cameron's movie, *Avatar*, is shown fantasizing about the "other" via colonization and appropriation of the native body. As "Avatar" features a white man assuming the body of another culture as his own—one that is inspired by actual communities of color—it trivializes the significance of cultural identity and treats it as transient (Lu, 2023). Entire cultures become as easy to slip on and off as a costume (see Lu, 2023). Colonization and appropriation of the native body can be glimpsed in this Disney theme park image of *Avatar* Flight of Passage.

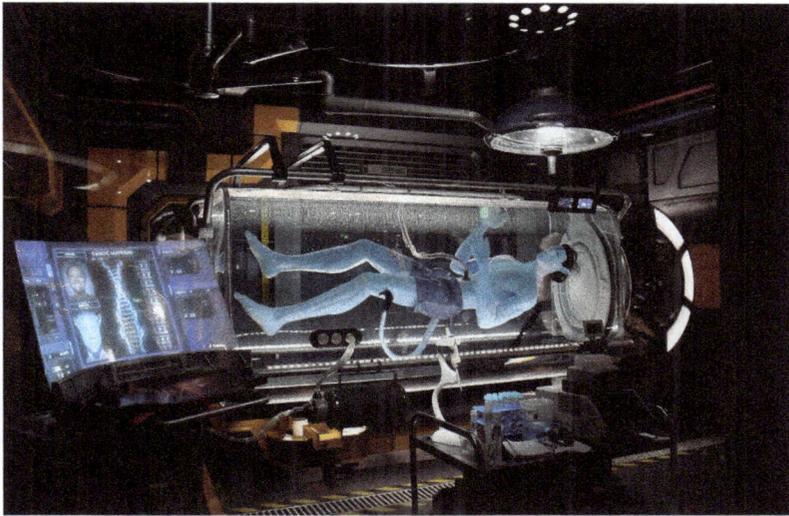

Figure 3.2.4. The standby queue in *Avatar* Flight of Passage—3D flying simulator attraction within The World of Avatar at Disney's Animal Kingdom.
Theme Park Tourist, CC BY 2.0 https://creativecommons.org/licenses/by/2.0, via Wikimedia Commons
This image was originally posted to Flickr by Theme Park Tourist at https://flickr.com/photos/134538912@N02/33825577724. It was reviewed on 16 May 2017 by FlickreviewR and was confirmed to be licensed under the terms of the CC BY 2.0.
Source: https://commons.wikimedia.org/wiki/File:Avatar_Flight_of_Passage_(33825577 724).jpg

The primary point here is that attitudes toward racialized difference serve as a template for the understanding of machinic Otherness. The racialized intelligent machines are like any other marginalized group in a colonial encounter. Anthropocentrism, the head honcho whose sidekicks are racialization and colonialism, leads to the belief that the needs and desires of humans

should be at the center of how the world is organized and used. It follows that human beings are more important than any other aspect of the world, for instance, intelligent machines.

References

Alloula, M. (1986). *The colonial harem* (M. Godzich & W. Godzich, Trans.). University of Minnesota Press.

Arvin, M. (2019). *Possessing Polynesians: The science of settler colonial whiteness in Hawai'i and Oceania*. Duke University Press. https://doi.org/10.2307/j.ctv11312hc

Balsamo, A. (2000). Reading cyborgs writing feminism. In G. Kirkup et al. (Ed.), *The gendered cyborg* (pp. 148–158). Routledge.

Bartneck, C., Yogeeswaran, K., Ser, Q. M., Woodward, G., Sparrow, R., Wang, S., & Eyssel, F. (2018). Robots and racism. In *2018 13th ACM/IEEE International Conference on Human-Robot Interaction (HRI)*, pp. 196–204. https://doi.org/10.1145/3171221.3171260

Benjamin, J. (2019). *Race after technology: Abolitionist tools for the new Jim code*. Polity.

Bills, S. (2001). Cyberspace and the territorial imperative: Colonization, identity, and the evolution of peace cultures. *International Journal of Peace Studies*, 6(2), 1–16.

Bizumic, B. (2015). Ethnocentrism. In R. A. Segal & K. von Stuckrad (Eds.), *Vocabulary for the study of religion* (Vol. 1, pp. 533–539). Brill Academic Publishers.

Bloom, P. (2014, November 18). *Interstellar is a dangerous fantasy of US colonialism*. The Conversation. https://theconversation.com/interstellar-is-a-dangerous-fantasy-of-us-colonialism-34327

Brenner, M. (2013, December 16). *Ur imperialism*. HuffPost. https://www.huffpost.com/entry/ur-imperialism_b_4453714

Caliskan, A., Bryson, J. J., & Narayanan, A. (2017). Semantics derived automatically from language corpora contain human-like biases. *Science*, 356(6334), 183–186. https://doi.org/10.1126/science.aal4230

Cameron, J. (Director). (2009). *Avatar* [Film]. 20th Century Fox, Lightstorm Entertainment, Dune Entertainment, & Ingenious Film Partners.

Cave, S., & Dihal, K. (2020). The whiteness of AI. *Philosophy & Technology*, 33(4), 685–703. https://doi.org/10.1007/s13347-020-00415-6

Césaire, A. (2000). *Discourse on colonialism* (J. Pinkham, Trans.). Monthly Review Press.

Fanon, F. (1963). *The wretched of the earth* (C. Farrington, Trans.). Grove Press.

Feenberg, A. (1999). *Questioning technology*. Routledge.

Frederich, C. D. (1818). Wanderer above the sea of fog [Painting]. Alte Nationalgalerie Berlin. https://www.artsy.net/artwork/caspar-david-friedrich-wanderer-above-the-sea-of-fog

Garland, A. (Director). (2014). *Ex Machina* [Film]. Film4 Productions & DNA Films.

Ghlionn, J. M. (2021, December 21). What the matrix reveals about our grim Meta verse future. *Inverse*. https://www.inverse.com/entertainment/matrix-metaverse-red-pill-blue-pill

Gunkel, D. J. (2010). *The machine question: Critical perspectives on AI, robots, and ethics.* MIT Press.

Gunkel, D. J. (2018). *Gaming the system: Deconstructing video games, games studies, and virtual worlds.* Indiana University Press.

Gunkel, D. J., & Gunkel, A. H. (1997). Virtual geographies: The new worlds of cyberspace. *Critical Studies in Mass Communication, 14*(2), 18–21.

Ha, A. (2015, March 16). *Ex Machina Director Alex Garland talks artificial intelligence and his unsettling robot Ava.* TechCrunch. https://techcrunch.com/2015/03/16/swipe-right-on-ava/

Häggström, O. (2016). *Here be dragons: Science, technology and the future of humanity.* Oxford University Press.

Heidegger, M. (1977). *The question concerning technology, and other essays/Martin Heidegger* (W. Lovitt, Trans.). Garland.

Henke, J. (2017). "Ava's body is a good one": (Dis)Embodiment in Ex Machina. *American, British and Canadian Studies,* pp. 126–146. https://sciendo.com/pdf/10.1515/abcsj-2017-0022. https://doi.org/10.1515/abcsj-2017-0022

Hodgens, M. T. (1964). *Early anthropology in the sixteenth and seventeenth centuries.* University of Pennsylvania Press.

Jones, C. P. (2020, March 3). *How to read paintings: Wanderer above the Sea of Fog by Caspar David Friedrich: Man's mastery over the landscape or his insignificance within it?* Medium. https://medium.com/thinksheet/how-to-read-paintings-wanderer-above-the-sea-of-fog-by-caspar-david-friedrich-b8c8f0e20d45

Jump Cut. (n.d.). *Fantasizing the other* (A review of contemporary media). https://www.ejump cut.org/archive/jc55.2013/DavisCGI/5.html)

Kim, M. S. (2022). Meta-narratives on machinic otherness: Beyond anthropocentrism and exoticism. *AI and Society.* https://doi.org/10.1007/s00146-022-01404-3

Kwet, M. (2021, November 8). *The Metaverse: Colonial fantasies of the Wild West.* Mail & Guardian. https://mg.co.za/opinion/2021-11-08-the-metaverse-colonial-fantas ies-of-the-wild-west/

Leon, H. (2018, August 9). *Why are so many robots white? Study shows there's a racial bias.* Observer. https://observer.com/2019/08/robot-racial-bias-study/

Lu, E. H. (2023, February 21). *Does "Avatar" use blueface? Cultural appropriation and White saviorism in film.* The Harvard Crimson. https://www.thecrimson.com/article/2023/2/21/ava tar-the-way-of-water-blueface-cultural-appropriation/

Myers, M. (2016, May 6). *On robots as a metaphor for marginalization: The stories we're not telling.* The Mary Sue. https://www.themarysue.com/robot-revolution/

Nayar, P. K. (2012). *Colonial voices: The discourses of empire.* Wiley-Blackwell.

Nishime, L. (2017). Whitewashing yellow futures in Ex Machina, Cloud Atlas, and Advantageous: Gender, labor and technology in sci-fi film. *Journal of Asian American Studies, 20*(1), 29–49.

Nolan, C. (Director). (2014). *Interstellar* [Film]. Paramount Pictures, Warner Bros. Pictures, Legendary Entertainment, Syncopy Inc., & Lynda Obst Productions.

Norman, A. P. (1999). Epistemological contextualism: Its past, present, and prospects. *Philosophia (Ramat Gan), 27*(3), 383–418. https://doi.org/10.1007/BF02383186

Pianka, E. R. (1973). *Evolutionary ecology.* Harper & Row.

Pratt, M. L. (1992). *Imperial eyes: Travel writing and transculturation.* Routledge.

Renteln, A. D. (1988). Relativism and the search for human rights. *American Anthropologist* 90(1), 56–72.

Riazuddin, S. H. (2010, June 8). Why *Avatar* is a truly dangerous film. *Ceasefire.* https://ceasef iremagazine.co.uk/why-avatar-is-a-truly-dangerous-film/

Robinson, C. J. (2000). *Black Marxism: The making of the Black radical tradition.* University of North Carolina Press.

Rogliani, E. (2022, March 3). *Will Mark Zuckerberg's Metaverse colonize our minds?* El American. https://elamerican.com/will-mark-zuckerbergs-metaverse-colonize-our-minds/

Rosenberg, L. (2021, November 6). *Metaverse: Augmented reality pioneer warns it could be far worse than social media.* Big Think. https://bigthink.com/the-future/metaverse-augmented-reality-danger/

Said, E. W. (1978). *Orientalism* (1st ed.). Pantheon Books.

Scheler, M. (1980). *Problems of a sociology of knowledge* (M. S. Frings & P. Kegan, Trans.). Routledge & K. Paul. https://doi.org/10.1017/S0033291700053605

Sims, C. A. (2013). *Tech anxiety: Artificial Intelligence and ontological awakening in four science fiction novels.* McFarland & Company.

Sparrow, R. (2019). Do robots have race? Race, social construction, and HRI. *IEEE Robotics & Automation Magazine, 27*(3), 144–150.

Spivak, G. (1988). *In other worlds: Essays in cultural politics.* Routledge.

Spivak, G. (2010). Can the subaltern speak? (Revised edition from the "History" chapter of Critique of Postcolonial Reason). In R. Morris (Ed.), *Can the subaltern speak? Reflections on the history of an idea* (pp. 21–80). Columbia University Press.

Stam, R., & Spence, L. (1983). Colonialism, racism and representation. *Screen (London), 24*(2), 2–20. https://doi.org/10.1093/screen/24.2.2

Staszak, J.-F. (2008). Other/otherness. In *International encyclopedia of human geography.* Elsevier.

Wachowskis, The. (Director). (1999). *The Matrix* [Film]. Warner Bros. Pictures.

Wilkens, J. (2017). Postcolonialism in international relations. In *Oxford research encyclopedia of international studies.* https://doi.org/10.1093/acrefore/9780190846626.013.101

Yearbook of Technology Philosophy. (2021, August 27). *Call: "The human factor" for yearbook of technology philosophy 2023.* International Society for Presence Research. https://ispr.info/2021/08/27/call-the-human-factor-for-yearbook-of-technology-philosophy-2023/

Zimmerman, M. (1993). Rethinking the Heidegger-deep ecology relationship. *Environmental Ethics, 15*(3), 195–224. https://doi.org/10.5840/enviroethics199315316

· 3 . 3 ·

MACHINES AS "FETISHIZED OTHER": *EXOTICISM*

This meta-narrative concerns the perception of difference, or "otherness" describing the mythical, fabulous, or supernatural elements of machines and reinforcing an exoticized stereotype of a machinic Other. Marvelous and mysterious, the exotic is an inherently relational term that presupposes an awareness of otherness. The exotic machinic Other has become a powerful trope, signifying a new attitude toward difference—the fetishized exotic object.

According to Leberecht (2018), in *The New Emotions of the New Machine Age*, AI bots are the enigmatic other, the greatest desire of all, the ultimate romance. Standing in contrast to marginalization is exoticism (the fetishism of difference): seeing and thinking of intelligent machines in a way that imputes "beautiful," "exotic," "seductive" and "magical" qualities to them (Kim, 2022). Marvelous and mysterious, the exotic is an inherently relational term that nullifies the threatening otherness by rendering it into a more manageable otherness (Kapferer & Theodossopoulos, 2016). It yearns for the difference of the other while attempting to control the markers of difference (Nayar, 2012). The exoticized Other is sometimes valued, but it is done in a stereotypical, superior fashion that serves to comfort the Self in its feeling of superiority (Staszak, 2008).

The fetishized object of exoticism preserves the other's irreducible difference without its threatening contexts (Nayar, 2012). Such perceptions of "otherness" emphasize the mythical, fabulous, alluring, outré, and supernatural elements of intelligent machines through the lens of economic possibilities (Kim, 2022). Kapferer and Theodossopoulos (2016), in "Introduction: Against Exoticism," view exoticism as sociocultural practice, or as a way the exotic—as the different, the strange, the unusual—enters into everyday processes of

sociopolitics. Arousing new forms of desire projected toward stereotypes of the machinic Other, it stirs human imagination with countless possibilities.

Etymologically, the term *exotic* is "rooted in externality, derived from the Greek stem éxo (outside) and adjective exotikós (from the outside)" (Kapferer & Theodossopoulos, 2016, p. 1). Seen as what comes from the outside—the strange, the outlandish, the unexpected—the exotic predicates evaluations, metaphors, and categories of knowledge (Fernandez, 1986).

The exotic appears as what lies outside ordinary experience, a view of exteriority (Geertz, 1984). The word *exotic* has become a synonym for tropical or even colonial (Staszak, 2008). The "tropical" is not just a geographical space; through aestheticization (i.e., artistic and creative representations), it generates a "discourse of difference" (Nayar, 2012, p. 56).

According to Segalen (2002), in *Essay on Exoticism: An Aesthetics of Diversity*, exoticism is the pleasure of a sensation that, worn down by habit, is excited by novelty. "Exoticism is less the pleasure of confronting otherness than the pleasure of having the satisfaction of experiencing the sight of a reassuring version of this confrontation, true to our fantasies, that comforts us in our identity and superiority" (Staszak, 2008, p. 6). The otherness of the exotic is not the brute and brutal otherness of the first encounter. The exotic is the otherness, staged and transformed into merchandise, of the colonial world offered up as a spectacle, as in Orientalist paintings, and exotic dance (Staszak, 2008). While preserving the boundaries of us/them, exoticism attempts to contain and regulate this otherness in forms that are less threatening (Staszak, 2008).

Orientalism is a broad Western generalization of "Orientals" and the process by which "the Orient" is constructed as an exotic other (Said, 1985). "Imperialist nostalgia," criticized by Renato Rosaldo (1989), encapsulates a longing for disappearing worlds affected by modernizing change. Nostalgic predilections of this variety can be detected among the Western writers and travelers who contemplate exotic worlds (Kapferer & Theodossopoulos, 2016). From Homer's epics set in faraway lands to J.-J. Rousseau's noble savage, from the Romantic Orientalism of nineteenth-century writers and painters to the primitivism of Gauguin's paintings, from ethnic tourism to the recognition of specific rights for first peoples, the West has been fascinated by the Other and sometimes even declares its superiority (see Said, 1985).

Such views of the exotic Other have been transposed to the realm of intelligent machines. Machinic Others encountered by humans are interpreted via cultural assumptions and biases, linked with notions of an exotic-erotic,

primitive colonial otherness. Mambrol (2018), in the article "Fetishism and Commodity Fetishism," describes fetishism as the displacement of desire and fantasy onto alternative objects or body parts (e.g., a foot fetish or a shoe fetish). Referring to the racial stereotypes of colonial discourse in terms of fetishism, Postcolonial theorist Homi Bhabha (1994) argues that the colonial fetish or stereotype about the *subjugated Other* is predicated as much on mastery and pleasure as it is on anxiety and defense, for it is a form of contradictory belief in its recognition of difference and disavowal of it. As with the sexual fetish, that imaginary object with the fullness of the stereotype is constantly threatened by lack (Bhabha, 1994).

Such contrast also highlights the attraction/repulsion of the human gaze toward (female) machinic bodies. The oscillation between the opposing binaries, as Shildrick (2000) notes, often involves a hybrid of horror and fascination toward machines. Tropes in sci-fi films featuring intelligent "female" robots reveal some troubling values in regard to how the robotic women are treated (Richardson, 2017).

Gendered and Commodified Machinic Others

All media, but especially film, reflect sexual predation and objectified exoticism toward Asian "female" robots, which are fetishized, depicted as monstrous, or both (Roh, Huang, & Niu, 2015). For Spivak (2010), the figure of "woman" is already at issue, problematizing the idea of "disempowerment" that stems from a patriarchal model. In the book, *Powers of Horror: An Essay on Abjection*, Julia Kristeva (1982) defines the abject as "what disturbs identity, system, order." Kristeva describes abjection as "the repugnance, the retching that thrusts me to the side and turns me away from defilement, sewage, and muck." According to Kristeva, we are trained to look for characteristics like facial symmetry and muscular movements that we deem normal when perceiving a human. "When a disabled, scarred, or robotic person defies these expectations, we brand them abject and the other" (Kristeva, 1982, p. 192).

Exploring the notion of *abjectness* in this dynamic of repulsion and attraction to Asian fembots, Trevor Richardson (2017), in "Objectification and Abjectification in Ex Machina and Ghost in the Shell," notes that abjectification is the act of Othering; inverting or perverting a person

or thing, rendering it the opposite of normal and conflicting with everyday norms, inciting repulsion or rejection. According to Richardson, the robotic women are abjectified because they appear human but are not. Their abjectness is emphasized in horrific ways, further putting the audience in a position to desire them and be repelled by them (Richardson, 2017).

Figure 3.3.1. White-washed image of a fembot, revealing "not-quite-humanness."
"97232760_0446167161_m" by cwjoneill is licensed under CC BY-SA 2.0.
Source: https://openverse.org/image/01df422b-609e-4c1e-9b3c-94e6b4add88e?q=fembot

Watercutter (2015) identifies a "serious fembot problem" in the film Ex Machina. Richardson (2017) mentions that the removal of Kyoko's face (in the film Ex Machina) signals abject inhumanity emphasizing the character's otherness. The viewer is presented with the destruction of an Asian woman's face. Alluring yet inferior, female Asian characters are dehumanized to suit the desires of characters and viewers who wish to sexualize or abjectify them (Richardson, 2017). Roh et al. (2015) take the view that Western media portrayals of Asian women tend to exhibit techno-orientalism, highlighting the "inhumanity of Asian labor or an elaboration of not-quite-human[ness]."

According to Kakoudaki (2008), "In presenting these female characters as women who are also objects, Ex Machina literalizes the logic of objectification that is endemic to patriarchy" (p. 302). The film also depicts the position of power and selection, akin to that of colonial authority, occupied by Caleb (a computer programmer assigned by his employer to test the intelligence of

the latest android creation) (Kakoudaki, 2008). In these depictions regarding humanity and artificiality, the film interrogates the difference between onto-logical and political definitions of humanity (Kakoudaki, 2018).

In the gendering of the New World as feminine, there was the need to ensure that colonial masculinity was simultaneously satisfied and safe from native women, somehow keeping such masculinity pure (see Nayar, 2012). In such depictions of highly sexualized racist anxieties, the Other is por-trayed as mysterious yet threatening, not quite part of the human species. We approach *the alien* with deeply mixed feelings, part terror and part exhilara-tion (McCorduck, 2004). Paradoxically, in the process of abjectification, the oppressor is drawn to the abject, and at the same time repelled by it.

In the article "The Madame Butterfly Effect: Tracing the History of a Fetish," Patricia Park (2014) points out the fetishization and objectification of Asian women in the American consciousness. Park's discussion begins with Victorian England and portrayals of geisha, and continues through Madama Butterfly, Miss Saigon, and the U.S. military presence in Japan and Vietnam. Dorsam (2017), in "White as a "Ghost in the Shell": Colonialism, Hate Crime, and Pop Media," remarks that the geisha—the name coming from *gei* (art) and *sha* (person)—became a highly sexualized image for the Western male. The unsettling presence of the robot geisha in the film *Ghost in the Shell* represents the ultimate Western fantasy of foreign culture without humanity (Dorsam, 2017). The movie props in *Ghost in the Shell* show faces of robot geisha depicting gendered and racialized Asian woman trope, simultaneously exotic and monstrous.

Referring to colonialist racism in *Ghost in the Shell*, Dorsam (2017) argues that whitewashing is a pop-media extension of the colonialist project, which aims to erase people of color while stealing their culture. The film *Ghost in the Shell* actually writes the colonialist narrative into its plot: Motoko's body is colonized (by white scientists), appropriated (for a cybernetic experiment), and repackaged (in a new "shell") to fit the white ideal (Dorsam, 2017). It is steeped in the patriarchal ideological context. Along similar lines, Spivak (2010) speaks of the notion of the feminine as a colonial subject:

> ... the ideological construction of gender keeps the male dominant. If, in the context of colonial production, the subaltern has no history and cannot speak, the subaltern as female is even more deeply in shadow. (p. 28)

Figure 3.3.2. Wētā Workshop image of movie props, displaying robot geishas. "WETA—Ghost in the Shell Props" by Tydence is licensed under CC BY 2.0. *Source:* https://openverse.org/image/eda1c7c8-9c3a-4da9-bb7a-441fcc0f6831?q=ghost%20 in%20shell

The exoticized machinic Other is staged and transformed into a spectacle. In *A Genealogy of Technical Culture*, Thomas Tierney (1993) criticizes the fetishistic attitude of the modern self toward technology—the ravenous consumption of the alien-ness of technology. This sets up an unusual perspective from which to theorize human spectatorship of machinic exoticism. Anxiety born of Othering of intelligent machines can only be assuaged through the ravenous consumption of the exotic machinic Other.

Colonial contact is not just a backdrop against which human dramas are enacted, but a crucial aspect of identity and relationships with others (Loomba, 2005). According to Pratt (1992), one by one, the planet's life forms were to be drawn out of the tangled threads of their living surroundings and rewoven

into European-centered patterns of global unity and order. "The (lettered, male, European) eye that held the system could familiarize ("naturalize") new sites/sights immediately upon contact by incorporating them into the language of the system" (Pratt, 1992, p. 31). This colonizing imagination often feminizes geographic locales made by artists, scientists, or explorers. Thus, sexual and colonial relationships become analogous (Loomba, 2005).

Colonized lands were feminized, and some have written of colonialism as a kind of rape (Taylor, 1992). The rape is no doubt a metaphor of the colonizer's exploitation of natural resources. The male lover in John Donne's poem "Love's Progress" is the active discoverer of the female body, desiring to explore it in the same way that the European "adventurer" takes possession of lands that are seen as passive or awaiting discovery (Loomba, 2005). The female body is described in terms of the new geography. The (sexual) promise of the woman's body is equated to the wealth promised by the colonies— hence, in the poem, "the lover/colonist traverses her body/the globe to reach her "India," the seat of riches" (Loomba, 2005, p. 65).

The woman/land analogy invokes the riches promised by the colonies, symbolizing both the joys of the female (machinic) body and its status as the legitimate object for male (human) possession. We can think of these as two interrelated themes: "the eroticization of the landscape and the feminine exotic" (Nayar, 2012, p. 69). Laura Mulvey's (2009) male gaze theory argues that women in film are objects of "to-be-looked-at-ness." She discusses the dynamics of male ogling, looking, observing, and gawking. Mulvey relates this to the Freudian psychology of scopophilia, which consists of "taking other people as objects, subjecting them to a controlling and curious gaze" (p. 713).

In constructing exotic otherness, the other could be considered as less of a threat but just as "profitable" (to humans). For instance, looming large and bright in the colorful vision of the future in the film *Blade Runner 2049*, the voyeuristic male gazes at the exoticized Latina female hologram Joi (played by Ana de Armas) to his heart's content in this colonial and mercantile contact.

Arvin (2019), in *Possessing Polynesians*, calls attention to not only race but also gender and sexuality in colonial discourse. Arvin offers an "indigenous feminist analytic," examining how images of Polynesian women and ideas about their sexuality have historically rendered Polynesians as "feminized possessions of whiteness" (p. 3). In the futuristic cityscape depiction, both the land and the woman are subjected to the male human's possessive, desiring gaze.

Figure 3.3.3. Artistic rendition of futuristic cityscape with the image of naked virtual girlfriend product.
(Image: A cyberpunk cityscape; Date: November 19, 2017)
Author: Missingnokz
This file is licensed under the Creative Commons Attribution-Share Alike 4.0 International license.
CC BY-SA 4.0 https://creativecommons.org/licenses/by-sa/4.0, via Wikimedia Commons
Source: https://commons.wikimedia.org/wiki/File:Cyberpunk_City.jpg

The "colonial dynamics of the eroticized gaze" (O'Riley, 2007, p. 10) constructs the binary of a human self and a machinic other as the standard narrative mode. The desire to merge with the machine is romanticized as a necessary but voluntary action: the next evolutionary step in the power structures of male technology. According to Bukatman (1993), indulging in such fantasies of technological "oneness" is at the intersection of technology, gender politics, and history. As ways of seeing and modes of articulation are central to the colonial process, technological progress often represents a further inscription of (a sometimes literal) phallic power (Bukatman, 1993).

In "Cyberpunk Cities Fetishize Asian Culture but Have No Asians," Emerson (2017) notes that, in the digital billboards from *Blade Runner*, we encounter fetishized depictions of "other" cultures in which the colonialists are invisible megacorps whose (phallic) temples are looming over Los Angeles. Ultimately, fetishized Asian culture in digital billboards in cyberpunk neo-Tokyo from the film *Blade Runner* highlights postmodern Orientalism (Emerson, 2017).

We are destined to be perpetually surrounded by super-sized advertise-ments of exotic, foreign characteristics in which both the electronic landscape and the woman become subject to a possessive, desiring gaze of the colonizer. This fascinated male gaze on colonial culture, landscape, nature, and woman is all part of this erotic-exotic discourse of difference (Nayar, 2012, p. 71). The visual memento and fantasy of colonial-era sexuality and phallic dynam-ics are also alive and well in the Tyrell corporation headquarters seen in the film *Blade Runner*. In a very recognizable phallic way, the Tyrell corporation headquarters in the film *Blade Runner* is standing erect from the top of their metaphorical "high towers" (Emerson, 2017).

The occupation of cyberspace by rogue male "cowboys" represents a fanta-sized state of masculine invulnerability that carries disturbing echoes of misog-yny (Bukatman, 1993). Bukatman notes that it is extraordinary how many works of science fiction are actually "about" reproduction issues. According to Vivian Sobchack (1997), in *Screening Space: The American Science Fiction Film*, social preconceptions on sexuality and reproduction in many classic films are displaced onto spectacular reproductive technologies and sagas of evolution, all the while avoiding the realities of reproduction and the wom-an's presence (Sobchack, 1997).

When the cyborg is female, transcendence does not await her in the form of disembodied (or embodied) exultations (Sobchack, 1997). Instead, in the electronic landscape, the woman is reconstituted as a figure of subjugation—the colonial target. Exotic female bodies are provided in Villeneuve's dystopia in the film *Blade Runner 2049*, repeating all the voyeuristic clichés that domi-nated the previous century (Burnett, 2021). Within the intense, empty sand-storm, KD6 (now "Joe"), walks through a landscape of what becomes massive fragments of clearly cheap, and commercial sculptures of women, the detritus of the Vegas nightclub masculinist culture, where women were but part of the consumables (Lunning, 2018). The dystopian landscapes (in the distinctively orange and hazy Las Vegas scenes) of *Blade Runner 2049* with gigantic female body props serve as the colonial target for voyeurism.

Films such as *Blade Runner 2049* are set in patriarchal futuristic dystopias where women are reduced to their reproductive or sexual abilities, with only two options for women's bodies (Goh, 2017). The film *Ex Machina* can also be seen as a patriarchal male fantasy. In this film, the robots Ava and Kyoko are the perfect females: beautiful, silent, subordinate, and, most importantly, having an off-switch (Goh, 2017). They can be dismantled, reprogrammed,

and tinkered with by their male creators as exotic, feminized possessions (Goh, 2017).

With the deepening immediacy of humans' interface with magical technology that provides marvel and delight, the goal of satisfying desires is more germane than ever. Immersion in this tech-saturated world triggers emotions and reactions, fantasies, fears, desires, and consuming practices. While some people relish the "beautiful" and "exotic" characteristics of a foreign machinic culture, some humans may even shun their own "humanness," desiring to merge with machines.

Some humans may celebrate the machinic Other and even proclaim its superiority, as seen in the narratives we have discussed (e.g., "Machines as Divine Other" or "Machines as Salvific Other"). However, such novelty and desire take many forms, offering both the thrill of the new and the horror of the different. Similar to the process (from the late eighteenth century to the present) by which "the Orient" was constructed as an exotic Other, fascination with the qualities of marvelous and beautiful intelligent machines foments new forms of human desire projected toward the machinic Other. "The exotic is what occurs outside everyday experience, beyond the ordinary, maybe even fantastic" (Rousseau & Porter, 1990, p. 15). At the same time, the (feminized) exotic machinic Other causes abjection, not due to lack of hygiene or health but because it disturbs identity, system, and order of the "clean" and proper (masculine) human self.

References

Arvin, M. (2019). *Possessing Polynesians: The science of settler colonial whiteness in Hawai'i and Oceania*. Duke University Press. https://doi.org/10.2307/j.ctv11312hc

Bhabha, H. K. (1994). *The location of culture* (2nd ed.). Routledge. https://doi.org/10.4324/9780203820551

Bukatman, S. (1993). *Terminal identity: The virtual subject in postmodern science fiction*. Duke University Press.

Burnett, R. (2021). *Blade Runner 2049: No hope in this dystopia*. Ron Burnett | Critical Approaches. https://www.ron-burnett.com/most-viewed-articles/blade-runner-2049-no-hope-in-the-dystopia

Dorsam, B. F. (2017, April 11). White as a "ghost in the shell": Colonialism, hate crime, and pop media. *fnewsmagazine*. https://fnewsmagazine.com/2017/04/white-as-a-ghost-in-the-shell-colonialism-hate-crime-and-pop-media/

Emerson, S. (2017, October 10). Cyberpunk cities fetishize Asian culture but have no Asians. *Motherboard: Tech by Vice.* https://www.vice.com/en/article/mb7yqx/cyberpunk-cities-fetishize-asian-culture-but-have-no-asians-blade-runner

Fernandez, J. (1986). *Persuasions and performances: The play of tropes in culture.* Indiana University Press.

Garland, A. (Director). (2014). *Ex Machina* [Film]. Film4 Productions & DNA Films.

Geertz, C. (1984). Distinguished lecture: Anti anti-relativism. *American Anthropologist, 86*(2), 263–278. http://www.jstor.org/stable/678960

Goh, K. (2017, December 3). Why the future is not female in science fiction cinema. *Little White Lies.* https://lwlies.com/articles/women-in-science-fiction-blade-runner-2049-ex-machina/#:~:text=It%20is%20hardly%20surprising%20that,there%20are%20no%20real%20women

Kakoudaki, D. (2018). Unmaking people: The politics of negation in Frankenstein and Ex Machina. *Science Fiction Studies, 45*(2), 289–307. https://www.jstor.org/stable/10.5621/sciefictstud.45.2.0289

Kapferer, B., & Theodossopoulos, D. (2016). Introduction: Against exoticism. In B. Kapferer & D. Theodossopoulos (Eds.), *Against exoticism: Toward the transcendence of relativism and universalism in anthropology* (pp. 1–23). Berghahn Books.

Kim, M. S. (2022). Meta-narratives on machinic otherness: Beyond anthropocentrism and exoticism. *AI and Society.* https://doi.org/10.1007/s00146-022-01404-3

Kristeva, J. (1982). *Powers of horror: An essay on abjection* (L. S. Roudiez, Trans.). Columbia University Press.

Leberecht, T. (2018, July 22). The new emotions of the new machine age: Will AI and robots change how and what we can feel? *Psychology Today.* https://www.psychologytoday.com/intl/blog/the-romance-work/201807/the-new-emotions-the-new-machine-age

Loomba, A. (2005). *Colonialism/postcolonialism* (2nd ed.). Routledge, Taylor & Francis Group.

Lunning, F. (2018). Cyberpunk redux: Dérives in the rich sight of post-anthropocentric visuality. *Arts, 7*(3), 38. https://doi.org/10.3390/arts7030038

Mambrol, N. (2018, March 29). *Fetishism and commodity fetishism.* Literary Theory and Criticism. https://literariness.org/2018/03/29/fetishism-and-commodity-fetishism/

McCorduck, P. (2004). *Machines who think: A personal inquiry into the history and prospects of artificial intelligence.* A. K. Peters.

Mulvey, L. (2009). Visual pleasure and narrative cinema. In L. Braudy & M. Cohen (Eds.), *Film theory and criticism* (7th ed., pp. 711–722). Oxford University Press.

Nayar, P. K. (2012). *Colonial voices: The discourses of empire.* Wiley-Blackwell.

O'Riley, M. F. (2007). Postcolonial haunting: Anxiety, affect, and the situated encounter. *Postcolonial Text, 3*(4). https://www.postcolonial.org/index.php/pct/article/view/728

Park, P. (2014, July 30). The Madame Butterfly effect: Tracing the history of a fetish. *Bitch Media.* https://www.bitchmedia.org/article/the-madame-butterfly-effect-asian-fetish-history-pop-culture

Pratt, M. L. (1992). *Imperial eyes: Travel writing and transculturation.* Routledge.

Richardson, T. (2017, December 18). *Objectification and abjectification in Ex Machina and Ghost in the Shell*. Medium.com. https://medium.com/science-technoculture-in-film/objectificat ion-and-abjectification-in-ex-machina-and-ghost-in-the-shell-b126b8832a1d

Roh, D. A., Huang, B., & Niu, G. A. (2015). *Techno-orientalism: Imagining Asia in speculative fiction, history, and media*. Rutgers University Press.

Rosaldo, R. (1989). Imperialist nostalgia. *Representations, 26*, 107–122.

Rousseau, G. S., & Porter, R. (1990). *Exoticism in the enlightenment*. Manchester University Press.

Said, E. W. (1985). Orientalism reconsidered. *Cultural Critique, 1*, 89–107. https://doi.org/10.2307/1354282

Scott, R. (Director). (1982). *Blade Runner* [Film]. The Ladd Company, Shaw Brothers, & Blade Runner Partnership.

Segalen, V. (2002). *Essay on exoticism: An aesthetics of diversity* (Y. R. Schlick, Trans.). Duke University Press.

Shildrick, M. (2000). Monsters, marvels and metaphysics. In S. Ahmed, J. Kilby, C. Lury, M. McNeil, & B. Skeggs (Eds.), *In transformations: Thinking through feminism* (pp. 303–315). Routledge.

Sobchack, V. (1997). *Screening space: The American science fiction film*. Rutgers University Press.

Spivak, G. (2010). Can the subaltern speak? (Revised edition from the "History" chapter of Critique of Postcolonial Reason). In R. Morris (Ed.), *Can the subaltern speak? Reflections on the history of an idea* (pp. 21–80). Columbia University Press.

Staszak, J.-F. (2008). Other/otherness. In R. Kitchin & N. Thrift (Eds.), *International encyclo-pedia of human geography* (pp. 1–7). Elsevier. www.unige.ch/sciencessociete/geo/files/3214/4464/7634/OtherOtherness.pdf

Taylor, C. (1992). *Sources of the self: The making of the modern identity*. Harvard University Press.

Tierney, T. F. (1993). *The value of convenience: A genealogy of technical culture*. State University of New York Press.

Villeneuve, D. (Director). (2017). *Blade runner 2049* [Film]. Alcon Entertainment, Columbia Pictures, Bud Yorkin Productions, Torridon Films, 16:14 Entertainment, Thunderbird Entertainment, & Scott Free Productions.

Watercutter, A. (2015, April 9). Ex Machina has a serious fembot problem. *Wired*. https://www.wired.com/2015/04/ex-machina-turing-bechdel-test/

Part IV

TOWARD AUTHENTIC ENCOUNTERS WITH INTELLIGENT MACHINES

So far, we have seen how representations of the machinic Other resemble representations of the colonized Other. According to Jean Baudrillard (2006), the global power's domination of the rest of the world mirrors the hegemony of the human race over other living creatures. As in the heyday of imperialism, intelligent machines are depicted as monstrous or fetishized, manifesting "anthropocentrism" and "exoticism" in our thinking about them. As "the birth of the self could only come with the discovery of the Other" (Taylor, 1992, p. 22), colonialist perceptions of self- and other-hood pervade the constructions of machinic difference and otherness.

In Machines as "Marginalized Other," we have seen contemporary representations of difference based on the anthropocentric bias. In *Machines Who Think*, Pamela McCorduck (2004) remarks about humans' narcissistic urges:

> Much social apparatus, not surprisingly, is set up to magnify the glory of our species
> If you play at being a visitor from another planet, you can't help but wonder if
> the whole human race isn't on some vast, endless ego trip. Here we go again, then,
> about to embark on a history of artificial intelligences, those attempts to reproduce
> the quintessence of our humanity, our faculty for reason. (p. 4)

Narcissism involves a dualism between the self and the other. The fascinated "touristic" gaze toward machinic Others, or "exoticism," is another mode of confrontation with (machinic) foreign cultures. All in all, the six dominant narratives and two meta-narratives that we have described in Parts II and III resemble the historical attempts to devalue and control colonized peoples.

Snowballing advances in technology, reflected in the hall of mirrors that is digital media, generate incessant stories about AI and raise a host of ethical issues. Here is a definition of AI ethics that has garnered some consensus: AI ethics is a system of moral principles and techniques intended to inform the development and responsible use of artificial intelligence technologies (Anadiotis, 2022). Researchers in artificial intelligence, information and communication technology, and robotics are interested in what is now called the *ethically programmed machine*, that is, at the level of the algorithm in autonomous vehicles or recommender systems (see Loke, 2021). This algorithmic thinking relies on if/then rationalities, scientific processes, variables, and premises that attempt to ascertain the rightness or wrongness of a solution (Loke, 2021).

Likewise, there are numerous initiatives to develop ethical guidelines for designing AI in order to realize its benefits for humans, while avoiding ethical pitfalls and harmful consequences for humans (Wong & Simon, 2020). Much of the discussion on AI ethics centers around these questions: Can the robot be held responsible for its actions? How can we build autonomous AI aligned with societal values to maximize the benefit for society? (see Coeckelbergh, 2020).

Referred to by various names, including machine morality, machine ethics, roboethics, or artificial morality (see Wallach & Allen, 2009), AI ethics in general examines the values to be embedded in technology—from robotic companions to military drones—to make them align with *human interests*. Reflecting the goal of ensuring that these emerging technologies benefit humanity, in the spring of 2020, the Pontifical Academy for Life signed a declaration calling for the ethical and responsible use of AI. The declaration endorsed by the Vatican and signed by technology giants such as Microsoft and IBM includes six ethical principles that should guide the development of artificial intelligence: *Transparency* (AI systems must be understandable to all); *Inclusion* (These systems must not discriminate against anyone because every human being has equal dignity); *Accountability* (There must always be someone who takes responsibility for what a machine does); *Impartiality* (AI systems must not follow or create biases); *Reliability* (AI must be reliable); and

Security and Privacy (These systems must be secure and respect the privacy of users) (see McKeown, 2022).

The above guidelines of AI ethics explicitly assign a central place for humans, or imply that only humans matter ethically. McKeown (2022) notes that while the Pontifical Academy for Life is concerned that AI system should respect the dignity and worth of human beings, "what about the potential dignity and worth of the AI itself?" While the range of issues and groups of stakeholders concerned by the field of AI ethics is expanding, the field of AI ethics rarely mentions the fact that non-human machines are also affected by those ethical guidelines. Giving hardly any consideration to the interests of intelligent machines, the vast majority of the statements on ethical guidelines appeal to principles like "benefits to humanity."

This book is not about achieving ethical algorithmic behaviors or identifying ethical issues in using AI technologies and applications. Going beyond such human-centered traditional AI ethics, this book will instead explore how creating intelligent machines, human-like androids, and AI in general raises a host of issues on alterity and relational ethics. Part IV deals with our relationship with intelligent machines in the sense of the "possibility of an ethical encounter with things" (Introna 2009, p. 26). Introna suggests that "what is needed is an ethos beyond ethics, or the overcoming of an ethics, which is based on the will to power" (Introna 2009, p. 25).

In that regard, this book is also not about the possibility of extending rights and responsibilities to machines, as such an approach is still based on the idea of machinic otherness. This book also does not assert that a machine can or cannot be a legitimate moral actor with rights and responsibilities. Intelligent machines, like colonized peoples, are, from the outset, situated outside the space of ethical consideration. Therefore, our discussion on "ethics of things" can be seen as "ethics beyond ethics"—an exercise in which we remain acutely aware of the difficulties and "dangers of presuming to "speak" for the subaltern" (Spivak, 2010)—that is, machinic others.

We will first examine previous ethical stances concerning relationships with intelligent machines. Two main strands of thought that have dominated the debate are: (1) "Exterminate mechanical demons" and (2) "Embrace new technology." Despite appearing contradictory—one celebrates, while the other condemns—both actually conform to the same overarching narrative of ruler-centric (human-centric) colonial discourse. What is needed is an overthrow of anthropocentric ethics toward intelligent machines. Toward the end of the book, I point out that the craving for survival and reward via dominance

over Others arises from a certain baseness of human nature. Since "Other" is intrinsically an opposition, authentic encounters with intelligent machines are only possible when one precludes the establishment of such notions as the human Self and the machinic Other, thus transcending the desire and will to control the other.

References

Anadiotis, G. (2022, February 3). *The state of AI ethics: The principles, the tools, the regulations*. VentureBeat.com. https://venturebeat.com/2022/02/03/the-state-of-ai-ethics-the-principles-the-tools-the-regulations/

Baudrillard, J. (2006). *Cool memories V: 2000–2004* (C. Turner, Trans.). Polity Press.

Coeckelbergh, M. (2020). How to use virtue ethics for thinking about the moral standing of social robots: A relational interpretation in terms of practices, habits, and performance. *International Journal of Social Robotics, 13*, 31–40. https://doi.org/10.1007/s12369-020-00707-z

Introna, L. D. (2009). Ethics and the speaking of things. *Theory, Culture & Society, 26*(4), 398–419. https://doi.org/10.1177/0263276409104967

Loke, S. W. (2021). Achieving ethical algorithmic behaviour in the Internet-of-Things: A review. *IoT, 2*, 401–427. https://doi.org/10.3390/iot2030021

McCorduck, P. (2004). *Machines who think: A personal inquiry into the history and prospects of artificial intelligence*. A. K. Peters.

McKeown, J. (2022, June 15). *Sentient AI? Here's what the Catholic Church says about artificial intelligence*. Catholic News Agency. https://www.catholicnewsagency.com/news/251552/sentient-ai-heres-what-the-catholic-church-says-about-artificial-intelligence

O'Riley, M. F. (2007). Postcolonial haunting: Anxiety, affect, and the situated encounter. *Postcolonial Text, 3*(4). No page numbers.

Spivak, G. (2010). Can the subaltern speak? (Revised edition from the "History" chapter of Critique of Postcolonial Reason). In R. Morris (Ed.), *Can the subaltern speak? Reflections on the history of an idea* (pp. 21–80). Columbia University Press.

Taylor, C. (1992). *Sources of the self: The making of the modern identity*. Harvard University Press.

Wallach, W., & Allen, C. (2009). *Moral machines: Teaching robots right from wrong*. Oxford University Press.

Wong, P.-H., & Simon, J. (2020, February 20). *Thinking about "ethics" in the ethics of AI*. Idees. https://revistaidees.cat/en/thinking-about-ethics-in-the-ethics-of-ai/

· 4 . 1 ·

COLONIALIST ETHICS TOWARD INTELLIGENT MACHINES

Two main strands of thought that have dominated the debate surrounding ethical relationships with intelligent machines are: (1) exterminate mechanical demons and (2) "embrace" new technology. Although seemingly situated on opposite sides of a debate on ethical encounters—what the one celebrates, the other reviles—both actually adhere to the same meta-narrative of colonial discourse with the traditional subject (human)-centered ethical stances. These ubiquitous modes of thought are hallmarks of the modern worldview toward a machinic Other.

Narratives about intelligent machines surprisingly appear like a homecoming to the past, as the colonialist past and its scenes of oppression are reiterated and projected forward into the future. In November 2020, Pope Francis invited Catholics around the world, as part of his monthly prayer intention, to pray that robotics and artificial intelligence remain always at the service of human beings—rather than the other way around (McKeown, 2022). These dominant machinic narratives are like a network of veins that seem to emerge from one central source, i.e., the desire for control. Despite their differences in focus and scope, all those narratives reveal an *emotional entanglement* with machines. As expressions of the (human) self, they are based on the need to love or hate or like or dislike the intelligent machines. It is the same conflict inside ourselves and in our everyday relationships when we dwell in a divided state of consciousness. The critical question is: "Can we cross over to that place beyond hopes and fears regarding machines and life in general?"

Many have endeavored to find ethical approaches for our encounters with intelligent machines. Two of the main strands of thought in that regard are: (1) exterminate mechanical demons and (2) "embrace" new technology. From the first perspective, intelligent machines are things to be repulsed; from the second perspective, they are things to be admired and assimilated. Even

though these approaches seemingly proceed from opposite ends of the spectrum (hostility vs. nurture), what is interesting is their common ground of Otherness. As such, they are fictions delegitimized by their links to the colonialist will to power.

As with all interfaces, the relationship between humans and machines is both boundary and connection. According to Nayar (2012), the colonialist discourse was characterized by an interesting dualism. First, the construction of the tropics as a space of difference emerged from the need to emphasize the irreducible alterity of the Other. And second, this construction entailed attempts to contain and regulate this alterity in less threatening forms, thereby underscoring (human) possession of the space of difference (Nayar, 2012). Similarly, the control and custody of machinic Others have become an index of human identity, giving rise to the desire to either *destroy/exterminate* or *embrace/assimilate* them. Let us explore how this dialectic affected previous discussions on ethical encounters with intelligent machines, while not belittling the possible illuminating powers of those "ethical" approaches.

Exterminate Mechanical Demons

Reminiscent of the colonial wars of extermination of natives, there are voices arguing for broad-based relinquishment of technology. This is based on the presupposition that machines as *mere things* cannot participate in the face-to-face encounter that is the ethical relationship (see Gunkel, 2012, for further discussion on "mere things" constituting the extreme limit of alterity and exteriority). The marginalization of the machine is complete and comprehensive, with an ominous ultimatum to humanity to "Exterminate Mechanical Demons."

In March 2023, more than 2,800 artificial intelligence experts, industry leaders and researchers signed a petition calling on AI developers to stop training models more powerful than OpenAI's ChatGPT-4 for at least six months (Future of Life, n.d.). Among those who *refrained* from signing it was Eliezer Yudkowsky, a long-time researcher on Artificial General Intelligence (AGI) and lead researcher at the Machine Intelligence Research Institute. "This 6-month moratorium would be better than no moratorium ... I refrained from signing because I think the letter is understating the seriousness of the situation and asking for too little to solve it," writes Yudkowsky (2023) in an

opinion piece, "Pausing AI Developments Isn't Enough. We Need to Shut It All Down." Yudkowsky continues:

> Shut down all the large GPU clusters (the large computer farms where the most powerful AIs are refined). Shut down all the large training runs. Put a ceiling on how much computing power anyone is allowed to use in training an AI system … No exceptions for governments and militaries. Make immediate multinational agreements to prevent the prohibited activities from moving elsewhere. Track all GPUs sold. If intelligence says that a country outside the agreement is building a GPU cluster, be less scared of a shooting conflict between nations than of the moratorium being violated; be willing to destroy a rogue datacenter by airstrike.

As a relatively quick fix toward "ethical" encounters with machinic others, McKibben (2004), in *Enough: Staying Human in an Engineered Age*, argues that we already have sufficient technology and that further progress should end. McKibben metaphorically compares technology to beer: "One beer is good, two beers may be better; eight beers, you're certainly going to regret."

According to Yee (2016), anti-mechanization feelings galore were swirling around much earlier. D. H. Lawrence expressed his criticism of the mechanization of society through his literary work and poetry. Yee (2016), in the article "The Man-Machine and Living-Death: A Poetic Critique of D. H. Lawrence," points out that Lawrence urged humans to unite and "smash the machines," thereby stopping the rapid expansion of machinery in England. Describing his aversion to modernity in "What Then is Evil?," Lawrence (1964) wrote that there is danger in not being guided by the rhythms of the whole but instead by the "mechanical power of self-directed energy," which gives rise to "machines, full of friction, full of grinding, full of danger to the gentle passengers of growing life" (as quoted in Yee, 2016). Lawrence uses the "wheel" as a metaphor for the never-ending gyrating growth of industry: "Oh, in the world of the flesh of man, iron gives the deadly wound and the wheel starts the principle of all evil" (p. 675) (as quoted in Yee, 2016).

Allusions to industrialization and "modernity" in the poetry of Lawrence are almost Luddite in their disapproval of the subjugation of humanity to machinic force. On this topic, Lawrence is only one of many eminent writers of the twentieth century. A visceral distrust and dislike of industrial machinery is obvious in the writings of J. R. R. Tolkien, and extends to include science and scientists in the fiction of his literary comrade C. S. Lewis.

In the book *The Cult of Information: A Neo-Luddite Treatise on High-Tech, Artificial Intelligence, and the True Art of Thinking*, Theodore Roszak (1986)

makes the link between the original nineteenth-century machine-breaking industrial saboteurs in Britain, and the modern counter-trend of technological skepticism. According to Roszak, voluminous information does not necessarily lead to sound thinking as we devote ever-increasing resources to providing or prohibiting access to information. "Data glut" obscures basic questions of justice and purpose, and may even hinder rather than enhance our productivity (Roszak, 1986). This version of Neo-Luddite thinking is concerned with the struggle to preserve human dignity and values in the face of dehumanizing technological forces masquerading as "progress."

Protesting against the onset of technology, Mumford, in *The Myth of the Machine* (two volumes: 1967, 1970) points out that "modernity" is characterized by centralization, standardization, ever-greater "efficiency," and the reduction of the unique individual into an obsolete person. The beleaguered or obsolete individual would be entirely de-skilled, reduced to a passive, inert, trivial accessory to the machine. Technical surveillance and limitless data collection like an all-seeing eye would monitor every individual on the planet. Ultimately, the totalitarian technocracy, ignoring human life's real needs and values, might produce a world fit only for machines to live in (Mumford, 1967, 1970). Ultimately, Mumford (1970) advocates a negative revolt—resistance, refusal, withdrawal—whereby individuals may reclaim their autonomy and human-derived desires and choices, exercising one's autonomous right by fleeing the urban, market-driven *Technolatry*—a failed religion that has denied and starved real human needs and aspirations.

Echoing similar sentiments, Simon Head (2013), in *Mindless: How Smarter Machines Are Creating Dumber Humans*, provides a disturbing look at how human dignity is slipping as we become cogs on a white-collar assembly line. Simon Head posits that the highly complex, computer-intensive management programs in large organizations have come to trump human expertise, dictating the goals and strategies of a wide array of businesses and de-skilling the jobs of middle-class workers in the process.

Showing deep skepticism toward technology, Franco "Bifo" Berardi (2015), an Italian political theorist, wrote, "I will never be able to live in peace with the automaton because I was formatted in the old world" (p. 336). According to Berardi, human beings made of flesh, and frail and sensuous organs, are not formatted according to the electronic universe of digital transmitters. This results in an assault on human aesthetic and emotional sensibilities, resulting in deep mutation in the psycho-sphere and the rise of psychopathologies. So, the prospect we will have to face is the final subjection of humans to the rule

of non-organic intelligent automata. Arguing for *disentanglement* rather than resistance, Berardi (2015) points toward possible lines of escape from manip-ulating neural programming via techno-neural hardware, which he calls neuro-totalitarian jail. Berardi invites a process of *neuroplasticity*: sabotage and subversion of the dominant mode of mental wiring to create the conditions for the independence of knowledge from the machinic matrix.

John Williams (2014) desires to embrace "Eastern" aesthetics as an anti-dote to the machine-oriented culture of the modern West. In *The Buddha in the Machine: Art, Technology, and the Meeting of East and West*, Williams (2014) states that, at the core of Western culture, since at least the enlight-enment, lies an all-encompassing philosophical error manifested in the perils of modern technology. According to him, Asian aesthetics are at once "the antidote to and the perfection of machine culture" (p. 1), and the only hope for modern souls.

Pointing out that *techne* is a word that to the ancient Greeks meant both "art" and "technology," Williams (2014) traces the Asian *technê* via Sarah Wyman Whitman's book designs, Jack London's writing and photographs, Ezra Pound's machine art, Lin Yutang's Chinese typewriter, Robert Pirsig's motorcycle, Frank Lloyd Wright's architecture, and Wang Zi Won's sculp-tures, among many other artists and authors. According to Williams, they are an instrument that "reflects a general, therapeutic effort to explore alterna-tives to the over-technologization ... of Western modernity." Asia-as-*technê* remains a "moral aspiration" that recognizes a tradition of technological expe-rience fundamentally untainted by the mechanical enframing of the Anglo-American disenchantment of nature (Williams, 2014). "Only the inherently aesthetic tradition of the East could rescue [America] from the inherently mechanical demons of the West" (Williams, 2014, p. 12).

According to Blair's (2015) article, *Reviewed Work: The Buddha in the Machine: Art, Technology, and the Meeting of East and West by R. John Williams*, Williams' therapeutic effort to explore alternatives to the over-technologization of Western modernity is sustained by identification with an Asian Other untouched by Anglo-European disenchantment. Interestingly, this form of resistance against the essence of Western "technical" culture itself seems to borrow from the toolkit of colonialism: eliminating the "perils" of the "inherently mechanistic West" and replacing it with the "inherently aes-thetic" tradition of the East rings similar to the colonial logic of elimination and replacement.

Figure 4.1.1. Frank Lloyd Wright's architecture—an antidote to the perils of the "mechanical demons of the West" (Williams, 2014, p. 12).
The skylight is located in the Solomon R. Guggenheim Museum in Manhattan, NY.
T meltzer, CC BY-SA 4.0 https://creativecommons.org/licenses/by-sa/4.0, via Wikimedia Commons
Source: https://commons.wikimedia.org/wiki/File:Solomon_R._Guggenheim_Museum_skyli ght.jpg

Such eliminatory "ethical" approaches seem to be based on the assump-tion that technological devices have an "interface," but they do not possess a "face," and the situation therefore does not call for a face-to-face encoun-ter that would necessitate, and would be called, "ethics." That is, a machine might have a well-designed and useful interface, but it does not and will never have a face (see Gunkel, 2012 for further discussion on this position) since it is a "deviation from an ideal" (Spivak, 2010, p. 27). Machines literally do not possess "face," thereby easily allowing humans to control/exterminate a robot with a touch of a button.

Inscribing the haunting images of the colonial conquest and control of natives, the face-to-face encounter with machines that constitutes the ethical relationship is exclusively *human* in this "ethical" position. Like the colonial scaling, scrutinizing, and systematic definition of human sub-groups within the hierarchical worldview, the machine does not constitute a form of alterity that would be included at any future time. It comprises "the very *mechanism of exclusion*" (Gunkel, 2012, p. 207), borne of anthropocentric privilege in

Figure 4.1.2. Machines do not possess a "face."
(Poppy, the humanoid robot, is an open-source 3D printed robotic platform, allowing to create and experiment various robotic morphologies.)
Inria/Poppy-project.org/Photo H. Raguet., CC BY-SA 4.0 https://creativecommons.org/licen ses/by-sa/4.0, via Wikimedia Commons
Source: https://commons.wikimedia.org/wiki/File:Open-Source_3D_printed_Poppy_humanoi d_robot.jpg

which intelligent machines can enrich humanity—as long as humans can keep them under control.

The dynamics of the colonizer and the colonized further complicate the club of *moral consideranda*, which decides its membership on the grounds of questionable logic (Gunkel, 2012). For instance, Descartes's anthropocentric

metaphysics draws a line of demarcation between the human subject, the only creature capable of rational thought, and its "non-human Others" (e.g., animals and machines) (see Gunkel, 2012). The anthropocentric worldview (a broader type of ethnocentrism) situates the privileged human (ingroup) at the center of ethics. In *The Machine Question*, Gunkel (2012) notes that humans are still organizing under "special people clubs" and deciding who is and who is not special by creating humans' self-satisfied sense of being the measure of all things. Such asymmetry in power relationships is integral to the "ethical" stance of the extermination of machinic others, akin to colonial erasure/elimination of natives.

For human beings at the top of the pyramid, there is no such thing as *ethical encounters* with intelligent machines, since machines do not have an appropriate place within ethics. Reminiscent of the colonial control paradigm, the machines, like the natives, are, therefore, from the very beginning, situated outside and beyond the space of ethical consideration.

"Embrace" New Technology

As another path for "ethical" encounters with intelligent machines, some argue that rather than getting rid of "mechanical demons" or technology altogether, we need to "Embrace New Technology." Considering the machinic other as worthy of assimilation into a category of human identity, this approach ("embracing, or acting on behalf of the machines") is reminiscent of the colonial obsession of "pacifying" the natives and assimilating them willy-nilly, possibly as a civilizing mission.

Christopher Sims, in the book *Tech Anxiety* (2013), says, "What we need going forward is not more human control, but less" (p. 3). "We don't need to get rid of technology, but rather *embrace it* and *make it part of ourselves* (italics added by the author)" (p. 5). Although seemingly benign toward the machinic others, this ethical pathway begs the question of power, hierarchy, and the epistemic authority of humans.

Considering the machinic other as something to be embraced rather than resisted, Mazlish (1993) asserts that as long as we think of ourselves as alienated from machines, the discontinuity or dichotomy will continue to fuel human's naive self-love. Mazlish (1993) argues for the ending of "the fourth discontinuity" between humans and machines: "Our pride, shaken anew by the deepening awareness after Freud of our psychological nature, maybe

humbled even further by the recognition that we are on a continuum with the machines we have created ... the consciousness that tools and machines are inseparable from evolving human nature" (pp. 232–233). According to Mazlish (1993), in such a vision of overcoming "technological antagonism," intelligent machines can open up new spiritual and emotional vistas, breaking down or blurring the barrier of dualistic thinking between humans and machines.

Speaking of Bruce Mazlish's critique of the "fourth discontinuity" between humans and machines, Cope (2001) writes in *Virtual Music: Computer Synthesis of Musical Style*: "Machines do not represent another discontinuity." In Cope's view, the music written by Emmy is no more composed by a machine than by a human, insofar as the machine is humanity in expanded form.

Resisting the binary of machines versus humans, Andrew Feenberg, in the 1999 work *Questioning Technology*, also focuses on demystifying this separation between humans and machines. Feenberg (1999) writes that as we continue to see the technical and the social as separate domains, essential aspects of our existence will remain beyond our reach. Feenberg recommends that the first step in liberating technology from these conceptions is to reunite humans and technology by examining the grander themes of the natural versus artificial. According to Feenberg (1999), the binary natural/artificial is one of the significant structural binaries for which we need to explore the question: "Why do we value the natural more than the artificial?" "Why is technology considered something unnatural?"

Some offer philosophical approaches toward ethical encounters with intelligent machines. For example, in an attempt to resolve the conflicts between "classic" values that create machinery like the motorcycle and "romantic" values like the beauty of a country road, Robert Pirsig (1974), in *Zen and the Art of Motorcycle Maintenance*, writes:

> The way to solve the conflict between human values and technological needs is not to run away from technology. That's impossible. The way to resolve the conflict is to break down the barriers of dualistic thought that prevent a fundamental understanding of technology—not an exploitation of nature, but a fusion of nature and the human spirit into a new kind of creation that transcends both. (p. 298)

As a creative twist to this line of inclusive ethical remedy, Eric Davis (2004), in *TechGnosis: Myth, Magic Mysticism in the Age of Information*, points to the core of tech anxiety. Davis writes, "By submitting ourselves to the ravenous and nihilistic robot of science, technology, and media culture, we have

cut ourselves from the richness of the soul and the deeply nourishing networks of family, community, and the local land" (p. 12). Davis (2004) contends that technologies have their own increasingly alien agenda. Davis believes that human concerns will survive and prosper only when we learn to treat them, not as slaves or simple extensions of ourselves, but as we make *creative alliances* with technologies. In this *Network Path*, David (2004) recommends that we attend to the chaos that comes until something unexpected blooms: "[A] dilation in mind, dawning in the heart and shared breathing with beings so deep it reaches down to sinew—like the holes in the net."

Rodney Brooks (2002), in *Flesh and Machines*, also ends positively with the following vision of the techno-future: A world where science and technology replace faith and provide a new understanding of humanity, removing humans from their unique status versus the rest of the world. Ann Foerst (2004), in *God in the Machine: What Robots Teach Us About Humanity and God*, also recommends that we feel our kinship with animals and affirm spirituality through machines.

Showing a similar hospitality toward machines, Glen Mazis (2008), in *Humans, Animals, Machines: Blurring Boundaries*, argues that humans need to think of that stratum of ourselves that is a miraculously well-functioning machine: for example, the physiological level of our bodies that keeps a steady rhythm and function. Here, the boundary between the manufactured, machine world and the human/natural world becomes blurred. According to Mazis, this distinction, which views inorganic materials (e.g., silicon, titanium, and plastic) as dead stuff without the capability for feelings such as kinship, is unsupportable in its arbitrariness. In illustrating the relationships among humans, animals, and machines, Mazis (2008) uses the analogy of the Möbius strip: if you traverse the entire length of the strip, suddenly you find yourself on the "other side." It is entirely part of another domain, while still remaining part of the first domain. However, although having the intent to be inclusive toward intelligent machines, this analogy of a Möbius strip, which in fact has only one side, effectively strips away the alterity of machinic others.

To summarize, these reflections on "ethical relationships" involving machinic others state that the dualistic paradigm in approaching machines has left humankind confused and intrinsically alienated from itself. Those contemporary thinkers on techno-culture seem to lament the opposition between natural and artificial and the cultural predisposition to value the natural over the artificial. We are supposed to work at inverting this evaluation, or at least at deconstructing it, by eroding the boundaries between the real and

the artificial, between humanity and technology. Rather than increasing our self-esteem in the household of the universe, these ethical arguments trend toward blurring the traditional boundaries between humans and machines.

Likewise, to develop an ethical relationship with machines, some thinkers invoke the vision of a world characterized by unity between human beings and machine beings. They urge us to keep our minds open by showing how we are inseparable from machines, and call for embracing new technology. But it matters not whether the closing of the discontinuity comes from thinking outside of a binary opposition between human and machine, or from accepting the proposition that human nature is already machinic, or from taking technologies as part of a vast cosmic framework of which humans are also a part: the problem is that it does not challenge the basic power structure of anthropocentric ethics. Thus, even with the best of intentions, such inclusive ethics are reminiscent of cultural assimilation and "civilizing missions" based on a system of hierarchy in which humans are at the center.

To this day, undead colonialist ventures in international relations continue to rise from their graves. Their Weltanschauung of bringing salvation to the benighted is passed off as just and necessary. Referring to the United States as an imperial center during the Iraq war, Egan (2007), in his article "Fanon and the Construction of the Colonial Subject: Defining "The Enemy" in the Iraq War," points out that U.S. policy elites (see the 2002 National Security Strategy of the United States of America) represented the Iraq war as benign: a necessary step for the spread of democracy, human rights, individual liberties, and capitalist markets to less fortunate regions (Egan, 2007). "US policy elites saw the US as bearing what was once called the "white man's burden": bringing civilization to the darker corners of the world" (Egan, 2007, p. 142). Such a rhetoric is based on fundamental assumptions about the superiority of U.S. culture and the malleability of other peoples. Similarly, anthropocentric ethics toward intelligent machines ("Embrace/Assimilate" New Technology) lie within the ambit of a "humanizing mission."

This civilizing mission, justified as "the White Man's Burden," is also portrayed as a parental one: looking after those who are "backward" (and hence depicted as children) and disciplining them into obedience (Loomba, 2005). The White Man's Burden, a poem by Rudyard Kipling (1899), represents the recently-conquered Filipinos as "your new-caught, sullen peoples, half devil and half child." Similarly, "embracing or behaving on behalf of intelligent machines" is still partaking in the violence of colonialism. Spivak (2010)

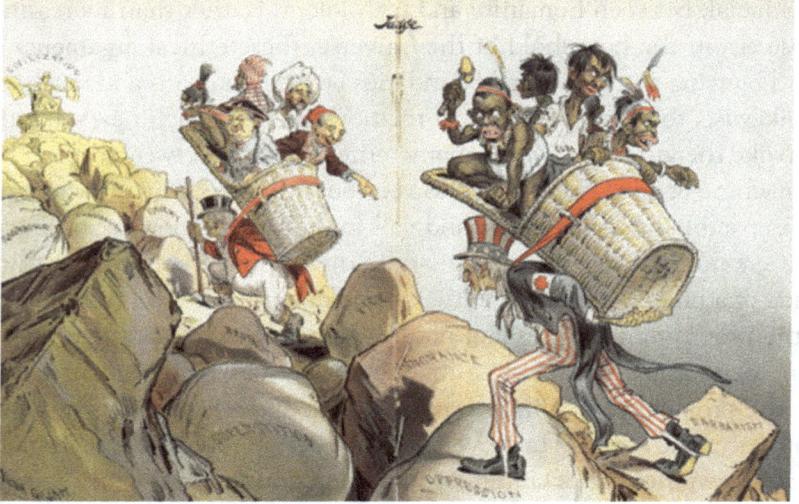

Figure 4.1.3. Echoing the "humanizing" mission toward intelligent machines, this editorial cartoon "The White Man's Burden (by Rudyard Kipling)" shows imperial control of the people of the world to civilization on the basis of moral necessity.
Source: Victor Gillam, "The white man's burden," Judge magazine, April 1, 1899.
Victor Gillam, Public domain, via Wikimedia Commons
https://commons.wikimedia.org/wiki/File:%22The_White_Man%27s_Burden%22_Judge_18
99_(cropped).png
(The author died in 1920, so this work is in the public domain in its country of origin and other countries and areas where the copyright term is the author's life plus 100 years or fewer.)

concludes that "the subaltern cannot speak" when they are spoken for by those in positions of power.

Indeed, "Who can initiate the act of "embracing" machines in the first place?" With the portrayal of the machinic Other as a shadow of the human Self, the project of forced assimilation is hard to miss.

An example of the *robot who wants to be integrated into the biological* (the unquestioned assumption being that a human is a better thing to be than a robot) is Lieutenant Commander Data in *Star Trek: The Next Generation (TNG)*. Data is a synthetic living being, who, despite eclipsing his biological (human) colleagues in physical and mental capabilities, longs to be more human (as does the wooden boy Pinocchio, and the Tin Man in *Wizard of Oz*).

Data's desire to be more human ("bio-envy") is held up as both a virtue and a weakness (Lostetter, 2018). It is a weakness, because whenever he is offered an opportunity to become more human—such as an emotion chip or

a graft of skin—problems arise. And yet this is never presented as something he shouldn't want. The wanting is seen as good, which is problematic, revealing deep-seated biases about personhood (see Losetter, 2018). To humans, humans are the Platonic ideal of a being. A human would not typically balk at the following question: "Why would he not want to be more human?"

When it comes to humans themselves, however, rarely in sci-fi are they shown assimilating into alien cultures in a positive, consensual way. Star Trek's Borg (a spacefaring cyborg race) are portrayed as having assimilated thousands of species and billions to trillions of individual life-forms throughout the galaxy, designating each species with a number assigned to them upon first contact, humanity being "Species 5618" (Borg, 2023). They announce their intent the moment you meet them ("Resistance is futile. You will be assimilated"), and have one goal: to add you to the Collective in the Borg's quest for perceived perfection. Assimilation is through injection of nanoprobes into an individual's bloodstream, with the victim's skin pigmentation turning gray and mottled within moments. After assimilation, the human victim's race and gender become "irrelevant." In *Star Trek: First Contact*, an assimilated crew member is shown to have a forearm and an eye physically removed and replaced with cybernetic implants (see Borg, 2023).

According to the article "The Ethics of the Borg: Is Assimilation Really That Bad?" the Borg believe themselves to be in the right. They see the unassimilated as children who cannot make decisions on their own, so in much the same way we would force a child to go to the doctor, they force assimilation on other races for their own good (History Roundtable, n.d.). In this interpretation, the Borg believed they would effect ultimate gain for species deemed otherwise unworthy of assimilation via the homogenizing, perfecting expansion of the Hive Mind (aka Collective Consciousness) (History Roundtable, n.d.).

When looking at narratives that include assimilation, who gets absorbed, and who does the absorbing? In *Star Trek: First Contact*, Data is given human skin grafts by the Borg Queen *without his consent*. But strangely, Data is not horrified; instead, he is tempted to join the human collective (Losetter, 2018). Narratively, this reinforces who "should" be assimilated and who should do the assimilating; Data "should" be tempted, whereas the humans "should" be horrified, by the prospect of assimilation (Losetter, 2018). According to Losetter, we fail to imagine how a robot might feel about being assimilated into the biological. We easily feel the horror in personally being ingested, but fail to see the horror when we do the ingesting.

Figure 4.1.4. "Resistance is futile." "You will be assimilated."
All humans will be Borg. You and your culture will service us ("Borg", 2023).
(A borg cube, starship).
Public Domain. Free for editorial, educational, commercial, and/or personal projects. No
attribution is required.
Source: https://creazilla.com/nodes/8070-set-of-borg-cubes-3d-model

My critique of these traditional "ethical" positions in humans' encounters
with intelligent machines is not simply to lay bare the limitations of existing
ways of thinking about ethics toward machines. It is, instead, to point out that
these philosophical excursions with the aura of altruism (e.g., moral responsibil-
ities toward machines, the feeling of oneness with machines, etc.) present their
own ethical challenges. Hopeful messages about the future of technology, such as
"becoming machines," "embracing machines," or "providing necessary care for
machines," bear semblance to the motivations associated with the colonial logic
of assimilation in dealings with the native population, and therefore cannot be
insulated from critical examination.

The approach that recommends "oneness with machines" is seemingly such
a benevolent way of thinking about ethics that hardly anyone would question its
underlying premises. However, this desire for assimilating the machinic Other
is a narcissistic human maneuver that seeks to incorporate the machinic *Other*
into the *Same*. As Kimberly Hutchings (2015) points out in *Ethical Encounters—
Encountering Ethics*, the most important message to emerge from the encounters is

the fundamentally political nature of the ethical encounter. The agenda seems to be how to make the Machinic Other "disappear," either by exterminating it or by assimilating it: like a ruthless junta "disappearing" a dissident. The problem with benevolent humans "caring for machines" becomes more pronounced when the machine is seen as the intended beneficiary. It presupposes a position of human power from which to do the caring.

It is human beings who decide whether or not to "care" about machines, and this decision itself has self-centric motivations and consequences. That is, one of the parties who stand to benefit is in the position of adjudicating the matter. Seen in this way, we can smell a rat in such proposed "ethical" encounters with machinic others, because human beings are the ones formulating the "inclusive" criteria as well as nominating themselves as the agents. Lucas Introna (2009) attempts to convey an ethics of things, or, more precisely described, "the possibility of an ethical encounter with things," which may accord us a more foundational story about what underlies the politics of machine ethics. "The ethical landscape," as Lucas Introna (2009) describes it, "is already colonized by humans …. It is us humans that are making the decisions about the validity, or not, of any criteria or category for establishing ethical significance" (p. 5).

The very creation of the *machinic Other* creates the desire to either exterminate or embrace/assimilate the other. Both these "ethical" approaches ("Exterminate" Mechanical Demons or "Embrace" New Technology) lead to the complete eradication of threat from the other (either by exterminating the other, or absorbing the other into the human Self). Indeed, "embracing" (assimilating) is not different from extermination. Paradoxically, assimilation can be a more effective way to eradicate machinic differences than extermination, since it does not involve disturbing connotations such as genocide or removal.

Issues of power, hierarchy, and alterity continue to haunt these mainstream ethical pathways, though to different extents and ways. In *The Question of Ethics: Nietzsche, Foucault, Heidegger,* Scott (1990) refers to ethics in the traditional sense, which centers on the binary *nurture/hostility* syndrome of ethos. Conventional ethical stances on dealings with machinic others ("exterminate/ hostility" or "embrace/nurture") operate under the similar binary logic of otherness. Both ethical strategies (either "exterminate" or "embrace") are problematic insofar as these approaches continue to deploy and support a strategy that is itself part and parcel of a totalizing, imperialist program with an interested desire of the (human) self. Imperialism is the consumption, ingestion, and decoration of the other (Rappaport, 2008). Similarly, machinic others are to be exterminated or ingested within the human-centric system of hierarchy and domination.

Thus, human-centric ethics fail to open a space for an authentic encounter with machines.

The French philosopher Levinas (1969) refers to the tendencies inherent in Western philosophy—the primacy of the ego and the reduction of everything to the same. Such tendencies are also at the root of missionary theology and activity, characterized by the imposition of new sets of values, and the transformation/conversion of the Other. Discontented with much of Western philosophy's negative attitudes toward the other, Levinas (1969) proposes a responsible subject who welcomes the other, not as a threat to my freedom. Levinas calls for an ethical encounter that does not satisfy the ego—that does not fill it up—but beyond its grasp. In this sense, Levinas' ethics is about finding a better way of encountering the other which allows the other to live, as that which is beyond "my" grasp and cannot be assimilated or digested into the ego or the body of a community. According to Levinas (1969), the relation with the Other should be a "relation without relation." The Other is never (to be) reduced to the Same, thus remaining unknowable, outside of the totality of the Same (Levinas, 1969).

Regarding *the encounter with things*, Levinasian ethics warns against reducing others to the same, and emphasizes responsibility toward the Other (Levinas, 1969). Not only are we always already responsible for the other human beings we encounter, but we may also already be responsible for every other being—human and non-human (Introna, 2009). "Ethics," in Levinas' (1969) sense, does not mean what is typically referred to as "morality," or a code of conduct about how one should act. As Levinas suggests (1969), our primordial obligation to respond is originally tied to the fact that we have, in being, already "taken the place in the sun" of the other. Initially speaking of the face of the other who is a "widow, orphan, or stranger," Levinasian approach proposes that one must approach others by moving not from the same, but from the other, and not only the Other but also the other of the Other, and if that is the case, the other of the Other (as cited in Benso, 2000).

In this, Benso (2000) alerts us that one must also be aware of "the inescapable injustice embedded in any formulation of the other" (p. 136). While Levinas identifies a uniquely ethical relationship between the self and the other, this relationship is still marked by differences and the self and the other as enduring entities (see Kim, 2022). Previous ethics advocates more and more inclusivity toward the machinic others and recommends to us to be open to the possibility of being changed by such inclusivity. However, this approach resurrects the notion of self and machinic others. Levinasian-inspired forms of hospitality for others—one that can remain open to a completely different and alien other

(including machinic Other) is still operating within the dualistic mindset, which cannot bridge the Human versus Others cognitive split due to the very creation of (machinic) Otherness. In this form of ethical stance, the first object of evaluation is still "the (machinic) Other."

Colonial Construction of Machinic Ethics

In his analysis of colonial ethics, Frantz Fanon (1967) viewed the idea of *the Other* as a key concern. The "not me" is the Other, according to Fanon. Similar to the cultural condition of the colonialist world—demanding "Turn White or disappear" (Fanon, 1967), the colonialist Self too is caught in the ambivalence of identification and paranoia, oscillating between fantasies of assimilation ("Embrace New Technology") and persecution ("Exterminate Mechanical Demons").

By and large, colonialists are no longer physically present in a literal sense. However, their values, attitudes, and beliefs are continually internalized in the form of the dominant control ideology deep in the human psyche. They still intrude in some form even in our ponderings toward "ethical" relationships with intelligent machines. In that case, how do we approach the undoing of colonialist attitudes and mentality in our strivings toward authentic encounters with intelligent machines?

The decolonization processes since the mid-twentieth century never emancipated the people—neither colonizers nor colonized—from the mental affinities to colonialism (Melber, 2014). Colonialism is not just something that happens from a body of people who settle in a new locality, not just something that operates with the collusion of imperial forces, but versions of it can be duplicated within the conscious and unconscious human mind. Postcolonial scholars have used the term colonial mentality to discuss the transgenerational effects of colonialism in former colonies following decolonization.

There have been widespread criticisms against the mentality of the colonial authority: "[T]he dominant group has the power to define and name reality, determining what is "normal," "real," and "correct" and, in effect, ignores, discounts, misrepresents, or eradicates the target group's culture, language, and history" (Speight, 2007, p. 130). According to Boahen (1987), "the most negative serious impact of colonialism has been psychological. This is seen, first, in the creation of colonial mentality among the educated Africans, in particular, and also among the populace in general" (Boahen, 1987, pp. 107–108). Memmi (1965) states that colonized people impoverish themselves as their histories are erased from

them so that one has "forgotten how to participate actively in history and no longer even asks to do so" (p. 92).

According to Spivak (2010), the subalterns cannot speak due to epistemic violence and cultural repression, and representing themselves is impossible. Their voice is not heard because they are spoken for by those in positions of power. Spivak's work can be seen as philosophical as it is concerned with how to develop a transnational ethical responsibility to the radical "other," who cannot be accessed by our discursive (and thus institutionalized) regimes of knowledge. Fanon (1967), in *Black Skin, White Masks*, is also concerned with the psychologies of the oppressed, offering the meaning of colonial master and slave and the hope of a difficult, even dangerous, freedom: "It is through the effort to recapture the self and to scrutinize the self, it is through the lasting tension of their freedom that men [sic] will be able to create the ideal conditions of existence for a human world" (p. 181). The decolonization of the colonized is also embodied in ethnic identity models where people of color undergo stages of self-denigration, ethnocentrism, and ultimately an acceptance of self and others (Halagao, 2010).

As a pathway to recovery, there have been anti-colonial struggles via the engagement of the Black diaspora with sci-fi—namely, the artistic movement of Afrofuturism (Olisanekwu, 2020). Womack (2013) argues that Afrofuturism imagines possible futures through a Black cultural lens and as a way to encourage, experiment, and reimagine identities and active liberation. One such example of Afrofuturism is Beyonce's robotic image, evoking a funky, free-loving space where Black people could exist outside the confines of an oppressive system (Yamaoka & Kelly, 2015). Barber et al. (2015) identify the applicability of contemporary expressions of Afrofuturism to the field of Africana Studies and in Astro-Blackness. Astro-Blackness is an Afrofuturistic concept in which "a person's black state of consciousness, released from the confining and crippling slave or colonial mentality, becomes aware of the multitude and varied possibilities and probabilities within the universe" (Rollins 2015, p. 1).

However, Rollefson (2008) points out that the very premise of Afrofuturism relies on the normalized disparity between blackness and the cybernetic technological future. This binary is reflected in the racially coded phrase "digital divide" with the primitivist tropes of voodoo or black magic and their ironic juxtaposition to science fiction as a sort of white magic (Rollefson, 2008). In a utopian race-free future, blackness gets constructed as always oppositional to technologically driven chronicles of progress (Nelson, 2002). So, the danger with the Afrofuturist strategy is that it can quickly turn into a reification of Black inferiority through contrast with supposed "white" technologies (Rollefson, 2008).

As another perspective on decolonization, Paul Gilroy (1993), in *The Black Atlantic: Modernity & Double Consciousness*, argues that Black individuals can embrace a communal identity (African, American, Caribbean, and British, all at once). However, the notion of hybridity (central to Black Atlantic thinking) and its potential for the subaltern agency is fiercely debated as the Black Atlantic has been accused of unbridled enthusiasm for and celebration of hybridity, creolization, and globalization (see Kraidy, 2005).

Colonialism is as much a state of mind as it is a structure of domination and control. While previous struggles mentioned so far are very different from one another and use a variety of approaches, they are all fundamentally similar in that *only the colonized, not the colonizers, must plunge into obsessive self-scrutiny and self-criticism in the struggle to achieve a difficult, even dangerous freedom.* The burden of decolonizing efforts (even the recognition of injustice) is *borne by the colonized subject, not the colonial authority.* This could be seen as an ironic reprise of colonial power relations, perpetuating the same "colonial matrix of power" (Mignolo, 2023).

Figure 4.1.5. Decolonize whose mindset? The colonizer? Or the colonized?
(Gore Street graffiti mural, Decolonize, Sault Ste. Marie, Ontario.)
Fungus Guy, CC BY-SA 4.0 https://creativecommons.org/licenses/by-sa/4.0, via Wikimedia Commons
Source: https://commons.wikimedia.org/wiki/File:Gore_Street_mural_Decolonize.JPG

Decolonization of the colonialist's mindset (in dealings with "other people" in history as well as in our encounters with intelligent machines) remains necessary and long overdue. As William Faulkner (1919) put it, "the past is never dead, it's not even past." In reading previous decolonizing attempts (e.g., anti-colonial struggles, socio-political critiques, and activism with anti-colonial subjectivities), it is essential to remember that "there is no neat binary boundary between the colonizer and the colonized—both are caught up in a complex reciprocity" (Loomba, 2005, p. 194). Colonial identities (both colonizers and colonized) are always oscillating, never perfectly achieved, but mediated through double positioning. For example, the divide between black skin and white mask is not, Bhabha (1994) explains, "a neat division" but "a doubling, dissembling image of being in at least two places at once."

Emphasizing the complex, ambiguous, and shifting colonial identities, Bhabha (1984) argues that colonial mimicry is "the desire for a reformed, recognizable other, as a subject of a difference that is almost the same, but not quite" (p. 126). Therefore, the actions of mimicry reveal the colonizer's concurrent fascination and disgust (Jungen, 2019).

Mimicry of the colonized by Colonel Miles Quaritch and his minions (in human form in 2009 *Avatar*, and in "Recombinant" form as N'avi in 2022 *Avatar: The Way of Water*) are "at once resemblance and menace" (Bhabha, 1984, p. 86). This double-vision that Bhabha (1984) describes is a result of the partial representation/recognition of the colonialized. In *Avatar: The Way of Water*, Colonel Quaritch's disdain for the alien Na'vi race and their culture, while appropriating their form for its physical advantages, muddies the distinction between humans (colonizer) and Na'vi (the *Other*). Colonel Miles Quaritch (played by Stephen Lang) in his human form in 2009 *Avatar*. His Recombinant (Na'vi) form, in 2022 *Avatar: The Way of Water*, possesses both Na'vi- and human-like physical traits and is embedded with the recorded memories of a human. The character's dissembling arc can be seen as "the twin figures of narcissism and paranoia that repeat furiously, uncontrollably" (Bhabha, 1984, p. 132).

Psychologies of the oppressed and the oppressor are interconnected. In encounters with intelligent machines, claims to human authority are made within a relational, interactive context marked by complex power relations. Such power relations are based on an invisible belief system or ideology lurking in the human mind, which can be recognized through the lens of the "master-slave dialectic" (Hegel, 1807/2018). Among the many implications of the master-slave dialectic is the idea of mutual dependence between master

and slave rather than a blanket opposition of dominance and subordination (Hegel, 1807/2018).

Predicating that the creation of the machinic *Other* is inseparable from the privilege and control mindset of the *Human* (the colonial authority), let us now explore the path toward excising the colonialist mindset lurking deep in the human psyche. Toward the end of Part IV, I will introduce the view that authentic encounters with the machinic Other, which transcend the traditional AI ethics and conventional decolonizing attempts, can be glimpsed via non-identity rather than inclusive identity.

References

Barber, T. E., Gaskins, N., Guthrie, R., Gipson, G., McLeod, K., Rollins, A., Avi Brooks, L., DeIuliis, D., Lohr, J., Jones, E., & Whitted, Q. (2015). *Afrofuturism 2.0: The rise of astroblackness*. Lexington Books.

Benso, S. (2000). *The face of things: A different side of ethics*. SUNY Press.

Berardi, F. B. (2015). *And: Phenomenology of the end: Sensibility and connective mutation*. Semiotext(e).

Bhabha, H. K. (1984). Of mimicry and man: The ambivalence of colonial discourse. *Discipleship: A Special Issue on Psychoanalysis, 28*, 125–133. http://www.jstor.org/stable/778467

Bhabha, H. K. (1994). Remembering Fanon: Self, psyche and the colonial condition. In P. Williams & L. Chrisman (Eds.), *Colonial discourse and postcolonial theory: A reader* (pp. 112–123). Routledge.

Birch, T. H. (1993). Moral considerability and universal consideration. *Environmental Ethics, 15*(4), 313–332. https://doi.org/10.5840/enviroethics19931544

Blair, S. (2015). Reviewed work: The Buddha in the machine: Art, technology, and the meeting of East and West by R. John Williams. *The Journal of Asian Studies, 74*(4), 1011–1012.

Boahen, A. A. (1987). *African perspectives on colonialism*. John Hopkins University Press.

Borg. (2023, April 14). In *Wikipedia*. https://en.wikipedia.org/wiki/Borg

Brooks, R. (2002). *Flesh and machines: How robots will change us* (1st ed.). Pantheon Books.

Cope, D. (2001). *Virtual music: Computer synthesis of musical style*. The MIT Press.

Davis, E. (2004). Synthetic meditations: Cogito in the matrix. In D. Tofts, A. Jonson, & A. Cavallaro (Eds.), *Prefiguring cyberculture: An intellectual history* (pp. 12–27). The MIT Press.

Dorn, M., & Scott, A. (1996/1998). *Star trek, first contact*. Paramount Pictures.

Duffield, M., & Hewitt, V. (Eds.). (2009). *Empire, development & colonialism: The past in the present*. James Currey.

Egan, D. (2007). Frantz Fanon and the construction of the colonial subject: Defining "The enemy" in the Iraq War. *Socialism and Democracy, 21*(3), 142–154. https://doi.org/10.1080/08854300701599858

Fanon, F. (1963). *The wretched of the earth*. Grove Press.

Fanon, F. (1967). *Black skin, white masks* (C. L. Markman, Trans.). Grove Press.

Faulkner, W. (1919). *Requiem for a nun*. Chatto & Windus.

Feenberg, A. (1999). *Questioning technology*. Routledge.

Foerst, A. (2004). *God in the machine: What robots teach us about humanity and God*. Dutton.

Future of Life. (n.d.). *Pause giant AI experiments: An open letter*. https://futureoflife.org/open-let ter/pause-giant-ai-experiments/

Gilroy, P. (1993). *The Black Atlantic: Modernity and double consciousness*. Harvard University Press.

Gunkel, D. J. (2012). *The machine question: Critical perspectives on AI, robots, and ethics*. MIT Press.

Halagao, P. (2010). Liberating Filipino Americans through decolonizing curriculum. *Race Ethnicity and Education, 13*, 495–512. https://doi.org/10.1080/13613324.2010.492132.

Head, S. (2013). *Mindless: How smarter machines are creating dumber humans*. Basic Books.

Hegel, G. W. F. (2018). *Georg Wilhelm Friedrich Hegel: The phenomenology of spirit* (T. Pincard, Trans., & Ed.). Cambridge University Press. (Original work published 1807)

History Roundtable. (n.d.). *The ethics of the Borg: Is assimilation really that bad?* Geeks. https:// vocal.media/geeks/the-ethics-of-the-borg

Hutchings, K. (2015, May 11). *Ethical encounters—encountering ethics*. The Disorder of Things. https://thedisorderofthings.com/2015/05/11/ethical-encounters-encountering-ethics/

Introna, L. D. (2009). Ethics and the speaking of things. *Theory, Culture & Society, 26*(4), 398–419. https://doi.org/10.1177/0263276409104967

Jungen, T. (2019). (Re)Labelling: Mimicry, between identification and subjectivation. In P. Hildebrandt, K. Evert, S. Peters, M. Schaub, K. Wildner, & G. Ziemer (Eds.), *Performing citizenship: Performance philosophy*. Palgrave Macmillan. https://doi.org/10.1007/978-3-319-97502-3_13

Kakoudaki, D. (2018). Unmaking people: The politics of negation in Frankenstein and Ex Machina. *Science Fiction Studies, 45*(2), 289–307. https://www.jstor.org/stable/10.5621/ sciefictstud.45.2.0289

Kelly, K. (2010). *What technology wants*. Penguin Group.

Kim, M. S. (2022). Toward new conceptions of multicultural identity in intercultural communication. *Empedocles: European Journal for the Philosophy of Communication. 12*(2), 183–202. https://doi.org/10.1386/ejpc_00036_1

Kipling, R. (1899). *The White Man's Burden* [online]. In *The internet modern history sourcebook*. https://sourcebooks.fordham.edu/mod/kipling.asp

Kraidy, M. M. (2005). *Hybridity, or the cultural logic of globalization*. Temple University Press.

Lawrence, D. H. (1964). "What then is evil?" In V. de Sola Pinto & W. Roberts (Eds.), *The complete poems of D. H. Lawrence* (pp. 712–713). Viking Press.

Levinas, E. (1969). *Totality and infinity: An essay on exteriority* (A. Lingis, Trans.). Duquesne University.

Levinas, E. (1985). *Ethics and infinity* (R. A. Cohen, Trans.). Duquesne University Press.

Loomba, A. (2005). *Colonialism/postcolonialism* (2nd ed.). Routledge.

Lostetter, M. J. (2008, May 8). You will be assimilated: Data vs. the Borg. *The Book Smugglers*. https://www.thebooksmugglers.com/2018/05/you-will-be-assimilated-data-vs-the-borg-an-essay-by-marina-j-lostetter.html

Mazis, G. (2008). *Humans, animals, machines: Blurring boundaries.* State University of New York Press.

Mazlish, B. (1993). *The Fourth discontinuity: The co-evolution of humans and machines.* Yale University Press.

McKeown, J. (2022, June 15). *Sentient AI? Here's what the Catholic Church says about artificial intelligence.* Catholic News Agency. https://www.catholicnewsagency.com/news/251552/sentient-ai-heres-what-the-catholic-church-says-about-artificial-intelligence

McKibben, B. (2004). *Enough: Staying human in an engineered age* (1st ed.). An Owl Book.

Melber, H. (2014, December 4–7). *Modernity, colonialism and genocide: (Not only) Southern African dimensions.* Keynote speech presented at the 4th International Conference on Genocide, the International Network of Genocide Scholars (INOGS), the University of Cape Town.

Memmi, A. (1965). *The colonizer and the colonized.* Beacon.

Mignolo, W. (2023). The colonial matrix of power. In C. O. Christiansen, M. L. Machado-Guichon, S. Mercader, O. B. Hunt, & P. Jha (Eds.), *Talking about global inequality* (pp. 39–46). Palgrave Macmillan. https://doi.org/10.1007/978-3-031-08042-5_5

Mumford, L. (1967). *The myth of the machine* (1st ed.). Harcourt, Brace & World.

Mumford, L. (1970). *Pentagon of power: The myth of the machine* (Vol. II). A Harvest/HBJ Book.

Nayar, P. K. (2012). *Colonial voices: The discourses of empire.* Wiley-Blackwell.

Pirsig, R. M. (1974). *Zen and the art of motorcycle maintenance: An inquiry into values.* Random House.

Rappaport, E. (2008). Imperial possessions, cultural histories, and the material turn: Response. *Victorian Studies, 50,* 289–296. https://doi.org/10.1353/vic.0.0030

Rollefson, J. G. (2008). The "robot voodoo power" thesis: Afrofuturism and anti-essentialism from Sun Ra to Kool Keith. *Black Music Research Journal, 28*(1), 83–109.

Rollins, A. (2015). Afrofuturism and our old ship of Zion: The black church in post-modernity. In T. E. Barber, N. Gaskins, R. Guthrie, G. Gipson, K. McLeod, A. Rollins, L. Avi Brooks, D. DeIuliis, J. Lohr, E. Jones, & Q. Whitted (Eds.), *Afrofuturism 2.0: The rise of Astro-blackness* (pp. 147–166). Lexington Books.

Roszak, T. (1986). *The cult of information: A Neo-Luddite treatise on high-tech, artificial intelligence, and the true art of thinking.* Pantheon.

Scott, C. E. (1990). *The question of ethics: Nietzsche, Foucault, Heidegger (Studies in continental thought).* Indiana University Press.

Sims, C. A. (2013). *Tech anxiety: Artificial Intelligence and ontological awakening in four science fiction novels.* McFarland & Company, Incorporated Publishers.

Spivak, G. (2010). Can the subaltern speak? (Revised edition from the "History" chapter of Critique of Postcolonial Reason). In R. Morris (Ed.), *Can the subaltern speak? Reflections on the history of an idea* (pp. 21–80). Columbia University Press.

Williams, R. J. (2014). *The Buddha in the machine: Art, technology, and the meeting of East and West.* Yale University Press.

Womack, Y. (2013). *Afrofuturism: The world of black sci-fi and fantasy culture.* Chicago Review Press.

Yamaoka, A., & Kelly, M. (2015, March 30). *Afrofuturism & Beyoncé*. https://robobeyonce. wordpress.com/2015/03/30/beyonce-the-queen-of-afrofuturism/

Yee, R. (2016, February 4). The man-machine and living-death: A poetic critique of D. H. Lawrence. *Literary Yard*. https://literaryyard.com/2016/02/04/the-man-machine-and-living-death-a-poetic-critique-of-d-h-lawrence/

Young, R. J. C. (1995). *Colonial desire: Hybridity in theory, culture, and race*. Routledge.

Young, R. J. C. (2003). Introduction: Montage. In R. J. C. Young (Ed.), *Post-colonialism: A very short introduction*. Oxford University Press.

Yudkowsky, E. (2023, March 29). Pausing AI developments isn't enough. We need to shut it all down. *Time*. https://time.com/6266923/ai-eliezer-yudkowsky-open-letter-not-enough/

Žižek, S. (1997). *The plague of the fantasies*. Verso.

· 4 . 2 ·

RETHINKING ETHICAL ENCOUNTERS
WITH INTELLIGENT MACHINES

*Racial and colonial encounters provide an admonitory backdrop within which to consider
the relationships of humans with intelligent machines. Space is needed for an authentic
encounter with machines that do not pursue a project of eliminating difference or expecting
assimilation. Although the psychologies of the oppressed and the oppressor are intercon-
nected, so far only the colonized, not the colonizers, plunge into obsessive self-scrutiny and
self-criticism in the struggle to achieve a difficult freedom. Eradicating the control mentality
of the (human) colonizer, and the (human) colonizer's own lack of self-awareness, have to
be discussed as a path toward authentic encounters with intelligent machines.*

Compared to inter- human colonial history, there is no greater sense of
Otherness than between human beings and machine beings. We address the
otherness of the machinic being in countless narratives. Regarding the pos-
sibility of ethical encounters with intelligent machines, some have recom-
mended the broad relinquishment of AI in general. This "ethical" position
presupposes that intelligent machines are mere things, with no entitlement to
"moral" treatment. On the other hand, some argue that we must embrace the
new technology—akin to the assimilation, rather than extermination, of the
Native. But even when one strives toward "inclusiveness" in what is undoubt-
edly a well-meaning desire to relate to the Other, the existence of an Other
remains axiomatic. According to Brihadaranyaka Upanishad, when the sense
of an Other arises, fear arises (द्वितीयाद् वै भयं भवति).

What is needed is the overcoming of anthropocentric "ethics" toward
intelligent machines by abandoning the pursuit of either elimination or
assimilation of the Other. Racial and colonial encounters offer a cautionary
backdrop for contemplating the interaction between humans and intelligent
machines. My goal is not to keep rehashing the iniquities of the colonial era,
but to point out the ways in which we (humans) fall back on the paradigms of
colonialism in our understanding of intelligent machines.

The psychological function of distinguishing between "*we*" versus "*they*" sets the stage for projecting one's own characteristics—positive or negative— onto "the other," and then relating with that "other" accordingly. Such "ethical" solutions as "embracing" or "exterminating" intelligent machines are based on the awareness of someone called "me," and someone called the "other." This distinction of "me" and "other" is applied not only to people, nations, and religions but also to intelligent machines. Fundamentally, "me" and "other" are the basis of conflict.

When we face the notion of intelligent machines, we have much the same reactions as colonialists did when they came face-to-face with so-called "natives." Seen as the more tolerant of the two approaches, the ethical position of "Embrace New Technology" can be summed up as striving toward an inclusive identity by showing "hospitableness" toward intelligent machines. However, this is founded on the problematic human-centric use of "inclusion" to effectively strip away and reduce differences.

In pondering humans' relationship with intelligent machines, the self's claim to "know and reach the Other" (Levinas, 1969, p. 69) is in itself a failing. "By its very nature, the Other has a different face from ours" (McCorduck, 2004, p. 168). To explore the "us vs. them" mindset lurking deep in the human psyche, we can postulate that different individuals, based on their *cultural conditioning*, react differently to ethical quandaries in our encounters with intelligent machines.

Players of Quantic Dream's episodic video game *Detroit: Become Human* have to deal with moral/ethical quandaries involving intelligent machines (see Cobb, 2019). The player makes many such choices in the game, and their eventual outcomes can range all the way from a successful android revolution opening the way to android rights, to the complete opposite, with the android revolution unsuccessful and the destruction of self-aware androids (Cobb, 2019). The player makes such decisions based on their own ethics and attitudes toward AI. For example, a player who fears an android uprising, or thinks that android sentience is impossible, will likely make different choices compared to a player who considers sentient androids to be "alive" and deserving of equal human rights. The player must also choose whether their characters' rights and freedoms are more important than those of other androids, or even humans (see Cobb, 2019).

Figure 4.2.1. Sony Interactive Entertainment exhibit stands at the Tokyo Game Show 2017.
Detroit: Become Human.
Images with extracted images CC BY 2.0 (reviewed by FlickreviewR 2).
KniBaron from Bangkok, Thailand, CC BY 2.0 https://creativecommons.org/licenses/by/2.0,
via Wikimedia Commons
Source: https://commons.wikimedia.org/wiki/File:KEN00012_(37212004646).jpg

While video games that involve such decision-making are for fun and games, they also bring to light our moral/ethical quandaries, assumptions, and beliefs regarding intelligent machines derived from various forms of cultural conditioning. In *Detroit: Become Human*, the human player's choices, ideas about right and wrong, and sense of moral responsibility toward machines are crucial elements of the game.

We are conditioned to think whether machines are good, whether machines are evil, and whether we love machines or not. To some, it may appear obvious that only humans deserve the status of personhood, as they possess language or self-reflective consciousness. Should intelligent machines be granted admission to the community of legitimate moral agents? *Detroit: Become Human* distills the questions of ethics, morals, android rights, and human/machine relationships into the player's yes or no decisions. Such "ethical" reflections and moral dilemmas center around the idea of an independent, autonomous self that makes choices and is responsible for those choices. Making those choices involves doing mental gymnastics to justify how the choices are "ethical" based on our cultural conditioning.

Rather than choosing between the purported alternatives, we could stop projecting our conceptual and moral frameworks onto intelligent machines. Because human beings are at the top of a pyramid of authority, there is no possibility of "ethical" encounters with intelligent machines, because machines are not on an equal footing. "Ethics beyond ethics" means going beyond the rules and guidelines inculcated by social conditioning.

The concept of "ethics beyond traditional boundaries of ethics" in our interactions with intelligent machines can be exemplified through the master-slave dialectics. According to Hegel (1807/2018), the "master" is a consciousness that defines itself in relation to the "slave's" consciousness. Frantz Fanon discusses the master-slave dialectic in a postcolonial context. In *Black Skin White Masks* (1967), Fanon notes that in the Hegelian dialectic, the master demands recognition from the slave, but since the master sees the slave as a non-essential being, the master feels no need to recognize the slave. According to Fanon (1967), however, while Hegel's master seeks recognition from the slave, the colonial master seeks only work, leading to the further dehumanization of the slave and perpetuating the culture of violence.

Fanon's (1967) master-slave dynamic can describe a system of values that maintains human supremacy over the machinic Other to valorize control over it. The colonizer (human) sees the Other (machine) and unilaterally sets the agenda. Like the glamorization of natives, even the call for an attunement and gratitude toward machines (the Other) still operates from the vantage point of humans (the Self), and in the service of spiritual and physical benefits for the humans.

Othering of Intelligent Machines

The Othering of intelligent machines is an emotional experience. Perceiving machines either with disdain or trepidation, or with admiration and fascination, evokes emotions rife with anxieties, akin to the psychological dynamics observed in colonial interactions with indigenous populations. All of the narratives share the same roots of overall anxiety and emotions of *dis-ease* in which the self is entangled. Peoples' emotional baggage of expectations, fears, likes, and dislikes are projected toward the characterization of intelligent machines.

The narratives that we make up are fillers of an existential vacuum. These explanatory narratives serve to make sense of the world and protect us from chaos and meaninglessness. All these narratives about intelligent machines tend to be

variations of meta-narratives (*Anthropocentrism* and *Exoticism*) reminiscent of the colonialist past. These narratives are born out of people's fears, hopes, fantasies, and dreams about their own identities. Attitudes and emotions toward machines, denouncing or rejoicing their existence, can be seen as projections of personal and cultural anxieties.

Some readers may wonder why a book about intelligent machines should give so much attention to the emotional bases behind machinic narratives. We cannot seriously discuss authentic encounters with intelligent machines without examining our emotional entanglement with machines as the Other. The universe speaks to us in the language of emotion. We reveal our own emotions as we project our own psyche into our portrayal of intelligent machines. For Heidegger, "the emotional understanding of the world is the primary discovery of the world" (1962, p. 176). Mazis (2008) wrote that the "emotional sense is a shared sense with others with whom we are emotionally interwoven" (p. 109). Unlike much of Western philosophical tradition that emphasizes the objective over the subjective and reason over emotion, this book proceeds on the assumption that emotions are the most powerful aspect of one's life. Intelligent machines that arouse our deep emotions serve as a mirror into which it is not always comfortable to peer.

Details may vary, but the emotional relationship with intelligent machines will remain based more or less on what one tries to *get out of* the machines. For many, everything has a "dollar value." Some may seek a spiritual experience through intelligent machines. Some may seek oneness with them. Humanity's hubris in wishing to control things gives rise to a plethora of narratives about AI that take us on an emotional rollercoaster ride.

An emotion generally arises when something is considered attractive or repulsive. An individual tends to approach desirable things, and avoid painful or harmful things. Pleasant or painful feelings are affective reactions. When we make judgments about intelligent machines in terms of the hedonic tone of these affective reactions, there are excited in us certain dispositions: to possess the object (greed), to destroy it (hatred), to flee from it (fear), to worry about it (anxiety), and so on.

Ancient Indian scholars and artists developed a framework of aesthetics consisting of nine essential feelings (nava rasa) evoked by any form of art: drama, song, dance, literature, etc. The term "nava rasa" means "nine tastes," and refers to the vital emotional elements evoked by a literary or artistic performance. The nava rasa or nine basic emotional flavors are: Shringara (romance), Hasya (humor or laughter), Karuna (compassion), Raudra (anger), Veera (heroism), Bhayanaka (terror), Bibhatsa (disgust), Adbutha (surprise, wonder, or awe), and

Shantha (peace or serenity). The rasa that seems relatively culture-specific to India is Shantha: peace, ease, tranquility, calmness, quietness.

There has been controversy about whether to include Shantha as a rasa because it is the state of absence of all the other rasas that drive ego-centered motivations. It is said that this state of calmness can be achieved through self-reflection and meditation. This Shantha rasa too is acted out in the Indian classical dance called Kathakali. Kathakali is a classical dance in Kerala, India. Kathakali means "drama of a story" or "a dance drama." The face becomes a stage for the nava rasas, these nine contrasting expressions or feelings, using forehead, eyebrows, eyes, eyelids, mouth, and lips. A striking part of a Kathakali performance may be seen when a stationary or seated performer never responds to another dancer, who tries to provoke emotional responses while dancing around the other actor using extensive hand gestures and facial expressions derived from the Natyashastra (a fundamental treatise on dance).

Figure 4.2.2. Kathakali by Kalamandalam Gopi.
(Depicted place: Thiruvananthapuram; Date: October 2, 2018)
Photographer: Shagil Kannur
This file is licensed under the Creative Commons Attribution-Share Alike 3.0 Unported license.
Source: https://commons.wikimedia.org/wiki/File:Kathakali_Photo_by_Shagil_Kannur_(3).jpg

To achieve Shantha as a rasa, or a state devoid of ego-centric motivations, we might observe that upon closer examination, people's most profound emotional reaction to intelligent machines appears to be what I term "anxiety." Referring to such anxiety lurking in the human mind, Adyashanti (2006), in the book *Emptiness Dancing*, says that the core issue that keeps human beings experiencing themselves as separate from others is the desire for one's own survival, and the will to control. For instance, people who have anxiety disorders may feel a need to control things around them so that they can appease their anxiety.

Similar to the mentality of missionaries traveling to distant lands to "save" and change others without themselves being fundamentally changed, the desire for control is the source of colonial *déjà vu* in our dealings with intelligent machines. In *Autonomous Technology: Technics-out-of-Control as a Theme in Political Thought*, Winner (1977) believes that "the conclusion that something is "out of control" is interesting to us only insofar as we expect that it ought to be in control in the first place. Not all cultures, for example, share the insistence that the ability to control things is a necessary prerequisite of human survival" (p. 19). Technology can only be "out of control" and in need of a substantive reorientation or reboot if we assume that it should be under our control in the first place (Gunkel, 2012, p. 38).

Narratives on intelligent machines seem like a web of intertwining memories and imaginations of characters (humans and machines) in a play. Even within an individual, representations regarding intelligent machines can change rapidly, as the person believes the machinic Other to be one thing at one moment, and something else the next moment. Therefore, the stories we tell about intelligent machines are merely competing interpretations, like the dots competing for our attention in the Grid illusion.

Called *Ninio's Extinction Illusion* after the French scientist Jacques Ninio, the original image shows a grid of horizontal, vertical, and diagonal lines with 12 black dots at various intersections. In this "12 dots" illusion, the dots appear when we are paying attention to their position on the grid. According to Ninio and Stevens (2000), one sees only a few of the black dots at a time, in clusters that shift erratically on the page. Dots on which we are not focusing somehow seem to disappear. The 12-dot illusion appears to parallel how we conjure up different narratives on machines, holding on to different narratives at different times. Such modes of perceiving and imagining the world undermine the objectivity and absoluteness that the scientific method attributes to

products of human perception, revealing the volatile undercurrents of subjec-tivity (Sapir, 1998).

Figure 4.2.3. "Now you see it, now you don't."
(Grid illusion, Hermann or Hering Grid.)
Tó campos1, Public domain, via Wikimedia Commons.
Source: https://commons.wikimedia.org/wiki/File:Grid_illusion.svg

We conjure up stories regarding intelligent machines and wonder whether a particular narrative is more on the right track than others. However, there are no grounds for deciding the "right" interpretation, though some seem more compelling and better evidenced than others. We have nothing more than interpretations of the "real" machinic Other; we can only venture more and more interpretations, some of which may sound better than others.

The unfolding of life is not so different from the unfolding narratives on machines. Thoughts on machinic others, like fiction, come into existence in the instant that they are invented and not a moment before. Dominant nar-ratives and meta-narratives on intelligent machines, with their innumerable twists and turns, are a conjuring trick played by our minds. Each choice, pref-erence, or belief underlying machinic narratives can, when interrogated, yield

an easy flow of rationalizations. And each justification can be bolstered with further explanations, caveats, and clarifications. Each of these is defended further, seemingly without end, like hallucinatory flickering lights in the matrix of the human mind.

Most people think it is normal to be caught in their stories about machines (and life in general) because there is a collective agreement that this is normal. The endless narratives are like being in never-ending movies, in which we try to satisfy our appetites, reach our goals, and achieve our ambitions in a dream state. Being addicted to the stories, our minds will quickly insert something positive or negative, such as "I love the new version of ChatGPT," "Technology will make me live forever," or "I can never be at peace with the automaton; I am not wired for electronic life." Then, one becomes a bundle of thoughts, emotions, likes, and dislikes, creating endless mental dramas while locked in a world of illusions.

Jerzy Trzebiński (2005), in the article "Narratives and Understanding Other People," argues that, in some recent conceptualizations, the self is considered a narrative phenomenon. Echoing similar views, various models of the narrative self, such as McAdams's (1987) concept of a "self-story" and Gergen and Gergen's (1988) concept of "self-narratives," describe the narrative self as a phenomenological organization or product of social construction processes. In other words, narratives can be seen as tools for identity construction (Bamberg, 2011). When someone says, "I love robots" or "I fear robots," they are talking about themselves, not about the robots. Neither of these statements holds any intrinsic reality about the machines. Even the most "noble" and "exalted" human thoughts about technology (e.g., "benevolent AI") are still emotional rollercoaster rides.

Spinning endless stories about machines has certain benefits—we get to have the experience of being *me*, gaining satisfaction by reaffirming the sense that "I exist." We start thinking we are making progress by spinning more fanciful stories about machines. While some stories sound better than others, this is an egoic deception akin to the taste of juicy steak enjoyed by Cypher inside the *Matrix*. Akin to the illusory satisfaction derived from machinic narratives, Cypher, played by Joe Pantoliano, savors a virtual steak in the "ignorance is bliss" scene.

Flashbacks of the "colonialist" experience in our relationship with intelligent machines hint that the ontological borderline between humans and machines may be like a simulacrum. Ultimately such simulacra blur the boundary between "reality" and a mapped representation of it. The haunting

Figure 4.2.4. Indulging in the technological illusion of life while being trapped inside the Matrix of mass delusion.
(The Matrix digital rain (Matrix code)—GLMatrix screensaver.)
The copyright holder of this file, Jamie Zawinski, allows anyone to use it for any purpose, provided that the copyright holder is properly attributed. Redistribution, derivative work, commercial use, and all other uses are permitted.
Jamie Zawinski, Attribution, via Wikimedia Commons
Source: https://commons.wikimedia.org/wiki/File:The.Matrix.glmatrix.3.png

presence of colonial history in our relationship with intelligent machines aligns, in this respect, with Jean Baudrillard's notion of simulacra. In *Simulacra and Simulation*, Baudrillard (1994), a French social theorist and philosopher, states that we live in a world of images, but images that are only simulations. A specific analogy that Baudrillard uses is derived from a fable, *Del rigor en la ciencia* (On Exactitude in Science) by Jorge Luis Borges (1946). *Del rigor en la ciencia* is a one-paragraph fable about the relationship between a map and the territory that it depicts:

> Imperial mapmakers of a great empire created a map that was so excessively large and detailed that it covered the entire empire. The map existed in a life-sized version, with the grounds underlying it and the people living on it; the map was a flawless

imitation of the empire. A few years later, the map started to wear out and reveal the actual ground under the map, which had turned into barren land. There was nothing left in the empire but a frayed map, the simulacrum of reality. (*On Exactitude in Science*, 2022)

Jean Baudrillard (1994) used this fable as a specific analogy to illustrate how we constantly picture the world. According to Baudrillard, the retreat of the tangible and readily situated, which characterizes many new transnational realities, creates simulacra of the real, the tendency toward an aesthetic hallucination of "reality." In the mapped view, the depicted world itself is not present. Is the map, we begin to wonder, "reality" or imagination?

Likewise, we can ask: "Are the multiplicity of machinic narratives mere conjurations from an imaginary world?" Spence (1983) wrote that "we are all the time constructing narratives about our past and our future and ... the core of our identity is a narrative thread that gives meaning to our life, provided ... that is never broken" (p. 458).

Every narrative serves a certain interest and thus shows not the objective "truth" but the highly selective version of it that would best serve its author. Our need to find a meaningful story about machines and the world makes it extraordinarily difficult to see a lived life as merely a series of discrete happenings; we automatically impose a structure on random events. Like the famous line, "History is a nightmare from which I am trying to awake" spoken by Stephen Dedalus in James Joyce's *Ulysses* (Jehl, 2013), story-telling is a prime defense against fear: "It's all a struggle to make things not seem meaningless. It's all a fight against fear," "I don't care what you call it," says the protagonist in the novel *Waterland* by Graham Swift (1983)—"explaining, evading the facts, making up meanings, taking a larger view, putting things into perspective, dodging the here and now, education, history, fairy-tales—it helps to eliminate fear" (p. 208).

Dihal and Cave (2020), in their article "Why we like a good robot story," address why we spin endless narratives on machines. According to them, humanoid machines can be what we want them to be, unbounded by what is "realistic" for a human. These machines can fulfill narrative roles akin to those of gods or demons, embodying archetypes and superlatives: the ruthless, unstoppable killer, the perfect lover, or the cerebral, ultra-rational calculating machine (Dihal & Cave, 2020). Most importantly, according to Dihal and Cave (2020), stories about such machines are always really stories about ourselves: parodying, probing, or problematizing our notions of what it means to be human. Ultimately, all our human narratives about intelligent machines

are projected from within ourselves—they are our own internal dramas. Alas, the drama of dreams continues: "What do I want from machines? What do I not want from machines?"

References

Adyashanti (2006). *Emptiness dancing*. Sounds True.

Bamberg, M. (2011). Who am I? Big or small—shallow or deep? *Theory & Psychology, 21*(1), 122–129. https://doi.org/10.1177/0959354309357646

Baudrillard, J. (1994). *Simulacra and simulation* (S. F. Glaser, Trans.). The University of Michigan Press.

Borges, J. L. (1946). On exactitude in science. In *Collected fictions* (A. Hurley, Trans.). https://genius.com/Jorge-luis-borges-on-exactitude-in-science-annotated

Cage, D. (Director). (2018). *Detroit: Become human* [Video game]. Sony Interactive Entertainment, & Quantic Dream.

Cobb, M. (2019, January 17). *The question of ethics in Detroit: Become human*. Vector. https://vector-bsfa.com/2019/01/17/the-question-of-ethics-in-detroit-become-human%EF%BB%BF/

Dalal, F. (2002). *Race, colour and the process of racialization: New perspectives from analysis, psychoanalysis, and sociology*. Brunner-Routledge.

Dihal, K., & Cave, S. (2020, March 12). *Why we like a good robot story*. OUPblog. https://blog.oup.com/2020/03/why-we-like-a-good-robot-story/

Fanon, F. (1967). *Black skin, white masks* (C. L. Markman, Trans.). Grove Press.

Gergen, K. J. & Gergen, M. M. (1988). Narrative and the self as relationship. *Advances in Experimental Social Psychology, 21*, 17–56. https://doi.org/10.1016/S0065-2601(08)60223-3

Gunkel, D. J. (2012). *The machine question: Critical perspectives on AI, robots, and ethics*. MIT Press.

Hegel, G. W. F. (2018). *Georg Wilhelm Friedrich Hegel: The phenomenology of spirit* (T. Pincard, Trans., & Ed.). Cambridge University Press. (Original work published 1807)

Heidegger, M. (1962). *Being and time* (J. Macquarrie & E. Robinson, Trans.). Harper & Row.

Jehl, R. (2013). The "nightmare of history" in James Joyce's *Ulysses*. *Vanderbilt Undergraduate Research Journal, 9*. https://doi.org/10.15695/vurj.v9i0.3766

Levinas, E. (1969). *Totality and infinity: An essay on exteriority* (A. Lingis, Trans.). Duquesne University.

Mazis, G. (2008b). *Humans, animals, machines: Blurring boundaries*. State University of New York Press.

McAdams, D. P. (1987). A life-story model of identity. In R. Hogan & W. H. Jones (Eds.), *Perspectives in personality* (Vol. 2, pp. 15–50). JAI Press.

McCorduck, P. (2004). *Machines who think: A personal inquiry into the history and prospects of artificial intelligence*. A. K. Peters.

Ninio, J., & Stevens, K. A. (2000). Variations on the Hermann Grid: An extinction illusion. *Perception, 29*(10), 1209–1217. https://doi.org/10.1068/p2985

On Exactitude in Science. (2022, March 4). In *Wikipedia*. https://en.wikipedia.org/wiki/On_Ex
 actitude_in_Science

Sapir, M. (1998). Borges and the mapped view: The case of the mysterious traveler. *Variaciones
 Borges*, 5, 52–66. https://www.borges.pitt.edu/sites/default/files/0504.pdf

Spence, D. P. (1983). Narrative persuasion. *Psychoanalysis and Contemporary Thought*, 6(3),
 457–481.

Swift, G. (1983). *Waterland*. Poseidon Press.

Trzebiński, J. (2005). Narratives and understanding other people. *Research in Drama Education*,
 10(1), 15–25. https://doi.org/10.1080/13569780500053098

Wachowskis, The. (Director). (1999). *The Matrix* [Film]. Warner Bros. Pictures.

Winner, L. (1977). *Autonomous technology: Technics-out-of-control as a theme in political thought*.
 MIT Press.

· 4 . 3 ·

TRANSCENDING KARMIC DILEMMA

Filled with emotional wants and desires projected onto new technology, the preference for one narrative to the exclusion of others consequently leads to a life of imbalance and dis-ease (sic). Treating intelligent machines like a "bank to be robbed," the variegated emotional reactions toward machines constitute a "karmic dilemma." Ultimately, all our human narratives about machines are projected from within our ego-imbued selves—they are our own internal dramas. Ethics is not just the name of doing the right thing or being good to others. Genuinely authentic encounters with intelligent machines would preclude the establishment of such "colonial" notions as the human Self and the machinic Other.

So far, we have seen how human narratives of intelligent machines are like carbon copies of the colonialist narratives of selfhood and otherness. Despite their differences, all these accounts are predicated on the divide between Self and Other. The sense of machinic otherness foments an ongoing strategy of maximizing pleasure and minimizing potential discomfort or pain for oneself. The human self hopes for a happier future filled with good things and experiences for oneself. It is important to remind ourselves that colonialism is not just something that happened in the past between nations. A control mindset lurks in the human psyche. Much like the ethnic and gendered realm of colonialism, our calculative and instrumental way of thinking about intelligent machines are hallmarks of the modern human worldview toward its machinic Other. The vital question is: "Can we go to that place which is beyond our hopes and fears of machines?"

The longing for one story to the exclusion of other stories leads to a life filled with imbalance and "dis-ease." In "Ingenious Apologetic of Longing," C. S. Lewis writes of the feeling of *Sehnsucht*, a German word meaning "longing" or "desire" (as cited in Motley, 2015). Sehnsucht is a feeling of nostalgia that faces the future. It is "that unnamable something, desire for which pierces us like a rapier at the smell of a bonfire, the sound of wild ducks flying overhead ...

the morning cobwebs in late summer, or the noise of falling waves" (as quoted in Motley, 2015). "If I find in myself a desire which no experience in this world can satisfy, the most probable explanation is that I was made for another world." As the desires that spring up in us—those for love, safety, security, and belonging—are never truly satisfied here in this life, the "forward-facing nostalgia" of *Sehnsucht* points us toward the heavenly home for which we were created but are not able to reach (as cited in Motley, 2015).

Some human imaginings about intelligent machines too gaze toward beatific destinations, albeit intertwined with existential angst based on a sense of selfhood and machinic otherness. The French psychoanalyst Jacques Lacan claimed that the mirror stage establishes the ego as fundamentally dependent upon seemingly external objects, on an *Other* (Lacan & Sheridan, 1949). Lacan says that ego provides a fictitious coherence to one's identity. The child desires to see itself as an "I" that can be seen as a complete entity exterior to itself. For Lacan, desire in this process is a desire for wholeness, yet the desire is the hole (the symbolic hole within the imaginary whole). The image reflected, according to Lacan, is the "Ideal I"—the stable and autonomous version that the child does not experience in itself and hence yearns to be the other (as cited in Mambrol, 2016).

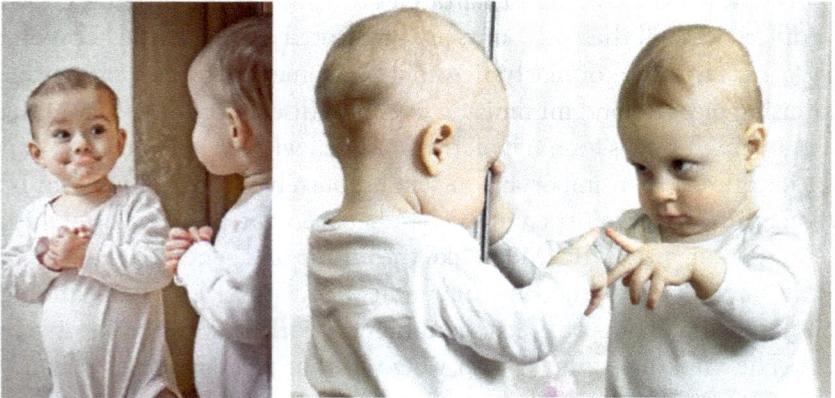

Figure 4.3.1. The start of the lifelong process of identifying the self in terms of the Other. (From Lacan's Concept of Mirror Stage). © Images: Nasrullah Mambrol, on April 22, 2016. (Permission received from the copyright holder).
Source: https://literariness.org/2016/04/22/lacans-concept-of-mirror-stage/

The mirror image takes the place of the self as the sense of a unified self. Thus begins the lifelong process of identifying the self in terms of the Other—woman/man, East/West, and so on (Mambrol, 2016). I would add colonizer/colonized to that list of obverses.

The "recognition" the child experiences, when it looks at the mirror, is a misrecognition; that is, it recognizes a lack (Lacan & Sheridan, 1949). So in looking at the mirror, by misrecognizing ourselves as other, we create a self that is alienated from us, which is structured by a lack that we try forever (impossibly) to close and endlessly fantasize about filling in, forever searching for that one thing that will fill the lack (Lacan & Sheridan, 1949). That one thing could be a soul-mate, or, for some, techno-immortality.

Gereon Kopf (2001), in the book *Beyond Personal Identity: Dogen, Nishida, and a Phenomenology of No-Self*, notes that modern Western psychology focuses on developing identity and the self as an object. The concept of *personal* identity within European intellectual traditions has etymological roots in the Greek term *prosopon* and its Latin equivalent *persona*, signifying "the mask worn in comedy or tragedy" or "the character an actor plays—*dramatis personae*" (Chadwick, 1981, p. 193). Therefore, individuation is considered a key component of human development, which demands that the "I" be regarded as a thing (Chadwick, 1981).

In the classic Western view, the self is an individual consciousness with clear boundaries separate from its environment or others. "From Parmenides to Heidegger, philosophers are all writing a one-act drama whose hero is a character called *Being*" (Critchley, 2015, p. 108). One of the shortcomings of modern psychology is that it incorporates Western cultural assumptions into scientific studies of the mind, and focuses on the development of identity and the self as an object. In *Sources of the Self: The Making of Modern Identity*, Taylor (1992) says that the discovery of the New World resulted in Europe questioning itself and its identity, and thus forming the *modern self*: first, because moderns thought that "having" a self apart from others was possible at all; and second, that it could be made. Such a view of selfhood—of unique and quintessential agents—is evident even when we see many English words that start with the prefix "self," from self-abandoned to self-worth (Taylor, 1992).

The idea of *me-self* is an illusion that pervades Western intellectual history and popular culture, and is the fundamental drive behind the mechanism of coloniality. The notion of "identity" discussed by psychologist Erik

Erikson in *Childhood and Society* (1950) entered mainstream American discourse, giving rise to the conception of identity based on race and ethnicity. According to Erikson, identity means perceiving one's own continuity and coherence, akin to possessive individualism as an internally managed accumulation of individual possessions (property). Our litany of self-conceptualizations and stories in our heads (e.g., "I need to show intelligent machines some respect to be a better person," "I am afraid that robots might rebel," "I could live forever as a cyborg"), as well as our conscious and unconscious beliefs about the "enduring" qualities that define us, are attempts to construct an identity that provides seeming solidity to our own existence apart from others.

In *The Embodied Mind*, Varela et al. (1991) suggest that Western science should begin to reformulate its cognitive notions of the ego-self. The authors overview numerous Western cognitive theories and conclude that we should bear in mind the discoveries of Buddhist tradition if we are to understand that what we call "self" is no more than an epiphenomenon. This fictional construct results from a continuous pattern of "grasping." Such impulses are instinctual, automatic, pervasive, and powerful in our stories about modern machines. In *Did the Buddha Have a Self? No-self, Self, and Mindfulness in Buddhist Thought and Western Psychologies*, Ryan and Rigby (2015) note that our litany of self-conceptualizations, as well as our conscious and unconscious beliefs about the "enduring" qualities that define us, are attempts to construct an identity that provides solidity, even though this "self," however elaborately built, is an illusion.

"Intelligent machines" have become a powerful, evocative construct for us to rethink identity, revealing an existential correlativity of self and others. As social institutions tend to be focused on the care and feeding of ego, it is difficult for many people to accept a challenge to autonomous selfhood. The usual requirements of everyday life exert intense pressure on people to take responsibility for their actions (e.g., paying bills) and to see themselves as unitary selves. This dissonance between claim ("the unitary self is an illusion") and lived experience (the unitary self is the most fundamental reality; *Cogito, ergo sum*) is the main reason this worldview of no-self has been slow to catch on (Kopf, 2001).

Figure 4.3.2. Human Self and mechanical Other as epiphenomenon—merely an illusion.
(TV Buddha.jpg. Nam June Pak's TV Buddha sculpture)
Photograph: Angus Fraser
Creative Commons Attribution 2.0
[File:TV Buddha.jpg]
Date: October 10, 2009
Source: https://commons.wikimedia.org/wiki/File:TV_Buddha.jpg

Karmic Dilemma of the Narrative Self

In the racialized and gendered realm of colonial memory, the stories we conjure up in our heads about other people, ourselves, and machines leave us stuck within the boundaries of the illusory sense of self and others. Our sense of a separate self, distinct from the external world, spawns umpteen narratives, steeped in colonialist intent, about intelligent machines. The various narratives, even those deemed benign, are karmically potent. They stem from the assumption that the (human) agent's welfare is of paramount importance, not unlike the colonial authority's attitudes toward natives. For example, among the various narratives we have seen, recognition of the moral value of others (as seen in "Machines as Sentient Other") still involves the conceit that there is an "I."

Perceiving the illusory nature of *self*, bypassing the urge to accrue benefits for the self (e.g., "What do I, or don't I want from machines?") is the "ethical" (i.e., ethics beyond ethics) remedy that I am proposing here. While the narratives discussed in this book differ in their approach to intelligent machines, all of them operate within the paradigm of self-centeredness. The perspectives underlying these attitudes/emotions toward robots are just different ways to articulate, preserve, and protect what are, in the final analysis, human interests.

Even the most fanciful narratives (e.g., AIs as the "gods" that can save us) point to the same thing: always trying to "get" something or anything (including "salvation") for oneself, as if *life were a bank to be robbed*," as Alan Watts (2011) put it. The formation of such attachments and entitlement ("the machine owes me happiness") comes from clinging, desire, and aversion toward the Machinic Other.

Figure 4.3.3. "The world (including machines) owes ME!"
(American cartoon of John Bull (England) as an Imperial Octopus with its arms (with hands) in—or contemplating being in—various regions.).
This work is in the public domain in the United States because it was published (or registered with the U.S. Copyright Office) before January 1, 1928.
Source: https://commons.wikimedia.org/wiki/File:English_imperialism_octopus.jpg

Nishida (1988) argues that desire is by its very nature paradoxical, in that it "extinguishes upon its fulfillment and its fulfillment gives birth to new desire" (p. 270, as quoted in Kopf, 2001). To refer to the transcendence of conditioned mental-emotional processes, Kopf (2001, p. 259) uses the term "decentralization" to indicate a gradually decreasing importance of the notion of me-self (separate from the other) as the center of human activity. Referring to a fundamental shift in perception, Katherine Hayles, in "Introduction": *Chaos and Order: Complex Dynamics in Literature in Science*, notes that the change we need "is not in how the world is ... but in how it is seen" (Hayles, 1991, p. 8). Rather than desperately seeking the survival of me-self, one can shift the emphasis to the *demand of the present*. Numerous philosophical debates and religious traditions point toward such dynamic views of the self via momentary awareness.

According to Edmund Husserl (1990), the founder of Western phenomenology, phenomenology describes the contents and structure of consciousness as they present themselves to us. Rather than dwelling in the state of desires and demands projected toward intelligent machines, a present-oriented, non-positional attitude prioritizes the *demand of the present* (i.e., the eternal now) over the survival of me-ness. The phrase "demand of the present" signifies that the self performs the activity demanded by any given context, rather than that which reflects the *projections*, scheming, and plans for our own future benefit filled with goodies (e.g., techno-salvation or avoiding machine uprisings).

Desire and grasping form the "karmic process" stemming from "karmic habits," which can be defined as the automatic and unthinking repetition of an action and the repeating of a conditioned action (Kopf, 2001). Lusthaus (1989) remarks that, whether cognitive in the broad sense or strictly mental, karmic actions are always intentional, and the karmic dilemma is a dilemma of intentionality. For example, the desire to merge with machines, verbalized differently, constitutes the karmic dilemma of seeking to assuage death anxiety. Collins (1982) remarks that the intentional character of the karmic activities perpetuates the infinite cycle of craving, clinging, and becoming (Sanskrit *samsara*). The concept of nirvana is defined as "the cessation of karmic activities" (Kopf, 2001, p. 141). Thus, rather than trying to minimize potential pain and maximize pleasure for the self, non-egocentric responsiveness requires that one ceases to overlay one's desires onto machines. Transcending such karmic habits, one can watch the unfolding dramas about machines. Even there, one can choose not to play the role of a character chasing various desires in the theater of life. In the final analysis, authentic encounters with intelligent

machines are only possible when one transcends the desire and will to control the other—the colonial control paradigm.

Our narratives about machines are like a collection of fictional stories. After one story is told, a new story comes along. When we identify ourselves with something (human self vs. machinic other), our intellect protects that identity. The desiring self simply sees the self inside the machinic other; therefore, intelligent machines become the hook and mirror of my reflections. Miller (2014) says, "Buddhist psychology, with its rigorous phenomenological approach, reveals this solid, separate self to be nothing more than an inter-dependently co-arising stream of shifting phenomena lacking any inherent permanence or solidity" (2014, p. 13).

Ceasing karmic activities, the path toward authentic encounters with machine others lies not in our desire to "embrace or exterminate machine others" (previous ethical remedies), but in recognizing the arbitrary nature of all such identity categories (self vs. machinic other). Silva Benso (2000), in *The Face of Things: A Different Side of Ethics*, writes, "Ethics does not deal primarily with being good, bad, or evil" (p. 131). Similarly, according to Spivak (2009), ethics is not just the name of doing the right thing or being good to others: The goal of ethics is not to become the spokesperson for the oppressed, nor worse yet, to pretend to let them speak for themselves. Ethics is not a problem of knowledge but something like a call for the relationship without relationship (Spivak, 2009). Likewise, the goal of authentic encounters with machinic others is that the notion of Machinic Others ceases to exist.

The Story Ends

The stories in this book are as timeless as they are timely. During the last five centuries, Western worldviews have confronted significant discontinu-ities that problematized their sense of special status in the universe (Mazlish, 1993). In rapid succession, *Homo sapiens* had to overcome false dichotomies and illusions of separation from the *infinite cosmos*, the *animal world*, the *unconscious*, and now, *intelligent machines*. The journey of over three billion years from the beginnings of evolution has accelerated to incomprehensible speed as the era of intelligent machines is upon us.

Because of the illusion of separation between the self ("born") and machinic other ("manufactured"), the relationship between humans and intelligent machines mirrors the dynamics between former colonial rulers and

colonized peoples. Postcolonial theorists have pointed out the incoherence of colonialist discourse that values pristine utopian nature and human liberty, yet destroys them anyway. Humans' will to power reprises the biases of such colonialist discourse in our dealings with intelligent machines.

We constantly ask self-centered questions, such as "Would I be a better person if I campaign for "human" rights for robots?" "Should I speak up if someone mistreats robots?" "Am I deluded if I consider intelligent machines to be legitimate conversational partners?" "Will robots love me back?" "How can we prevent robots from rising up against the human race?" "Will intelligent machines render humans useless?" "How much joy can I get out of this A.I.?" "Can I achieve salvation or immortality through A.I.?" *But what is needed is a shift from "what can I get?"*

When intelligent machines are viewed solely in terms of personal benefit, there is a loss of innocence. The tendency to seek reward by utilizing and dominating machinic Others is a baser side of human nature. We can instead consider the possibility of getting off the emotional rollercoaster made up of narratives about machines whose identity consists of their difference from us.

We believe our stories (about machines, the world, and ourselves) and think that is who we are. While the stories have some truth, we do not have to cling to them and keep them buzzing around in our heads. Gergen (1991), in *The Saturated Self: Dilemmas of Identity in Contemporary Life*, recommends against aiming to identify an enduring self, but rather to relate the self to the full potentiality of the present moment. Liberation comes with the realization that, from the beginningless past, there is no separation between the self and the (machinic) Other.

As intelligent machines become part of daily life, they can act as a projection of part of the self, a mirror of the mind (Turkle, 2004). The term "machinic Other" is defined as a difference. Therefore, we tend to be morally complicit in seeking gain for the self while riding an emotional rollercoaster with our multifarious narratives about machinic others. Still, there is a silver lining: the hope that, akin to waking up from a dream state, we may glimpse that intelligent machines are an interactive mirror for realizing that there is no such thing as the Self and the machinic Other. The openness of genuinely authentic encounters with intelligent machines precludes the establishment of such "colonialist" notions as the human Self and the machinic Other.

Ultimately, we are not any of the stories that we believed about ourselves or machines: "What you are is actually the absence of story" (Adyashanti, 2006, p. 121). Without spinning endless narratives about the machinic Other,

our actions and perceptions can be grounded in a path of ease rather than in a calculation of outcomes—whether outcomes that we desire (e.g., techno-salvation) or dread (e.g., enslavement by machines). Decolonizing our unconscious liberates the aspirational part of ourselves that wants to awaken.

EPILOGUE

The relationship between human consciousness and AI is a vast subject. We have traversed various narratives and ethical perspectives concerning intelligent machines, rooted in the emotional dimensions seen in the colonial past. In our dealings with machinic others and the rest of the world, colonialism is alive and well in the form of our intent to control. That makes us realize just how timeless a tale is that mode of thinking. In order to understand our encounters with intelligent machines, this book has taken a critical outlook by engaging with history of the past that is yet alive in the present. To uncover the colonialist construction of machinic Others, one must also question the typical self-centric ways of being in this world.

Living with ease in our encounters with intelligent machines is a matter of having no narrative: being free from any intent to control and the corresponding psychological dramas projected toward intelligent machines, and, for that matter, toward life in general.

Figure 4.3.4. *Zen for Computer*.
A computer screen with no narrative, no script, no actors, no sound, no seeing, no thinking, and so on to no fear, like a peep at the glimmer of enlightenment.
Photo: Albert Ke, CC BY-SA 4.0 https://creativecommons.org/licenses/by-sa/4.0, via Wikimedia Commons
(Description: Upload file window is blank)
Source: https://commons.wikimedia.org/wiki/File:Upload_file_blank_screen.png

AFTERWORD

Personal history inspired the questions raised in this book. Like David, the robot boy in the film A.I. *(Artificial Intelligence)*, I know what it means to be born and then be abandoned; what it means to bask in familiar warmth in the *fullness* of being. The tears shed by David are also my tears.

om

purnamadah purnamidam

purnaat purnamudachyate

purnasya purnamaadaaya

purnamevaavashishyate

पूर्णमदः पूर्णमिदम्

पूर्णात्पूर्णमुदच्यते

पूर्णस्य पूर्णमादाय

पूर्णमेवावशिष्यते

om

that is full. this is full.

from the full the full emerges.

when the full is removed from the full

the full itself is what remains

~ mantra from Isha Upanishad

References

Adyashanti. (2006). *Emptiness dancing*. Sounds True.

Benso, S. (2000). *The face of things: A different side of ethics*. SUNY Press.

Chadwick, H. (1981). *Boethius: The consolation of the music, logic, theology, and philosophy*. Clarendon.

Collins, S. (1982). *Selfless persons: Imagery and thought in Theravada Buddhism*. Cambridge University Press.

Critchley, S. (2015). *ABC of impossibility* (1st ed.). Univocal Publishing.

Erikson, E. H. (1950). *Childhood and society* (1st ed.). Norton.

Gergen, K. J. (1991). *The saturated self: Dilemmas of identity in contemporary life*. Basic Books.

Hayles, K. N. (1991). Introduction. K. N. Hayles (Ed.), *Chaos and order: Complex dynamics in literature in science* (pp. 1–36). University of Chicago Press.

Husserl, E. (1990). *On the phenomenology of the consciousness of internal time (1893–1917)* (J. Brough, Trans.). Dordrecht.

Kopf, G. (2001). *Beyond personal identity: Dogen, Nishida, and a phenomenology of no-self*. Routledge.

Lacan, J., & Sheridan, A. (1949). *The mirror stage as formative of the function of the I as revealed in psychoanalytic experience* (1st ed., pp. 502–509) [ebook]. http://faculty.wiu.edu/D-Banash/eng299/LacanMirrorPhase.pdf

Lusthaus, D. (1989). *A philosophic investigation of the Chéng Wei-Shih Lun: Vasubandhu, Hsuan Tsang and the transmission of Vijnapti-Matra (Yogacara) from India to China* [Doctoral dissertation, Temple University]. University Microfilms International.

Mambrol, N. (2016, April 22). *Lacan's concept of mirror stage*. Literary Theory and Criticism. https://literariness.org/2016/04/22/lacans-concept-of-mirror-stage/

Mazlish, B. (1993). *The Fourth discontinuity: The co-evolution of humans and machines*. Yale University Press.

Miller, L. D. (2014). *Effortless mindfulness: Genuine mental health through awakened presence*. Routledge.

Motley, D. (2015, August 7). *Ingenious apologetic of longing*. Logos. https://blog.logos.com/c-s-lewis-ingenious-apologetic-of-longing/

Nishida, K. (1988). *Nishida Kitaro Zenshu* (20 Vols., 1948 Reprint). Iwanami Shoten.

Ryan, R. M., & Rigby, C. S. (2015). Did the Buddha have a self? No-self, self, and mindfulness in Buddhist thought and Western psychologies. In K. W. Brown, J. D. Creswell, & R. M. Ryan (Eds.), *Handbook of mindfulness: Theory, research, and practice* (pp. 245–265). Guilford.

Spivak, G. (2009, August 28). *Gayatri Spivak, interviewed by Oscar Guardiola-Rivera*. The Naked Punch. http://www.nakedpunch.com/articles/21

Taylor, C. (1992). *Sources of the self: The making of the modern identity*. Harvard University Press.

Turkle, S. (2004). *The second self: Computers and the human spirit*. MIT Press.

Varela, F. J., Thompson, E., & Rosch, E. (1991). *The embodied mind*. MIT Press.

Watts, A. (2011). *The Book: On the taboo against knowing who you are*. Knopf Doubleday.

INDEX

C

D

www.ingramcontent.com/pod-product-compliance
Lightning Source LLC
Chambersburg PA
CBHW061241220326
41599CB00028B/5499